MW00861594

DESERT

BY

Arid Places

Tailor-Made Spaces

Molly Mandell
& James Burke

Abrams, New York

DESIGN

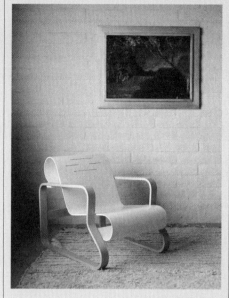
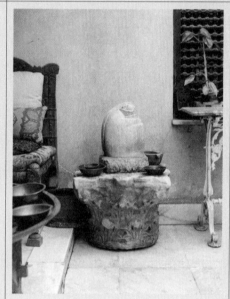

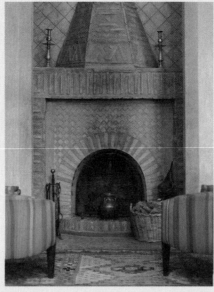

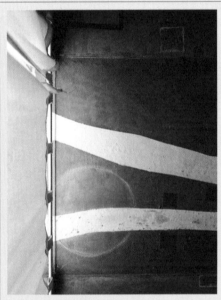

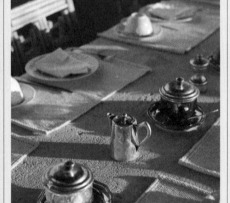

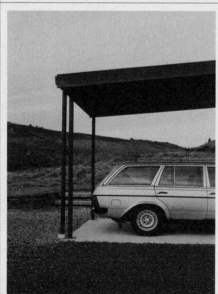

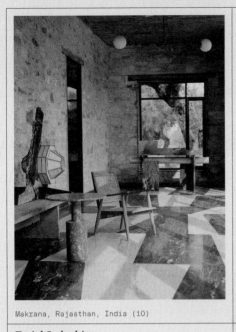

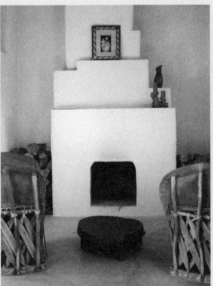

INTRODUCTION

We are sitting here with writer's block—not because there isn't plenty to say about the desert, but because we are left wondering how to translate the last seven months we spent with its people into one short text. What began as a book about spaces in Earth's arid climes and, more importantly, the creative minds who inhabit them, evolved into something greater. *Desert by Design* forged a community and thus transformed itself. It became a love letter to these dreamers and doers, all of whom have the same basic thing in common—lack of rainfall—but as it turns out, share in so much more.

The desert, and specifically a swath of the American Southwest known as the Big Bend, is exceedingly special in our own lives. In September of 2013, we were lured seven hours west of Austin, where we were both completing our undergraduate degrees, by the legacy of the artist-mystic Donald Judd and a landscape that neither of us knew existed in the Lone Star State. We began falling in love—with each other and with this singular place. But love is a funny thing. You don't always know it when you see it. While we finished our studies, Far West Texas served as a beloved escape from the hustle and bustle of the city. We didn't think of it as some destiny-altering locale, one that would faintly whisper in our ears until we finally listened. We said what we thought were our forever goodbyes to the land of the Alamo, cowboys, oil, and college football and moved abroad, working in Denmark, Germany, Mexico, and Cuba. Yet, the desert remained engraved on our hearts. When we could pull off a return, we found ourselves in what seemed like our natural habitat—strangely so because we hail from Cleveland and the Bay Area. In other words, for us this borderland was anything but natural. In the end, we lived in many parts of the world only to find out that this remote corner, one that was formative in our relationship but also in our work as writers and photographers, was where we wanted to be for the long haul.

In many ways, this book became our search for answers. Why do deserts—whether in Texas or on the India-Pakistan border—have such deep claws in us? Why do we feel at home whenever we find ourselves in these surroundings, no matter how far away and unfamiliar? And why do their people have a tendency to feel like kin, quickly and without effort?

When we were first beginning production for this project, we went to a lecture on desert smells from the Tucson-based ethnobotanist, professor, and author Gary Paul Nabhan. He gave us our first clue. "Deserts," he said, "are laboratories for the future." He meant that humans in these settings have long been learning to adapt to elements—whether water scarcity or severe temperatures—associated with climate change. Resilience, self-confidence coupled with a respect for the natural environment, and a sense of know-how, or at least a willingness to learn how, come across as near requirements for desert dwellers.

But Nabhan's words got us thinking. Deserts are laboratories for all kinds of experimentation. There is a freedom in the big sky and the vast expanses. Later, at a dinner put on by the chef Johnny Ortiz-Concha and his partner, Maida Branch, two extraordinary souls who appear within these pages, the Santa Fe shopkeeper Sophie Sagar recalled her introduction to the high-desert city. "I have never heard my thoughts so loud," the New York transplant mused between sips of a mezcal cocktail chilled over frozen chunks of rose quartz. In these wilds that many consider barren and lifeless (though, as we hope you will come to understand, they are not), a magical notion surfaces: In the midst of so-called nothing, *anything* appears possible.

We like to think of this as one of the reasons that Donald Judd chose the arid terrain where Texas and Mexico meet to carry out his vision, radically reinterpreting the ways that art, architecture, and landscape converge. Or why, when the artist James Turrell spotted a crater in the dramatic Arizona desert northeast of Flagstaff, he stopped in his tracks—or rather, in his contrails. He was maneuvering a single engine plane at the time. He purchased the site in 1979 and has been molding it into his magnum opus, which has been compared to the Mexican pyramids and Stonehenge, ever since. Georgia O'Keeffe in Abiquiu, Burners in Black Rock, Nevada, Frank Lloyd Wright at Taliesin West, Michael Heizer in his *City* a three-hour drive from Las Vegas—the examples are endless, and we're just talking about the contemporary.

Sitting at lunch beneath the palms of Siwa, Egypt, where we were welcomed into the sand, salt, and rope universe of India Mahdavi and Mounir Neamatalla, we met Dustin Donaldson and Robynn Iwata, who have spent fifteen-plus years researching the Sahara as the possible source of ancient Egyptian civilization. Could these pioneers of geometry, astronomy, architecture, and medicine be rooted in what is now the largest hot desert on Earth? Over Egyptian flatbreads slathered with homemade tahini and olives, they suggested as much. We went on to visit Petra, the famed Jordanian historical site where the Nabataeans carved an entire city into canyon walls and out of pink sandstone. This concept of drylands as a testing grounds for humanity? Spots rich with tradition where arts and culture thrive? Areas where people are learning how to live in the world *with* the world? They are nothing new.

We can attest that deserts are not always the easiest and most comfortable places to settle. And so there is something about those who choose to call them home, who don't opt for the path of least resistance, who constantly create and innovate. *Desert by Design* is our attempt to pinpoint what exactly "something" means. We set off on our quest. What better way, we thought, than to explore these people's spaces—or as we see them, physical manifestations of their personal values?

We started by looking for interesting architecture and interiors, but our search needed to go even deeper. We decided to take a different approach, asking ourselves, "If we were to throw the ultimate desert dinner party, who would we invite?" The final list included choreographers, hoteliers, sculptors, environmentalists, chefs, audio engineers, and preservationists. We joke that we then invited

ourselves to their places, instead of the other way around. Don't worry—we'll summon them all to a real dinner party one day soon.

The result is decidedly not your average interiors book but, in our opinion, is genuine, beautiful, and absolutely full of design inspiration. Yes, this book is for desert people—those who reside in it or who simply resonate with it. Yet, it also exists for anyone regardless of where they live or what they do. We frequently take influence from the most unlikely of references: a grocery store aisle, an abandoned house, a ski lodge that couldn't be farther from our own day-to-day reality. As you might discover flipping through these pages, we can be completely charmed by a quirky bathroom or a messy shelf, the warm tones that envelop a generational pecan farm's production facilities outside of El Paso, Texas, or a camper van kitchen in Patagonia. Other times, we are moved by a table of carefully curated rocks or a temporary outdoor dining room, a fixture of these dry climates that we have come to seriously appreciate. Across countries and continents, we realized that the boundaries between interior and exterior spaces are always blurred, even in weather zones that appear harsh and unforgiving at first glance. Temperatures may be extreme, but so are the shifts between day and night. Mornings and evenings—especially under a blanket of stars—would be wasted indoors.

By area, deserts make up a third of Earth's landmass. We traveled to the far reaches of the planet, making our way through the southwestern United States, down to Mexico and Argentina, across the pond to Egypt, Morocco, Jordan, and Lanzarote. We ventured to India and to a micro-desert in New Zealand. We admittedly didn't get everywhere that we wanted to go—our guest list is *long*—but we tried to cover our bases. We visited high desert and low desert, urban desert and rural desert, sandy desert and scrubby desert.

In the Western world, the word "desert" is often linked with uninhabited wastelands, literally connected to the concept of desertion. In Berber languages and in Arabic, the word is much more complex and related to aspects of color and space, generating other nouns and verbs, like *sahara*, which describes the process of changing food from raw to cooked. Sometimes, we had to look a little harder—so much is in the details or even underground—but we found life at every turn. Those who live in these ecosystems know better than to trust a dictionary to define their existence.

Back in our own town of Marfa, we're sitting on our front porch in a desert microcosm of our own making. Every few hours, the train passes, having chugged its way through other sunbaked stretches in Arizona and New Mexico or east of us from Del Rio and Alpine. Birds flutter around our feeder, a green, silo-shaped design. It matches the yuccas, whose stalks twist in otherworldly ways and dot our front yard. Our table—welded steel powder-coated in the same mellowed hue—withstands the annual spring gusts. Some of the writer's block has faded.

On multiple occasions this last year, we were asked to name our favorite desert location in the book. We would always come up with an offhand answer, but finally, on the first day of January—perhaps in the spirit of the new year—we thought about it for a minute longer and replied truly and honestly. "West Texas," we said. Since that moment, we have thought long and hard about that feeling and what it is to mean those words. In 2013, we were falling in love with each other and with this region. Now, we're in love. Maybe that's where "something" comes from: romance, a true devotion to the place that you call home, through the good and the bad, the ups and the downs, the heat and the dry and *all* of the dust.

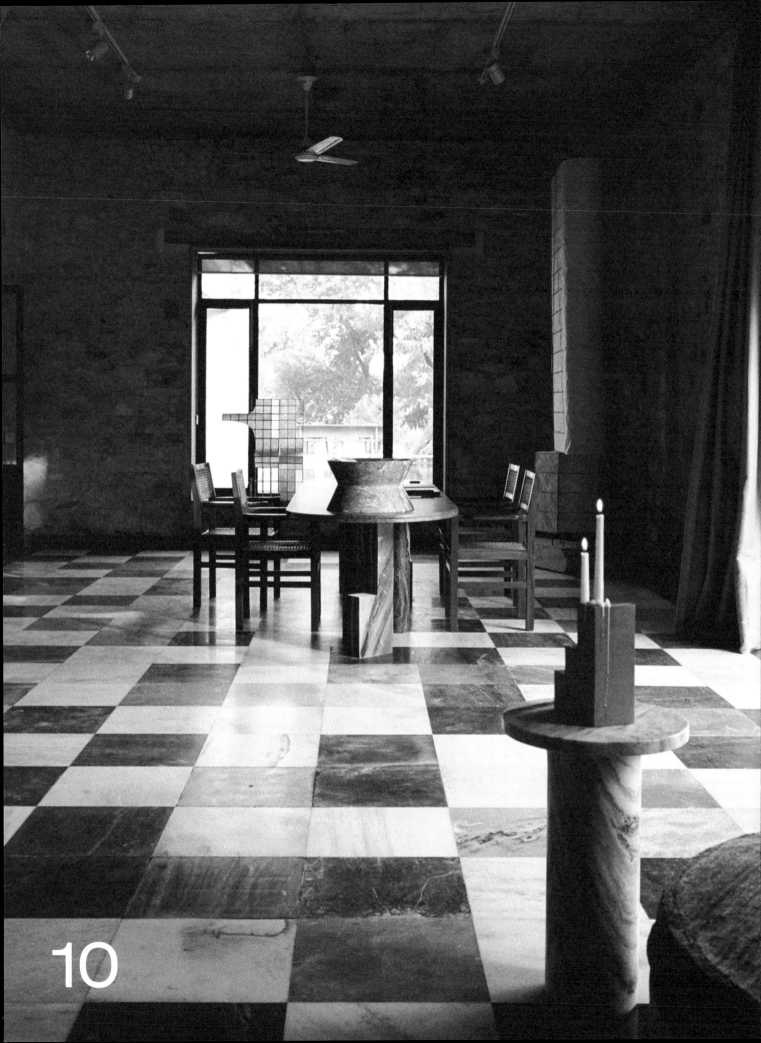

10

DUSHYANT BANSAL

Makrana, Rajasthan
India

& PRIYANKA SHARMA

A HOUSE IN MARBLE, AND A PRACTICE WHERE LITTLE IS SET IN STONE

It's an overcast fall day in Makrana, Rajasthan, a state that borders Pakistan in India's northwest. Dushyant Bansal's car creeps along a narrow land bridge. Marble dust hangs in the air, fusing with the pale sky in a cohesive cloud of white. Hundreds of feet below, the din of drilling and incoherent shouting rings out from a team of workers. They are attempting to leverage a chunk of marble the size of a living room free. Bansal's SUV, white like its surroundings, makes it to the other side of the man-made valley, passing a row of industrial cranes lying dormant until they are inevitably called into action to hoist a massive stone to the surface for processing. Priyanka Sharma, sitting in the passenger seat, signals for Bansal to stop next to a sprawling mound of leftover marble chunks. They get out and peruse the dumping ground for captivating specimens. Their hands quickly becoming full, they load the scraps into the trunk and head back toward town.

Bansal and Sharma give off an air of inseparability, like two halves of the same brain that gave rise to their independent design and research practice, Studio Raw Material. Though it was officially founded in 2016 when Bansal and Sharma were studying at London's Royal College of Art, a potent collaboration was all but a foregone conclusion when the duo became fast friends in Delhi in 2008, just after completing their undergraduate degrees. They spent time in the city exploring and sharing its special corners—until Sharma learned that Bansal hails from a family in the marble industry and insisted on paying its iconic capital a visit.

Bansal had left the land of his upbringing to pursue a design education, but it was his profound friendship with Sharma that brought him back. "When she arrived, I remember her saying, 'Oh my god, you are literally sitting on a mine,'" Bansal recalls. "Someone whose work and process I deeply admired thought this place was so interesting, which really got me thinking." Returning with a new frame of mind became the catalyst for all that would manifest. From this formative excursion came a resolution: Eventually they would work together, and stone would be their medium.

Makrana is marble mecca, the birthplace of the pristine white material that gave way to the Taj Mahal. In the centuries since the quintessential symbol of India was constructed, the town has become inextricably linked to the marble industry, its wares adorning homes across the nation and around the globe. Slabs line both sides of the road, ready for purchase, and craftsmen abound, putting finishing touches on delicately carved religious figurines and altars. Close to the quarries, workers have assembled impromptu tea stalls, as well as tables and shade structures for taking rest, from cast-aside marble waste. Here, what might be considered a luxury material

1

Bansal and Sharma frequently evaluate
their designs—like a collection of
large-scale paper lamps—from various
perspectives. "We like looking at our
pieces from far away, in nature, or
with the house as a backdrop," Bansal
says. "This really works as a space for
visual experimentation." (1, 3)

Plastering a marble home's
exterior is an exercise in
bending to fit within social
norms. "If you don't plaster,
your friends or relatives
might think you're trying
to save money," explains
Bansal. In small increments,
he and Sharma are shifting
the mindset by highlighting
the stone's natural beauty in
their own construction. (2)

As part of the 2023–2024 AlUla
design residency in Saudi
Arabia, Bansal and Sharma did
extensive research into the
Hegra archeological site. To
understand the carving methods
used by the Nabataeans in
the first century CE, they
manufactured replica tools
with the help of a blacksmith
in Makrana. (4)

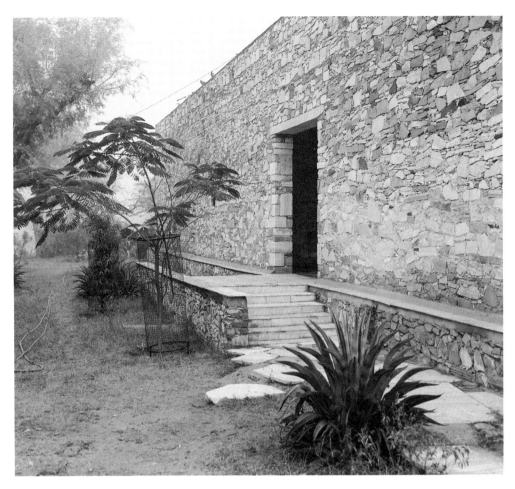

2

3

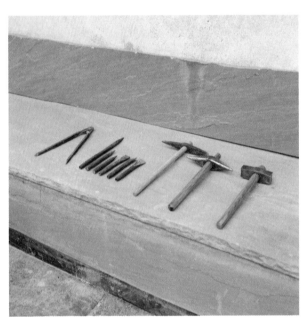

4

the world over is demoted to commodity, a necessary but unglamorous building material— the fruit of a tirelessly laboring industry. Immersed in, and inspired by, this landscape of a singular material and its vernacular incarnations, Bansal and Sharma find their focus.

They had made pieces here and there for friends in the years since their initial joint visit, but the first collection of works that would form Studio Raw Material's introduction to the scene came in 2015. Offcuts of marble were the seeds, and Bansal and Sharma embraced their lack of uniformity to create tables of unique configurations. These stones typically transform into elaborate temple ornamentation or a practical material to line the likes of kitchens and showers, but the designer duo wanted to address the substance from a mathematical angle, crafting one-of-a-kind pieces without mortar joinery. "We worked for four or five months on that series," Bansal recalls, "but it didn't resonate with people in India." Despite this false start, Bansal and Sharma were unyielding in their vision, refusing to bend for the sake of commercial viability. "We wanted to make what we wanted to make," Bansal explains simply. "But there was no next step," Sharma adds. "And that was challenging."

At around the same time, Bansal's family asked him to develop a structure for a piece of land they had owned for decades, and Thar House began to materialize. Bansal, who was living and studying in London, enlisted the help of Sharma. "We wanted to investigate the materiality of the region," she recalls, and with no fixed plan, they dove into research. Their efforts shed light on traditional building techniques, and one in particular—in which small marble offcuts are stacked and bound with stone dust, cactus sap, and lime—carried a special allure. "I was tasked with drawing up the initial plans for the house from memory,"

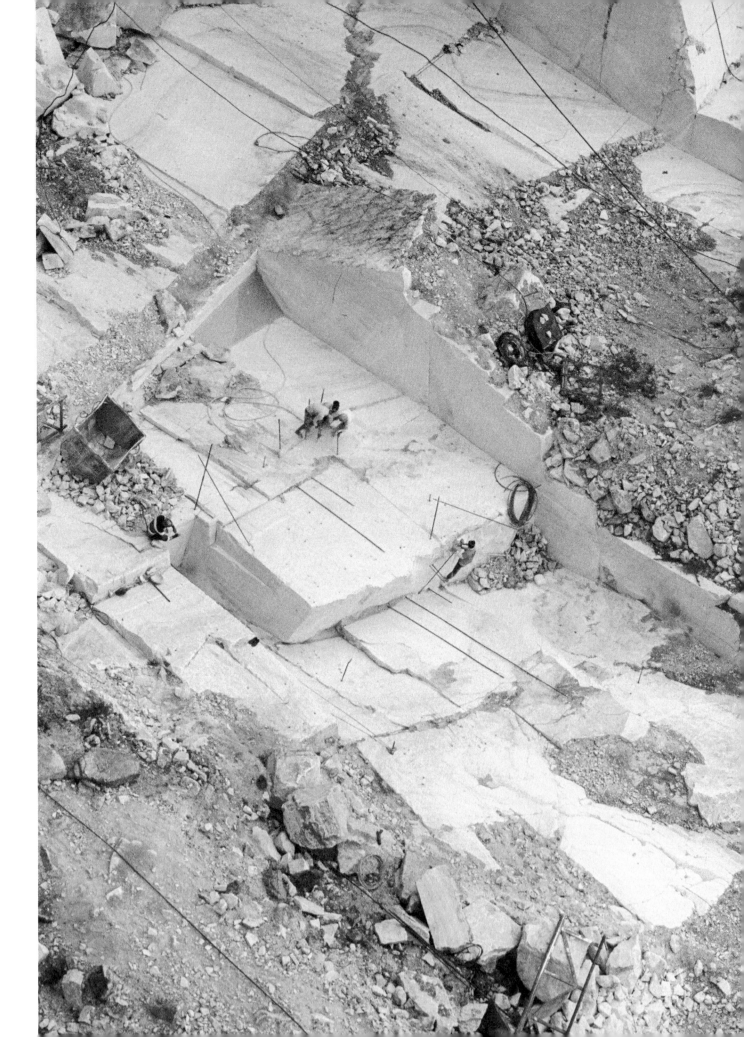

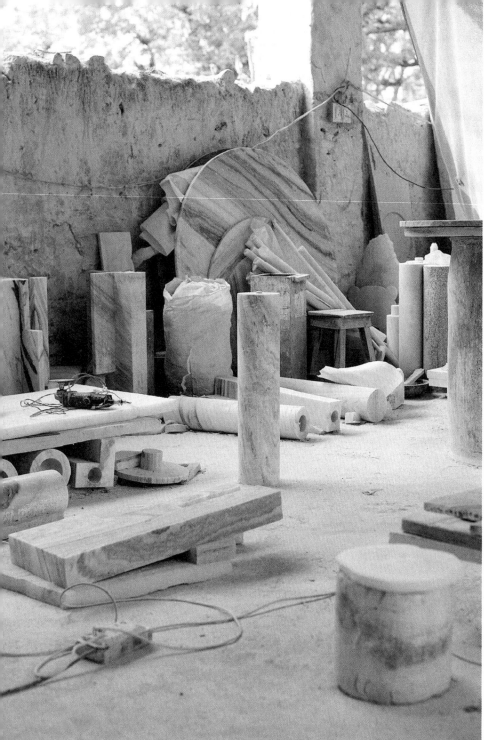

8

9

10

Adapting from the previous generation, Studio
Raw Material shares workshop space with the
Bansal family business. Minimal marble tables
from the one sit alongside more intricate
incarnations of altars and temple embellishments
from the other. (8, 10)

Sharma is responsible for putting pen to
paper, translating theoretical ideas into
lines, curves, and shapes. At Thar House,
she can frequently be found sketching
poolside, her markers strewn across the red
sandstone table. (9)

says Bansal. But when the plans didn't fit within the property's heritage trees, things needed to shift. In the end, these constraints defined the shape and vistas of the structure. The duo, in an effort to live harmoniously with what had existed long before them, created openings to accommodate each and every specimen.

Bansal had been in London for a year when Sharma finally joined him at the Royal College of Art. They began to show their series—the same one that didn't catch on with the Indian market—to friends and tutors. The response was unanimous: "You can't just create a project like this one and hide it away!" The testimonies of their peers proved pivotal in their submission to the 2016 London Design Festival, where the popular website Sight Unseen dubbed them "best of." The rest, as they say, is history. From that moment on, the ball hasn't stopped rolling for this formidable pair. "RCA opened a lot of doors," Sharma says. "People began to trust us." With newfound credibility and support, Studio Raw Material launched in earnest.

Set back from the highway on the outskirts of Makrana, Thar House rests among a grove of native Khejri trees, with agricultural land on all sides. The primary facade is an imposing rectilinear wall of exposed pieces of rough marble, devoid of openings but for a large square breezeway that leads to the house's central point of access. From the project's outset, working with local craftspeople, as opposed to conventionally educated masons and plasterers from afar, was critical in creating an everyday aesthetic that reflects the region. "What do people here know, and how can we work and engage with them?" Sharma remembers asking. The builders were initially surprised at Bansal and Sharma's desire to leave the walls unplastered, revealing the unfinished texture of the region's main resource. Upon closer look, signatures and small inscriptions can be seen on some of the blocks, vestiges of the building process that would typically be covered up. "In the end, everyone came to appreciate the effect," Bansal says. Even so, the

Bansal and Sharma source moss green marble from the mineral-rich Aravali mountain range to make everything from coffee, cocktail, and dining tables of geometric design to simple bowls. (11)

The Nawa console is named after and inspired by a village east of Makrana, where a large salt lake and naked landscape amplify the boxy forms of its rigid vernacular tools and architecture. (12)

12

11

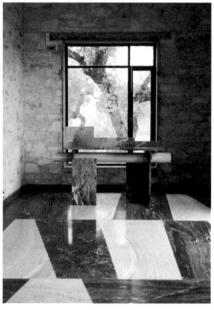

house's design is a stark departure from popular trends in the country, and its unusual character made it more of an appropriate outpost for Bansal, Sharma, and their work than a family gathering place.

The floors, composed of irregularly shaped polished slabs that vary in color, contrast with the textured walls. Staying true to the hodge-podge aesthetic ethos, they reflect the abundant light that streams through the large window panes. Natural light, as in many exhibition spaces, is paramount, and Thar House is no different. The space serves as a loose laboratory, a stage to evaluate new pieces both inside and around the property. The trappings of the home are in constant flux, with furniture, objects, and material studies moving in, moving out, going to exhibitions, and being replaced with something new.

With staggering views, the home is deliberately permeated by nature and at once mysterious, awe-inspiring, calming, and invigorating. The sun blazes then disappears behind a wall of fog as birds croon and cackle. Camel caravans and prides of peafowl pay frequent visits. The days become stretched, and Bansal and Sharma's rhythm begins to tie itself to the cycles of the natural world. Early to bed and early to rise, the sun becomes their clock. They will visit the studio or the quarry, but mostly they think, sketch, survey their own works in context, or meditate on new ideas. "We don't have a TV or any sort of outside entertainment," Bansal says. "We don't watch anything." After sundown, he and Sharma rely on the orange glow of low-wattage bulbs or candles. They eat a meal and share conversation before slowly fading. "Being this remote was a very gradual progression for me," explains Sharma. After growing up in verdant states like Arunachal Pradesh and Uttarakhand but then transplanting to Delhi for school and work, she frequently envisioned being connected to a slower pace of life. Though the duo more recently opened a second studio—an airy industrial space in Jaipur, the heart of the desert state, filled with models, drawings,

their book collection, and favorite furniture and light fixtures from abroad—the partners make frequent efforts to escape the comparably bustling city for the quiet introspection that Thar House offers.

"It's not a static space, but something that keeps evolving," Bansal says. In that way, the house is a reflection of their practice. In conjunction with skilled craftspeople, they now experiment with other materials, including textiles, organic paper, bamboo, and cotton. "We've even been trying to create different plasters from our workshop's marble dust," Sharma reveals. While expanding the limits of everything that Studio Raw Material represents to the world, the house has also become a test site for their interest in food. The farmers that live on the land and tend the fields laughed at Bansal's request to grow arugula. The little-respected green is so unused that "even the cattle aren't happy eating it," Bansal quips with a grin. Regardless, the local family grinds the leaves into a pesto and adds them into gnocchi-like dumplings. While arugula is far from becoming a staple, the culinary give-and-take between Bansal and Sharma and the native residents has yielded some delicious results. To complement the stunning home cooking, Bansal and Sharma invented a cocktail, the Makrana Sour. "The muddy and dusty concoction uses ginger, chile, and jaggery," notes Bansal, proudly.

The house and its surroundings push the duo to create more time for themselves and for exploration, or as Sharma puts it, "collaborative projects with no clear end." It's a land that many see as barren, according to Bansal, but is filled with beauty, and in it, the partners can let their creative impulses take them into uncharted territory. The success of their process speaks for itself. Fashion houses like Dior, Cartier, and Hermès have commissioned pieces from the pair. The Danish brand &Tradition brought the duo to Copenhagen for the annual 3 Days of Design festival to exhibit alongside known talents from around the world. Saudi Arabia's thriving arts and culture

The hulking dining table is one of the few pieces of furniture at Thar House that never moves. (13)

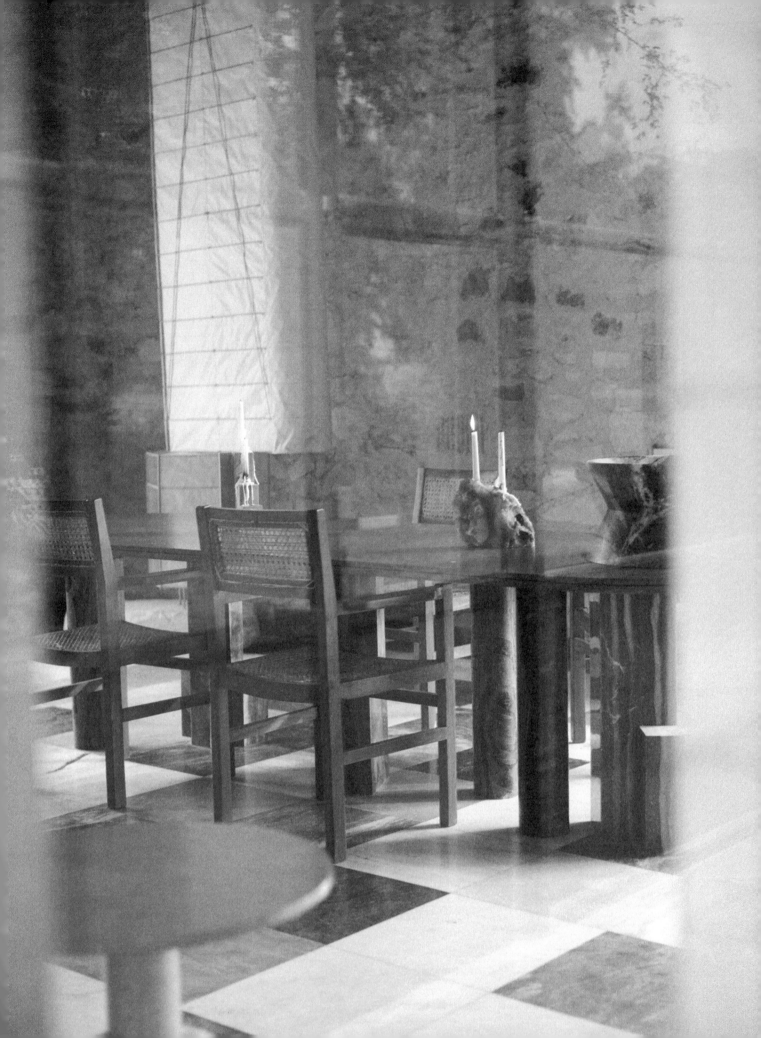

14

To bring their concepts to life, Bansal and Sharma collaborate with a specialized group of artisans. Expanding beyond marble, members of the Jaipur team delicately arrange pieces of bamboo to form the framework for their work-in-progress lamp series. (14)

The Raw Material team occupies two floors of a Jaipur industrial building. The lofty ground floor functions as a hands-on workshop and showroom, while the light-filled second-floor office is simultaneously a laboratory, archive, and library of inspiration. (14, 16)

Favorite books—*The Anatomy of Sabkhas*, Alison Britton's *Seeing Things*, tomes on creative minds from Louis Kahn and Noguchi to JB Blunk—rest next to furniture studies and prototypes. (15)

15

16

The wall of gridded windows brings the outside in—so much so that Sharma's indoor cat walks through the living spaces as though she has been let into the wild—while protecting the house from excessive heat and dust. (17)

destination AlUla tapped the two for its artists-in-residence program, and Dezeen named them judges for its renowned design awards.

Wherever their practice has taken them, Bansal and Sharma remain grounded in what got them there: the humble yet elegant marble, the vernacular practices, the material constraints that are the foundation of their shared practice. In fact, constraints make up the mortar that ties it all together. In these desert plains, there exists a strong tradition of preserving, of "making do," of working and being contented with what is available, a spirit that underscored the impetus for Studio Raw Material and their continued work since. "It's a harsh landscape," Bansal muses. "Yet, from it, a lot of really strange and special things come together."

A SOUR NOTE

The Makrana Sour, Bansal and Sharma say, should appear cloudy and taste tangy with a tinge of caramel sweetness from the imli, or tamarind, and the unrefined cane sugar known as jaggery.

$\frac{2}{3}$ oz (20 ml) whiskey / This can be replaced with vodka or a darker rum, depending on your preferences.

$\frac{2}{3}$ oz (20 ml) imli paste / Ideally, soak the imli pulp in water and then loosely squeeze out the seeds and woody parts. If using a concentrate, one level tablespoon should be plenty.

$\frac{1}{3}$ oz (10 ml) jaggery syrup / Dissolve equal parts jaggery and water to make a simple syrup.

Juice of half a lemon

$\frac{1}{4}$ green chile, seeded and roughly chopped

A small pinch of sea salt

Combine ingredients, shake with ice, and serve extra chilled. For a lighter drink, add a splash of soda water. Drink up and cool off.

18

19

20

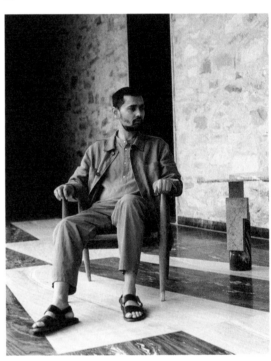

Visitors to the house are greeted by one of Raw Material's many plaster tests set in an octagonal frame and an entry table in Mist White marble. (18, 19)

Bansal's fondness for the colors of his native landscape extend beyond his work. He regularly sports outfits in the same golden sand and creamy white tones. (20)

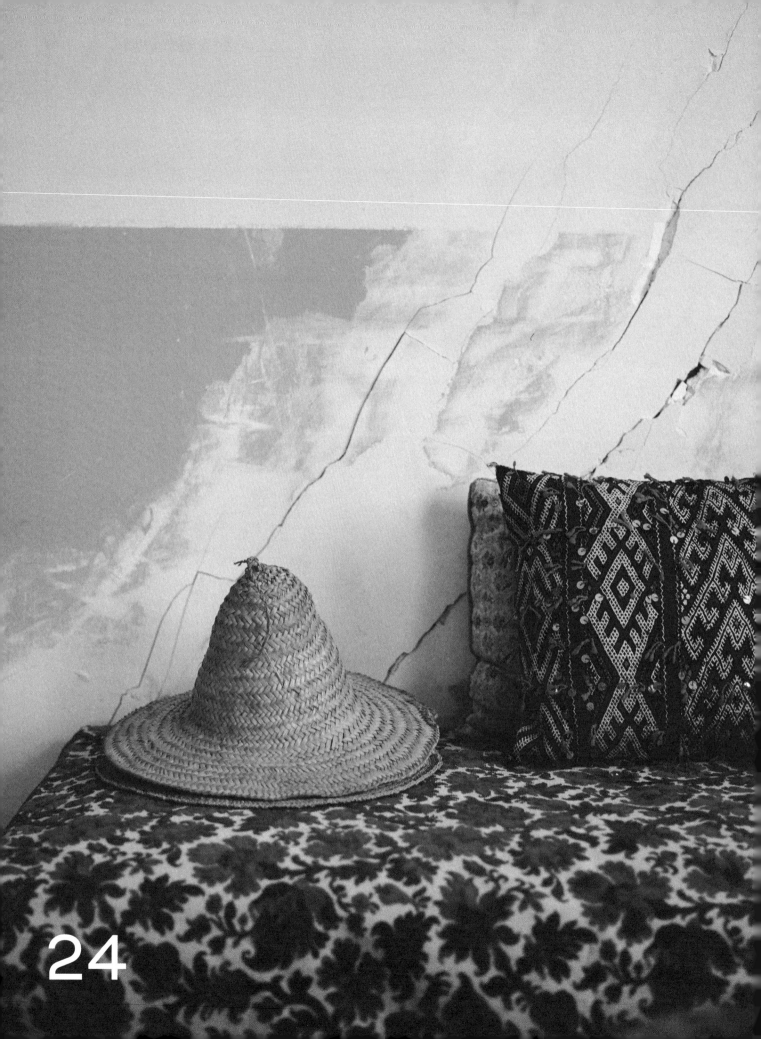

24

SOUHAIL TAZI

&

DELPHINE WARIN

Ait Ourir

Morocco

ENGINEERING AN
EVERYDAY UTOPIA

It was some kind of mystical telepathy. The property was bigger—nearly twenty-five acres—and farther away from Marrakech than either of them had set out to find. But when Souhail Tazi and Delphine Warin looked at one another, they *just knew.* "It's almost something chemical," Warin says. "That feeling, when you realize it's right—it's not something that you can explain."

They dubbed the land Domaine Sauvage, and in 2011, with mud bricks, straw, and lime, they began to design and construct a home, an escape from the noise, pollution, and day-to-day commotion of the city. "I asked around the village and found a guy who still works with clay," Tazi recalls. "He told me, 'With cement, we can make a house in two weeks.'" Even though clay would take exponentially longer, Tazi remained heart set on building with earth. With him

and Warin, it's about that feeling—and not only is this type of architecture traditional, but melding into the landscape, the browns and reds of the hillsides on which it sits, it *feels* just so. The process took nine months, but no matter. "We had the time to get to know each other," Tazi says of the relationship with his mud-brick mason. "Every day, we shared in the work, in conversation and food."

Tazi spent his youth on farms in Morocco, where his family cultivated grape vines, citrus fruit, and grains, and when he moved to Paris, his interest in agriculture didn't wane. It was in France where he began to meet small producers and learn about sustainable farming methods. Yet, the craftsman-designer continued to pursue careers in other fields. As he watched Warin foster her photography

2

1

practice, he knew something needed to shift in his own life. "Her work fulfilled her, and I could see how powerful that was," he recalls, "how it influenced our children." He studied the writings of Masanobu Fukuoka, the Japanese farmer and philosopher who pioneered the permaculture movement, waiting for the stars to align. When they did, he and Warin began to plant: acacia, cypress, eucalyptus, pepper, carob, almond, fruit, and olive trees, with rows of vegetables and herbs in between. "The land is bare," they say. "But there is everything to do." Tazi had finally come across his true calling. "We have a responsibility in this world," he says, "to be good, to work for love. If we do these things, we'll find paradise."

Meanwhile, at Domaine Sauvage, Warin discovered a new kind of inspiration, one that didn't require constant travel. "Being here in this poetic landscape," she explains, "is extremely meditative." She heads off on walks with the dogs and disappears for hours. "I find all of these strange, interesting plants that grow here," she says. "Their forms are like characters." When she comes across particularly unique specimens, she takes them to the house to decorate with or to photograph. She finds herself increasingly shooting in the space and, with Tazi, learning to live in praise of slowness. On an early trip to the farm, she pointed her lens at an old man sitting on the side of the road. "He was doing nothing, and that proved to be such a great lesson," she muses. "It's okay to just be."

Redefining time in the wilds of the desert has its perks—long, guilt-free lunches, hours spent digging in the dirt, an evolved sense of self—but also its challenges. "There is a different rhythm to the people," Warin says. "Somebody tells you that something will be done tomorrow, but tomorrow can mean one week from now." It's an unfamiliar pace, but one that she relishes after stints in Paris and Marrakech.

At some point, Tazi and Warin began to sense their own accountability. They might call Domaine Sauvage home for part of the year, but this place—its magic—didn't

3

Tazi and Warin, who frequently don clothes bearing screen-printed designs from their son Aliocha, define synergy in the kitchen and at the dining table. They dance around each other wordlessly, adding engraved trivets and hand-embroidered Valérie Barkowski napkins and tablecloths to the scene before bursting into song-like descriptions of their latest batch of kombucha and farm-grown vegetables. (2, 3)

The exterior's pale rose hues mirror the pinks and reds of the surrounding rocky landscape. (1)

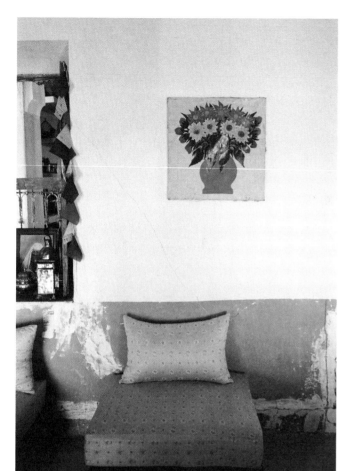

Low seating, employed by nomadic Berber peoples
who historically moved throughout North Africa,
materialized as an easy means to create comfortable
living spaces on the floor. It grew into a wider
cultural norm, indicating humility and unity,
and one that Tazi and Warin have adopted in their
rural home with floor cushions, platform chairs
and couches, and richly colored rugs. (4, 5)

5

belong to them. Moreover, with temperatures rising and water sources depleting globally, they could set an example: promoting sustainable, small-scale agriculture, avoiding chemicals that simultaneously poison the earth and its people, buying local, being the seeds for change, and discussing solutions that feel achievable.

Tazi and Warin collaborated with friends to launch a weekly organic market, bringing seasonal produce, fresh-baked bread, farmhouse cheeses, olive oil, almond paste, jams, ratatouille, and vinegar to the city. It's not only a place to purchase healthy, high-quality food, but to exchange ideas and develop community. They also started inviting people in Marrakech to take the forty-five-minute journey on the road toward Ouarzazate. At the farm, they host meals, cooking classes, and visits in the garden, with its unparalleled views of the volcanic surroundings.

Numerous covered terraces, carefully set outdoor tables adorned with flowers and metal stars designed by Tazi, the large outdoor kitchen featuring an earthen oven, and the lush desert plot encourage life to take place beyond the house's four walls. But plenty of energy exists inside, too. In fact, vibrancy overflows. The objects—from the vintage confectionery tins to the green-glazed candleholders from Tamegroute, woven baskets, and antique silver—the textiles, the art, which consists of a mix of Warin's own work, prized pieces from others, and flea market finds, as well as the color choices are all a genuine reflection of the couple.

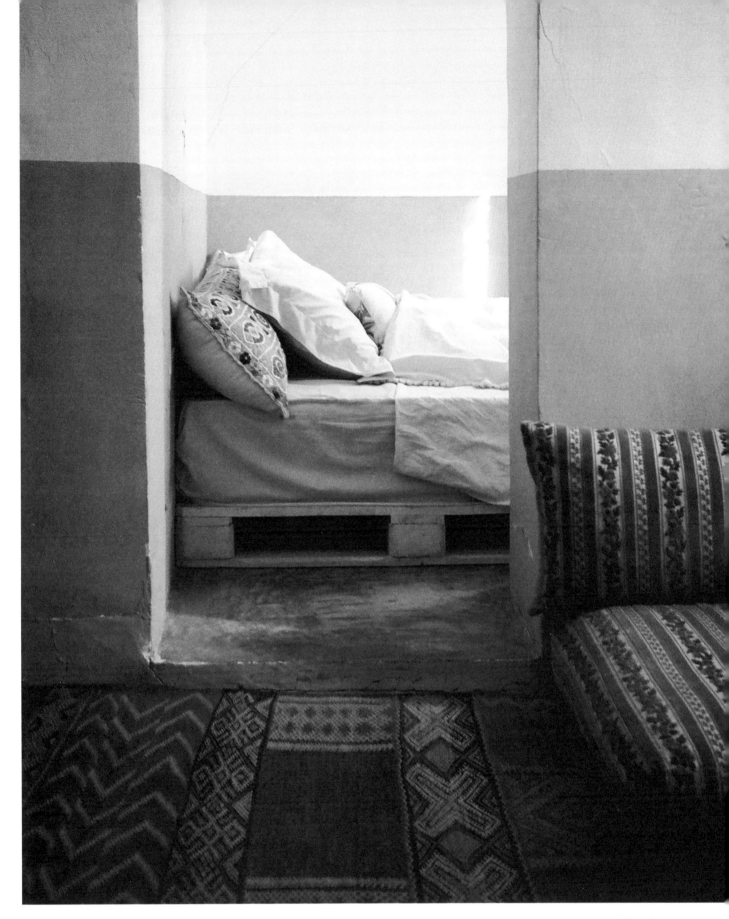

6

Tazi and Warin never shy away from an elegant, do-it-yourself design solution. They elevate the simple, white-washed pallet bed frame with cotton linens from the textile designer Valérie Barkowski, transforming the cocoon-like bedroom into an ideal place for hibernation as hot desert days inevitably give way to cool nights. (6)

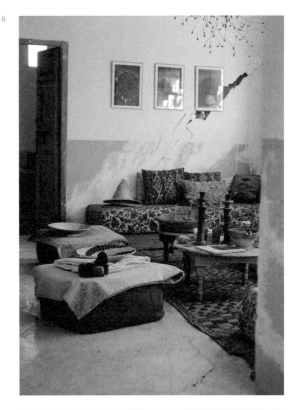

"We almost never buy new," Tazi says, holding a glass of water to the sun. "This might be 'new' but even so, it's made of recycled glass." They elected for vintage doors and window shutters, which meant forging irregular openings and entrances. Giving added life to old things brings them immense joy, as does the sourcing process, which takes more care and deliberation. The couple loves the act of filling a space so much that they have had to slow their purchases in recent years. They are to the brim with furniture, rugs, vases, kitchenware: everything that makes a house a home. "We're only buying small things now," Warin grins.

Instead of considerable aesthetic changes, it is the big personalities that bring a breath of fresh air into their universe. The neighbors in the surrounding villages are fountains of knowledge who Tazi and Warin strive to learn from constantly. The two women who make the hour-long donkey trek to help run Domaine Sauvage—maintaining the home and garden and bringing time-honored recipes into the kitchen—have transcended to the level of dear family members. Taking a rest with a cup of tea, they begin to sing. Suddenly, as the streaky afternoon light pokes through the cracks of the shutters, the room is flooded with the chillingly beautiful sound of melodic vocalizations and the gentle rhythm of fingers tapping on a metal tray. Tazi and Warin sit quietly, their heads bobbing as they absorb the vibrations that feel steeped in history.

Under the shade on the porch, Warin arranges a pre-lunch snack: a bowlful of freshly harvested vegetables and homemade kombucha. "Eat the root!" Tazi exclaims, holding up a golden orange carrot, before demonstrating. "It's like a straw, sucking up all the flavor of the soil." This soil, the couple's pride and joy, is akin to another child, something they nurtured for years and that now gives back in kind, season after season.

The lunch table is nearly set, but for a few final touches. Tazi, with his ceaseless grin, bottomless brown eyes, and hair that comically stands on end like Einstein's, cuts white roses from a wild bush. He and Warin tease and banter, laugh and shake their heads knowingly at each other. Tazi removes the top of a tagine with a flourish to reveal a slow-cooked bounty of their garden's riches, topped with nothing more than olive oil and salt. A simple green salad and just-baked bread play the role of deliciously worthy sidekicks. The sun on their faces and a cool breeze blowing in, Tazi and Warin pause to soak in the moment. Indeed, it seems that these two have found their paradise.

Two large living spaces, one of which opens into the yellow-tiled, eat-in kitchen, are places to escape the blistering sun or simply to gather with friends after a day spent outside. The house suffered some damage, like cracks in the plastered walls, from the 2023 earthquake—but Warin, who photographed the aftermath in even more remote settlements, counts her blessings. (8, 9)

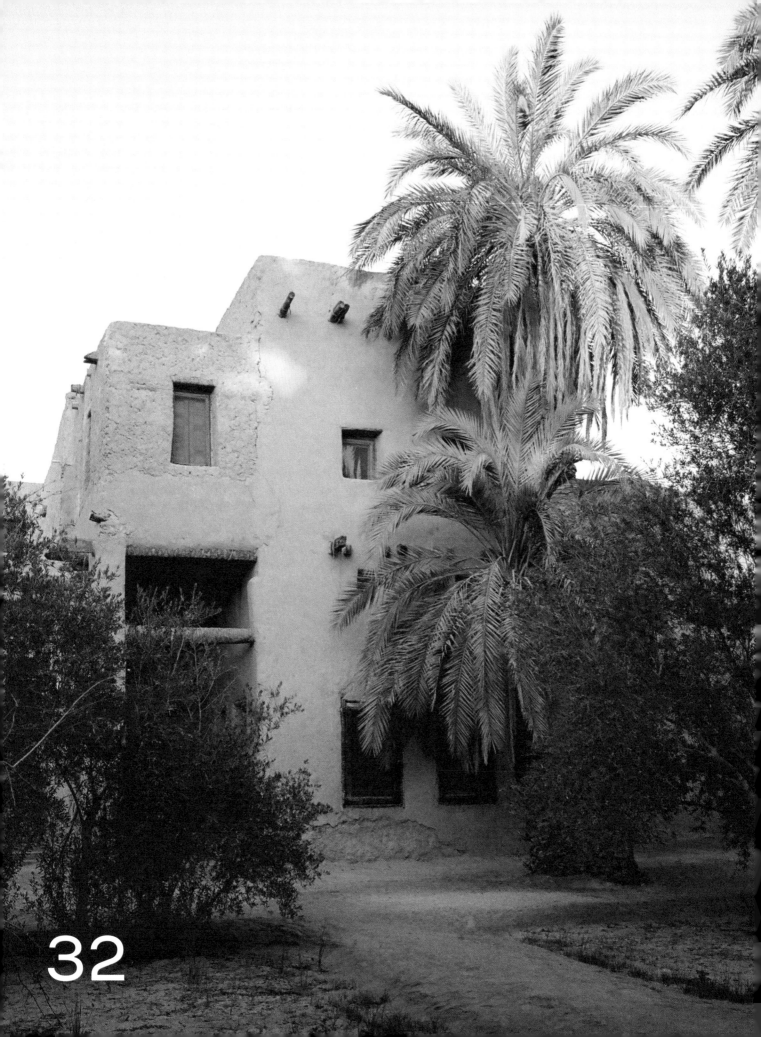

32

INDIA
MAHDAVI

Siwa

&

Egypt

MOUNIR
NEAMATALLA

A PHYSICAL MANIFESTO ON MATERIAL, LIGHT, AND ABOVE ALL, COMPROMISE

It's twilight. The vast horizon explodes with color before rapidly descending into total darkness as a fifty-seat propeller plane lands at the tiny military airport in Siwa, Egypt. Passengers descend onto the runway, greeted by a lineup of two dozen or so Land Cruisers and other similar desert-suited SUVs with accompanying local drivers. The loud hum of the aircraft is replaced by a cacophony of chatter while the congregation is herded into vehicles. The convoy proceeds out of the well-guarded base onto the highway. Nearly an hour goes by with minimal activity when the motorcade hits a dirt road, bumping along until a handful of lanterns pierce through the blackness and engines halt. The moon peeks its head above the surface of a lake, providing enough illumination to make out the silhouettes of a group of dispersed structures. As the brigade of visitors unloads, individuals are identified and guided across a plain of sand, sometimes up sets of stone stairs, and through creaky wooden doors. Hushed confusion and amazement rings out. "What *is* this place?" a voice utters, reaching an inky room. The flick of a match echoes as one candle is lit, and then another, until the quarters grow visible. Gasps and giggles from far corners of the premises punctuate the stillness.

This unusual hotel, Adrère Amellal, is the brainchild of Cairo native Mounir Neamatalla. He and India Mahdavi—born in Tehran to an Iranian father and Egyptian-Scottish mother and raised in the United States, Germany, and France—are shepherded next door to their personal outpost, Tamazid. Though they are based in metropolitan centers for most of the year, they are home. As they enter, it begins: the bickering, the banter, the hugs, and the laughter. They are not related by blood but instead by love and a deep commitment to place. "We share the most beautiful thing two people can share," Mahdavi muses. "A house." They may not be kin in the formal sense, but nobody would be faulted for confusing the magnetic pair for father and daughter.

Sipping an Egyptian coffee as black as the desert night sky, Neamatalla speaks slowly, telling stories with vivid detail. Mahdavi listens with intent and great admiration. She occasionally smirks, resisting the urge to clarify when he exaggerates or gets lost in a tangent. Harkening back to memories that span decades, the ecologist recounts how he got here. A graduate student at Columbia University in the early 1970s, he felt uneasy about chemical engineering and swapped his focus for environmental studies at the counseling of the blind professor Helmut W. Schulz. "I was his eyes," Neamatalla says of his mentor. "When he wanted a gift for his wife, I would consult." One such deliberation resulted in a pair of lapis lazuli earrings fashioned from his father's cufflinks.

After completing his degree, Neamatalla returned to his homeland and founded Environmental Quality International, an advisory firm that specializes in social and climate-conscious development, in 1981. "Sustainability was certainly omnipresent in my life," he says. But by the mid-nineties, the successful organization was "losing its path" and Neamatalla was ready for a change. "If what we're giving advice about is worth anything, it must have a life of its own," Neamatalla told his colleagues. "We must invest in it ourselves." In other words, it was time to put their own counseling and principles into practice.

The Siwa Oasis near Egypt's western border and on the eastern edge of the Great Sand Sea, with its forests of wild palms brought to life by salty water that percolates up from the ground, was largely unknown in contemporary times, even to educated Cairenes such as Neamatalla. For his own development, he sought an ideal spot in Sinai or on the coast of the Red Sea—never in remote Siwa. Then, in a meeting, an otherwise quiet anthropologist suddenly spoke up. "If we want to do something measurable and impactful in the domain of sustainable living," Neamatalla remembers her saying, "I think it is the best place." And so, with a team of scientists and environmentalists, he voyaged westward through the desert, like the ancient Greeks, Romans, and even Alexander the Great.

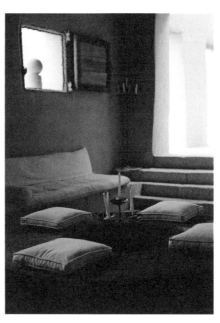

The structures at Tamazid—and likewise at the neighboring hotel—
are dotted with tiny windows that allow the passage of light and
offer dramatic views of the landscape. The small openings embedded
within the thick kershef walls combat sweltering temperatures in
the summer and retain warmth during winter nights, canceling out
the need for air conditioning or heat. (1, 2)

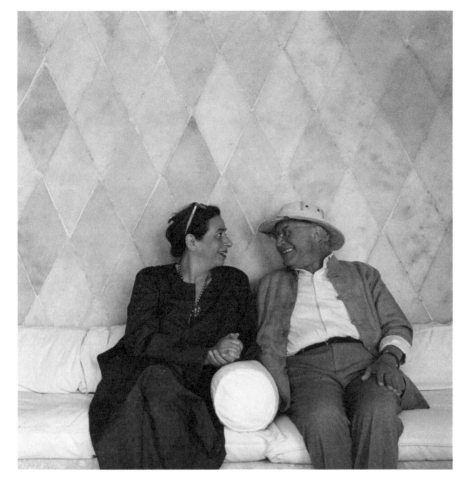

Lively evenings at Tamazid often begin
with drinks in the step-down primary
sitting room, which conveniently
stands opposite a sunken dining area
accented by a long table for communal
eating. Mahdavi designed site-specific
furniture, working hand in hand with
local masters in salt, wood, rope,
and stone, often collaborating to
forge products altogether new. (2)

"When I told him 'You should build
a house,' he really had an openness,"
Mahdavi says of her accomplice in
Tamazid. "He listens, he receives, and
he accepts." According to the designer
and architect, such receptiveness
does not always come easy. "Especially
with a discerning eye like yours,"
Neamatalla adds with a smirk. (3)

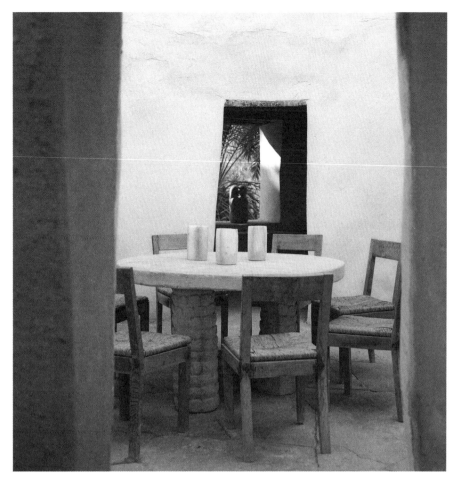

Deliberately without a ceiling, the circular dining room—replete with Mahdavi's votive holders in salt—is transformed into a lo-fi observatory. The airy volume gives way to one of many rectangular breaks in Tamazid's thick facade, in which a sculpture of two figures embracing designed by the Chinese artist Li Shuang and brought to life by a Siwi artisan rests. (4)

5 6

Guests can take breakfast beneath the shadow of Tamazid's palms or drape a towel across a carved chair before going for a dip in the stone-lined, spring-fed pool that reflects the outline of the striking mountain. (5)

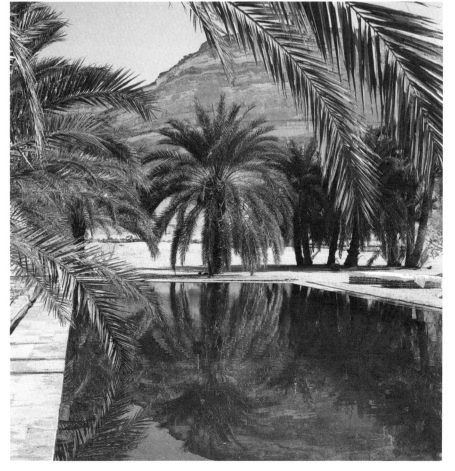

The surface of the table within Tamazid's foyer is ornamented with bowls and spheres of the same material. Hiding in plain sight is a stone safari helmet, a Mahdavi invention and a whimsical nod to Neamatalla's favored headgear. (6)

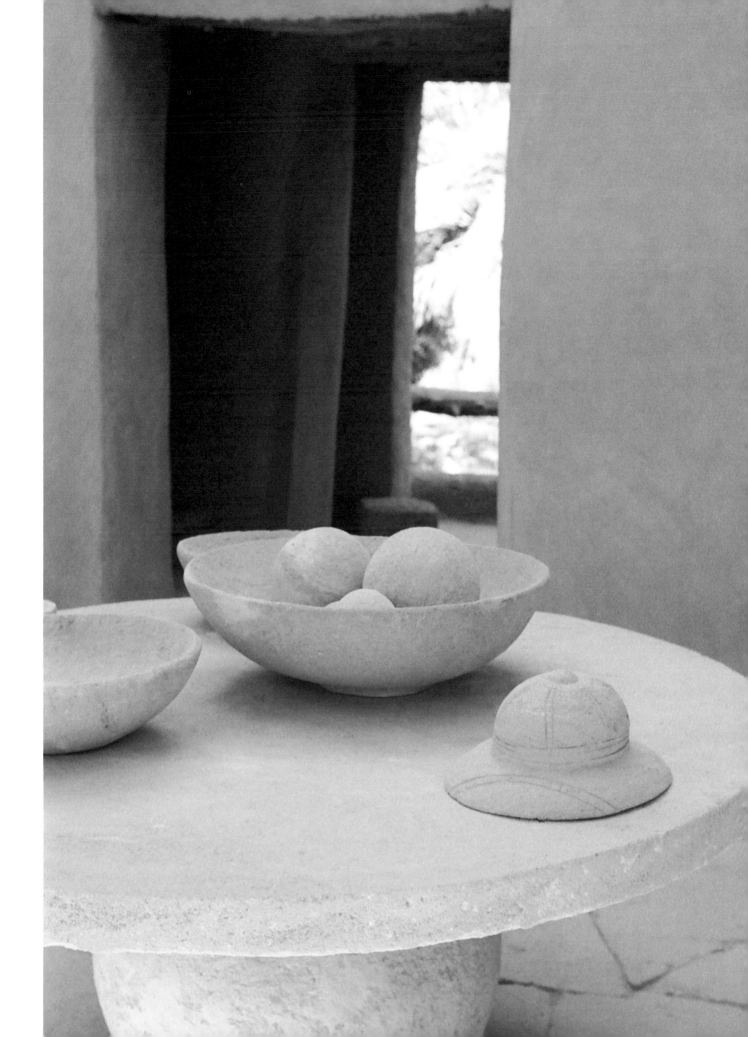

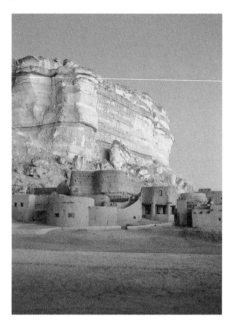

Between first light and sunrise, the grounds of
Adrère Amellal reverberate with tranquility.
Those willing to wake early can hike the short
trail to the top of the mountain to bask in the
sublime beauty of the daily celestial event. In
the slightly less peaceful construction years,
Neamatalla recalls being roused by what he refers
to as a "bio-alarm," when the huge chorus of
working donkeys would begin to bray. (7)

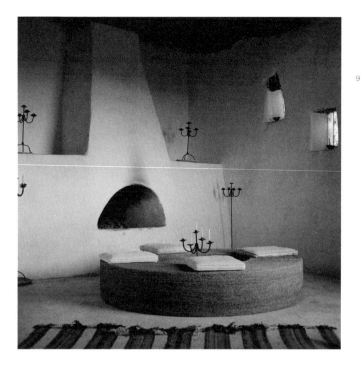

An eight-hour drive from the capital city—or in
Neamatalla's case, a full day and night thanks to a botanist who
"stopped every time he saw a plant"—Siwa's salt lakes, sandstone
mountains, and palm jungles appeared like a mirage on the
desolate landscape. Neamatalla was studying a passage about
this very desert refuge in *The Histories*, a fifth-century text by the
Greek explorer Herodotus, when his caravan made its arrival.
"What I was reading was what I was seeing," he says with wonder.
"It was as if it had been frozen in time." He transformed into a
modern-day Herodotus himself, and when asked to describe the
place, he said simply, "It's like living in the Biblical ages."

Neamatalla's personal evolution from awe to temptation
and, eventually, a resolution to build something permanent
was threefold. First came his love for the hospitable Siwis, the
local Berber population who embraced holistic and low-impact
traditions and fostered an uncanny understanding of their
seemingly inhospitable climate. "Everything that they did by
hand was impressive," Neamatalla emphasizes. The second was
the thirteenth-century Shali fortress—a sprawling compound
built from *kershef*, a brick in which mud and rock salt coalesce—
which left him astonished. The third, and final, was Adrère
Amellal, the "White Mountain" that rises from Siwa's lake, which
would eventually lend its name to Neamatalla's inimitable eco-
lodge nestled at its base.

Now, framed by the flat-topped monolith, Neamatalla sits at
a sandstone firepit. As he reminisces, his face lights up, unveiling
the unabashed pleasure he has for the life he has created and the
people like Mahdavi, positioned across from him, who enrich
it. Perpetually clad in soft, earthy tones, Neamatalla practically
matches their shared compound, Tamazid. Mahdavi, on the other
hand, sports a striking blue dress with a heart-shaped necklace

Adrère Amellal captures the essence of radical
minimalism, and its walls remain unadorned
with art, instead directing focus to the
serene landscapes and the compound's natural
materials. Time spent on property is defined by
experiences—coasting along the dunes of the
Great Sand Sea or floating in turquoise salt
pools—and the little comforts like outdoor
napping spots, beeswax candles lit before the
evening wind down, and hot water bottles snuck
into beds for a restful sleep. This redefined
sense of luxury has proved enough of a draw
to lure the then Prince Charles in 2006 and
Christian Louboutin the year after. (8)

Siwa is a "highly sensitive ecosystem,"
explains Neamatalla, and appealing to large
amounts of visitors has never been the
goal for the eco-lodge. Rather, success is
partially defined by attracting discerning,
culturally minded, and socially responsible
guests who give back and contribute to its
evolution through positive interactions and
engaging conversations, like at cocktail
hour around a rope-encased wooden wheel in
one of the myriad sitting areas. (9)

Mahdavi and Neamatalla's bedrooms, which
run perpendicular to one another on
opposite sides of Tamazid's courtyard,
share in a foundational design language
but offer insight into two distinct
souls. Mahdavi's space pops against
the neutral background, with surfaces
occupied by colorful pieces like a basket
sourced in town, while Neamatalla's
objects and wardrobe seem to become one
with the structure. (10, 11)

and bright red lipstick. "Ooh la la, *this* is lapis lazuli," a beaming Neamatalla says of his co-conspirator's chosen hue.

Mahdavi, it seems, looks through a different lens than everybody else. The designer and architect's distinct penchant for creating a phantasmagoria of colors, shapes, and textures in every space she touches has propelled her to a position alongside legends in her field. Her deft hand has graced the likes of the sixteenth-century Villa Medici, the Pierre Bonnard exhibition at the National Gallery of Victoria in Melbourne, boutiques for the confectioner Ladurée, and The Gallery at Sketch London—twice. The first edition of the latter, dreamed up in 2014, became one of the most coveted—and most photographed—rooms on the planet. Her special expertise has extended into the world of lighting, objects, and furniture, like with her iconic Bishop chair, and, of course, Tamazid.

In this courtyard between the primary construction, an elongated rectangular prism, and the L-shaped southern addition, Mahdavi and Neamatalla ruminate on their home—how it came to be, the process of assembling it, and a few bumps along the way. "My only contribution was the concept of co-creation," Neamatalla asserts. "I interfered. I *really* interfered. But my interference pushed her to do things in even better ways."

Composed primarily of *kershef* block and palm, the network of buildings that make up Tamazid's forebear, Adrère Amellal, seem to rise directly from the earth. "It's as if it formed from the mountain's fallen rocks," Mahdavi says. From materials to process, it is purely organic. Blueprints were drawn in the sand, and with a huge network of industrious Siwis—their donkey-drawn carts in tow—decisions were made on the fly. There is deliberately no electricity. Nighttime activities are illuminated by a spattering of oil lanterns, bonfires, and countless candles, and in darkness, the interiors feel cavernous, yet cozy. Adrère Amellal, with a lack of traditional draft work and amenities, seems as though it is almost a product of nature itself. "It's not architecture," Neamatalla says, quoting Mahdavi, who first made the trek from Paris in 1999. He was a close friend of Mahdavi's parents but recurringly failed to

10

11

Tamazid, with its more angular forms, is "an attempt to modernize the vernacular," says Mahdavi. Though the architectural approach contrasts with the organic shapes of the native environment, it still encourages connection with the oasis at every turn. Looking out of his window upon the mountain and palm trees is, in Neamatalla's opinion, "the most breathtaking view I have." From his second-floor suite or the rooftop sanctuary, taking in the serene vistas never gets old. (12)

Palm-fiber rope encircles window screens, which fly open to welcome the sun and breeze into one of Tamazid's seven sleeping quarters. Elsewhere, the practical material ornately decorates the frame of a bed for rooftop stargazing. (13, 14)

12

13

14

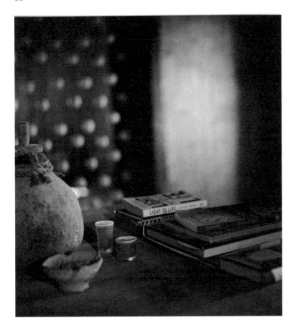

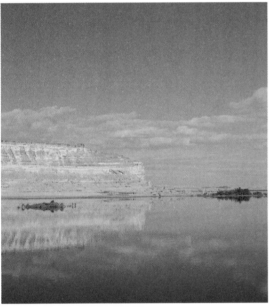

make contact with the architect designer in the French capital until, one day, they brought her to him. Shortly thereafter, their collaboration began in earnest, as Mahdavi lent her savvy to the eco-lodge interiors and crafted objects from endemic materials like salt, catalyzing an entire local industry with her cylindrical, hand-carved candleholders.

At the time, Neamatalla stayed in quarters dubbed the "Dr. Mounir room" when on site, handling operations and interfacing with guests. Though, as he says, he endeavored to "edit out the commercial dimension" of the visitor experience. "There's no reception," Mahdavi chimes in, noting that Adrère Amellal is not *really* a hotel. "You're a guest of nature." At Mahdavi's urging, Neamatalla grew convinced that he needed a place of his own. "When you open a space and you're in the middle, you don't know how many people will eat your energy," explains Mahdavi. "Being an operator takes your vision." In her opinion, he needed a healthy distance.

"But she had a condition, because India always has conditions," Neamatalla points out, gleefully throwing barbs. The house had to be done by her, using the same materials and vernacular, but with laid-out architectural plans. Seduced by her talent and powerful persona, Neamatalla yielded. Mahdavi's eponymous design firm, founded in 2000, was in its infancy when the seeds of Tamazid began to germinate. The visionary's enviable prowess for unthinkable color combinations had been—and remains—a staple of her unparalleled practice, part of a general approach that favors decorating and improving existing spaces over constructing new ones. Yet, in adhering to the established aesthetic of Adrère Amellal and the greater environment, Mahdavi shifted her focus away from vibrant hues, instead highlighting the textures and characteristics of Siwa's raw materials. The Tamazid plot, a bare rock surrounded by a palm grove on a piece of land adjacent to the forty-room guesthouse, would become the footprint of her first foray into architecture.

She imagined a long, narrow construction that opposed nature with boxy volumes and right angles. A square entry would give way to the sky, and step-down, open rooms on either side would provide a canvas for Neamatalla's blissful mode of candlelit entertaining. Bedrooms were to be accessed via narrow staircases parallel to the exterior walls with second-floor windows looking onto the canopy of fronds. In the rooms that now make up Mahdavi's personal apartment, an original model remains on prominent display alongside books, photographs, and hats. Such was the design. What materialized, however, is "not the project I envisioned," says Mahdavi, "but two projects and really, two people coming together."

An insatiably curious Neamatalla is something of a forever student, constantly absorbing information from the people he meets, the places he visits, and the books he reads. Texts on subjects ranging from photosynthesis to anthropology litter the table in the environmentalist's Tamazid apartment. (15)

Viewed from the opposite bank of Siwa Lake, Adrère Amellal becomes nearly invisible in the larger context. At the foot of the mountain's other side, Tamazid recedes from view but for another reason: a verdant web of palm and olive trees. (16)

Mahdavi may roll her eyes at Neamatalla's incessant cheekiness, but she marvels at his boldness, too. And bold he is. Take the decision to build Adrère Amellal in the first place, or the creation of a second wing at Tamazid that he admittedly did "on the sly," when Mahdavi was away. After his meddling, she returned. The moment was marked by shock, tears, and eventually, compromise. "She stood right there and told them to tear it down," Neamatalla says, pointing to a particular spot on the floor. The vision expressed in the model was no longer, but when he obliged in removing a section of the recently constructed upper floor thanks to trust—"and a little fear"—in his partner, they merged their competing concepts into a unified whole. Co-creation at its finest.

The new wing exudes Neamatalla with curved walls, lowered ceilings, and a circular roofless dining room that sits opposite his comrade's square volume. The design, though, is still all Mahdavi, who capitalized on the primary elements of salt, palm, olive wood, limestone, and sandstone in developing a consistent set of motifs. The plentiful sedimentary rocks were reshaped into chairs, bowls, small sculptures, and tables, some with hulking orb-like bases and others with chunky legs to match the surrounding grove. Spheres of salt were strung together on rope from date palm fiber to create room dividers. The same woven cord suspends wooden rods to hang clothes and towels, wraps window screens, and is twisted into various symbols and storytelling elements on headboards and chests, thanks to the brilliance of a Siwi artisan. Rectangular and diamond-shaped salt blocks tile walls. The natural color variations and translucence of the mineral make for glowing recesses.

"Everything is locally sourced," Mahdavi reveals, "from labor to materials and agriculture." These limitations and strong-willed, spontaneous characters like Neamatalla have influenced her work at large. She

approaches projects without preconceived notions and carefully considers context. With heightened awareness, she has learned a key lesson: When faced with a barrier, opt to surround it, rather than go through it. Engaging with this singular microclimate and the strengths of its people while eschewing hard schedules to lean into their pace of life has, as Mahdavi says, made this place "a true magnet." After all, corners like these are becoming rare in a fast-moving, globalized society. Perhaps, as Neamatalla believes, if international leaders could gather here, slow down, and relate to one another, the world would start to become a better and more accepting place.

Constellations of candlelight flicker across Tamazid. Votives nest in Mahdavi's famed salt holders, and tapers brighten nooks in the walls. The tables are set with antique silver and delicate china. Conversations in English, French, Arabic, and German fill the cool evening air. Neamatalla breaks bread with childhood pals, new friends, the Korean ambassador to Egypt and his wife, and long-time collaborators. At the next table, Mahdavi holds court with a cohort of her own. She discusses literature and laughs with her son and his friends from Paris. It's New Year's Eve. On this night, over two decades ago, Neamatalla recalls his horror when a dining area's roof remained unfinished for the evening's festivities. To his surprise, guests filtered out at the end of the meal and continued to stare longingly at the sky, immersed in the energies reverberating throughout the landscape. Now, all of these years later, Neamatalla, the dreamer, is a bit more zen when situations don't go exactly according to plan. Things have a way of working themselves out. A glass of red wine in hand, with Mahdavi by his side, he shrugs. Bathed in amber and orange, a goofy grin grows across his face. "I thank the universe for having this privilege," he says. "It's as simple as that."

Varied—often almost hidden—dining areas are tucked into the labyrinthine Adrère Amellal and the neighboring Tamazid. Neamatalla invites guests into both spaces for dinners, which rarely occur in the same venue twice, even over the course of a week-long stay. With no menu and dishes made from garden-grown vegetables and local staples like dates and olives, gathering around the table feels akin to eating at the house of a dear friend. (17)

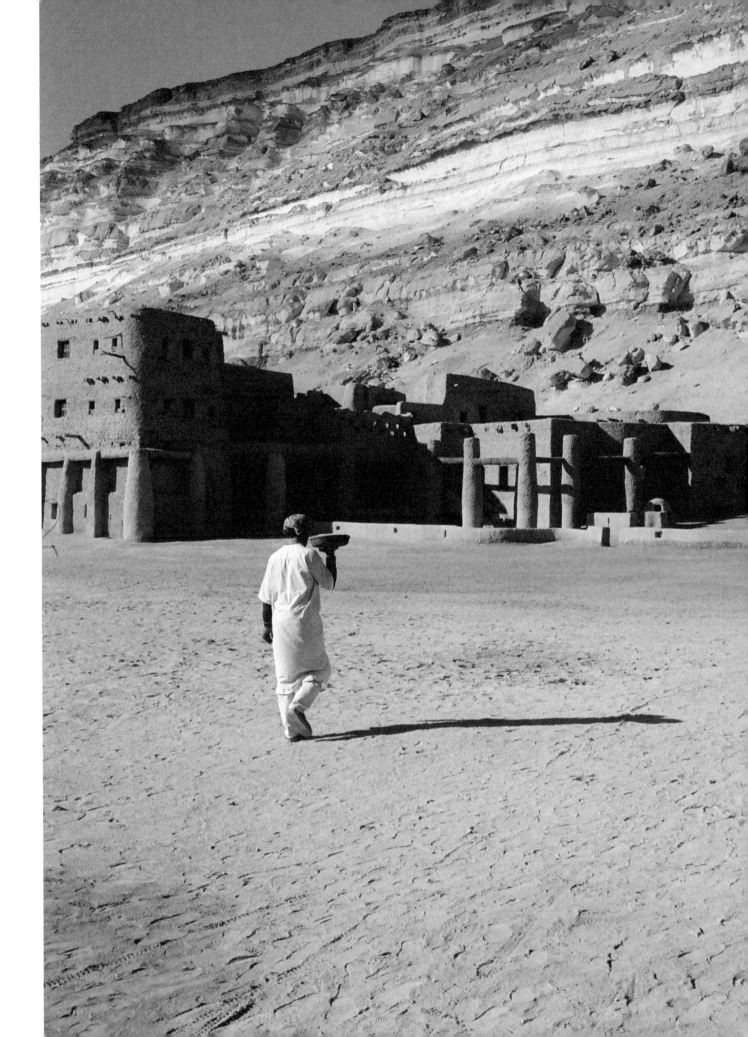

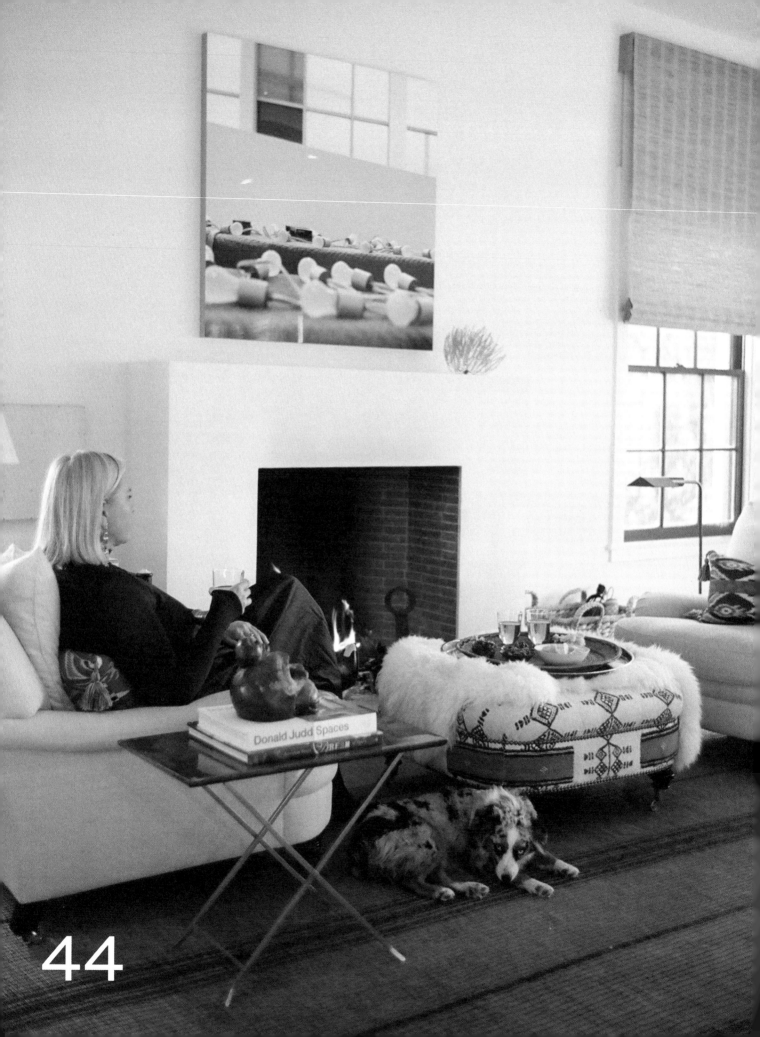

JENNY

LAIRD

Marfa, Texas

United States

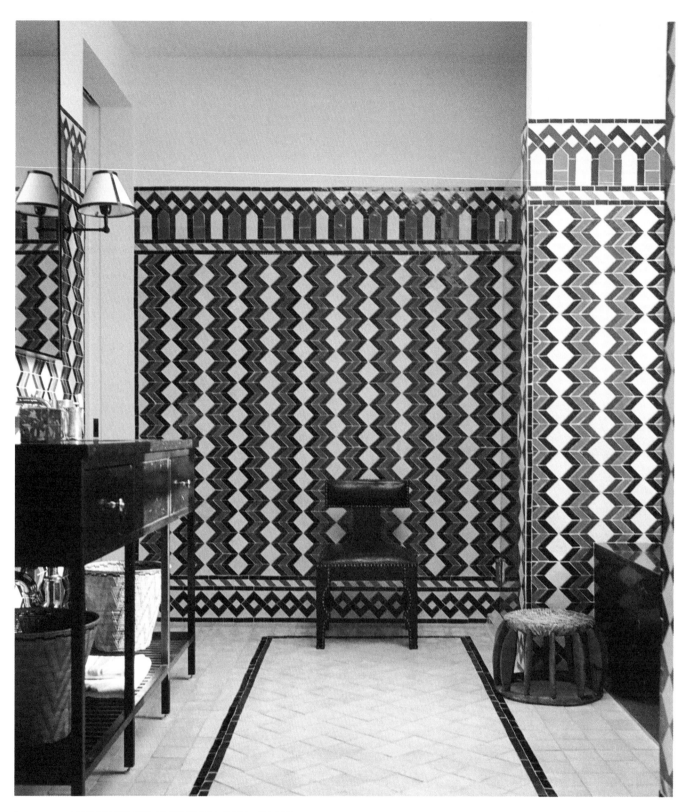

1 Laird and her team looked to Bill Willis, the late
Tennessee-born decorator and architect who emigrated
to Morocco, for tiling inspiration. The guest casita's
bathroom features zellige mosaics. They were sourced
in Casablanca but form a geometric pattern that nods
to Indigenous design and more specifically, Navajo
blankets. The striking reds, whites, and blacks reflect
a bolder, brighter incarnation of Laird's aesthetic
that contrast the wall-to-wall glossy cream hues of the
primary en-suite that she uses on a daily basis. (1)

ONCE A SECOND HOME,
NOW A FULL-TIME SANCTUARY

Whether whipping up a batch of Vesper
martinis to enjoy in the pavilion
alongside Thomas Schütte's etchings
or putting together an aperitivo hour
in the spacious sitting room, Laird
is the quintessential entertainer.
Since moving to Marfa, she has tweaked
many parts of the house to better
accommodate casual get-togethers. "It
takes living in a space," she says.
"I'm slowly finding my system." (2)

Jenny Laird is a retired social butterfly. Well, not retired exactly. She's still a woman around town—but town is no longer New York City. It's Marfa, Texas, and the population hovers just around 1,700. "I loved the fast-paced nature," she says of her time in the Big Apple. "But I was tired. I think that there are times in our lives when things call to us, when we are really ready for them—and Marfa, it called me here." Laird still knows how to throw some of the best parties in the tri-county region that includes Presidio, where Marfa is the seat, Brewster, and Jeff Davis. She's a consummate host, a valued conversation partner who can speak to almost any topic with sincerity, and an active participant in the community's lively arts and culture scene. Yet, here she is, tucked into the crook of her couch with a cup of coffee in hand, one dog curled up next to her and the other below. "The moment came," she reflects, "to live slower."

Laird was born in Texas, but Marfa didn't come onto her radar until she moved to New York. It was the 1980s, and she was working for the publisher and gallerist Brooke Alexander. "I was just a little gallery peon," she says. But she remembers everything: the sets of Donald Judd prints in black, cadmium red, and ultramarine blue, and that one time the imposing artist and his partner Marianne Stockebrand visited from their outpost in wild West Texas.

The place remained on her mind, but it wasn't until years later, when she and her then husband, Trey, were picking their children up from camp in the Lone Star State, that she would actually make it to Marfa. A sixth-generation Texan, Laird always aspired to be a landowner. For a while, it felt like a mere pipe dream, but when her father passed and she inherited a small sum, the idea set in even harder.

2

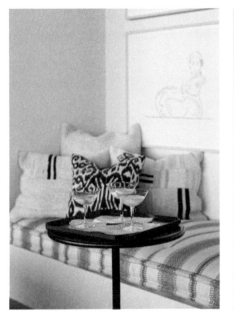

3

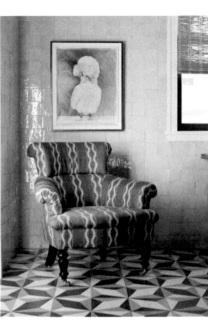

Even more practical portions of the
home—like the butler's pantry, which
boasts a Jean Pagliuso photograph—are
outfitted with thoughtful touches. (3)

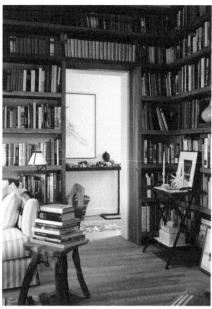

"I like to come into a space that welcomes you," Laird says of her entryway dining area. The front doors frequently remain open during meals. "It reminds me of Mexico or Europe, where you can walk through little streets and peer in at families around the table. I love that." Found yucca stalks lean against the wall opposite a piece from Maya Lin's Silver River series and a Richard Serra etching. Each room contains reminders, big or small, of Laird's reverence for raw materials, like a bulky gypsum centerpiece picked up on a rock hunt at a local gem show. (4)

The timber-shelved library, with its plush couches and chairs, serves as a haven of knowledge, especially for Laird, a perpetual learner. (5)

4

5

"The minute that I drove in," she recalls, "I knew. The mountains struck me. It's such a different picture of Texas. And the town—I'm an aesthetic person—and this town is very, very handsome."

When Laird returned for a party hosted by the nonprofit Ballroom Marfa, an organization that she now sits on the board of, she and Trey began the hunt in earnest. Then, they met Virginia Lebermann, who founded Ballroom and hails from a family of ranchers. Laird tucks her blond hair behind her ear, ready to recount the famous story. See, for Laird, being a landowner equated with a big sweeping plot, the kind where you can't see your neighbors, and cattle. "We were totally naive," she grins. "I was raised in Dallas. We didn't even wear cowboy boots." That's when Lebermann brought her back to earth, telling her, "Look, this is what's going to happen. There's going to be a time when you've come to town for dinner. Afterwards, you get onto the highway, turn onto your bumpy road, and bounce all the way home. You let yourself in, flip on the light, and head to your sink for a glass of water.

And there's going to be a rattler in your sink. You're going to have to get a gun and shoot that rattler." A horrified Laird stood shellshocked. "Sweetie," Lebermann said, shaking her head back and forth lovingly, "you're just not ranch material."

The following day, she and Trey visited a house within Marfa city limits. The 1920s construction was designed by Trost, who was responsible for much of El Paso's historic architecture, as well as the local Hotel Paisano, which hosted Rock Hudson, Elizabeth Taylor, James Dean, and Dennis Hopper during production of the 1956 film *Giant*. The structure had significance. Plus, Judd had even owned it at one point. By the time Laird came to town, the house wasn't in great shape. "There was a vine growing through the window, but I loved it," she says. "It needed a lot of TLC, and that was the real clincher." Laird might not want to be greeted by rattlesnakes, but she still isn't one to take the easy route.

She also isn't one to shy away from asking for help—and conveniently, she and Trey had developed a roster of star-

studded, talented friends who were up for the job. The German architect Annabelle Selldorf, whose art-laden client list includes the likes of David Zwirner, Larry Gagosian, Cindy Sherman, and Jeff Koons, took the lead. Trey proposed ideas, and Selldorf put them to paper. "We all sat around a kitchen island and sketched out plans on a napkin," remembers Laird. They removed walls to open up the main living space and promote the flow of natural light and implemented multiple compress-and-release moments, like a narrow staircase that leads to the ground-level primary suite. They also added a new, separate garage, a guest casita, and a pavilion complete with a caterer's kitchen for entertaining. The cubic volumes, stuccoed to match the surrounding landscape, nodded to Trost's original designs and the architectural language of West Texas.

Madison Cox, the globally renowned garden designer and the legal heir of the Yves Saint Laurent and Pierre Bergé estate, took on the landscape design, implementing fields of lavender, a play on the home's pre-existing Mediterranean

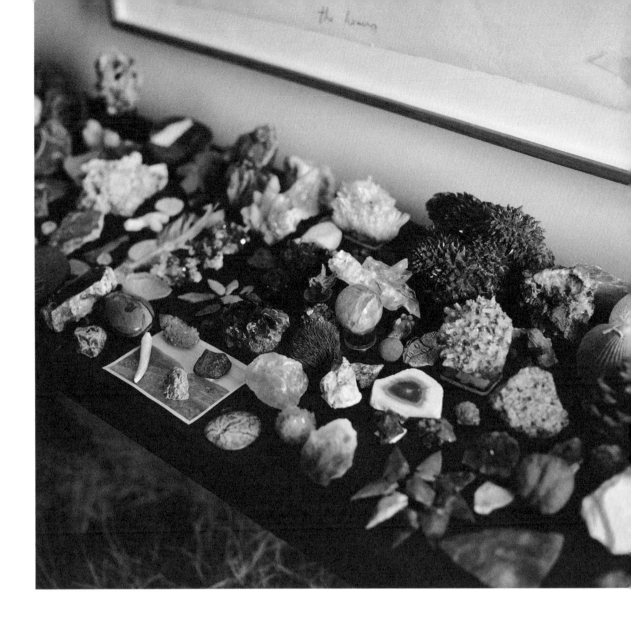

6

aesthetic, terracotta tiles, and earthen pots. The interior decorator and the then couple's long-term collaborator, Jeffrey Bilhuber, helped source vintage gems and far-flung textiles to pair with their contemporary art collection—pieces from artists like Jenny Holzer, Rashid Johnson, Louise Lawler, Grace Weaver, and Ai Weiwei. The result was a feast for the eyes—one that landed on the cover of *Architectural Digest*—but not a full-time residence. The Lairds primarily remained between the worlds of New York City and Bridgehampton. Their third residence in Marfa was a slightly more muted and pared-back version of those realities, a place to retreat with family and to host and entertain.

Laird may not have been ranch material, but after her separation from Trey, she realized that she wasn't New York material anymore, either. "I had no idea what was coming down the road for me," she says, "but I think Marfa presented the first opportunity to slow down and recognize a different way to live." She was at a turning point and on a path to self-discovery—what does it look like when you untangle yourself from your college sweetheart and longtime partner? She settled into town and began searching for answers.

7

The doors of the entertaining pavilion slide directly into the walls, creating a fluid indoor-outdoor space and providing expansive views of the Davis Mountains to the north. With multiple seating areas—from the wicker chairs and couch to the pillow-laden Donald Judd daybed and the long, wooden dining sets— the complex hosts a restful night in for one as easily as a party for fifty. (7)

"It's incredible to sit outside when everything is in bloom," Laird says from her front porch, surrounded by the silver lace vine and honeysuckle that grows along the railings. "It all combines to make a perfume. The air is fragrant." Lavender and sage, planted to keep with the Mediterranean style of the house, amplify the sweet-savory aroma that begins to pervade in the spring. (9)

8

The terracotta-tiled courtyard off the primary bathroom makes for a private outdoor refuge (8)

9

10

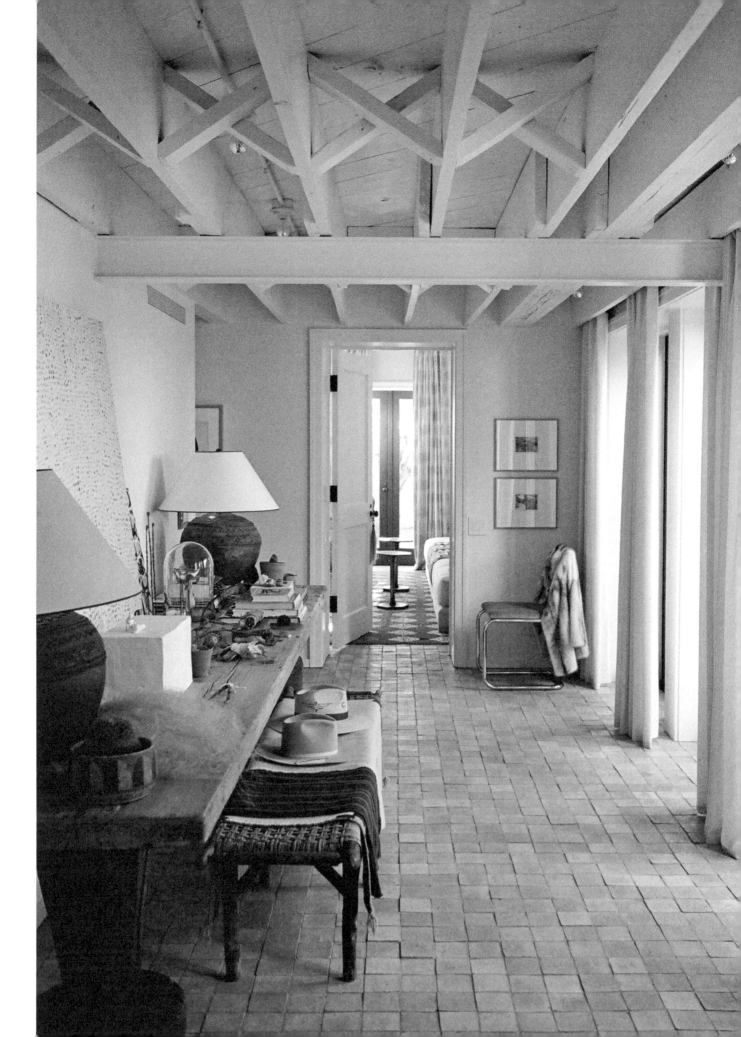

OBJECT MATTERS

Laird is well-versed in the art of collecting. As a child, she would hunt for sand dollars on South Padre Island and arrowheads in Salado. Later, her grandmother would bring her along on visits to antique shops and galleries. "She taught me how to look at things," Laird recalls, "even if it was mostly tchotchkes and Western art." Over the years, Laird became prolific. Her walls are adorned with art, her tables filled with gems, and her shelves brimming with books. "You have to learn to listen," she says. "You have to be in a mental place that is quiet enough to tune in. You will know when something should come home with you."

ON ART
I am *slow*. I like to meet the artist or, at the very least, research the piece. I have to see a work. I have to fall in love with a work. It's never just about how something looks—if it is only about aesthetics, it's likely to fall flat. I remember one of our first art fairs. We were at Miami Basel, and somebody told me, "Look, everyone here is legit. Nobody is in this fair who isn't doing legitimate work. Buy what is in your budget, and buy what you love." Coming from the art world, I had started collecting pieces from artists that interested me, who I had been exposed to, and that I could afford. At art fairs, it really struck me—there are so many great things by people that you don't even know. Follow your eyes and your gut.

ON BOOKS
I tend to collect by theme. I like when the books in a house tie to the place. In Marfa, for example, we filled the library with topics from Judd and Trost to Mexican silver, shamanism, and Native American craft. When we were working on the Bridgehampton house, we went absolutely crazy for gardening books. We pored over titles on Sissinghurst and Russell Page, and these became our references. If I buy a piece from a new artist, I try to buy everything—books, catalogs, you name it—that has been published. I will admit that I'm a sucker for a beautiful or interesting cover. Part of the fun and joy is just letting your eyes graze across the titles, waiting for something to catch your attention.

ON FURNITURE
A lot of people will ask, "Is this the right way to do it?" When it comes to decorating, everyone is so afraid to make a mistake. You can work with the most famous designer—pay them piles and piles of money—but they are bound to make a mistake, too. Some things just don't work, and so you change them. Nothing is set in stone. It's your house. It's your space. Pick out what you want, and move things around. Stop thinking about the rules—there are none! Embrace your own aesthetic.

ON NATURE'S JEWELS
I recently learned that in nature, you have to ask for permission. Not everything is there for the taking, and you can't be greedy. I was on a trek in Japan, and I was collecting a rock for every day that I was on the trail—that is, until a very important necklace went missing. I returned the rocks, and my necklace came back to me. I had received a message from above: "It's not about what you take. It's about what you receive." Later, on that same trip, I saw these heart-shaped stones. When my marriage was dissolving, I wanted to bring one back for Trey—a symbol of our time together. I quietly asked if I could bring a rock home and one appeared right in front of me a few steps away. Always ask. The world does answer.

11

12

13

14

Laird lights incense in the primary bedroom. (11)

A scene in the lower-level hallway (12)

A bowl of treasured finds: feathers, shells, and stones (13)

Invisible Man (after Ralph Ellison) by Tim Rollins and K.O.S. hangs above a desk in the annexed guest casita. (14)

Redefining Jenny Laird as an individual went hand in hand with revisiting the Marfa space on her own terms. "A house teaches you how to live in it," she says, and the layout, though aesthetically pleasing, lacked creature comforts. She added a banquette in the corner of the library and stacked it with pillows for informal meals. She bought porch furniture so that she could sit outside in the balmier months, and she augmented the pavilion, designed to entertain large groups, with cozy corners for smaller gatherings of friends. As the part-time sanctuary morphed into a home, it gained color and became a lot less spare.

"I've always loved a high-low balance," Laird says of her varied collections. The living room, its walls the backdrop for notable paintings, sculptures, and photographs, is warmed by upholstered antique furniture in a multitude of patterns and large sisal rugs, invariably worn by nibble marks from her miniature Australian shepherds. A large Richard Serra piece hangs alongside shearling-covered chairs in an intimate dining room. A Thomas Schütte suite of etchings looms above a cushy bench—the site of many a late-night cocktail—in the breezy pavilion. Adjacent to a fireplace-facing Judd daybed is a vitrine-hung sculpture from Do Ho Suh. Whimsical works made of dried gourds and grasses from the Marfa artist Tina Rivera accent the white marble kitchen island. Found birds' nests rest atop Moroccan-tiled tables.

West Texas, and the cast of characters who animate it, proved pivotal in Laird's journey of self exploration, too. "I find everyone spiritually independent and extremely interesting," she says. "They do their own thing and are very opinionated. There are no followers here." Inspired by the pioneering spirit and big skies that make it feel like anything is possible, Laird founded an enterprise of her own. She named the brand Traffic Safety, an homage to a blessing she received from a Buddhist monk while hiking a grueling trail in southern Japan. The first series of garments, primarily dresses in color-block silk and patterned cotton, speak to the comfort and versatility Laird strives for in her new desert-bound existence.

In this remote land, Laird felt an unshakable urge to create what she calls a "cave." To contrast the incredible vastness of the surrounding rangelands, she sought a place of safety, of profound relief marked by soft textures and vibrant colors. Dark and dingy, this is not. "I have basically become a couch potato," Laird laughs. Learning what she truly needs—bright over muted, homey over polished—was an introspective process. Most mornings, Laird carves aside an hour to meditate. She takes her dogs on long walks, or she just watches the light shift. The quiet time gives her the strength for whatever might come her way. "There is a quality of life here," she muses. "It's the land. It's the sky. It's the people. This place is a gift."

In it, she cedes control and embraces imperfection on a daily basis. When the puppy chews on a table, when someone tracks in mud, when a plate chips, or when her brain feels particularly scattered, she accepts it all in stride. "Marfa called to me in part because of some real flaws in my personality," she admits. "I was really searching for peace." She is dressed in a flowy creation of her own making and an oversized sweater for warmth as she talks about what's on the horizon: the development of her online platform, her daughter's impending visit, a natural dyeing workshop in the backyard with friends, a call with her photographer son, a long-anticipated trip to Egypt. She exudes a certain faith—in whatever the universe has in store, but above all, in herself.

A light-filled corridor on the lower level leads to the primary bedroom suite, creating a transition between public and private space. It contains an ever-evolving personal exhibition that appears like a physical manifestation of Laird's inner mind. Dried agave leaves, burr oak acorns, shells gathered in Africa, favorite hats, and sculptures by Tracey Emin and Nicole Wermers leave their mark on the scene. (10)

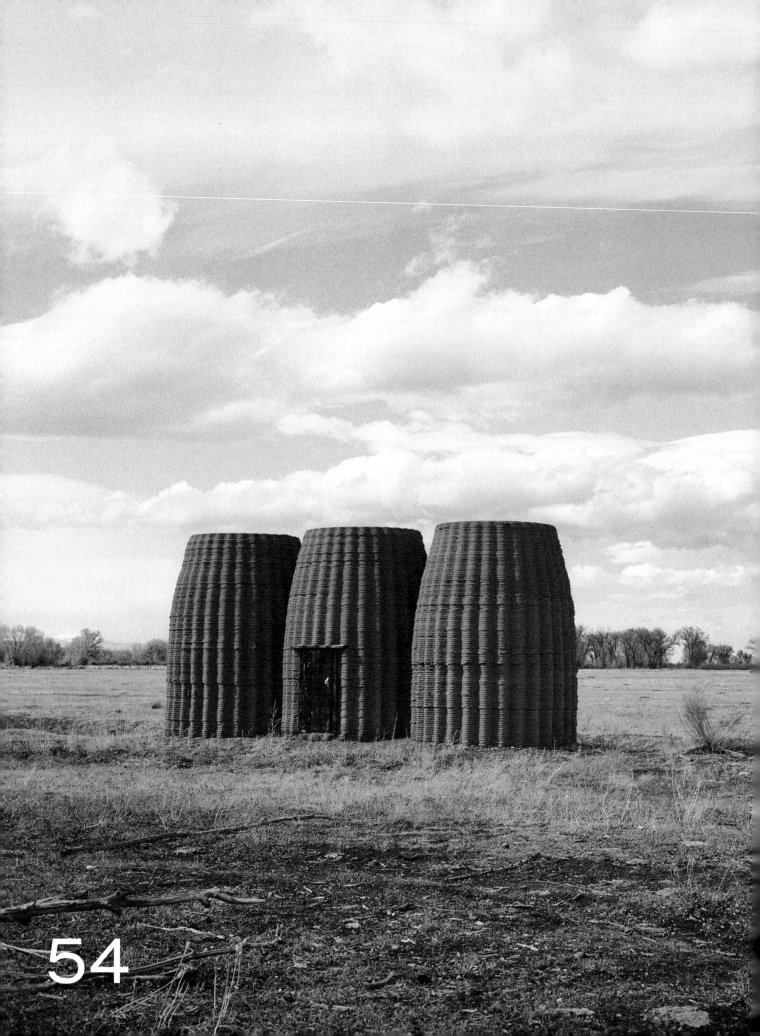

54

RONALD

United States

RAEL

BRIDGING PAST AND PRESENT:
WHERE RANCH AND ROBOTICS MEET

Ronald Rael dons a big furry hat while he splits logs into small pieces, tossing them into a wheelbarrow. In every direction, clouds swirl. The skies of Colorado's San Luis Valley grow increasingly dark and ominous, and it begins to snow. Contrary to popular belief, desert climates—especially high-altitude ones like these—aren't always scorching hot. Rael hauls his load back to the house, kicks off his boots, and takes an armful of the chopped chunks inside. The open kitchen is a toasty refuge from the inclement weather. Rael, who wields a Swiss Army knife of titles, spanning from designer to professor, author, artist, and entrepreneur, opens the steel hatch on the side of his wood-burning stove and stokes the fire.

"This was not a place anyone lived full time," Rael explains of the extreme alpine desert where he grew up. "The Utes didn't live here. The Navajos didn't live here. This was merely a hunting ground, a seasonal spot." The territory is characterized as a closed basin, a unique geological formation in which the snowmelt that runs off the southern Rocky Mountains settles directly into the valley below. "There is practically an ocean under us," Rael says. From bitterly cold winters—so cold that Rael remembers newborn calves weaseling their way into the warm house—to swampy springs replete with biblical plagues of mosquitoes and frogs to the *finally* idyllic summers, this corner of the earth has made human settlement a particular challenge. Nevertheless, some people, including Rael's ancestors, eventually made a life here.

His great-grandfather, Miguel Francisco Barela, built an adobe home in the tiny unincorporated village of La Florida. A three-room, pitched-roof construction, which transformed into an L-shaped dwelling with a 1960s addition, housed the patriarch and his family for decades. "I grew up with my great-grandparents, my grandparents, my aunts, and my uncles," Rael recalls. "Twenty-five members descended here to eat, and they all lived in

Using his great-grandfather's construction as a nexus of sorts and continuing to make adobe buildings and sculptures on the land, Rael is putting La Florida on a path toward becoming a place for more like-minded thinkers to stay and create. "There will be places for people to make interesting work and interact with the landscape," explains Rael of one of his many visions for its future. (3)

1

2

Surrounded by windows on three sides, a bedroom with wood-paneled walls retains vestiges of its sixties past and remains a work in progress. While debating the long-term layout of his now abode, Rael has made homey additions to his quarters, like a painted canvas in adobe by his partner, the artist Joanna Keane Lopez, found rocks, and one of three prints from Icy & Sot, the multidisciplinary art practice of Iranian-born, Brooklyn-based brothers Saman and Sasan Oskouei. (1)

In collaboration with Anderson Ranch Arts Center, Rael worked with cast aluminum and bronze to form objects based on his 3-D printed models. The garage-turned-workshop adjacent to his home, which houses power tools and practical elements of life on the farm, has also been a factory of experimentation. (2)

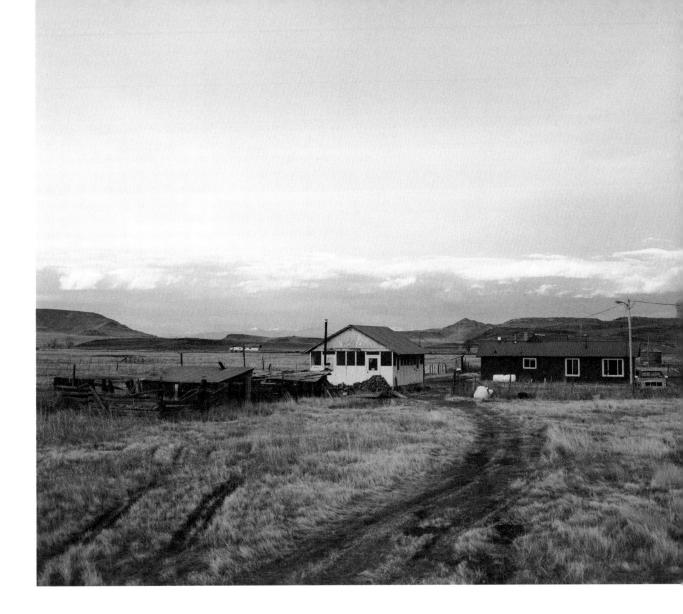

3

the little houses out beyond." Rael looks back with wonder at how his grandmother catered to such a hungry clan mostly from an earth oven outside the house. "She fed the whole town," he smiles.

In this patch of land a few miles east of the railroad town of Antonito, Rael's kin are everywhere. His mom lives in a ranch house across the street, and his brother is just down the road. They seemingly know the whole of Conejos County, and the community knows them right back. The family foothold may have dwindled slightly over the years, but traditions—farming, constructing and maintaining adobes, cattle ranching, managing the people-operated irrigation channels called *acequias*— run deep. Tending to the land is in Rael's blood.

"My dad was a carpenter," he says, though he is quick to qualify the term. "Carpenter" really meant the guy who townsfolk called to build anything and fix everything, whether roofs or adobe walls. Rael was raised in his father's shadow, assisting on projects around the valley from a young age. When his grandmother passed away in 1994, her historic residence was sold outside the family, despite loud protests from many of its members. Since then, in one way or another—including a failed attempt to secure a ten-thousand-dollar loan as a teenager—Rael has been striving to get it back.

Higher education was not a foregone conclusion for the young apprentice. He was needed at home on the ranch. Yet, at the urging of a school counselor

A true family heirloom, the heritage stove
continues to warm the home and produce
meals as it has for decades. On its ledge,
Rael displays grinding stones, 3-D printed
clay vessels, and cast-aluminum bricks. He
is known around the valley for converting
thousands of used cans into the latter.
Neighbors have taken to sending their used
soda and beer containers his way, curious to
see how they will eventually transform into
sculptures and other functional pieces. (4)

4

5

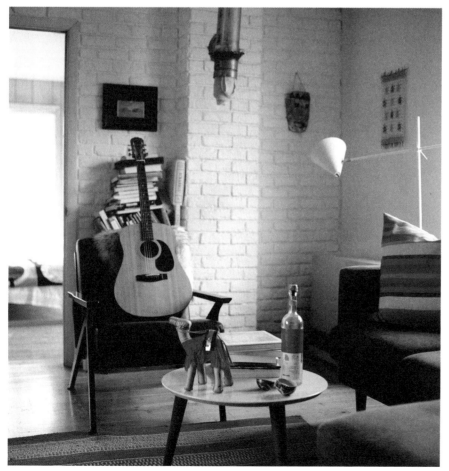

Rael balances a heavy workload with quiet
moments of unwind curled up in the living
room, fiddling on the acoustic guitar,
testing spirits like Bacanora or Sotol toted
back from Mexico by a friend, or crafting a
string of puns with his son, Mattias. (5)

who saw his standardized test scores, he found his way to the University of Colorado in Boulder. Under the impression that the college system existed to produce engineers or doctors, he started as a pre-med student but quickly shifted gears. Rael earned a degree in environmental design before going on to study architecture at Columbia University in New York. The master's program proved formative but was equally defined by what it was not. "I learned the dogmas of that world," he says. "It was very narrow." An abstract design exercise in his first class received a staunch critique from the professor: Rael's walls were too thick. "Buildings simply do not have walls like that," he was told. But the mud-brick architectural language of his youth said otherwise. Rael dove headfirst into the university's library. "I discovered that the modernists who we were studying upstairs and who used concrete, glass, and steel had at one time worked in adobe," he says. Between millennia of traditional earth building and modernism, he found a threshold moment for architecture and became completely enraptured.

Rael then fell into academia himself—but completely "by accident," he laughs. On a visit to his Colorado alma mater, curiosity led him to knock on doors. "How do you become a professor?" he remembers asking. Before long, he was showing his portfolio, and the university hired him to start the following week. He wound his way through various institutions including Clemson University and Rotterdam's Office for Metropolitan Architecture before landing at the University of California, Berkeley, where he rose to the Eva Li Memorial Chair in Architecture.

He began a free-form practice steeped in the notion of challenging the boundaries of architecture and objects. Take the provocative piece *Teeter-Totter Wall,* which transformed the slats of the United States–Mexico border wall into bright-pink, temporary seesaws. The installation, which briefly brought individuals together to remind viewers that "the actions that take place on one side have a direct consequence on the other," earned the project and its team members awards and recognition, further cementing Rael's beliefs in design as cultural expression.

In the meantime, Rael was becoming the face of 3-D printing in mud. Images and videos of his large-scale, robotically made adobe structures are now inextricably linked with his name. He has been featured in publications such as *WIRED,* the *New York Times,* and *Domus,* and his work has been exhibited at the Museum of Modern Art, London's Design Museum, and the Cooper Hewitt, among others. He has penned multiple noteworthy books, including *Earth Architecture*, a study of the oldest building material in the context of today's world, and *Borderwall as Architecture,* a potent examination of the physical barrier separating the United States and Mexico.

With nearly all he touches, Rael is a practitioner of the "remix." From the kitchen, where he puts a spin on tried-and-true recipes like *atole*, a porridge-like beverage made from corn, to his art and architecture, Rael blends ancestral knowledge and materials with personal overtones and frontier techniques. In 1996, when the Internet was dawning, Rael's brother started a website to showcase the young architect's restoration work on a historic building in La Florida. The dialogue that spawned from that rudimentary page catalyzed Rael to engage with online forums. There, he stumbled upon the work of Iran-born Behrokh Khoshnevis, a mechanical engineering professor at the University of Southern California. Khoshnevis had been developing a technology to produce large-scale, 3-D printed concrete objects. While he was perfecting with concrete, he experimented with mud. "*That's* the future," Rael realized upon seeing the test runs.

From the initial spark, a slow-burning fire lit inside him. After struggling with a self-made machine, Rael came across an engineer in Florida who was developing a ceramic 3-D printer.

"I contacted him and bought one of his very first printers. Then, I started making these weird things in clay," Rael recalls of his early days in the medium. "The ceramics world was like, 'Whoa!'" He went on to co-found Emerging Objects, an innovative 3-D printing brand that employs other varied materials like salt and rubber. But Rael felt a growing urge to print bigger. He imagined a robot capable of producing an entire building with earth, converted his vision into a video, and sent it off to the Florida engineer. The partnership paid off, and in 2019, Rael hit the ground running.

For the mud master, thinking about earth building is inherently connected to the San Luis Valley. After continuously asking the owners of his erstwhile family compound to sell, they finally relented. Then in 2020, when society was forced to slow down and in-person teaching was put on hold, he truly committed to his return. "I have never said that I live in California," he explains. "I work in California, and I live here." Though he values his West Coast existence, this tug of his homeland is constant. "This was my dream for the last twenty years," Rael says. "Being back in this house, I'm actually living it."

Reintegrating has been an ongoing effort for Rael. When he arrived, much of the property had fallen into disrepair or was simply outdated. Rael replaced old linoleum and carpet with Douglas fir from a local mill. He and his son, Mattias, removed concrete plaster applied in the 1960s to return the adobe facade to its natural state. Small window openings were expanded to allow more light to permeate, and Rael is currently redesigning the roof of the addition to match the pitch of the original home.

His grandmother's stove, which now serves as the hearth and emotional center, had left with the 1994 sale and roamed with an aunt. "She moved five times and hauled that giant thing around," he says, "but when I moved in, she insisted that it needed to come home, too." Elsewhere, he decorates with gifts from students—like a maté cup fashioned from a hoof, grinding stones that he and his mother find on walks, his own 3-D printed vessels and cast-aluminum objects, a miniature teeter-totter wall made from a joined dollar bill and Mexican peso, and ceramics from Johnny Ortiz-Concha. Walls are adorned with pieces from Icy & Sot that Rael traded his own work for, a framed woven specimen from the embroiderer Marcella Pacheco in the valley, and a poster from a gallery opening for West Texas legend Boyd Elder. In everything, Rael is writing a new chapter for the home and surrounding land, infusing his own identity while cherishing the outside influences that enrich it.

On Father's Day of 2022, Rael and Mattias—whose birthday happens to be just one day apart from Rael's—restored the primary home's outer layer to its original state by removing concrete and applying a mud plaster. From a young age, Mattias has worked alongside Rael building *hornos*, or earth ovens, collaborating on larger 3-D printed buildings, and even driving the tractor. (7)

On any given day in La Florida, Rael flows between a diverse set of heavy machines without skipping a beat. With equal mastery, he commands his family's tractor—fitted with a front-end loader to dig trenches and build dams—and his enormous, high-tech 3-D printer with its mechanical arm. (6, 8)

6

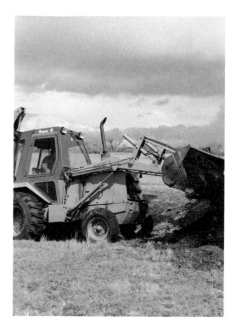

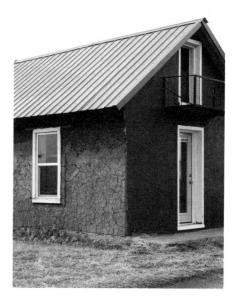

7

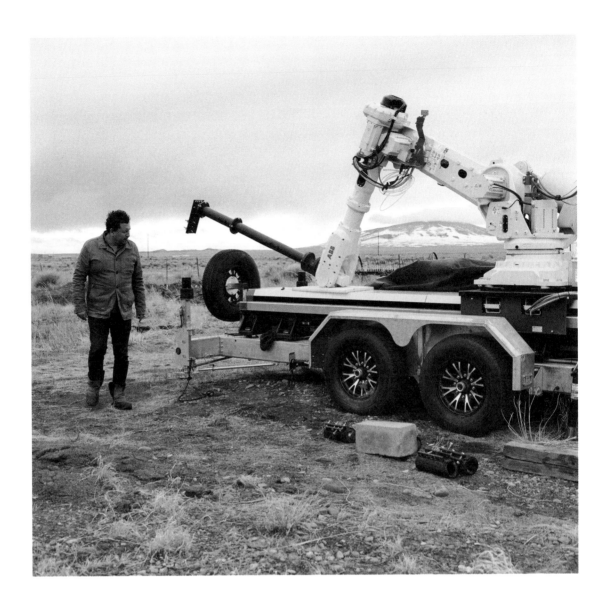

8

9 10

The Nubian vaults championed by legendary
earth-building architect Hassan Fathy became a
fertile source of inspiration for Rael in the
nineties. He sought out one of the Egyptian's
students and foremost stateside practitioners,
Simone Swan, who was constructing a home
with a team of volunteers on the border of
West Texas and Mexico. From those practical
seeds, the road to Terrano—the world's first
ever construction with a roof 3-D printed in
situ—was paved. "Building upon the genius
of the past," Rael once wrote, "is one small
step towards a larger goal of producing
architectural elegance using humankind's most
humble material." (9)

Each of the three massive adobe volumes
that Rael printed on property in 2020 open
to the sky and, with no foundation, connect
directly to the earth. Titled Casa Covida,
the project combined new approaches with
ancient, Indigenous traditions to reimagine
co-habitation and connection in the midst
of a global pandemic. (10)

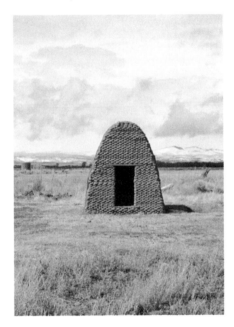

11 As he settles back into the San Luis Valley, Rael embraces the food of his youth. Dried hominy has been soaking in the kitchen since morning. Wielding a massive, hand-forged vegetable knife, he chops dried chiles to add some heat to a pot of pozole, an aromatic soup highlighted by pork and robust corn kernels. (11)

12 Cherished objects—clay spoons from the New Mexico ceramicist Brandon Adriano Ortiz, greeting cards from loved ones, 3-D printed atole bowls, carved gourds, and an Incienso de Santa Fe incense holder—sit atop a flat-file cabinet and in front of an Icy & Sot work. (12)

With the dwelling and a growing cache of historic buildings, Rael is at once safeguarding heritage, strengthening collective identity, and manifesting the future that he envisions. One of his structures, part of his self-designated "Adobe Archipelago," is a former Indian Agency that served as an outpost for the Native American slave trade and bears the scars of a region still coming to terms with its recent past. Across the border into New Mexico, Rael is striving to save an 1800s adobe village, which still hosts the private Catholic brotherhood Los Penitentes. He is a preservationist and, simultaneously, a futurist and inventor.

Without building codes, Rael and his collaborators can utilize the land of La Florida as a laboratory. On a parcel adjacent to his mother's house, Rael and a dedicated team dreamed up Casa Covida, a triptych case study of circular rooms for the purposes of sleep, bathing, and gathering around the fire. In another corner, various studies in mud from Rael and his students test the limits of 3-D printed adobe. The masterpiece, though, is the first-ever structure with a roof printed on site. Though Rael has yet to assign a specific purpose to the building named Terrano, it serves as a powerful representation of a rapidly approaching reality. Using a newer robot given to Rael by a philanthropic entity, his limits continue to expand. "I used to be stuck on circular designs in order to print the biggest thing possible," he says. "I was literally and metaphorically reaching as far as

I could." Terrano is also his first foray into vaulted architecture inspired by the likes of the Egyptian architect Hassan Fathy.

"I feel like I grew up in the 1800s, when electricity and running water were brand-new," Rael says of his rural upbringing. "And now I work with robots in the very same place." Through it all, Rael endeavors to make connections across the many borders within him. From vernacular architectural methods blending with futuristic construction to a complex personal identity that encompasses Indigenous and Mexican roots and an upbringing in the United States, returning to the land of his ancestors has allowed Rael to celebrate the many layered realities. "I no longer have to think about impressing all of those people who I was told to impress," he says. "It's actually about impressing my mom and my community and being respectful of this landscape and its history."

The wood in the stove crackles and pops as Rael brews a tea. Oshá, a medicinal root akin to wild celery and endemic to the lands of Southern Colorado and Northern New Mexico, simmers in the pot. Rael adds rose hips and local honey—another remix—to his concoction and sips gently from his cup. "This stuff is better than aspirin," he quips. His mother, Christina, knocks on the kitchen door, popping in to deliver the mail. Rael revels in the fact that his world—from his family to his students, fellow artists, architects, professors, and fans—has started coming to him. "It really feels like there is a positive exchange happening," he reflects. From his multigenerational abode to the testing grounds of La Florida, from Conejos County to New Mexico and the borderlands, Rael has found his purpose. It's a remixed nation of his own making. "This," he says, contemplating the gravity of all that *this* entails, "will be what I'm working on until the day that I die."

Rael has developed something of a reputation in the greater community for collecting old adobe buildings, with locals occasionally calling him up to gauge his interest in a new acquisition. Every structure, like the shell that is the former Gomez and Sons cabinetry store in downtown Conejos, brings him closer to understanding his roots in this former borderlands between the United States and Mexico. "After the Mexican-American War," Rael says, referencing the conflict whose 1848 culmination saw Mexico cede large swaths of the present-day western United States, "a bunch of people decided to stay" and become U.S. citizens, creating a complex web of cultures. (13)

13

14
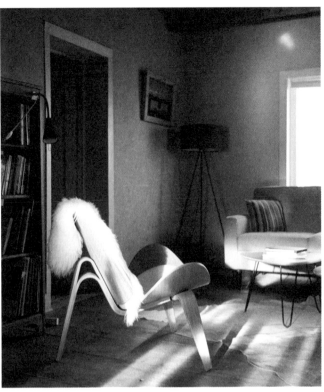

Rael hosts guests and students in the Dominguez House, a neighboring dwelling that belonged to his great-aunt's family and exists within the network of structures that he has dubbed the Adobe Archipelago. In the space, now an extension of his own home, he decorates with the likes of a Hans Wegner-inspired Shell chair covered in shearling and plentiful books and records. (14)

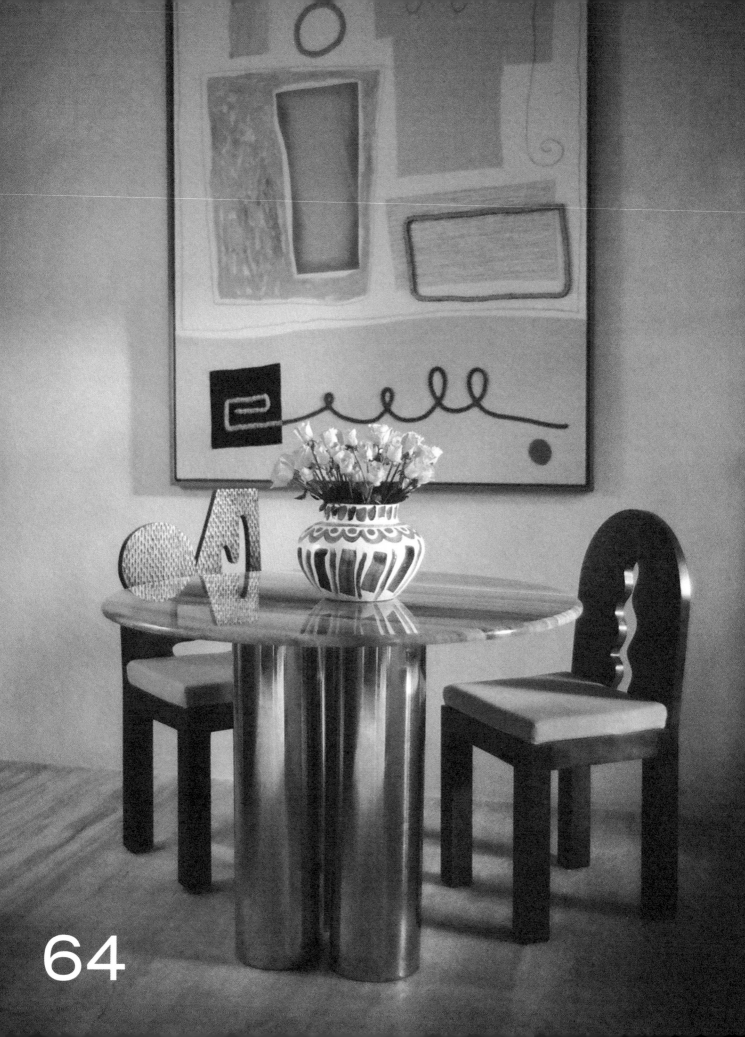

64

AYOUB
BOUALAM

Marrakech &

LAURENCE
LEENAERT

Morocco

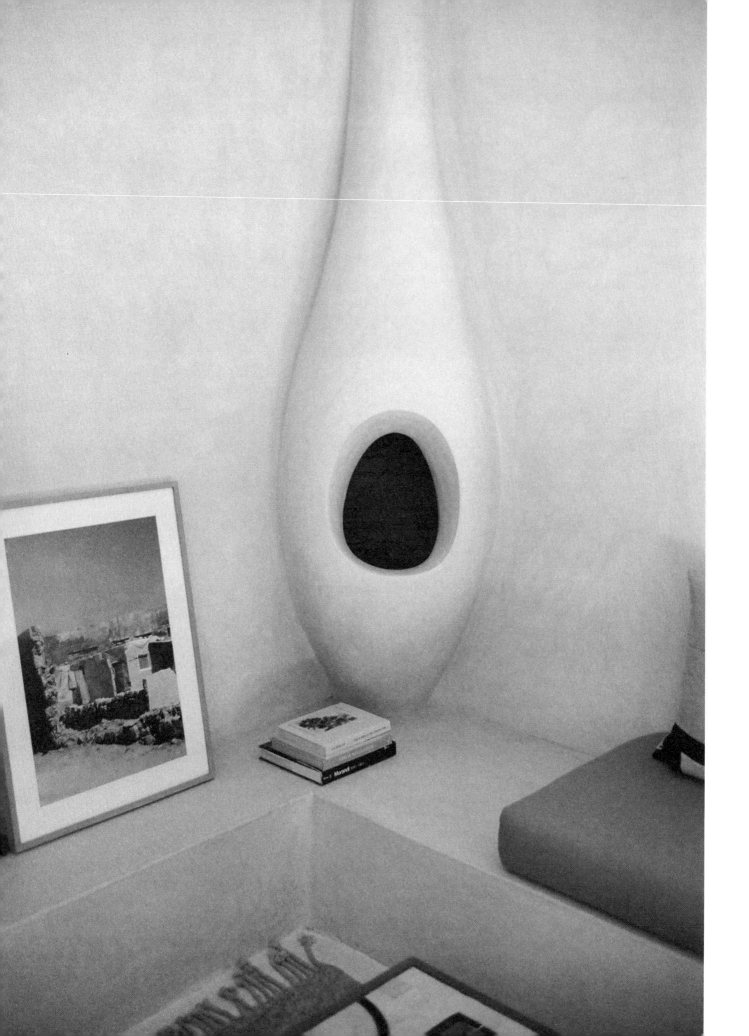

ACROSS THREE DISTINCT SPACES, ONE WHOLE UNIVERSE

2

3

When Ayoub Boualam talks about Laurence Leenaert—his partner in life and work and his best friend—he beams with pride. In fact, it can be challenging to convince him to speak about himself. And though he is an impressive character in his own right, adept at marrying creative intuition with business acumen, his affection for Leenaert is understandable. She moved to Morocco with a sewing machine, 400 euros, and little in the way of community at just twenty-five years old and blossomed into something of a design sensation. Now, eight months pregnant with their soon-to-be baby girl, the artist glides between the studio, their recently opened hospitality project, interviews and photoshoots, and social gatherings with the poise of a professional dancer and the focus of a chess player.

But then she returns home to the sanctuary that they have created together and arguably her favorite corner of the city. "It feels very much like an extension of you," Boualam says, looking to Leenaert with a twinkle in his eye. "It is her colors—she is obsessed with combining colors—but more than anything else, it's her energy." Leenaert chuckles.

To transform a once residence into the five-room hotel, Rosemary, Boualam and Leenaert teamed up with more than forty craftspeople from around the country.

They worked alongside women in Meknes to produce stained-glass doors and windows, sought out potters in Safi, traveled to Rabat for marble, and found hand-chiseled tilemakers in Fez. (2, 3)

4

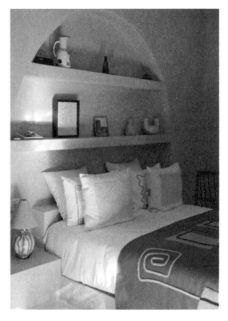

1 Much like rooms in a private home, each accommodation at Rosemary has distinctive character. The Bird's Nest, named for its fireplace inspired by the free-hanging nests of the North African Firecrest, is a sea of tranquility. Its lime-washed, curved walls meet a palette of burnt orange, soft pink, and honey. (1, 4)

TEA TIME

Guests at Rosemary, Boualam and Leenaert's two-story creative retreat, are welcomed like old friends. Check-in often begins in the salon d'été, an alcove off the sunlight-laden courtyard, with whimsical animal-shaped cookies and mint tea. Served from vintage silver pots, it is poured from high above into traditional bluish-tinted glassware to create aeration.

In Morocco, tea is more than a warming beverage. It is an art, a ritual, and a symbol of hospitality, one that Boualam and Leenaert proudly share with travelers from around the globe.

1. Add loose-leaf green tea to a pot.

2. Pour boiling water over top, and place pot on a low flame.

3. After three minutes and to avoid bitterness, throw in a handful of fresh mint leaves.

4. Remove from heat, and add dried orange blossoms or orange blossom water to taste.

5. If using sugar, dissolve into the hot mixture.

6. To ensure that the flavors properly combine, pour a cup of tea into a glass and return to the pot. Repeat two to three times.

7. Take a sip and settle in.

Boualam and Leenaert's bedside: Neutral
walls and a muted marble pedestal let
objects and art take center stage. (5)

Plentiful surfaces prove crucial for
Leenaert, who constantly has pen and
paper at the ready. An incessant sketcher,
she spreads across the house—the verdant
terrace, the dining room, or the office,
which features a favorite desk. An
example of Leenaert's experimentation
with material and texture, the work
table combines a burl-veneer top with
legs of stacked travertine balls. (6)

An object "needs to have a soul" to make it into the duo's home. They tend toward custom, one-of-a-kind pieces, secondhand items with patina, or work made by friends like Lieven Deconinck of the art collective Leo Gabin. (7)

The apartment, she muses, is really a product of both of them. Ceramics, textiles, various stones, and "grandmother things" like napkins fill every corner, acting as vestiges of travels to faraway places including Mexico, Vietnam, Greece, and India, where the couple got engaged. Each piece, it seems, tells a story in their collective visual diary. There's also, of course, Boualam's television, a concession Leenaert made so he could stay up to date on soccer and be home at the same time.

Located in Gueliz, a French-influenced Marrakech neighborhood that artfully combines traditional and modern sensibilities, the two-bedroom apartment was built in the 1980s and underwent a refresh in 2018 thanks to its former architect owner, Trab Design's Bruno Melotto. Coincidentally located in the same building as the medical practice of Boualam's father, Leenaert can pop down for an ultrasound at her convenience and return to her top-floor refuge of natural light, original terrazzo floors, and books—*lots* of books, carefully curated by the duo and referenced regularly. The place is also a haven for plants. They pervade the internal lightwell, which harkens to vernacular courtyard architecture, and the terrace, where Boualam and Leenaert begin most days.

Their space is many things: airy but intimate, minimal but warm, colorful but not overly so. What it might lack in size, it makes up for in personality, which suits the couple's personal preferences just fine. "I like small spaces," Leenaert explains. "People equate big with luxury, but I have never wanted to live in something grand." And who needs to when they also have a studio and shop in the industrial district Sidi Ghanem *and* a riad hotel, a classic construction, in the ancient medina quarter?

The ease with which the pair navigates their varied endeavors in Marrakech feels like a given, but their prominent

foothold in the city didn't materialize overnight, or even jointly. Leenaert's introduction came when she booked a two-week excursion for herself and her sister, Michelle, that started in the desert hub and led them from camp to camp in its rural outskirts. The only caveat? They had to travel for hours each day on foot. This surprise—the sisters expected to be moving by Jeep—came with its frustrations, but the two made peace and turned it into a profound adventure. "We met a lot of special people, and I began ruminating on a return," Leenaert says, "so I asked the owner of a camp if I could come help out for a bit." Maintaining the grounds, receiving tourists, and earning enough to survive, Leenaert began searching for artisans, sourcing fabrics, and making bags. "Nothing to sell, just cool stuff I thought," she shrugs. Yet, with a growing number of talented collaborators and her own steadily increasing savvy, Leenaert was resolved to move to Morocco full time. Though Marrakech proved the most practical landing spot, she took with her "the light and the colors and the laid-back energy" of the surrounding desert that contrasts with the hectic and fast-paced metropolis. The city is her base, but her practice remains tied to the lessons and feelings she acquired in the wide-open spaces beyond.

Leenaert's early output started gaining traction through a modest webshop and social media channels, and she packed and shipped her wares through the local post. "Everything was very amateur," Boualam laughs, side-eyeing Leenaert. Boualam was living in Paris, part of a ten-year stint, when he came home to Morocco for a brief summer holiday and met Leenaert in a roundabout way through mutual friends. The chemistry was instant. Three weeks later, the upstart couple convened in the French capital, and Leenaert invited Boualam on a return visit to her native Belgium. Common thinking on long-distance

"A house is a museum of its inhabitants,"
says Leenaert, and the apartment that she
shares with Boualam teems with personal
treasures: photo-booth strips of the couple
laughing tucked into bathroom fixtures,
towers of books and magazines on the back of
the leather couch, postcards and sonogram
shots attached to the fridge with food-shaped
magnets, and framed posters leaning against
the walls. "I like to see my stuff around,"
she continues. "It makes me happy." (8, 9)

8

9

relationships should be disregarded here. Two years of a Paris-Marrakech back and forth proved pivotal for Leenaert to establish her footing in the North African country on her own terms. Eventually, though, she needed a business manager, and Boualam came into the fold, drawn back to his homeland thanks to Leenaert's fierce, force-of-nature persona.

The idea to pursue a workspace came about during a Parisian rendezvous. "I thought, 'I cannot live and work in the same place,'" Leenaert affirms. "And I knew that I could help because of the connections that my family and I have in Marrakech," adds Boualam. The studio, which now serves as a multifunctional headquarters for the couple's design and interiors brand LRNCE, wasn't discovered by either one of them, but rather Boualam's parents. Though Leenaert had little in mind beyond a simple office, the industrial building, with its open plan, fostered a spirit of possibility. After moving in, they began to amass a robust team and later acquired the floor above to draw a healthy line between

the showroom and studio, as well as practical corners dedicated to inventory and packing. While Leenaert paints freely, spreads textiles across the floor, and pursues creative impulses without interruption, Boualam acts as the frontman. "I love to receive clients and explain what we do," he asserts, his sense of achievement palpable. Their respective strengths coalesce under one roof.

The studio has played host to countless visitors and been the site of life-altering chance meetings. In one early example, a French woman named Rose-Marie dropped in. It must have been fate, because in that first brief encounter, she was convinced that her riad, soon to hit the market in the city's medina, was destined for Boualam and Leenaert. Property hunting wasn't on their radar, but the following day, the couple went to look for themselves. They fell hard and fast for the home designed by Quentin Wilbaux. The renowned Belgian architect—who spent more than thirty years living in the medina, working on dozens of riads, and playing an instrumental role in UNESCO's designation of

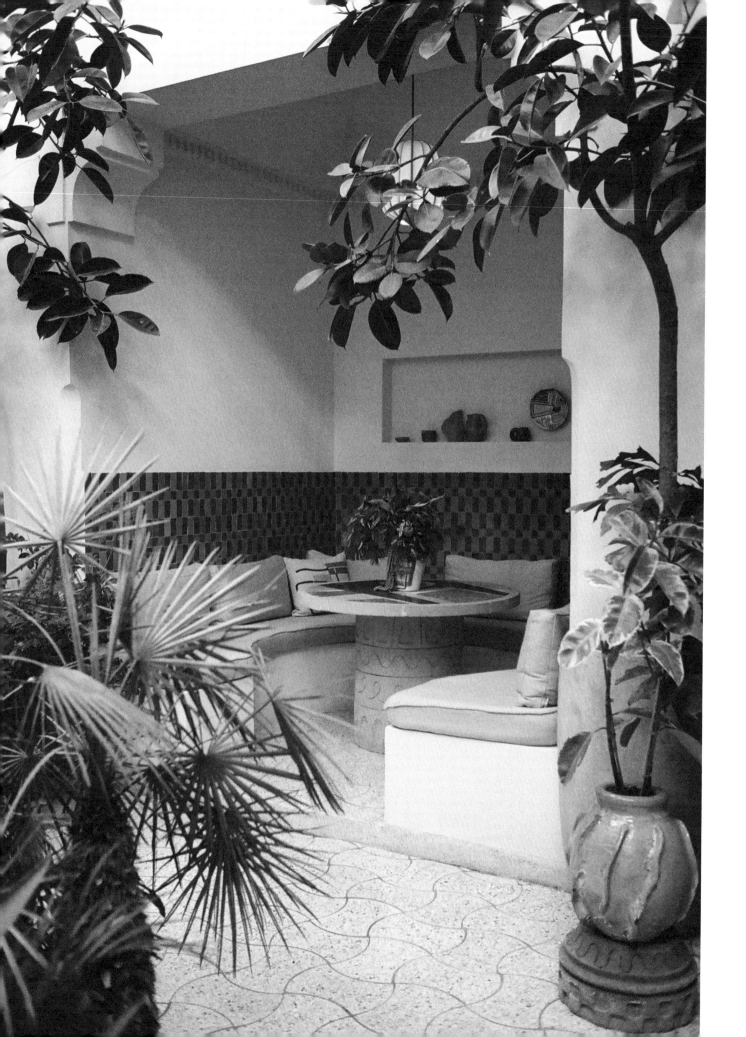

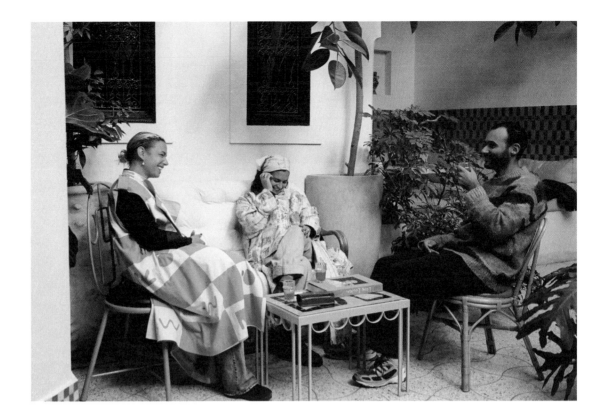

11

The salon d'été, a cozy nook
with curved benches and copious
ecru-colored pillows, radiates
calm. LRNCE is known for its
playful, color-forward aesthetic,
but Boualam and Leenaert wanted
Rosemary to be a pared-back "place
for everyone" that contrasts with
the crowded medina streets. (10)

the historic zone as a World Heritage Site—provided the ideal canvas on which Boualam and Leenaert could project LRNCE's contemporary feel. And so, with a tip of the cap to the former owner, Rosemary began.

The project, a five-room hotel, would be a direct reflection of the couple, their artistic community, and the urban desert surrounds. Blending well-established architectural standards with modern aesthetics is no easy feat, especially if you have no experience in renovation, but one that Boualam and Leenaert happily took on. While the brain trust behind Rosemary kept with the character of Wilbaux's design—as well as certain hard-to-replace details like a two-person Arabescato marble bathtub and an intricate skylight in Rose-Marie's former bedroom—every square inch from floor to ceiling was an opportunity to create and experiment.

"We did a lot of plaster work," Leenaert says, "which is typically very religious and Islamic-inspired." They found an artist in the medium who, going off of a Leenaert drawing, installed a custom ceiling. The new hoteliers were pleasantly impressed with the result, when he asked them, "What are we going to do next?" Soon enough, more ceilings, lamp shades, and smaller, one-off tiles became a defining characteristic of the guesthouse. "The riad allowed us to discover and explore all of these new materials," Leenaert says. Her simple sketches transformed into a handmade wooden door, a metal-framed furniture series, stained-glass windows, sandstone sculptures, and zellige-tiled tables. The list goes on. The team played with carving on pillars and gave wall space to other artists

Sister, sister: Michelle has been Leenaert's
co-conspirator, whether modeling for LRNCE or
managing the riad hotel, since birth. (11)

With Boualam tackling both behind-the-scenes
business decisions and front-facing client
relations, Leenaert has gained a certain
creative independence. "That freedom," she
affirms, "is key." Eschewing pressure, her
process is free-flowing and spontaneous,
and she finds inspiration everywhere—in
sun-soaked, seductive scenes from the film
director Luca Guadagnino, in the wrought-iron
chairs of her in-laws' backyard, and through
the lens of her beloved Canon A-1. (12)

12

13

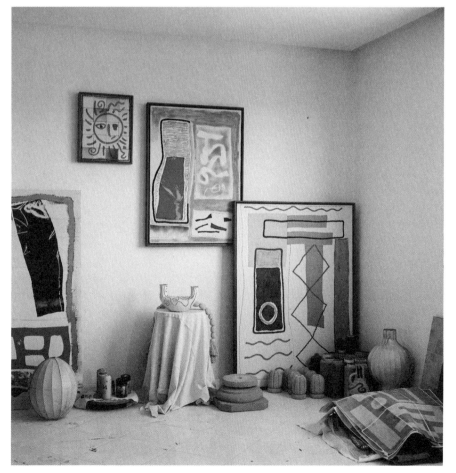

Boualam and Leenaert's spaces are neatly
organized, with the exception of one.
In the workshop, the artist lets loose.
Favorite works—those which she simply
isn't ready to sell—are carefully
assembled on shelves. But elsewhere, big
mounds of clay, paint samples, torn-out
pages from magazines, spools of yarn, and
jars of heavily used brushes and tools
take over. (13, 14)

LRNCE objects are a fixture across Boualam
and Leenaert's spaces. And they aren't just
for display—they are meant to be used. In
the studio, the Moroccan team drinks tea
and instant coffee from ceramic mugs and
espresso cups. (15)

they respected. They employed terrazzo around the base of the nearly half-century-old Jacaranda tree that punctuates the courtyard and rooftop alike and filled the space with greenery wherever possible. "We thought it would take six to eight months," Boualam recalls with a "hindsight is 20/20" look. "It took a year and nine months." In the end, the slow pace was necessary. "It's what we needed because we didn't make plans. We made our decisions on site," Leenaert says. Without any external deadlines, they allowed delays to become opportunities for evolution, flowing towards Rosemary's inevitable culmination: a place that masterfully weaves handcrafted LRNCE pieces with everything—furniture, music, food—that inspires the brand bosses.

Marrakech's medina is a magical universe filled with unimaginable worlds, until you cross the precipice from roaring alley to serene courtyard. Rosemary is no different. It feels like a home, partly because it was one and partly because the team kept the rooms spacious, welcoming, and apartment-like. Not to mention, Leenaert's sister and partner in crime, Michelle, runs the place. It feels like most things in Boualam and Leenaert's world become a family affair. The impulse to fall into their orbit just might be too much for some to

resist. With their first child—or as Boualam jokes, "our latest collab"—on the way, the Leenaert sisters' father is uprooting from Belgium and joining the ranks of transplants drawn by the mystifying magnetism of the city, and the formidable pair who call it home.

Becoming a singular unit, as Boualam and Leenaert have, has its obvious ups. "Traveling and meeting amazing people together," Leenaert reflects, her gaze directed at Boualam, "and sharing in our successes is a really nice feeling." The down side? Not being able to create limits and to shut off. "Sometimes, I'll wake up at three in the morning and see that she's on her phone writing emails," says Boualam. With teams to manage and products to fabricate amid a ruthlessly competitive marketplace where relevancy can be fleeting, slowing down can be the greatest challenge. And all of this, with a new family nucleus forming. Many have expressed—typically without solicitation—to Leenaert that having a baby might hamper her creatively, but she's approaching it with open arms. "I think it will only make things better," she says with a smile, "more balanced." For Boualam and Leenaert, building, learning, overcoming, and growing has been in their DNA from day one. Welcome to the next phase of the journey.

14

15

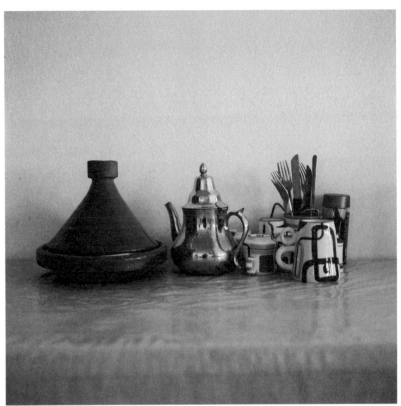

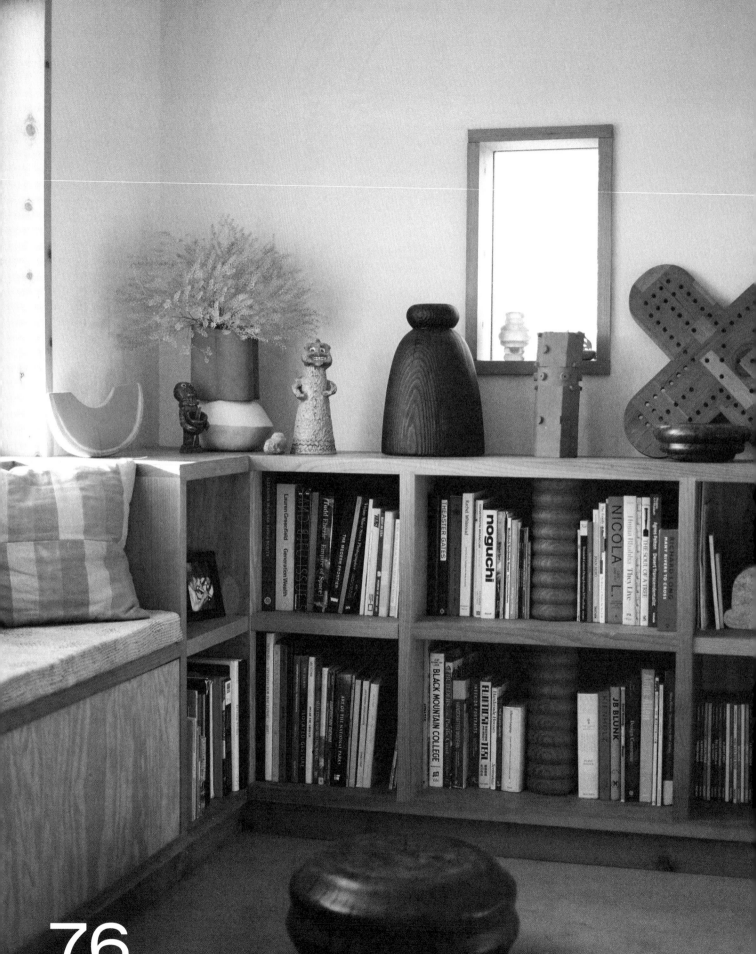

76

DAN JOHN ANDERSON

&

GENEVIEVE DELLINGER

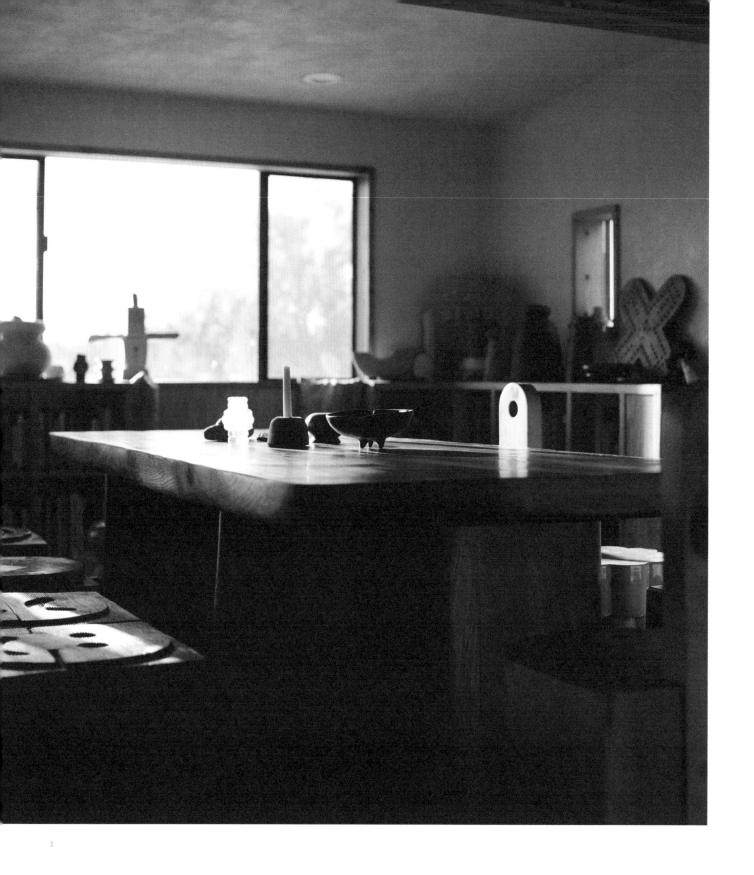

1

Anderson formed the redwood table from a slab sourced at
a mill that neighbors the creative retreat and cultural
commune Salmon Creek Farm in Albion, California, where he
has visited and displayed work. The high-backed chairs,
meanwhile, hail from his High Desert Dinner in 2020, an
event that marked the ten-year anniversary of his first
trip to the area. If these pieces could talk, they would
all have their own unique story to tell. (1)

FORGING A FREE-SPIRITED FAMILY PLAYGROUND

It's just before 7 am in the Yucca Valley home of Dan John Anderson and Genevieve Dellinger. An enormous Moka Express coffee pot is brewing on the stove, filling the open living space with the thick aroma of strong espresso. Anderson and Dellinger's two children, Mars and Uschi, bounce around the redwood dining table. They eat breakfast, build otherworldly Lego structures, play a round of cards, and slowly get ready for school. Looking east out of a wall of windows past the arroyo, on the crest of the next hill, the sun is beginning to rise. Suddenly, the entire space glows orange, as Mars and Uschi start shadow dancing, their silhouettes animating the walls above the family's sunken living room.

In 2010, at the age of 33—"the same age that Jesus was when he went to the desert," Anderson quips with a grin, his cheeky humor on full display—the artist and his Portland, Oregon–based collective Von Tundra were invited by Andrea Zittel to exhibit work at A-Z West. Zittel's multifunctional space, now a legendary incubator of artistic exploration, directly abuts the vast wilds of California's Joshua Tree National Park. The event was dubbed "High Desert Brunch Club" and included tables and chairs created by Von Tundra set against the dramatic, rocky backdrop of Zittel's property.

Dellinger's office is distinctly her own and not just in design. The space, occupied by favorite objects and trinkets, is not only where she helms her photo production studio but also where she tackles elaborate crafts and costume projects for the family. (2)

2

3

Anderson cropped a family heirloom to fit in the intricate wood grid of the primary bedroom. The blue painting, which his grandfather found at a thrift store and proceeded to take a Sharpie to, adding a bird, was a fixture of Anderson's childhood. (3)

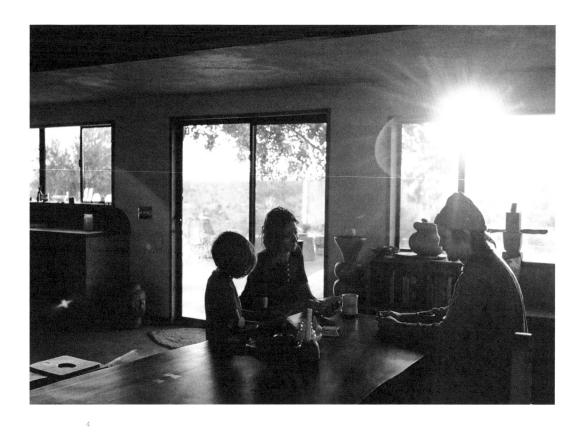

4

The dining surface is large to accommodate
meals and gatherings as well as an assortment
of activities—brainstorming, drawing, and
poker playing, to name a few. (4, 6)

5 6

The stained-glass window made by
Steve Halterman, a set designer,
artist, and co-founder of The
Station in Joshua Tree, transforms
sunlight into a dazzling display
of color.(5)

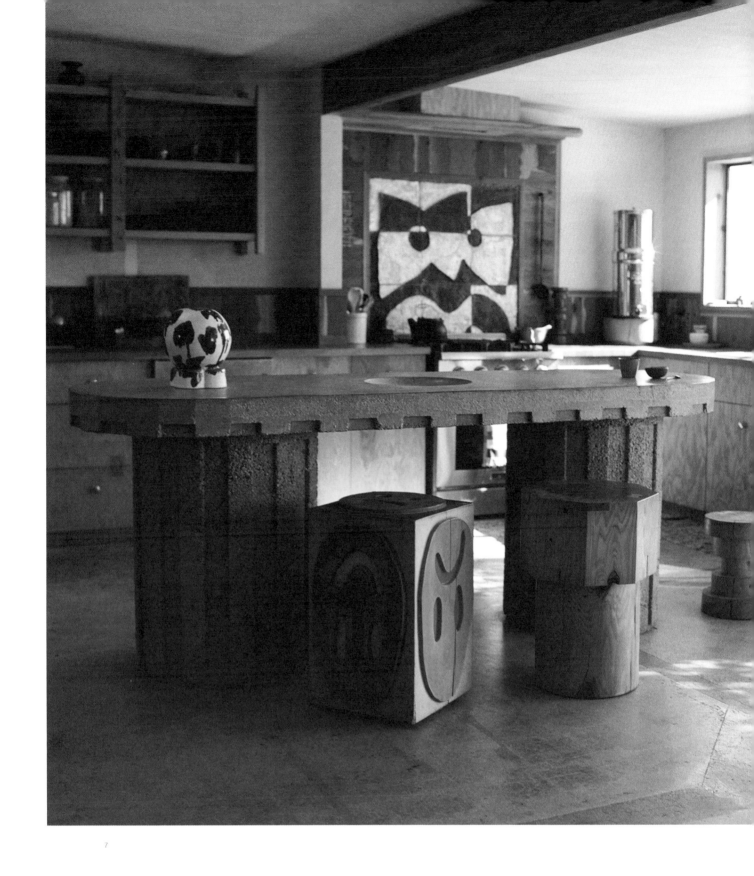

7

The 3,000-pound concrete island was poured
in place just days before Dellinger gave
birth to Uschi. The wood forms were removed,
revealing the kitchen's centerpiece—its
rough vertical surfaces contrasting a smooth
and polished top—on her due date. (7)

Von Tundra was gaining recognition and winning awards, but Anderson was distracted and survival meant moving from place to place in search of the neighborhood with the lowest cost of living. When Anderson eventually took the plunge to uproot his Portland life and relocate to Joshua Tree in 2012, he experienced a sense of groundedness that he hadn't felt beyond his boyhood stomping grounds of rural Eastern Washington. "I had my fun in the city, but I was ready for this kind of vibration," he says. "I felt at home here immediately."

Upon landing in his new desert environs, he acquired an old motel, which would serve as his first live-work space,

and got himself a dog, a pit bull mix named Rookie. The two started exploring the wilderness on foot, the first phase in developing what Anderson refers to as his "mental map" of the region.

In those early days, Anderson rekindled his relationship with Zittel, working alongside her as well as with the artist Alma Allen, whose practice focuses on large-scale sculpture in stone, wood, and bronze. Searching for inspiration, Allen and Anderson tore through the desert into uncharted territory in a Land Cruiser, revealing previously hidden layers of the surrounding nature. The off-road vehicle represented a tipping point in Anderson's ability to dive into the infinite

places around him and explore a different set of energies. "If you just go out a little bit in any direction, there are microcosms everywhere you look," Anderson says. "I could never get bored out here."

Dellinger, meanwhile, was working in photo production in Los Angeles when she and Anderson began dating. At the time, she paid frequent visits to the desert, a trend that finally culminated in the purchase of the home that they now live in, a 900-square-foot structure built in 1959. After closing on the house in late 2014, Dellinger made the trek to her new digs, which would also eventually operate as the desert outpost for her production company, Goldie. "When I first drove

8

A ceramic vessel from Bari Ziperstein sits in front of a painting by Lily Stockman, which Anderson set in a frame of his own making. (8)

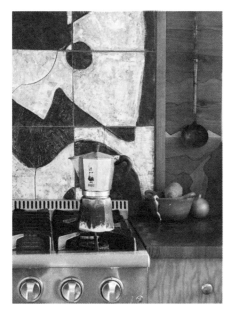

The black-and-white kitchen backsplash
was dreamed up by Anderson and brought to
life by the ceramicist Joseph Williams.
Though Anderson's work—from his general
creative direction to physical objects and
furniture—serves as the heart of the space,
collaboration between him and Dellinger and
fellow artists makes up its soul. (9)

10

out with all my stuff rattling around in the back of the U-Haul, I literally had a panic
attack," she recalls. "I remember thinking, 'This is so far away from everything. What
have I done?'" It was two days before Thanksgiving when she moved in, and with
Anderson, she managed to celebrate the holiday in the house with friends, leaving her
entirely at ease. Beyond a warm welcome to the area, the festivities were pivotal for
another reason: dirt bikes.

A friend brought two to the gathering, and the following day he and Anderson
set off on a mission to unearth a mysterious location. After consulting various sources
and roaming the desert on two wheels, they found it. The secret spot, sheltered
by boulders, now represents so much for Anderson and Dellinger. It's a place of
celebration—Anderson's fortieth birthday, for one—and frivolity. For the couple,
existing in tucked-away desert zones like these is about finding the space to stretch the
mind and being comfortable living with and in nature. As parents who have taken their
kids on off-grid camping adventures since before they could walk, they hope to pass
the same values to the next generation.

Anderson and Uschi walk hand-in-hand,
weaving through rocky crevices on
nearby public lands. (10)

They also hope to infuse their home with that sense of adventure and openness. One of their first tasks was installing a pool. "We needed an awesome outdoor space, somewhere to swim and host," Dellinger explains. "That connection is what being out here is all about." They have since expanded the house's footprint, opening up the kitchen and living area and adding touches that include doors handcrafted down to the knob and a concrete island with a built-in fruit bowl in the center. An indoor-outdoor space off the children's bedrooms replete with a rock-climbing wall, a take on the monkey bars, and a sandpit filled with toys has proved one of the best add-ons, or as Anderson likes to call it, "a built-in babysitter."

In many ways, the house is much like his practice. Anderson isn't attempting to mimic the desert but learning to find harmony with it. He and Dellinger frequently reference an old copy of *Handmade Houses: A Guide to the Woodbutcher's Art* by Art Boericke and Barry Shapiro, a showcase of mostly hippie-era dwellings. "As a builder and designer, I was inspired by some of the houses I grew up around," says Anderson. "They were pieced together in a sort

of Frankenstein way and totally unique." His own childhood home was built by his father from a log cabin kit. For Anderson, it's not about striving for perfection and having the best tools or techniques. Rather, it's about finding solutions—often strange ones—that become part of the fabric of a place. "Necessity is the mother of invention, right?" he muses. "Even temporary fixes can become valuable—almost artistic—by virtue of the amount of time that they have existed in a space."

In that sense, their home is not rooted in a certain aesthetic, color palette, or motif, but a feeling. That concept extends to Anderson's open-air studio, complete with its slow-drying solar kiln, and the raw landscape itself, punctuated by his totem-like sculptures. The living space exudes a labor of love, not just from Anderson but from the whole family and their artistic community. The cabinetry and furniture are of Anderson's creation, while Dellinger tapped into her passion for textiles to fabricate the pillows in the conversation pit. Elsewhere, contributions from friends abound: the circular, stained-glass window made by "Uncle Steve," a dark, geometric vessel

In remote desert climes, infrastructure for children can be few and far between---so what did Anderson and Dellinger do? They built an amusement park with their own hands. The kids' bedrooms are zones devoted to freedom of expression. In them, Mars and Uschi invent games, devise new uses for toys, and fashion themselves with flair. (11, 12)

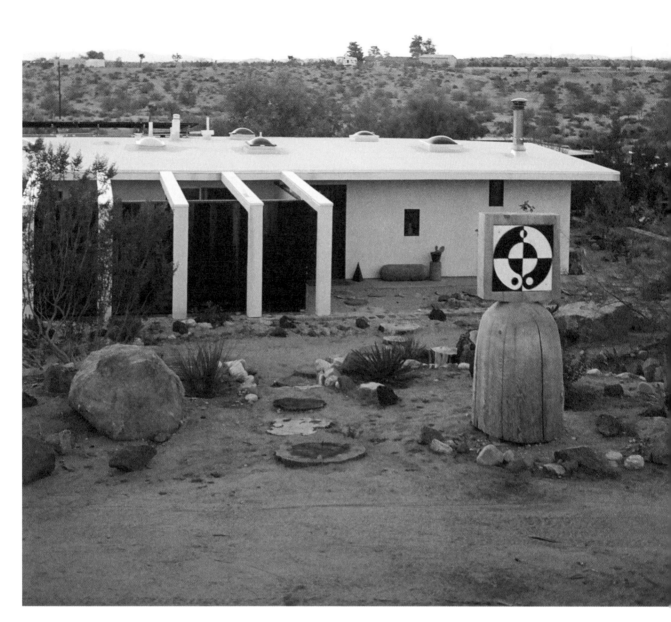

13

For his off-grid High Desert Dinner series,
Anderson conceived of a wooden carving with a
black-and-white tile insert to symbolize the
point of arrival. Now, the elephantine object
marks the entry to his family's home. (13)

A boyhood portrait of Anderson
hangs on a wall in Mars's bedroom. (14)

15 16

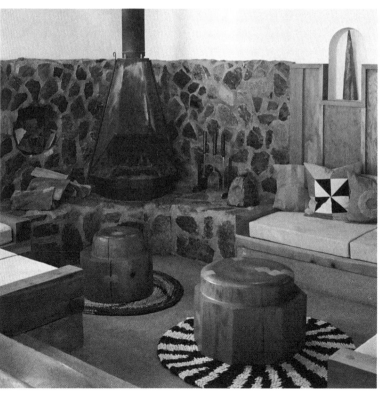

The house started as and continues to be a work in progress. In its earliest days, Mars played among wall framing, and later a young Uschi created a den in the soon-to-be-filled bookcases. As construction and design projects progress, so too does the Anderson-Dellinger family. (15, 17)

As one of the first big renovation projects, even before the roofline was extended to cover the house's expansion, Anderson and Dellinger set about building a cozy corner complete with a vintage fireplace, a stone and mortar mantle, and a carefully crafted slot for loading in and storing wood. (16)

17

from Wills Brewer, and a large-scale painting by Lily Stockman. A small wooden whale, one of Mars's first explorations in the medium, sits on the dining table, while a collaboration between father and son—an abstract wooden airplane sculpture fashioned by Anderson to model a Mars drawing—stands in the window. Uschi has left her impression as well. With marker, she stamped a circle of red dots on the wall beside the back door. Anderson and Dellinger have since discouraged drawing on permanent surfaces, but for now they have no plans of removing her whimsical addition.

As the day winds down, Anderson and the family pile into his lifted Ford F-250 truck. They leave their neighborhood and gun it toward a swath of nearby public land. On the turbulent road to a favorite collection of boulders a few miles away, Mars and Uschi are each allowed to play one song of choice. Uschi mimes being a DJ, holding one hand to her ear

and one hand on the imaginary record, doing her best impression of Dellinger, who is well known for her skills at the turntable. There is no sign of another soul as they reach the rock pile and start to climb.

With the sun setting over a nearby mesa, Mars and Uschi hurl small rocks to the desert floor below. Anderson ruminates on the underground network connecting creosote bushes before moving on to the prehistoric giant ground sloth. The latter ate Joshua trees and were instrumental in the proliferation of the now ubiquitous species. Dellinger describes "a feeling of peace when we are deep in the wilderness with Dan," an inherent calm that comes from being in a place with someone who knows it like the back of their hand. "It's a pretty powerful experience." Though the couple often daydream of living even more remotely than they do now, they rest easy at night. After all, their corner of the world already borders on the magical.

18

A focal point of the family's indoor-
outdoor universe, the pool provides a place
to celebrate the surrounding desert, while
simultaneously offering reprieve from the
scorching summer sun. (18)

Mere minutes from home,
a go-to boulder spot feels
like a world away. (19)

19

Anderson's personal practice resides in an
enigmatic place between furniture, totems, and
sculpture, leaving room for interpretation in
the eye of the beholder. He primarily works
with pine, cedar, and oak, native woods that
he often acquires in the nearby forests that
surround Big Bear Lake. (20)

20

21

His pieces, crafted from chainsaw, lathe, grinder,
sander, and chisel belie classification. "I think
part of why my work is suited to being out here is
because it shouldn't make sense—there's no wood
in Yucca Valley itself—and yet it just does," the
artist and designer says. (21)

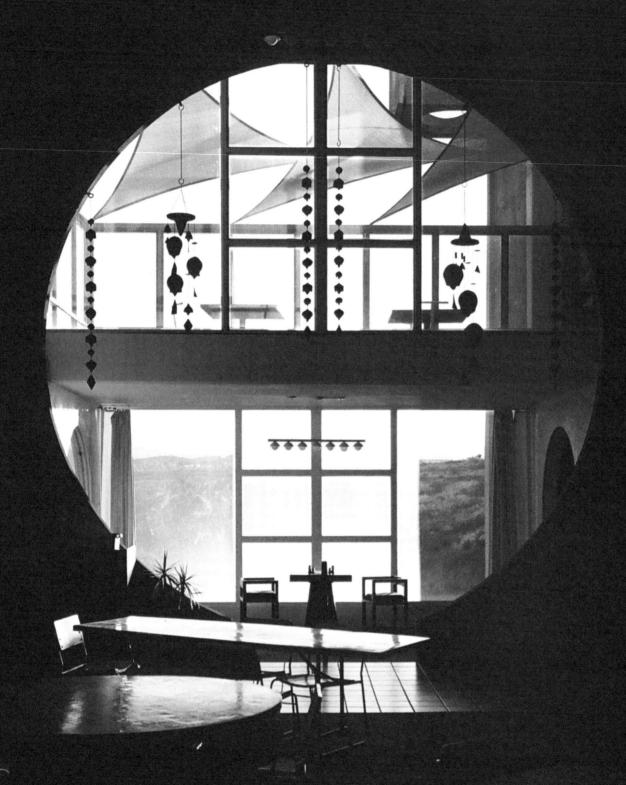

90

THE
ARCOSANTI

COMMUNITY

1

A TESTING GROUND FOR URBAN PLANNING AND ALTERNATIVE ARCHITECTURE

The private apartment that once belonged to Paolo Soleri has gone through multiple iterations in the modern era, sometimes being rented to overnight guests and other times housing The Cosanti Foundation's director. (2)

2

3

A cool evening breeze whistles through the valley, causing the mature Mediterranean cypress trees to sway and setting off a chorus of ceramic bells. David Tollas pilots a well-used white pickup truck along the road cut into the side of the valley wall. His hands are caked with dirt after a full day of planting and weeding. He arrives at his front door, kicks off his boots, and heads inside. The angled kitchen window adjacent to the entry has been limewashed to combat the summer sun, and in the later hours of the day, the concrete abode feels especially fresh. Meanwhile, Tollas's wife, Nadia Begin, follows shortly behind on foot, winding her way up a steep set of switchbacks lined with paving stones from the dry creek bed below. With their dog, Ace, in tow, she waves to her neighbors and pauses to have a chat with a friend. Her late afternoon promenades may seem common, but her setting—a radical cooperative of sorts—is anything but.

It is frequently said that Arcosanti—its future-thinking designs in the harsh Arizona landscape—inspired George Lucas to create the *Star Wars* city of Mos Eisley on the desert planet Tatooine. The Italian writer and filmmaker Carlo Maria Rabai also suggests that the compound's influence is visible in Denis Villeneuve's *Dune* and the artistic practices of Moebius and Roger Dean. (1, 3)

4

Punctuated by an expansive atrium and panoramic
views of the surrounding desert, the Crafts
III building, which houses a café, shop, and
apartments, remains a prime representation of
the core principles of "arcology": combining
living, working, and recreational spaces under
one roof. (4, 5)

Begin is a firm believer in the communal—or at the very least, more collaborative—lifestyle. "It's the way of the future," she says. "We have to think about growing more resilient, living with less, and finding ways to be resourceful with who and what we have." And those are the very ideals that have kept her at Arcosanti, an urban laboratory and experimental eco-city seventy miles north of Phoenix, Arizona, since 1993. "We're on this small, remote little island that is full of extremes—heat, cold, lack of water," Begin says of her chosen home, the place that she found work and love and raised her two children. "We constantly have to develop more sustainable systems, which means that we have to learn to effectively engage with those around us. Isn't that what the world needs more of?"

Paolo Soleri, an Italian visionary and Frank Lloyd Wright disciple, gave birth to the idea for Arcosanti, a concept of epic proportions, in 1970. He envisaged the prototype compound to serve five thousand residents in an all-encompassing, high-density environment that would include learning facilities, housing, employment, entertainment, and a deeper connection to the surrounding nature. Postwar urbanization (and suburbanization) had many people, like Soleri, contemplating the balance between the built world and the natural one, and so with his plans came scholars, urban planners, architects, and environmentalists. Soleri's modular models, marked by cubes, apses, and large, circular windows, caught the attention of design enthusiasts, too.

Yet, while the town has seen thousands upon thousands of volunteers and visitors over the years, its population peaked at around two hundred occupants in its first decade. Then, after Soleri died in 2013, his daughter Daniela publicly accused him of sexual abuse and attempted rape, embroiling the community in controversy. The Cosanti Foundation, which manages Arcosanti, stood in solidarity with Daniela and instead of erasing its founder's legacy, opted to reconsider it: "to celebrate his ideas by using them to make a better world, and acknowledge that to support great ideas is not to condone the conduct of their creator."

It is, indeed, impossible to remove Soleri from the Arcosanti story, but it is also imperative to recognize that the construction of the city and its modern-day relevance are the result of many dedicated minds, including Begin and Tollas, an architect who first arrived in 1981. "Arcosanti is not *the* answer," he says. "And it isn't going to solve all of the problems. But it endures as a living symbol. There are other ways. We can look for other solutions. There is hope." The space, he says, remains a testing ground for a myriad of things: passive solar architecture, a different kind of urban development, and permaculture and alternative food movements. The latter is his current focus as the program's agriculture manager. In his tenure, he has worn a number of hats, from working as a cook to managing the bronze foundry, which produces wind bells sold on site, and overseeing construction.

Arcosanti's ceramic and bronze
bells are sold as a means to support
the foundation but are also widely
utilized throughout the property from
public buildings to tree branches and
individual apartments. (6, 7)

6

7

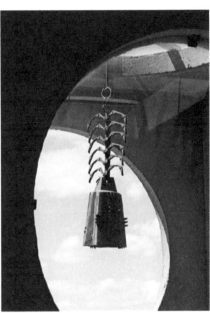

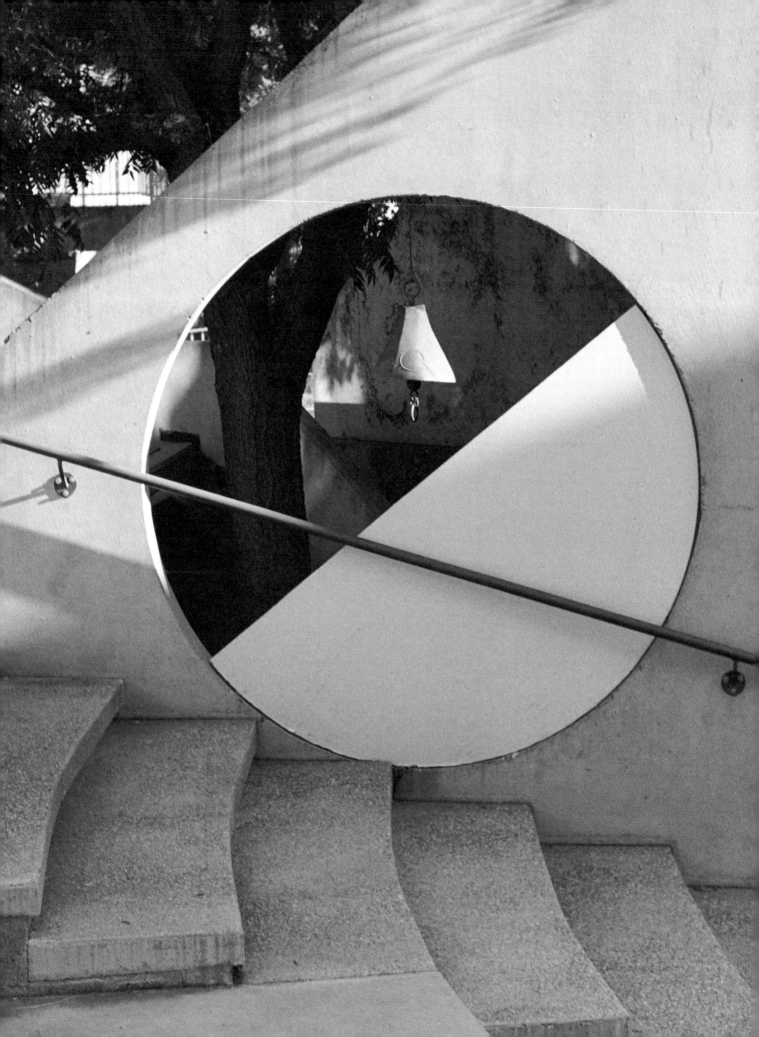

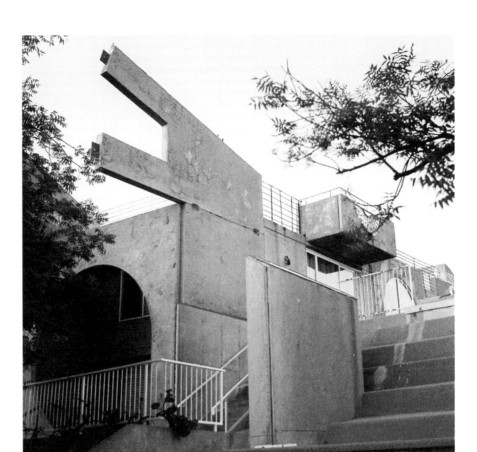

Arcosanti is a standing reminder that
functionality and art need not be at odds.
Take the circle, which "Arconauts" frequently
employed where square or rectangular forms
might be standard. The recurring motif, along
with the avant-garde city's vaults and apses,
also pays homage to the Earth. (8, 9, 10)

10

"One of the key points of this philosophy is that you can't just sit and meditate to really grow," says Begin. "You have to interact with the world through some kind of work, through actual creation." In the case of a couple, one member can pursue a career outside of Arcosanti and though Begin's job is now at a nearby architecture firm, she still takes part in meetings, participates in clean-ups, and brings new knowledge from other projects back to the site. She explains the benefits, which range from personal evolution to the cultivation of real-life skills, in investing so heavily in the place that you live—and she doesn't mean investing monetarily. Residents pay a low monthly, standardized "co-use" fee, which includes room and board, Wi-Fi, and the likes of pool maintenance, but never earn legal ownership of the property.

11

12

Soleri's ideas attracted volunteers and students,
whose hands-on participation directly contributed
to Arcosanti's growth and development, from across
the world. The project endures as an ongoing,
evolving community effort today. (11, 13)

A young Soleri handcrafting
bells in the studio (12)

13

Arcosanti's buildings are
embedded directly into its
natural environment. (14, 15)

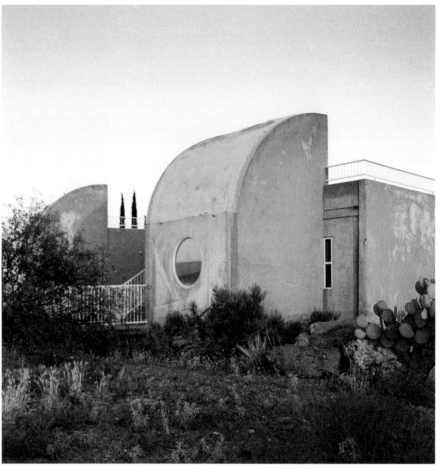

14

15

16

17

18

The kitchen in what used to be Soleri's private apartment (17)

19

Housing is determined by seniority, so Begin and Tollas live in one of the more impressive two-bedroom units. Their home, which sits above the foundry and across from the ceramics studio, reflects Soleri's unique design sensibility, with its slanted silt-cast walls, skylights of assorted shapes and sizes, and built-in seating. Its character, however, is emphasized by the pair's collection of books, family photos, and trinkets acquired on travels to places like Japan and India. Begin and Tollas prepare their own meals most nights, and their kitchen is filled with worn cookbooks and dishes and ceramics in a multitude of styles. After their cherished range died, they searched for a replacement, scoring big at a thrift shop in the nearby city of Prescott. "For twenty-five dollars on sale from fifty!" Tollas exclaims. Preserved childhood artwork from their sons hang on the fridge and around the living space. In the curved staircase that leads to the bedroom below, well-tended potted plants thrive. The interiors that comprise Arcosanti, like this one, are a direct product of the people who inhabit them. They

Seeking a more efficient commute would be near impossible as Soleri's bedroom was situated within a few steps from his drafting table. This work space, visible from the administrative offices below through a large window, exemplifies the deliberate overlap between a building's functions. (19)

"Everything that you see has been built by people who
have stayed and worked here," Begin and Tollas say of
Arcosanti and its many corners. When the couple moved
into their current apartment, they inherited the design
choices of those who came before them. Now, they are
tasked with adding their own layer of history and patina
for a future generation. (20, 21)

range from eight-by-eight-foot cubes that share communal bathrooms and kitchens to apartments of varying size, the particularities of each dictated by its specific tenants, both former and current.

The structures are almost entirely south-facing, allowing the sun to provide natural heat in the winter (Begin and Tollas note that contrary to popular belief, they need to heat the spaces more often than they need to cool them). "We are intentionally not isolated from the desert," Begin says. "Soleri consciously wanted us not to get too comfortable. We should feel cold in winter and warm in summer. We shouldn't be in a total bubble." Tollas releases a lever, and a pane from their wall of windows that overlooks the foundry swings open like a trap door to let in the fresh air. The duo employs fans and covers their windows but laments the increase in portable air conditioners across campus. "We've learned to adapt," says Tollas, "And we're lucky to be in a situation that gives us the tools to do that."

A number of meeting places—the central amphitheater with its muted, multicolored stairs, a performance venue and gathering space known as "the Vaults," a gym, a library, and a music room— along with courtyards and walkways in place of roads encourage social interaction at every turn. People frequently ask Begin and Tollas about their sense of security. Though it offers health benefits and paid vacation, Arcosanti pays employees like Tollas a modest salary, and the couple can't count their longtime home as a sellable asset. "The security," Tollas admits, "is entirely in the connections. You can have all of the money in the world, but if you're alone, what does that translate to?" Arcosanti may physically exist in the high-desert lands of the American West, but its ideology extends across the world. "We really belong to something so much bigger than ourselves," Tollas says before Begin jumps in. "The beauty is that we don't feel stuck. We aren't here because we have nowhere else to go or nothing else we can do. We're here because it's exactly where we want to be."

20

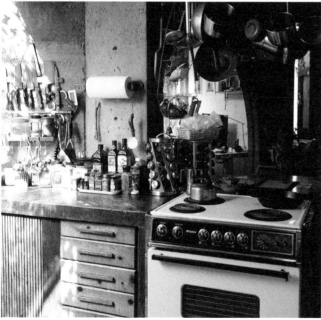

21

VERONICA ALKEMA

Ophir

&

New Zealand

GARY STEWART

EASY ON THE EARTH,
EASY ON THE EYES

Veronica Alkema walks along a craggy ridge, a pair of clippers in hand. This rugged landscape is riddled with small, greenish-brown bushes of wild thyme. The aromatic herb is, quite literally, everywhere. Alkema bends down to snip off a generous handful from an obliging specimen. She's making roast chicken and oca—a knobby, pink tuber native to the far-flung high Andes and beloved by Kiwis—for dinner. Alkema's other half, Gary Stewart, puts a pot of water on the stove for tea, a ritual that sees seemingly endless repetitions throughout the day. The wind is picking up as the pair's trusty border terrier, Gus, bops from rabbit hole to rabbit hole. From a north-facing window the size of a projector screen, the landscape plummets into a flat valley, then rises in layers, capped by the majestic, snow-covered mountain range that cuts its way across New Zealand's southern island.

For Alkema and Stewart, this is a home born equally of a love for thoughtful design, a staunch willingness to experiment, and a bold lifestyle choice—to slow their roll, to forge more meaningful connections, and to put down deeper roots. When they originally purchased the plot of land outside of Ophir, New Zealand, a town with just sixty residents, in 2012, they imagined it as a much-needed getaway from their busy Wellington lives. But over time, and many camping expeditions under the clear night skies, the duo realized that the land held their future.

"People often ask us, 'Don't you miss the sea?'" Alkema says. "I love the sea. I love being near the coast. But I don't feel the lack of it because we've got sky. The sky is like our sea." In the country of never-ending horizons and a Central Otago landscape known for its extremes—the coldest, hottest, and driest in the nation—they began to dream. "Everything is so bare and barren," Stewart explains, "that it feels like it's full of potential or possibilities."

Being in an ecosystem that New Zealand classifies as desert for its lack of rainfall, Stewart and Alkema began looking to architecture in similar climates and creating mood boards to home in on their desired style. When Charlie Nott, who would soon after become the architect for their project, showed them a copy of the Arizona architect Rick Joy's book

1

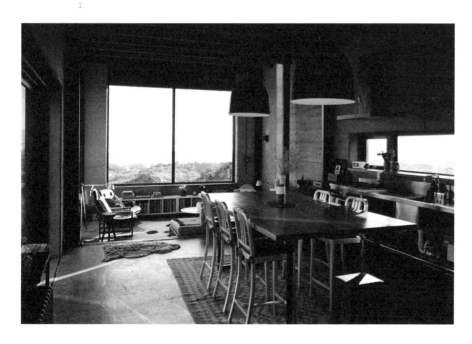

Alkema and Stewart are well-versed in all things retro, vintage, and mid-century modern and constantly keep their eyes peeled---in person and online---for rare scores like Pendleton blankets and treasured figurines from Japan. (1)

Wellington finds: A 1970s-era painting from
Sam Worthington, which depicts a city road
that has since become a six-lane highway, and
a Børge Mogensen Sled chair remind Alkema
and Stewart of their former home city. (2)

Desert Works, they knew, instinctively and immediately, that they had found their answer: rammed earth.

"Architecture has to respond to the environment," Alkema muses. "And I think that the material sits really well in our landscape. It just fits." Not only does the result of the technique, which compacts raw ingredients like soil and silt into formworks, blend in seamlessly with the surrounding flora and fauna, but it also requires minimal maintenance, regulates temperature, and provides immense aesthetic pleasure to its owners. Together with Nott, Alkema and Stewart wondered how they would execute their plans, but the pair serendipitously discovered that Jimmy Cotter, who runs Down to Earth Building and is an expert in the field, lived just an hour away. And so, the real journey began.

At the start of 2019, the couple moved into a restored 1979 Airstream Overlander to participate in the construction. "It was important to have some sweat equity in the build of the house," Stewart says of their involvement. "We weren't, you know, banging in nails, but on the weekends, we were picking up things that the builders had dropped, which we're still reusing for other projects."

After months of hard work and cold nights, they found themselves with a house, one with a tapered wedge form and patterned, textured walls that serve as art in their own right. Two wings—one with living, dining, and cooking spaces and the other with a bedroom and bathroom—are connected by the breezeway, the heart of the structure. "It offers shade from the summer sun," Alkema says. "But it also provides constant interaction with the weather and the climate and gives us that open-air camping sensibility that we love so much." A separate building of different construction, made with Nudura insulated concrete forms, is home to their studio. From the space, a large, open room filled with books and other carefully considered trinkets and tchotchkes, Stewart runs his one-man graphic design consultancy, Gas Project, and Alkema helms her studio, Vero Design, which develops

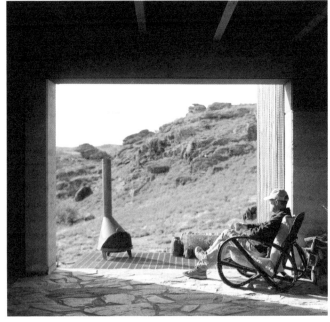

In Ophir, making a conscious effort to ring
in each new day has become integral for the
couple. "I'll sit in front of the window with
my cup of tea, maybe do some yoga, and just
watch the world change," says Alkema. Stewart,
on the other hand, most often takes residence
in the breezeway with his morning coffee. (3)

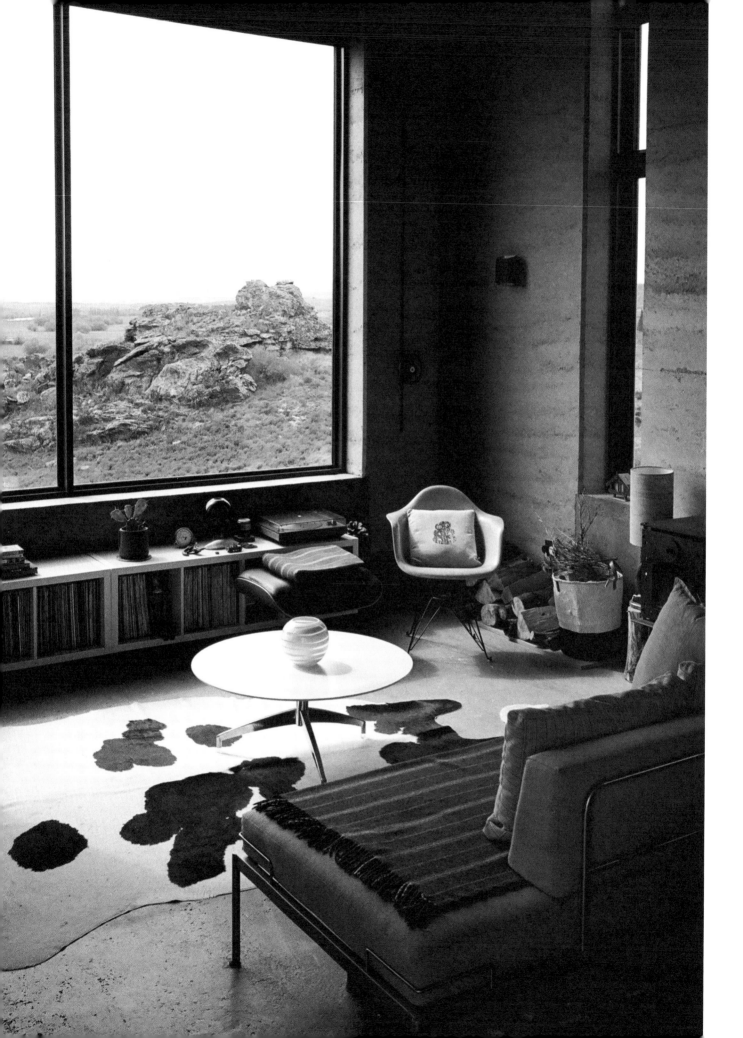

gardens that thrive in the surrounding arid climate, on the days when she isn't on site and elbow-deep in soil. Here and in the main house, the couple prides themselves on no wasted floor area. They use each and every square inch with regularity.

Together, Alkema and Stewart have created interiors that feel like a natural extension of the landscape and architecture. Yet, with the exception of a dining table that also operates as a kitchen island of sorts, none of the furniture is custom-made or bought especially for their new dwelling. Alkema thinks back on a visit from an American friend at their former home in Wellington. "She walked in and said, 'It's just like Santa Fe!' It must have been our aesthetic," Alkema recalls. "Our move to Ophir was meant to be." Stewart attributes their alignment to the desert-like climes to their penchant for honest materials, expert craftsmanship, and functional design. His prized Eames lounge chair, which he purchased as a gift to himself for his fortieth birthday, holds court in their sunken living room. "I didn't utilize it much when I was in Wellington," he remembers. "It didn't feel like I had earned the right to sit on it and feel comfortable." Now the piece, across from the wood-burning stove and in front of the oversized picture window, is well-used and makes for a favorite corner. It is where he and Alkema, a couple whose banter and chemistry flows with ease, frequently end their evenings.

But for all the magic of the interiors, it is still the wild exterior—the fragrant thyme that grows in abundance, the rocky outcroppings, the remains of stone walls that harken back to the region's gold mining past—that keep Alkema and Stewart grounded from day to day. "I find myself outside more, finding new skills or talents I didn't even know I had, or simply just enjoying myself and doing things like walking the dog." He and Alkema stroll the perimeter of the property with Gus twice daily and have yet to tire of the loop. "Actively engaging with a place—being connected to the way things change season to season, understanding the cycle of nature—has been really great for our mental balance," Alkema adds.

That engagement also manifests with the local community. The importance of good neighbors becomes more pronounced in a sparsely populated, remote community where asking for help is a way of life. Stewart starts the engine of their 1970s Mercedes station wagon, ever-grateful for the aging automobile's continued existence, and Gus promptly hops in the front seat. An accommodating Alkema kindly shares with her canine companion as Stewart pulls away, guiding the buggy down the bumpy hill and into town. At Blacks, the local pub, Alkema and Stewart greet what seems like half of the population on their way to order their dinner and a pint. They offer sympathies to a woman who has just lost her pet and debate what movie to play next at their self-initiated screening. "We have

4

5

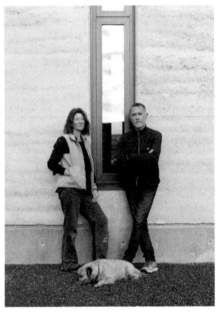

Alkema and Stewart constantly tend to the property, managing invasive Scotch broom and repairing the walls built by gold miners in the 1800s. Gus, meanwhile, spends most of his time seeking out rabbits. In the region, which is home to almost no native mammals, he is their biggest and most dangerous predator, and the population has run rampant. (4,5)

6

8

"Beauty is something that we need to pass
on, to protect, and encourage," the duo says
of their home and the collection of objects,
chairs, and art that it houses. (6, 7)

7

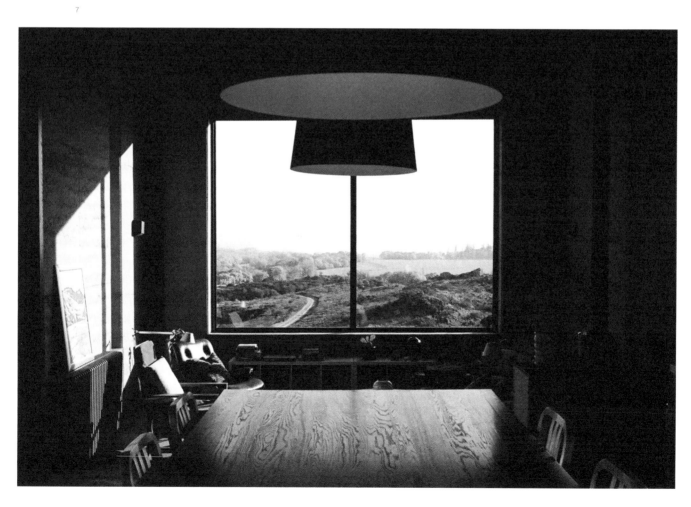

more of a social life in this town of sixty than we did in a city of two hundred thousand," says Stewart, digging into a lamb chop with mashed potatoes and mint sauce. With fewer entertainment options, they have had to get more creative and more engaged with their fellow denizens. In addition to movie showings, they tap into their inner audiophiles to organize concerts in the historic Ophir Peace Memorial Hall, bringing musicians from across the country, to their micro-desert outpost. "We've discovered a freedom," Stewart continues. "It comes from not being tied to routine. But it also comes from the country and the wide-open space. We're just incredibly lucky."

Gus patiently waits in the front seat, ready to meet up with his friends in town. At the local pub, photos of the village canines are posted on the wall, should one ever go missing. (8)

Alkema relishes in the drought-resistent, wild herbs that have taken root in the region. "Being outdoors and having our hands in the earth is such a good way to ground all of our energy," she explains. (9)

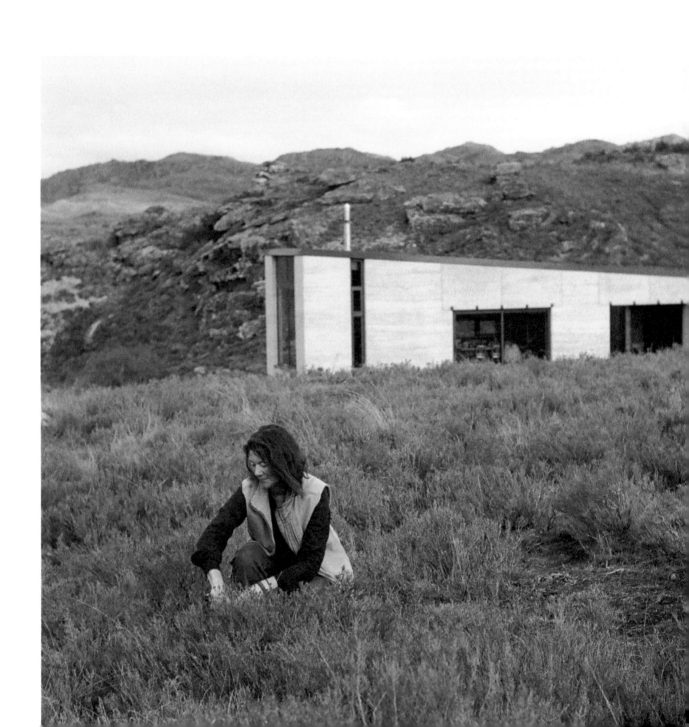

BIG SKY SOUNDS

Music, whether playing through their Tivoli Model One, their turntable setup, or the caravan's eight-track system, is a constant for Alkema and Stewart. Here, they each reflect on three albums that resonate with their new desert digs. "Looking at my choices, there is a theme of expansiveness, which speaks to our sense of this place up on the hill," says Alkema. "Play it loud."

According to Alkema and Stewart, friends often become more akin to family in their small, remote community. They are consummate hosts, known for playing good jams from the cozy confines of their renovated Airstream to their open-plan living room.

For nostalgic nights, friends gifted the couple a selection of eight-track tapes that include the likes of Quincy Jones, Perry Como, and George Benson for the camper, where they lived while they built their home and still occasionally take reprieve.

Blackbird [GS]
Fat Freddy's Drop

This is a band from Wellington, the city we lived in for over twenty-five years before moving to Central Otago. The album is a mix of dub, funk, soul, jazz, reggae, and techno. It makes me think of our old life in the city, where we would go and watch them play live. It's a little nostalgic but also reminds me of how much things have changed (and for the better). New Zealand is the land of birds, and we have plenty around us. Because our house is elevated on a rock we get all the angles of birds in flight, sometimes even watching hawks glide below us.

The B-Side of Hounds of Love [VA]
Kate Bush

The whole album is a joy, but the B-side is one long track made up of smaller song vignettes loosely based on a shipwrecked sailor. It's what I put on when I'm looking for beauty and mystery. It ends on a sweet, joyous note. Uplifting and life-affirming, it's my comfort blanket. Just the thing for a difficult build.

Push the Sky Away [VA]
Nick Cave & the Bad Seeds

The darkly poetic, messianic, and slightly warped world of Nick Cave's songs uplift me in its own way. This album played on repeat many evenings in the Airstream, before we built the house, while we were getting to know the land. It takes me to warm summer nights, long light, and the smell of thyme when we were dreaming life here into being. Endless possibility.

The Köln Concert [GS]
Keith Jarrett

A friend gave us a vinyl version of this album years ago. It's an improvised solo piano concert recorded in 1975, and every time I play it, I hear something new. It's immensely beautiful and relaxing, with an element of play. Jarrett makes these little sounds of joy as he performs—the perfect remedy to stressful times during the house build.

Time (The Revelator) [GS]
Gillian Welch

The BBC made a documentary years ago on country music, and Gillian Welch was the last artist featured. You could say it was love at first sight. Though I'm also a big Neil Young fan, this was the first true country album I could get into (Neil definitely leans more rock). Several plaid shirts later, with a house surrounded by dirt and rock, a hound, and a pickup, we've embraced the country lifestyle. Thanks, Gillian (and David Rawlings. Man, what a guitarist!).

Spirit of Eden [VA]
Talk Talk

This album makes me believe there is something worth fighting for when I'm tired and disappointed. It blows my mind every time I listen to it. Fills me with joy. The silences between the notes speak of eternity. Forgive me for gushing, but it is a work of genius—played so loud you can't hear yourself think, late at night after a few beverages, staring up at the night sky.

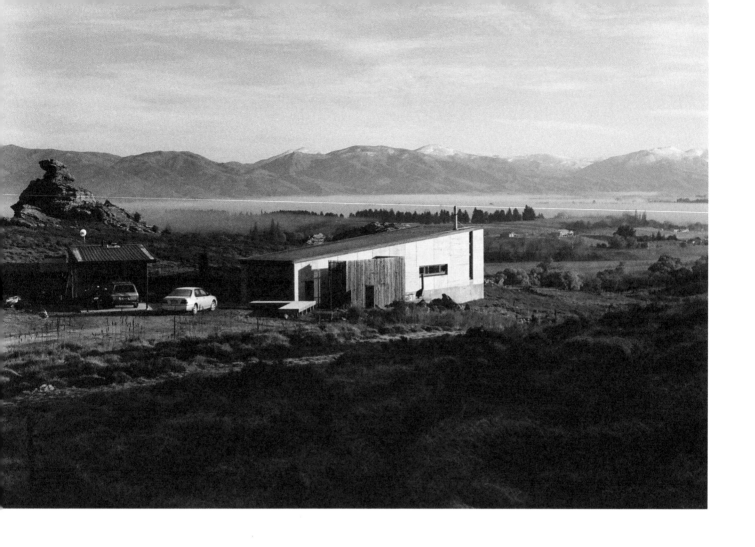

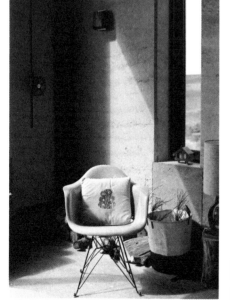

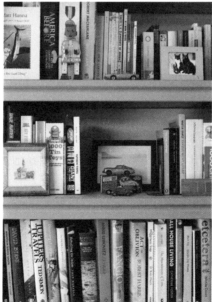

Alkema and Stewart are a fountain of knowledge when it comes to New Zealand's best furniture stores. They sourced their original Eames DAR chair from Mr Mod, a now defunct shop outside of Christchurch, in the early 2000s. The outpost was destroyed in the 2011 earthquake, but the owner continued trading. When he finally shuttered, he auctioned off his entire collection—"about three warehouses' worth," the couple laments. (10)

The couple's office is a booklover's haven. The bibliophiles have amassed a wide range of reading material on subjects from art to toy design and cooking. (11)

12

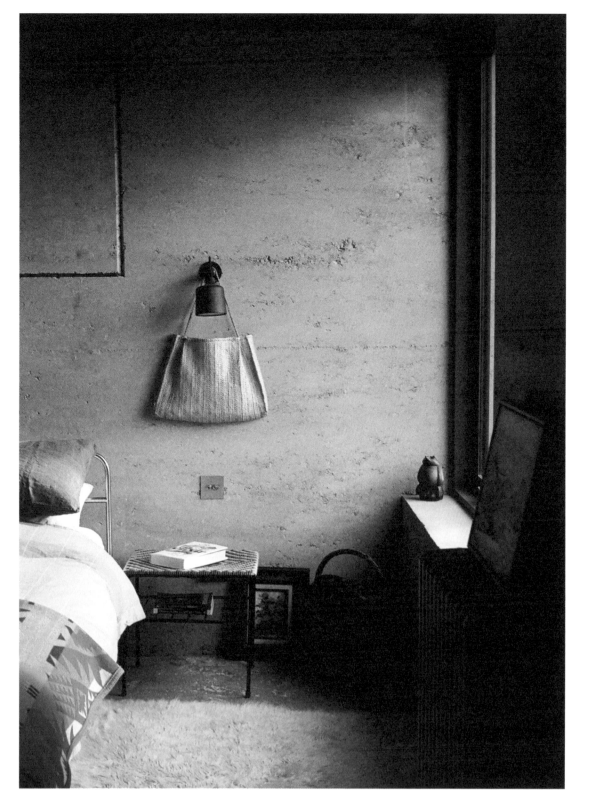

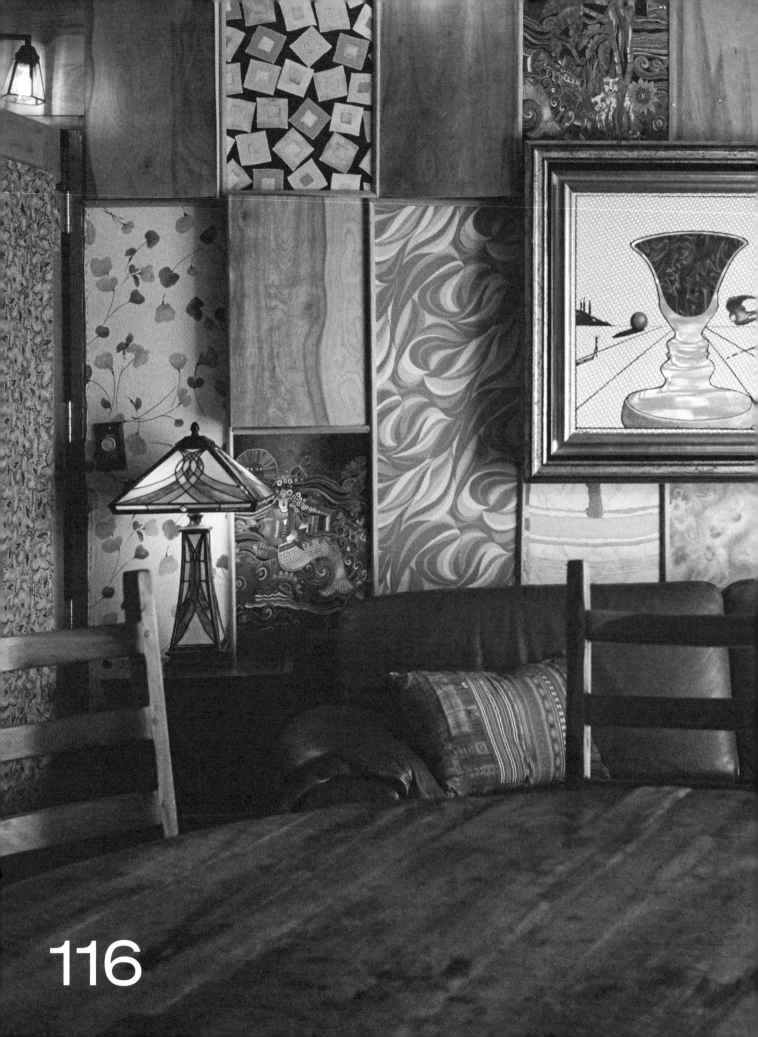

THE

Tornillo, Texas

SONIC

RANCH

United States

CREW

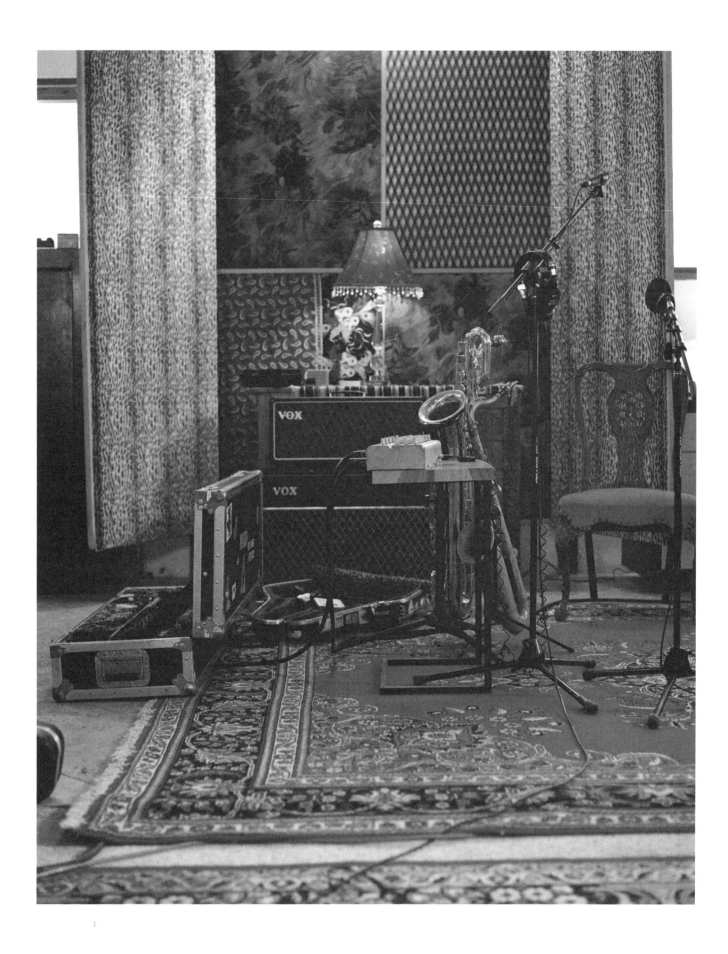

1

WHERE THE WHOLE
IS GREATER THAN THE
SUM OF ITS PARTS

Adaptability is key to success in
desert and recording settings alike.
The Stone Room in Studio A currently
displays an impressive collection
of amps surrounded by carpets and
baffles, but when stripped to its
core, the space becomes an echo
chamber for explosive live drum
recordings. (1, 2)

2

3

The breakfast table is set with Tupperware containers of tangy, spicy salsa at its center. The rich, smoky aroma of frying bacon fills the air. An industrial-sized automated coffee machine whirs, slowly producing a macchiato or cappuccino—something milky and strong. People gradually filter into the kitchen. Lutalo Jones, a twenty-something multi-instrumentalist whose sound *The Guardian* describes as "eminently comforting," grabs a glass of orange juice. Tim Lefebvre, the Grammy-nominated bassist who appeared on David Bowie's last album, *Blackstar*, rolls in for some eggs. Members of the reggae, hip-hop, and punk-rock outfit Slightly Stoopid poke fun at one another between bites of chorizo. "I woke up, and it was like someone vacuumed the hydration out of me!" a producer from Miami cries out. It's the dry desert air, yes, but it could also have something to do with the drinks from the night before.

Tornillo, Texas, might seem an unlikely setting for this meeting of musicians—and it is. The sleepy border town, located some forty miles east of El Paso, is a small farming community with a handful of local businesses and two dollar stores. In 2018, it landed in the news when the federal government installed a controversial youth detention center,

Rancich's attention to light sources, which allow artists and their teams to set the mood, borders on the fanatical (the back seat of his BMW is frequently filled with replacements for the hundreds of fixtures throughout the ranch). Options range from rainbow-hued track lighting to warm overheads and sconces with dimmable functionalities. Lamps, whether elaborate Tiffany replicas or minimalist, industrial fabrications, offer added variance, while imbuing a decorative touch. (3)

housing migrant children separated from their parents, in its city limits. A state representative, Mary González, lamented the attention. The "loving, humble community," she thought, should be known for its resilience, for "trying to make its own way." She feared Tornillo came into the limelight for the wrong reasons, for political decisions out of its control, and would disappear just as quickly. But in the music industry, Tornillo is a place of legend—one that an almost mythical man, Tony Rancich, put on the map in the late 1980s and that has shown no signs of going anywhere since.

Rancich grew up on this strip of the I-10, shuttling back and forth between the big city and its agricultural outskirts. When his mother and maternal grandparents died tragically within months of one another, an eleven-year-old Rancich and his siblings inherited the family farm. "My mother was a multifaceted genius," he recalls. He is sitting in the dining room, pointing to a large Arabian-themed mural that he watched her paint in a "day or two" when he was "six years old, or nine years old—somewhere in there." Rancich, as it turned out, had inherited more than property. His mother had also conveyed her creative spirit.

In his teens, Rancich learned to play the guitar. He bought a Sony recorder, began cutting his own tapes, and became an El Paso fixture. When his equipment expanded to two four-track recorders, he started to attract local bands. The young entrepreneur was onto something, so he called an acoustic design agency based in San Antonio to the scene. He showed them twenty-five locations—twenty-four in the city and one, a partially underground building that once housed a chinchilla farm, at the ranch. They visited the remote site last. "This is it," the company's emissaries affirmed almost immediately upon entering.

"It's all about evolution," Rancich reflects, pushing his golden blond locks from his face. "You start with something and you give it a push and it might help you a little bit—or an old wall might fall down. But if you bring good will and if you're doing something that serves people on multiple levels, the universe often responds with reciprocity." He put in a lot—every fiber of his being, really—and in return, landed himself the world's largest residential recording studio.

Rancich drives a bright blue BMW around the property, weaving between realities. Rumor has it that he inspired Quentin Tarantino's titular character in *Kill Bill.* He speaks rarely but when he does, he always offers a clever or sincere remark. "This was the other side," he says, pointing out blue herons, ducks, and a

4

5

New York–based producer Jake Aron, who has worked with artists ranging from Yumi Zouma to Grizzly Bear and Solange, in Adobe Studio's control room (4)

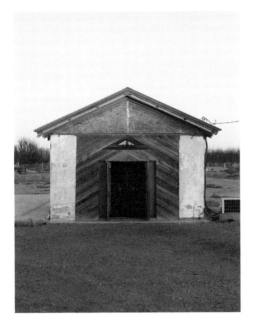

Big Blue, Sonic Ranch's largest
and newest studio, sits across from
its smallest, the Adobe Bungalow.
The intimacy of the one-room
building, a transformed equipment
shed that dates to the 1920s,
makes it a favorite for late-night
sessions. (5, 6)

Rancich has established a common
design language that includes
natural-wood surfaces and plentiful
fabrics inside the compound's many
structures. Though each interior
has its own distinct character, the
varied studios and living quarters
coalesce to create a signature look
(7)

coyote, "before the United States stole more land from Mexico." He stops at
Studio A, the first of five designed by the celebrated acoustician Vincent van
Haaff. Original lithographs from Joan Miró and Marc Chagall line the walls.
A 1929 Steinway piano is positioned next to the fridge, where the Dallas-based
artist Burt Hussell stores kefir and juice to keep him going between sessions.
Rancich heads next door to Neve, named for its vintage console. Part of the
eighty-channel board, which is the largest of its kind, belonged to Motown's
West Coast studio, Madonna, and X Japan's Yoshiki Hayashi before it
serendipitously wound its way here. A horn section plays as Rancich points out
the quilt-like sound panels. He is a fabric connoisseur, and his collection, which
ranges from groovy prints sourced in Belgium to Day of the Dead–themed
patterns found at Jo-Ann, has been transformed into patchwork wallpapers,
curtains, and baffles to mitigate reverberation.

Every corner, whether in the hundred-year-old adobe structure turned studio
or the ranch house that once contained a government holding cell on the Mexican-
American border, mirrors Rancich's eclectic taste. If it isn't Miró and Chagall, it's
Salvador Dalí, Rembrandt, Picasso, and Matisse. Or Mati Klarwein, who designed
album covers for Leonard Bernstein, Miles Davis, and Santana. Or a completely
unknown regional artist, whose oil paintings just happened to catch Rancich's

9

At Sonic Ranch, as much takes place inside as outside. While visiting artists like Lutalo Jones lay down tracks and a master tuner adjusts a piano, farmworkers tend to the ranch and production facilities surrounding the studios. (8)

During pecan harvest, huge machines, like the tree shaker, can be seen maneuvering through rows of leafless specimens. (10)

Consistent colorways—warm reds, greens, and oranges—pervade the property, tying its more industrial zones together with creative corners like the hacienda's formal dining room, where Rancich and visiting artists decompress from a day's work. (9, 11)

10

11

The mix room, which boasts a sixty-four-
channel console and a wide range of analog
outboard gear, doubles as a hang-out spot
with a pool table on one end and a punching
bag on the other, cozy leather couches,
and vintage furniture finds. (12)

12 13 14

eye. Antique furniture from Mexico, India, and Romania sits alongside nineteenth-century barber chairs and 1980s airline seats and atop elaborate rugs. Shelves are crammed with books spanning philosophy, screenwriting, art, and film.

Then, there's the equipment. Two new interns arrive from Mexico City as members of the Sonic Ranch team delicately remove microphones, like the Telefunken U47 that Frank Sinatra recorded on, from a gun safe. They stare, aghast. "There are mics in there that are worth more than my house," one whispers. The list of awe-inspiring gear goes on. There is the 1961 Gibson Les Paul Special, the worn yellow Telecaster that belonged to Stevie Ray Vaughan, the upright Brazilian rosewood piano that dates to 1895, and the equalizers owned by the late Blink-182 and Morrissey producer Jerry Finn.

Rancich hops back in the car and with a coffee in hand, zooms down a dusty stretch toward the pecan processing plant. The studios occupy several small corners of the 3,300-acre plot, but the rest is still a working farm, and Rancich is at its helm. He picks up Oscar Jauregui, who was raised on the ranch and now manages operations, and Dr. Jaime Iglesias, a seasoned crop consultant. In the blink of an eye, the discussion shifts from stories of Lil Yachty and Bon Iver's Justin Vernon to in-depth rumination on irrigation and the current harvest. They pause at different blocks to check on workers and survey the land. The conversation toggles between Spanish and English, but it's difficult to hear

At Sonic Ranch, isolation booths,
or private spaces optimized for
recording vocals and acoustic guitar,
provide opportunities to express
personality, much like smaller rooms
in a house. They range from muted
oases of calm to vibrant nooks,
like the Mayan Booth, which features
fabrics from the Yucatán Peninsula.
(13, 14)

15

16

over the monstrous three-wheeled machine that looks like it belongs more on the moon than Earth. The gray behemoth takes the tree in its arms and produces something akin to an earthquake, sending pecans cascading onto the ground.

Cracking nuts in the palm of his hand and snacking on the go, Rancich returns to base camp, the 1930s hacienda built by his grandfather, which houses his bedroom, the kitchen and communal living spaces, the mix room, and a number of accommodations for

visiting musicians. When artists and their teams come to Sonic Ranch, they stay on site, here or in several other buildings, some new and some historic. They can opt in for meals and laundry services. "Total focus," says Rancich of the goal. It's about the music, plain and simple—and the same concept probably wouldn't hold up in an urban setting. "Being out here with the nature and the sky puts you in a totally different frame of mind," says Mario Ramirez. He is the only audio engineer employed at Sonic Ranch who is actually from

17

On such a sprawling property, moving by car is an essential part of life, even for those who live on campus. Rancich surveys operations between the farm blocks, pecan factory, and five recording studios, while engineers and farm staff circulate between home and "office." The rough dirt roads are even subject to minor traffic jams and the occasional fender bender. (15, 17)

With views in all directions, the water tower is a favorite sunset venue but also a place of catharsis for the Sonic Ranch crew following long days hunkered down in the studio. "After being in the same place day in and day out," says audio engineer Felipe Castañeda, "it is a nice change of pace, a literal expansion of our horizons." (16)

West Texas, "the only true desert kid," and the environment's inspirational qualities aren't lost on him. "When I got here, it was hard to adjust to the silence," adds Josh San Martin, an engineer from Mexico City. "But without the noise, it's easier to connect to yourself and to your art. It's more productive."

Sonic Ranch has hosted lesser-known acts and household names: singer-songwriters Fiona Apple and Natalia Lafourcade, indie bands Arcade Fire, Beach House, and the Yeah Yeah Yeahs, country sweetheart Cody Jinks, R&B crooner Miguel, metal's Ministry, and the pop group Bandalos Chinos, to name a small few. For these artists, it is band camp. But for the producers, Sonic Ranch is home. With the exception of Ramirez, who is building an adobe house of his own, everyone lives on the sprawling compound. It's a full-time affair and requires an initiation of sorts. "You start by delivering coffee," San Martin explains of each new hire's early days. "You have to believe that any given coffee is the most important coffee in the world." Earning Rancich's trust is critical. "How can he trust you with a mic if he can't trust you with a coffee?" asks San Martin. "Artists pour their heart out here, and it's our responsibility to do the same." There is rarely a night when the young crew isn't scattered across the studios well after sundown. Most often, they're on assignment, but they might be developing their own projects or just jamming. "You *want* to stick around," Ramirez says. "You *want* to be working."

And perhaps that is what makes Sonic Ranch so special. Rancich is its shaman, the spiritual leader who engineered its existence. But this isn't his world alone—it wouldn't exist without the loyal team of producers, the artists, the kitchen staff who make huevos rancheros and breakfast burritos, the ranch hands, pecan factory workers, forklift drivers, and the adopted cats who have earned album credits. "It's a little bit of magic," Rancich muses. "A certain person comes into a certain space and plays on a certain guitar. They create and engage a specific universe." He attributes almost everything to synchronicity. "Certain atmospheres and attitudes," he explains, "tend to gravitate into each other's orbits."

Some of modern music's most compelling albums—and some of Texas's sweetest, most buttery pecans—exist thanks to these cosmic coincidences. But they have also produced a family. "I feel like Tony has become the world's greatest foster parent," says Natalia Chernitsky, a newcomer to the team of audio engineers. "We have our fights," admits San Martin. More importantly, though, they have their traditions. On birthdays, they gather around one of the three dining tables. The honoree, like a samurai ready for battle, hoists a curved Japanese sword high in the air and cuts their cake in rapid-fire motions to the taunts and cheers from the crowd of residents and guests.

Other times, they adventure to the water tower. Rancich likes to speed up to the rusted structure, peppered with tags from various musician visitors, like a race car driver. This time, he skids to a stop just before he hits it (there is a sizeable dent from previous mishaps). He climbs the ladder first and lies down on the cold metal surface, looking up at the sky. It turns cyan, and the gradient of the horizon dissolves from a blush pink into a deep purple. Chernitsky and the new interns follow behind, laughing as they ascend. When they reach the top, they go quiet. The subtle buzz of the interstate to the north is interrupted by the occasional birdsong. To the south lies a strange, wondrous expanse that few people understand. It is where Mexico and the United States fade into one another, cultures merging to create something altogether new. Sonic Ranch—this world where tree nuts and recording studios and farm workers and famed artists all collide—is somewhere out there, too. Rancich sits up. He takes a deep breath and breaks the silence. "It's all pretty mystical," he says. "Don't you think?"

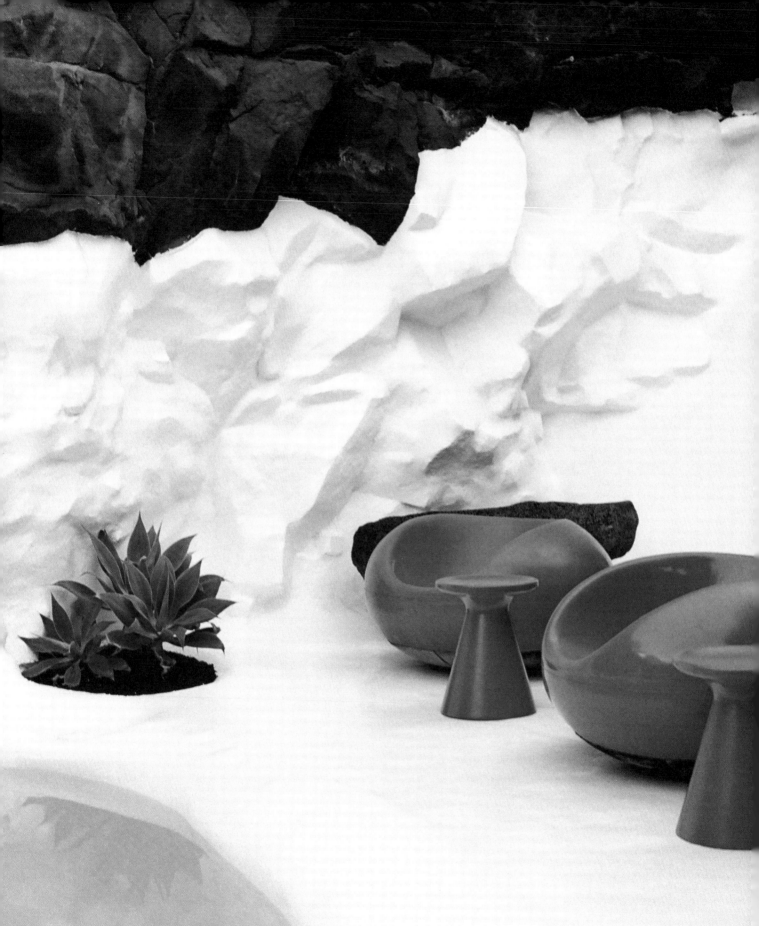

CÉSAR MANRIQUE

DESIGNING LIFE ON
A DESERT ISLAND

Situated eighty-some miles off of the coast of Morocco and shaped by volcanic activity, Lanzarote bears an uncanny resemblance to the moon and to Mars. The easternmost of Spain's Canary Islands, it is used by the National Aeronautics and Space Administration and the European Space Agency for astronaut training and other exploration initiatives. The dry, rocky, and desolate landscape is home to earth so warm that an egg can fry directly on its surface. Yet, for hundreds of years humans have successfully worked in concert with nature, extracting life from the harsh but captivating terrain. "We live such a short space of time on this planet that each of our steps must be aimed at building more and more of the dream space of utopia," wrote the artist and island native César Manrique. The expanse of land was his canvas. "Lanzarote," he explained, "was like a work of art without framing." Today, his most intimate spaces—his two private dwellings—remain open to the public. Visitors can see this supernatural setting through his very eyes.

Born in 1919, Manrique exhibited artistic tendencies from a young age. He had his first one-man show in Arrecife, the capital and his hometown, in 1942, but his early career otherwise blossomed mostly abroad. After a brief stint studying architecture, he moved to Madrid to pursue an education in fine arts. He lived on the Spanish mainland for nearly a decade until his treasured partner, Pepi Gómez, died of cancer. A grant from Nelson Rockefeller transplanted him to New York, but he quickly grew disenchanted with urban conditions. "Humans were not created for all this artificiality," he concluded. "There is a necessity of coming back to Earth. Feeling it, smelling it." In his time away, he had developed a nostalgia for

his Lanzarote upbringing: "For the real meaning of things. For the pureness of the people. For the bareness of my landscape and for my friends." At the age of forty-seven, he had exhibited in twenty-eight cities across sixteen countries, and it was time to return home.

When he did, he spotted a fig tree growing in the middle of a lava field. The simple sign of life was enough, and he designated it as the site of his first house. "Volcanologists have told me that these are the biggest volcanic bubbles they have ever seen," he proudly told a reporter for London's *The Daily Telegraph*. From the outside, his complex Taro de Tahíche looks like the one-story, whitewashed homes traditional to the island, but in these bubbles below, Manrique forged a subterranean Shangri-la. "Temperature and humidity are constant, whatever the weather, because volcanic bubbles have their own natural air-conditioning," he said. The series of interconnected rooms are wed by smoothly painted white floors, skylights, walls of black basalt, and banquette seating integrated directly into the natural curves. Trees grow up through the ground and into holes in the ceiling. A sunken garden, swimming pool, dance floor, and barbecue sit at their center. Upstairs, the structure engages with the landscape in a different manner altogether. Large windows, some of which are literally built into lava rock, provide views across the terrain, making it difficult to differentiate indoors from outdoors.

"His houses were always hubs of encounter and exchange, highly socialized spaces for the celebration and praise of the body," says Fernando Gómez Aguilera, the director of Fundación César Manrique, which continues to preserve his domestic spaces to this day. During the 1970s and '80s, Taro de Tahíche

Manrique's thoughtful ornamentation
of natural materials—rocks, branches,
earthen vessels, and palm basketry—
pervades the rooms of his homes, but
his eye for beauty did not discriminate.
Contemporary designs like molded plastic
chairs sidle up to more raw expressions
of craft. (1)

1

2

Manrique was a man of routine and
regularly began his days with a swim.
He built many pools in Lanzarote,
including here at Casa del Palmeral,
at his first house-turned-headquarters,
Taro de Tahiche, at Casa Omar Sharif,
and among the lava caves at Jameos del
Agua, which the American actress Rita
Hayworth dubbed "the eighth wonder of
the world." (2)

Manrique, who studied painting and drew influence from
the likes of Matisse and Picasso, became associated with
Spain's abstract and gestural "informalist" movement
alongside artists like Lucio Muñoz and Antoni Tàpies.
With half-finished canvases and sketchbooks strewn
about, his studio——a large separate structure and
unrestrained place for creation——in Haría remains almost
exactly as he left it when he died. (3, 4, 5)

With floor-to-ceiling windows and a parallel wall of mirrors, the exterior elements are on full display from every angle in the Casa del Palmeral bathroom. Connections to the surrounding land are prevalent in any one of Manrique's spaces. "They contribute to educating and forming sensitivity, an enlightened purpose always present when Manrique was constructing his aesthetic-social utopia: to mentalize, to make aware," says Fundación César Manrique's director Fernando Gómez Aguilera of the artist's micro-worlds. (6, 7)

saw a slew of painters, photographers, actresses, writers, models, and architects enter its doors—though per Manrique's rules, never with shoes on. Aguilera describes it as "a genuine film set, a party venue, a location for international get-togethers." Manrique didn't smoke or drink, but he had a zest for life "right to the very end," and according to the filmmaker Pedro Almodóvar, hosted "some pretty wild parties." Guest lists included Frei Otto, Ricardo Bofill, Irene Papas, Bernardo Bertolucci, and the king and queen of Jordan. Manrique, his skin browned from the sun, often padded around among guests and through his desert universe barefoot. "I always say that I didn't come into this world wearing socks and a tie," he mused. "I arrived naked, and I attempt to go through life like that."

The artist called Taro de Tahíche home for twenty years, the longest he ever lived in a single location. In 1988, he began converting his whimsical but sophisticated digs, which *The Guardian* once aptly characterized as "Barbarella meets the Flintstones," into a public attraction and headquarters for his eponymous foundation. With its lasting purpose defined, he traded the abode for a more serene location in Haría, where he took up residence at Casa del Palmeral, a once decaying farmhouse transformed to meet his needs. For this project, he paid even greater attention to the principles of the island's vernacular architecture. Manrique had long admired the juxtaposition between the boxy, white reflective buildings and the dark organic shapes of the surrounding environment. He preserved the ruins of the original structure and grew the space with new volumes, like an annexed workshop where he is said to have painted every day. Inside, timbered ceilings with gigantic beams and mammoth stone fireplaces meet brightly painted tiles of Manrique's design and colorful textiles. Antique furniture sits alongside modern designs in wood and plastic.

7

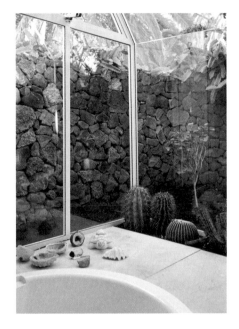

6

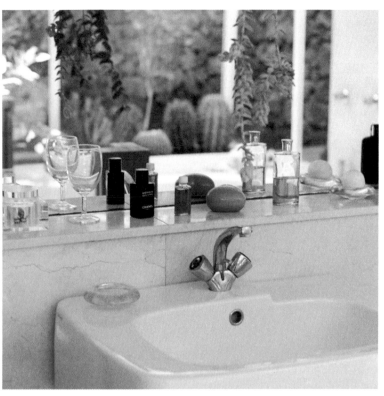

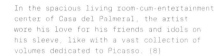

8 In the spacious living room-cum-entertainment center of Casa del Palmeral, the artist wore his love for his friends and idols on his sleeve, like with a vast collection of volumes dedicated to Picasso. (8)

Manrique integrated green-tinged dishes, cutlery, and tiles with timber—furniture, cabinets, and beams—that reflect the palm grove oasis surrounding his second and final home. (9)

Manrique was a collector through and through. His books span topics from Marcel Duchamp to natural history, Carl Sagan, and anthropology. "He was passionate about objects that came from the agricultural and fishing worlds, which he decontextualized and employed to decorative effect," Gómez Aguilera says of the buoys, nets, and plows hung throughout. He painted mannequins that populate various corners and shelves and displayed found items and daily implements, including mortars and clay pots, like art. "A child has to be educated in an environment full of beauty and harmony so that he can be a man for the future," Manrique wrote, "full of fantasy and talent, with an ethical sense of life." He likewise believed that adults should be surrounded by such beauty, whether in the form of a framed contemporary photograph, an old sewing machine table, or a Danish teapot.

It seems that Manrique left no stone unturned. The studio, with dripping paint cans and practical tools, is completely functional yet appears almost destined for a life on the silver screen. But the bathrooms might be the pinnacle of it all. "He used to comment that they were fundamental spaces in modern domestic culture," explains Gómez Aguilera, "because after waking and getting up, our first contact with reality takes shape in the bathroom." Manrique sought to infuse them with warmth and happiness, and they continue to burst with life. Tubs fit for a crowd nod to the part-time nudist's penchant for communal dips. Windows let in an abundance of light and frame outdoor scenes. Gómez Aguilera considers them "majestic" points of connection "between the sky and its surroundings." Greenery, like a row of cascading String-of-Pearls succulents, fills the spaces, and objects that line the countertops and sinks feel as considered here as anywhere else.

Manrique gave equal emphasis to exterior quarters like the sun terraces and gardens, or "anywhere there was contact with nature," says Gómez Aguilera. "Above all, he was interested in fusing the arts—architecture, gardening, sculpture, painting, landscaping, and craftsmanship. What he aspired to was a total artwork in natural surroundings." This extended well beyond his homes, or even galleries and museums. Manrique hoped to reach what Gómez Aguilera describes as "any member of the public willing to revel in the pleasure of beauty."

While bathrooms often serve as refuges of
solitude, Manrique's were designed to be
cavernous. The open areas, like the green-
themed iteration at Taro de Tahíche, were
even the site of social gatherings, hosting
the likes of architect Frei Otto within
their walls. (10)

10

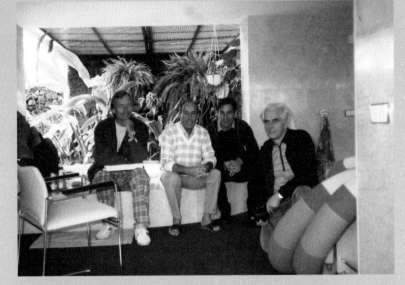

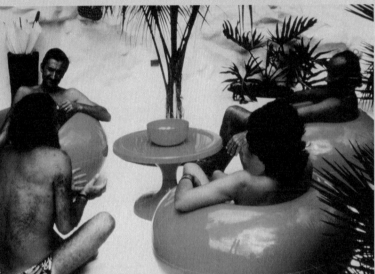

11

12

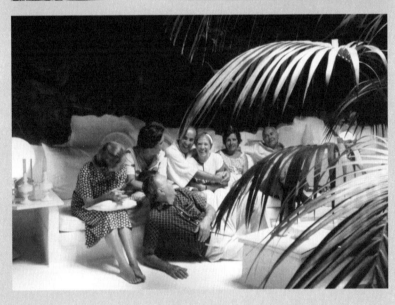

Manrique frequently transformed corners of
his home to accommodate small exhibitions,
costume parties, and music recitals. "Freedom,
beauty, and pleasure" were the cornerstones
of his interior life, according to Gómez
Aguilera. (11, 12)

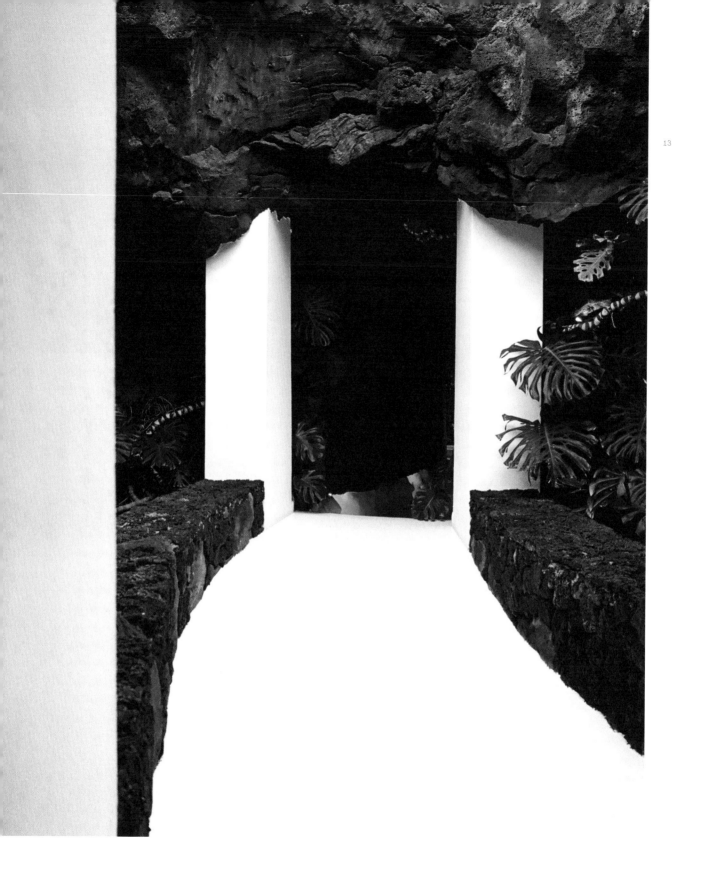

Taro de Tahiche is defined by a series of
compress and release moments. Narrow, dark
channels within the cave home require precise
movements to navigate and open into expansive
volumes that frame the sky. (13)

When he initially arrived back in Lanzarote, Manrique imagined an artist colony on the island's interior, inspired in part by Luis Barragán's Pedregal development in Mexico City. He realized, however, that such a concept could be more expansive, more inclusive, and more based in community. To start, he convinced the island's inhabitants of its merit. "At first, people were unaware," Manrique said. "Talking about the beauty of a stone was like speaking Chinese. Then, little by little, talking a lot because I was tireless, I convinced people and the authorities." He went on to construct the arts and culture center Los Jameos del Agua, a panoramic viewpoint named Mirador del Río, a museum dedicated to endemic farm culture, an ode to local plants in the form of Jardín de Cactus, and a restaurant at Timanfaya National Park. He designed waste bins and wind sculptures that dot the expanse, advocated for native landscaping, and advised local officials on sustainable tourism.

He wanted to attract a "high-quality" tourist, which did not equate with financial means but spiritual value—or in his words, "people prepared to understand the landscape of the island, which is like a great symphony that requires time." He despised any project done for the sole purpose of short-term gain and lamented an excess of visitors in his later years. Nevertheless, he felt close to victory before he died an untimely death in 1992, the result of a car accident just outside his beloved Taro de Tahíche. "We haven't achieved utopia," he said, "but we have managed to brush up close."

14

When Eero Aarnio, the Finnish visionary responsible for designs now considered inseparable from the sixties, dreamed up his iconic Pastil and Bubble chairs, he couldn't have known that one of their first homes would be poolside at the volcanic compound. Manrique often drew from colors representative of the island when choosing hues like the lava orange of Aarnio's seats. (14)

15

The low height and verdant display in the bathing corner of Manrique's bathroom at Taro de Tahíche give the feeling of a subterranean jungle. The latticework ceiling, which enables a greenhouse effect, matches the moss-colored, turf-covered floors. (15)

The yellow-themed volcanic bubble room with its enormous natural skylight was a noted site for Manrique and guests to enjoy a private moment of nude sunbathing and seamlessly transition to built-in benches cast in moody lamplight for evening escapades. (16)

16

ZIAD

Wadi Rum

AZAR

Jordan

DOWN TO EARTH
AND BACK TO BASICS

At the edge of a small village, a settlement of Bedouin inhabitants who manage the nature preserve beyond, the paved road ends and a seemingly endless stretch of sand begins. Ziad Azar blazes through in his 70-Series Toyota Land Cruiser, racing to beat the sun. The truck bed is filled to the brim with building supplies and provisions—some clothes, bottled water, and boxes of brightly colored produce from Mujeb Organic Farm in Amman. While Azar may still technically call the capital city home, Wadi Rum, a desert valley bordering Saudi Arabia in Jordan's south, is where he feels it.

He arrives at Gamra, the eco-camp that he began conjuring up in 2022 with the fashion designer Tania Haddad and the entrepreneur Hussein Kahil. He hurriedly unpacks and touches base with a group of workers—they came to drop off materials but stayed to lend a hand upon catching sight of the postcard-worthy location. The mountains that protrude from the sand begin to darken against a sky painted with hues of pink and bluish-purple. Azar has no time to waste. He flies back into his truck, a work-in-progress vehicle that he has meticulously modified to fit his needs, and takes off, heading deeper into the wilds. He makes it to his go-to sunset spot with 360-degree views and not another human in sight, and pauses to take in the fresh air. A smile flashes across his face. "This is—what's the word?" he asks himself, mulling. "Involuntary. This is involuntary happiness."

Azar wears his love for the desert on his sleeve. He is constantly looking for—sometimes, he admits, even manufacturing—excuses to head in its direction. He knows the region well. At the age of nineteen, he arranged a brief stint in the tourism industry, exploring the very place where he now lives part-time. Thanks to an uncle, he learned the ropes of film production, helping to bring movies like *Dune*, *Aladdin*, and *The Martian* to life in its landscapes. "Matt Damon was the nicest guy," he declares before growing pensive. It was fun to be around talented actors and film crews, but for him, they weren't the

real highlight. "Having a car and support out here," he recalls, "gave me the courage to truly explore."

Azar, who went to school for Environmental Studies, might be what some call a jack-of-all-trades, though he is a master of plenty, too. He worked as a double for Sean Penn in the film *Fair Game*. Friends have employed him for various construction and remodel projects, including a design-build commission for a two-story container home. At one point, he owned and operated a juice bar and eatery focused on local, seasonal ingredients in Amman's popular Weibdeh district. Now, he manages his multigenerational family business, which has produced soaps, cosmetics, and skin care products since the 1930s. He talks about all of these projects with great passion, but nothing puts a fire in his eyes quite like diving into the micro-world that is Gamra.

It appeared on his horizon almost like fate. Azar bumped into his friend Mohammed while on a camping trip in Wadi Rum, which, with its towering rock formations, vast orange and red sand dunes, and expansive sky, is the size of New York City but without the eight million residents. A UNESCO World Heritage Site, the area is protected by the Jordanian government, which respects the historic land rights of Bedouin families like Mohammed's by providing them parcels to care for and earn from. "Between small talk, he asked if I knew of any investors who were interested in renting land," says Azar. "And of course, that little lightbulb went off in my head."

He was with Haddad at the time, and the two called Kahil. The three had never worked together, but they knew that they were the right combination of dreamers and doers to get a job like this one done. A short visit to the site, some tea, and business talk later, and they were formal partners. From the outset, the trio wanted to infuse a spirit into Gamra that bucked trendiness, avoiding bubble tents or mass-produced, faux-Bedouin materials. They imagined a place that provided the same introspective, free-spirited camping experience that drew them back

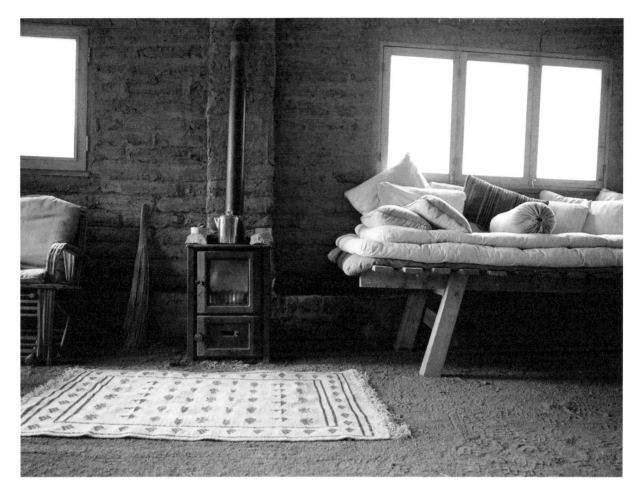

1

Mud-brick homes self-regulate temperature,
keeping cool in the summer and warm in the
winter. No air conditioner is needed, but
a wood-burning stove situated next to a
daybed of Azar's design keeps the one-room
structure toasty on particularly chilly
desert nights.(1)

2

3

A caravan of camels crosses the valley
in front of Gamra on their daily trek
to find water. (2)

Plentiful textiles and floor pillows line
the tents, creating ideal lounges for
snacking or sharing a cold glass of arak,
an anise-based spirit. (3)

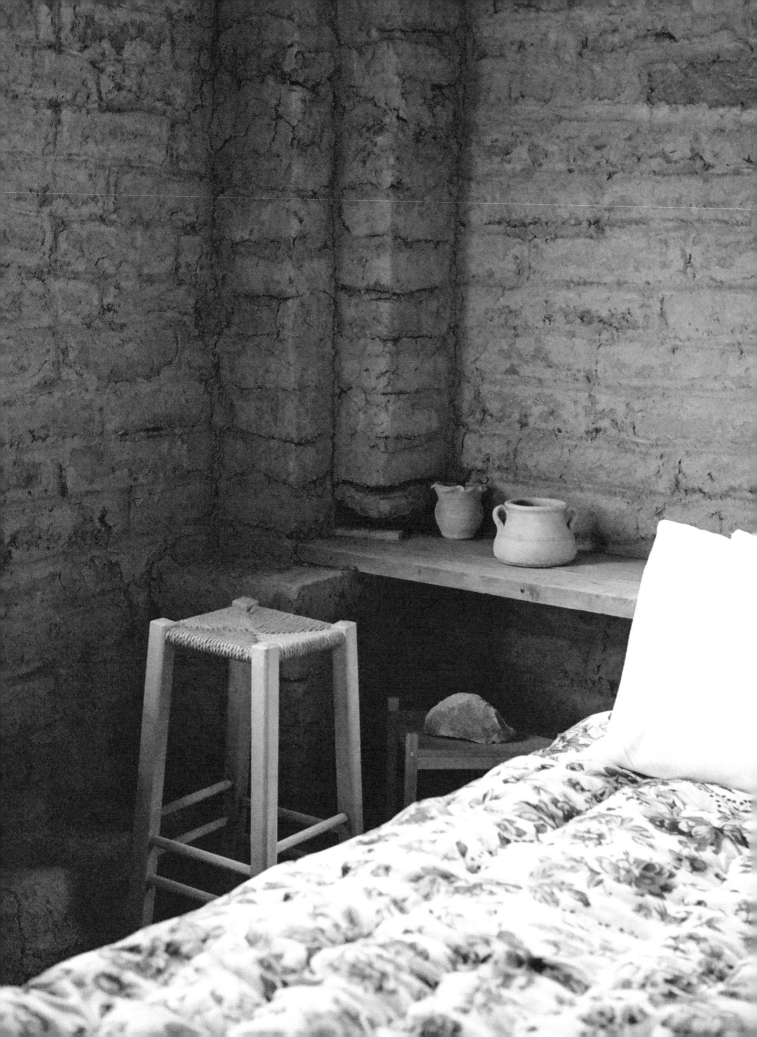

4

Azar and his partners strive to know and respect the local community that has lived in harmony with nature for generations. Gamra's unique spirit exists in no small part because of the close relationship they have developed with members of the Bedouin family, like Abdullah, who maintain the rights to the land. (4)

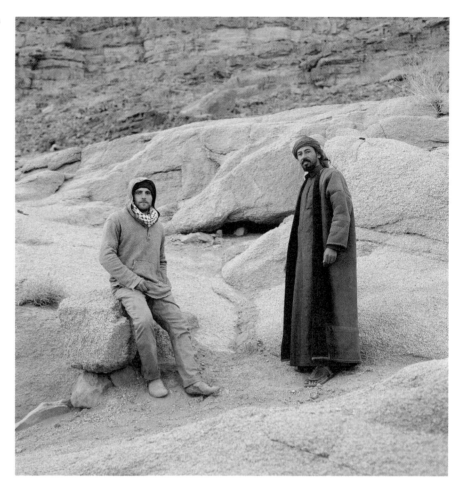

5

Wadi Rum's natural expanses become outdoor dining rooms, where Azar sets up picnics on the dunes or in the shadows of an overhanging cliff face. Decamping from Gamra and the built environment proves as much a part of the property as actually being on site. "Having everything that you need here," he explains, "gives you the freedom to leave and just be." (5)

6

In an effort to decorate with locally crafted pottery, furniture, and rugs, the Gamra team continues to research and meet with makers and artisans. "Handicrafts are nearly extinct in the area as people resort to imported goods," Azar laments. "Our long-term goal is to reintroduce these crafts to the village of Wadi Rum." (6)

Open tents anchored into the tiered rocks offer moments of relief from the midday sun or a spot to spend the night under the stars. (7)

9 10

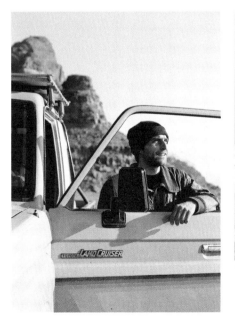

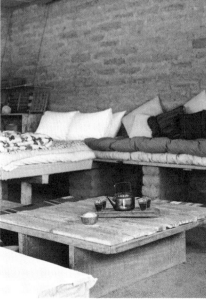

"Getting in the car and driving," Azar says, "is my version of taking a walk in the park." Cruising over the red sand stretches of Wadi Rum in his Toyota, the entrepreneur's mind goes free. (8, 9)

The open floor plan, where sleeping spaces flow directly into the living and dining areas, further facilitates a camping-like feel but with the creature comforts of home, including plush mattresses, seating of various kinds, and ample storage. (10)

time and time again but with more infrastructure. "I was always the person who was responsible for prepping and packing to create the perfect camping trip," explains Azar. "I loved the idea of a group of friends or a family being able to come here and have that experience with just their personal belongings." Gamra wouldn't be big or widely publicized. It would exist for discerning travelers like them who seek more genuine, meditative, and thoughtful journeys.

What exactly their camp might look like otherwise, they did not know. To start, the Gamra team acquired thick, almost-forgotten tents handwoven by past generations of Wadi Rum women from camel and goat hair, which they pitched over simple bed frames and mattresses. Then, while brainstorming ideas for a more permanent caretaker's cottage, a mason from Syria examined the soil and suggested that they consider earthen construction. Through trial and error, they erected their first wall. Looking out at the view of the sandstone hills beyond and visualizing the harmonious connection between their facade and the nearby nature, they realized that they had found their golden ticket. Their path forward solidified. "It was unreal," Azar remembers. "That moment changed everything."

He considers the building material, composed of entirely natural matter and sun-dried, as alive. "It becomes a part of the landscape," he says. "It's literally of the earth." Now, Gamra is home to a small but growing compound of mud-brick structures, traditional tents, and outdoor gathering areas. The design exudes a modest beauty, a product that could only be born of a purely organic process. "I feel that the flexibility and freedom of working with earth and simple structures can be described as freehand, in contrast to engineered," Azar explains. A momentous undertaking, developing the "almost village" has been inspiring, to say the least. "If I were to go back to school," he muses, "I would study design or architecture." But if it is knowledge that he thirsts for, he seems to be drinking plenty.

He transforms excess wood from the bathroom into storage solutions. He crafts angled kitchen shelves to accommodate the irregular dirt floors and non–load bearing walls and devises pulley systems for the doors ("these tasks all motivate me to think about simple physics," he says). He tests different finishes for the countertops and other surfaces, repurposes props from movie sets and designs modular daybeds, hooks from leftover bathroom pipes, and spice racks that hammer directly into the earthen walls. In effect, if you want it, he's got it—or rather, he'll make it. "I like the unconventional," he grins. "And out here, we might be bound by materials and resources, but we are otherwise limitless. We can do anything, and it is so much fun."

It may be clear that Azar is the project's spark plug, but it is equally as evident that Gamra wouldn't run without its other components. Haddad is the visual heart, obsessing over the aesthetic details, fabrics, and finishing touches. "If I operated entirely my way, it would look very different," says Azar. "The style here? That's all Tania." Kahil, meanwhile, is the mastermind behind execution. Since his family is in the power tool business, he knows exactly what to implement and when. "He's not only incredibly resourceful," Azar continues, "but he also brings with him a much-needed sense of structure and stability."

They each offer their unique expertise, but as a unit, the threesome formulates design answers that add up. Take the seating options. Traditionally, these would be floor-bound, but they noticed that down low they were missing the views. To ensure perfect vista points, they determined an ideal height for their benches and beds. They fell madly for their bathroom, which features a giant stone as the shower floor, but couldn't fathom the practicality of long, steamy showers in their dry climes—that is, until they rerouted their gray water for reuse in the outdoor mud-brick workshop. When later putting a second unit together, they discussed the magic of being able to look up at the stars from inside, so in one portion they opted for a clear polycarbonate panel in lieu of their regular roofing solution.

A deep appreciation for the natural environment and its stewards—Bedouins like Mohammed and his brother Abdullah, who they now work closely alongside—brings them together when they have their differences. It starts to drizzle, a rare occurrence in a place that receives two to four inches of rain per year, and Azar basks in the graying clouds and tiny droplets that hit his jumpsuit. "*Mabrouk matarkom*,"

he says. "Everyone will go around saying that to one another. It means, 'Congratulations on the rain'—a small, but beautiful acknowledgment." He also admires the Bedouin sense of hospitality. When he, Haddad, and Kahil arrived, neighbors welcomed them with fresh camel's milk, sharing their riches.

That gratitude and warmth has become integral to Gamra's ethos but also to their own individual characters. Azar hops in his beloved truck to chase the storms. The genre-bending Jordanian band Autostrad plays over his stereo as he follows the various tracks in the sand, driving up steep inclines and zooming down to Bedouin beats with a childlike sense of joy. "When you're in the city," he says, "there are so many little interruptions—notifications, ads, phone calls, traffic—to distract you from what's really on your mind. Out here, when you're in the zone, you're *you*."

He arrives at a spot that can only be described as Mars on Earth. He parks on the crater-like surface and sets up a picnic of labneh, olive oil, dates, and sliced tomatoes and kohlrabi, ready to share with the odd person or two who might drive by. He looks out for a while, alone with his thoughts. Perhaps he is considering the latest structure back at camp or just the sheer wildness that he's even doing this in the first place. "Dude," he says, shaking his head. "I am honestly just having the time of my life."

Whether the team is adding a new building or installing an outdoor shower on the side of a cragged rock, Gamra is in constant evolution. Azar, his partners, and a savvy team of workers tap into local resources such as palm fronds, which are readily available nearby and in large quantities, to line the roofs. (11, 12, 13)

An earthen bathroom complex fades seamlessly into the surrounding hillside. (13)

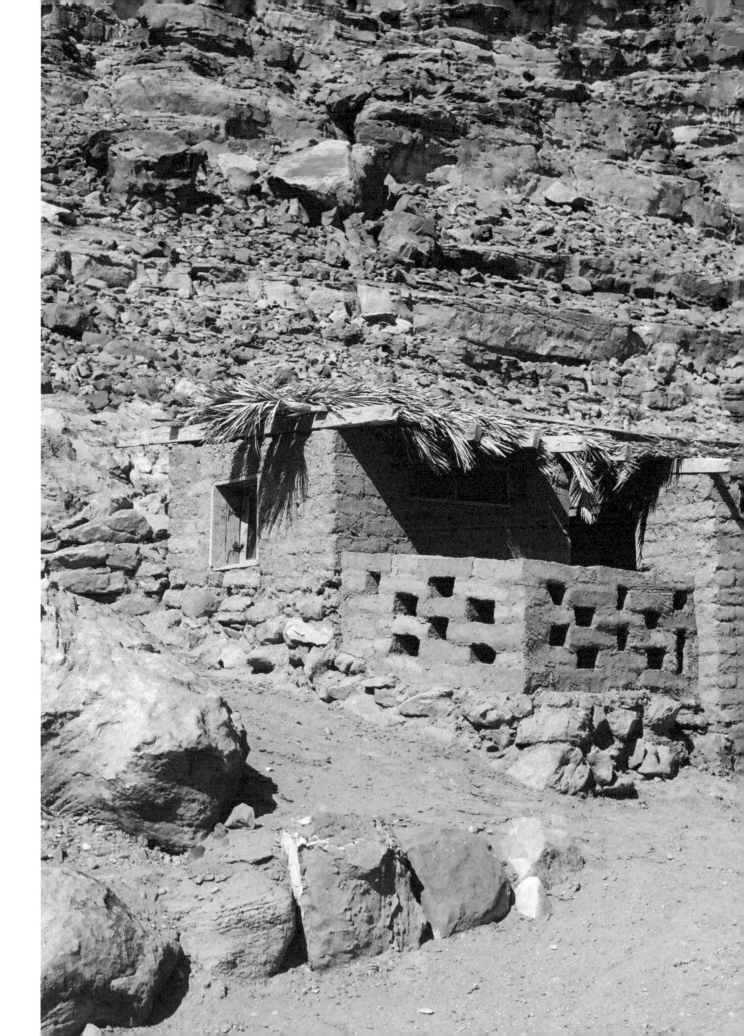

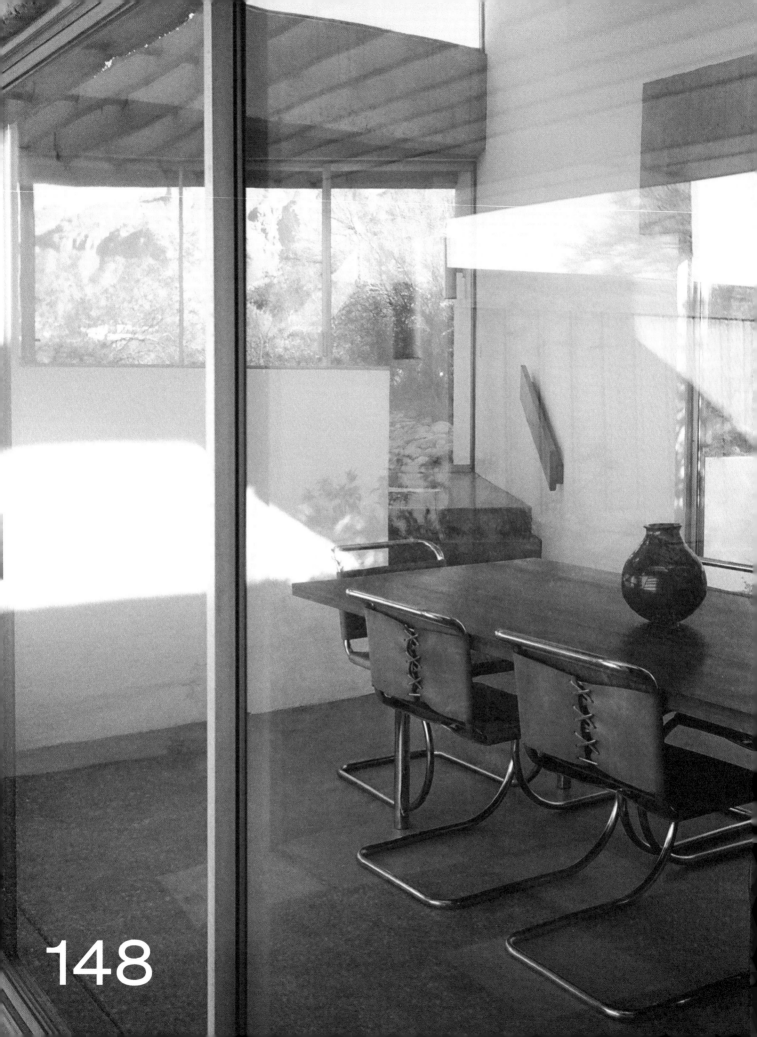

DEMION

Tucson, Arizona

CLINCO

United States

STEWARDING
AN ARIZONA LEGEND

Tucson, according to Demion Clinco, is like a rubber band. "A lot of people who are born here leave. There is an angst, a need to find something else," he explains. "And then, when they least expect it, they are snapped back." He knows the analogy well—and not just because it applies to friends and family. Clinco studied art history in Los Angeles and design in Milan with no plans to return to his hometown full time but alas, Tucson was in his DNA. A simple stopover on his return from Europe developed into a long-haul commitment to Arizona's second-largest city. "There's something about the big sky of the desert," he says, the jagged silhouette of the Santa Catalina Mountains rising behind him. "It's just where I feel at ease."

For Clinco, it is the landscape, yes, but it's the community, too. "There's a kindness, a real human aspect to people in the desert," he says. "I found my people in this place, and it sort of was like, 'how could I leave?'" He not only stayed in Tucson, but he became deeply embedded in its past, present, and future. He served as a member—and at the time, the only openly gay one—of the Arizona State House of Representatives, lobbying for LGBTQ+ rights in a traditionally conservative state. He was elected to the Pima Community College's Governing Board, where he fostered education programs to fuel the local economy. He employed his arts and design background to help relaunch the Tucson Historic Preservation Foundation, where he now serves as the CEO. Clinco, it seems, is a man of the very people that brought him home.

He is also a man of houses. Though he resides in a small, one-bedroom dwelling downtown, he has come to acquire several other residences in partnership with his family. There is the Fort Lowell property where his mother lives, and in the same neighborhood, the Charles Bolsius House where he grew up. There is the homestead at the base of the Chiricahua Mountains, where Clinco and a few friends co-own the award-laden winery Sonoran Wines. And then there is the Jacobson House.

Designed in the mid-1970s by Judith Chafee, the trailblazing architect who synthesized modern sensibility with environmental practicality in the arid Arizona climes, the bold, brutalist structure in concrete quickly captured Clinco's heart. "I mean, it's spectacular," he says, beaming. "The windows create this almost invisible line that makes you feel like you're outside, like you're physically in the desert."

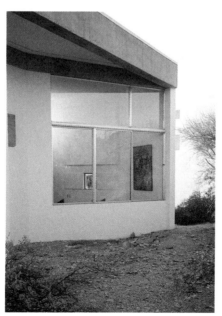

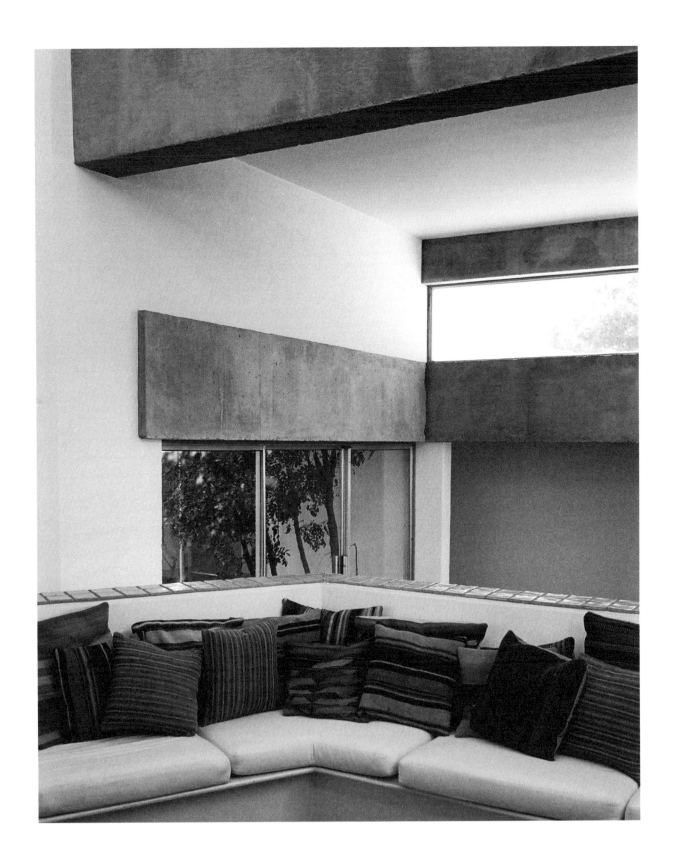

2

At the Jacobson House, Chaffee continued to descend from modernism into its byproduct brutalism, "with these massive, site-cast beams that had to be craned in," Clinco says. Despite its celebration of stark simplicity and honest materials, several inviting seating areas and oasis-like courtyards create a soft and welcoming atmosphere. (1, 2)

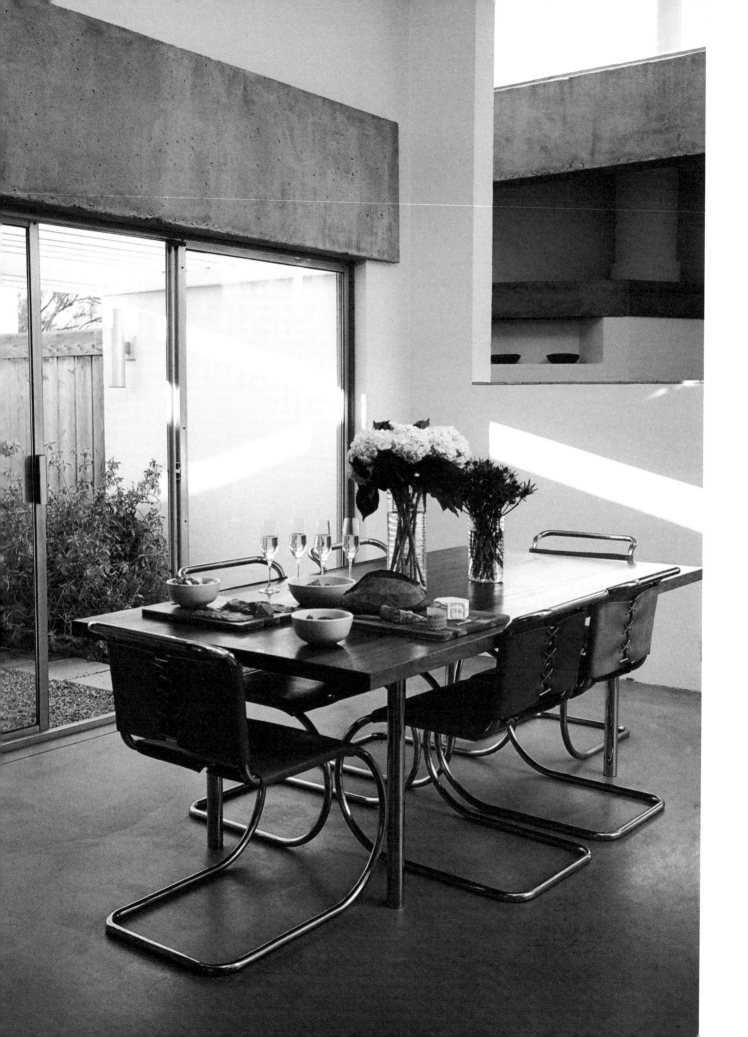

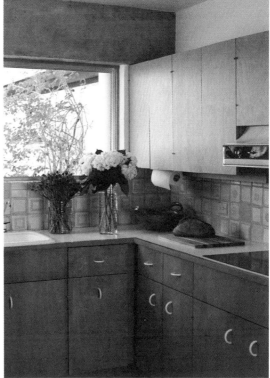

4 5

To build something that truly responded to the environment, Chafee had spent extensive time on the four-acre site, learning the movement of the sun and the shade. Commissioned by Art and Joan Jacobson, a philosopher and a weaver who had traded the Midwest for the Southwest, the geometric design winds around courtyards of varying size and shape. It centers on natural light and ventilation and was brought to life with exposed concrete beams, painted concrete block, aluminum-frame windows, and glass. The result, according to Clinco, is seductive—so much so that he has to limit his time there.

Originally, Clinco intended to use the space as an office of sorts, but he found himself distracted. Likening the house to a work from James Turrell, the American artist known for his large-scale, immersive installations that explore human perception of light and sky, he would sit in awe for hours watching the light shift or staring out the window. "This remarkable landscape..." he says, drifting off. "It never gets old." Though the home wasn't destined to be Clinco's workspace, its magnetic qualities have opened doors and forged new relationships.

"This house is 100 percent about sharing," Clinco affirms. Given that Chafee never received a single civic commission in her illustrious career, every example of her small canon of work is a private residential project and thus inherently less visible.

3

Clinco's world revolves around crafting tasteful events, be it his annual birthday gathering, a fundraiser, or an aperitivo hour for a handful of friends. Essential ingredients for any of his social affairs include fresh-cut flowers and sparkling wine like Perrier-Jouet champagne or Gruet, made from grapes grown in the deserts of New Mexico. (3, 4, 5)

For most of the day, Clinco remains bewitched by the natural light that permeates in various ways, whether punching through the bedroom windows or bathing the dining nook in an ambient glow. When the sun goes down, lamps like a modern version of Vernor Panton's Flowerpot design take over and illuminate spaces with a different kind of flair. (6, 7)

6

7 Clinco artfully nods to Chafee's legacy alongside design legends with choices like an Eero Saarinen table and a set of Eames chairs tucked into the breakfast alcove. After graduating from Yale in 1960, the visionary behind the Jacobson House went on to work at Saarinen's firm and later received a fellowship at the American Academy in Rome when Charles Eames was a resident director. (7)

8

Throughout the interiors, Clinco adorns with a light touch. In the more formal gathering space, furniture pieces——a table by Giorgio Belloli and the Executive chair by Eero Saarinen——are offset by hand-painted, vintage figurines picked up on one of his many trips across the border to Mexico. (8)

FROM THE LIBRARY
OF JUDITH CHAFEE

Miniature Rooms
by Mrs. James Ward Thorne

I have always been fascinated by the art of miniature-making and the way it challenges conventional notions of space and perception, sparking creativity and imagination. The miniature rooms depicted here and made by Thorne, a Chicago socialite, offer a unique perspective on spatial design, inviting exploration of scale, proportion, and detail in a condensed form. I imagine Chafee being drawn to the intricacies of these tiny worlds, seeing them as microcosms of architectural possibility in the same way a model might provide the preliminary expression for a project.

Moose Mousse and Other Exotic Recipes
by Robert Gilbert

One of many cookbooks in Chafee's collection, this quirky title suggests a sense of adventure and exploration into unconventional ideas. I like to think that she may have been drawn to the creativity and experimentation inherent to the cooking process. Personally, I have always been captivated by the convergence between food and culture, and this book definitely catches my attention with its diverse flavors and ingredients.

The Jacobson House bookshelves, which form a staircase leading to an upper-level reading nook, are something of local design legend. But it's still a little-known secret that the top two and a half rows are filled with their designer Judith Chafee's personal library. "Many of the books were gifted to her and have beautiful inscriptions," Clinco says. "Others show signs of being thoroughly read. It's a very intimate thing." Kathryn McGuire, one of Chafee's esteemed associates and co-author of the 2019 monograph *Powerhouse: The Life and Work of Architect Judith Chafee,* donated the collection to Clinco when she left Tucson. "It seems like there would be no better place for them than on these shelves," Clinco recalls her saying. He gladly accepted—but he says that the offer came with a responsibility. "Books say so much about a person," he explains. "They are meant to be shared" and so here, he offers up a few. "These titles express Chafee's diverse interests and serve as insight into her creative process," he continues. "And they resonate with me personally, reflecting my own curiosity and passion for exploring the intersections of design, nature, and history."

Landscaping with Native Arizona Plants
from Soil Conservation Society of America

Given Chafee's connection to the American Southwest, this book likely resonated with her commitment to sustainable design practices and her appreciation for the unique beauty of the region's native flora. I often reflect on Chafee's integration of the Sonoran Desert environment into her architectural projects. For me, landscaping with native plants has always been about honoring the natural environment and creating harmonious outdoor spaces that thrive.

A Museum of Early American Tools
by Eric Sloane

A reverence for craftsmanship proved key in Chafee's own design ethos, and this book explores the implements used by early American builders, highlighting the importance of understanding such foundations in an architectural practice. I have long been intrigued by historical tools like these as a tangible connection to the past. I can imagine Chafee feeling a similar sense of appreciation for the ingenuity and skill of the craftspeople who came before her.

Survival Through Design
by Richard Neutra

Richard Neutra's philosophy of "survival through design" emphasizes the role of architecture in enhancing human well-being and adapting to environmental challenges. To me, it is clear that Chafee's work was inspired by Neutra's holistic approach, which prioritizes both aesthetic and functional considerations. I find Neutra's ideas deeply resonant. They align with my own beliefs in the power of architecture to positively impact people's lives and the environment, and I hope people can see that capacity in Chafee's work.

Clinco's mission, then, is multifaceted. He aims to grow appreciation for Chafee's impact in Tucson and farther afield, while also highlighting a modern way of living in one of the earth's hottest and driest urban environments. Architecture, after all, "is about a specific place," or at least it should be as far as Clinco is concerned. The nearly half-century-old structure "looks like it could have been built yesterday" and is something that Clinco believes could serve as a future model. "Instead of tearing down and building cookie-cutter developments, we need to learn lessons from these places and imbue them into mass housing," he asserts. What better way to circulate his message than by making Chafee's construction available to all?

A true understanding of the house requires seeing it in person or better yet, spending a few hours—maybe even days—exploring it. "It's nearly impossible to articulate the spatial volumes and the way that light transforms within them," Clinco explains. "Everyone who walks in," from the technician who installed the dishwasher to the Democratic Whip under Nancy Pelosi, "has been awed by the space," he says. Being able to create such a wide impact has been an invaluable asset. From putting on community fundraisers to leading tours during Tucson Modernism Week, of which Clinco is founder, hosting intimate dinner parties, and welcoming short-term renters, the house's humble steward revels in it all. He does admit, however, that the most memorable occasions might be during his annual birthday bash. He takes a tried-and-true approach: "Champagne and princess cakes," he smiles. With bottles of bubbly strewn across the kitchen and the sweet confections displayed on surfaces throughout the home, the event hinges on taking in the legendary sunset before nighttime frivolity ensues. Then, in the early morning hours, Clinco retires to the coziness of his 900-square-foot bungalow in the center of the city, where his beloved cat anxiously awaits. "Watching the energy of the house and the people in it through different times of day" is a distinct pleasure, Clinco says, and a gift that keeps on giving.

Though the Jacobson House isn't Clinco's primary residence, it radiates the design language—one that pays homage to prominent Tucson makers of the twentieth century and their contemporaries around the world—that the politician and preservationist has cultivated across his properties. The home exists as a labyrinth of interconnected rooms with several transitional spaces like courtyards and patios that engage with the outdoors. Its unique layout requires a small but powerful selection of furnishings. Sling chairs from the heritage Tucson designers Max Gottschalk and Giorgio Belloli, who later moved to Mexico, occupy the formal sitting room. Such pieces further make leaning back to absorb the phases of light from the elevated windows a Turrell-esque exercise. Clinco positioned a pair of Marcel Breuer's Wassily chairs in tan leather opposite a built-in couch in the elevated living room. Just below, in the natural light-soaked dining room, a set of six vintage MR chairs from Mies van der Rohe encircle a bespoke wooden table with steel-chrome legs. When the chairs' seats and backs needed updating, Clinco called on a local tannery to replace the material with thick saddle leather. In the guest rooms, E-1027 tables from the Irish architect-designer Eileen Gray sit bedside.

The concrete walls are carefully adorned with work from local artists—like paintings from Veronica Hughart and stitcheries from Nik Krevitsky—and other inspirational figures who were making their mark across the 1950s, '60s, and '70s in a period overlap with Chafee and the house. Hanging next to the living room's sculptural fireplace is a post–World War II painting from Sarai Sherman depicting the beaches of Italy, a particularly resonant image for Clinco that harkens back to his time in Milan. Textures and colors of the desert from both sides of the border crop up in textiles—rugs, pillow covers, and blankets—as well as in pottery, figurines, and tiling. The staircase bookshelf houses hundreds of volumes from Chafee's personal library alongside Clinco's own treasured finds to produce the dwelling's most iconic visual.

The robust architecture maintained its form throughout the Jacobsons' tenure, but when Clinco arrived, he felt it needed an infusion of new energy. Removing excess paint to reveal the raw concrete and exposing the original hardware became paramount.

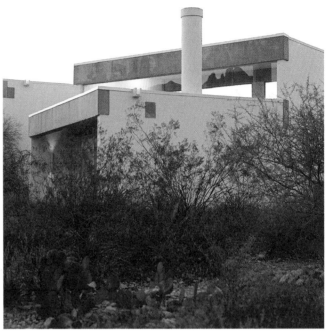

9

10

In such a dreamy abode, it's easy to
get lost in the pages of a book. Clinco
inherited hundreds of volumes from Chafee,
but a bibliophile in his own right, he is
constantly collecting new titles like the
comical *Dali's Moustache*, Alexander Girard
monographs, and tomes on Western aesthetics,
finding a place for them within the
different branches of his library. (9)

Chafee revered the fireplace, giving the
functional element high billing among the
design components of her homes. Extending
from these cherished hearths, monolithic
tubular chimneys, which pierce the roofline
of the Jacobson House, even influenced
the vernacular of the neighborhood when
a neighbor constructed a similar smokestack
in the eighties. (10)

Multiple professional opinions suggested that grinding down a deeply oil-stained section of floor would prove the best course of action, but Clinco resisted. Instead, he studied different products before painstakingly removing the massive blemishes with repetitive applications. Being a devoted steward of the structure meant "restoring but being as authentic to the original intent of the features as possible," Clinco says. "And when we gave a little, this house offered so much in return."

Experimentation and exploration are integral to communities here—from the Hohokam people who inhabited these lands millennia ago to the missionaries, gold miners, and cowboys that crisscrossed the landscape, all the way to founders of the university systems and visionaries dedicated to space science. Clinco sees Chafee's work as a physical manifestation of these same values and strives to spotlight her chapter in the proverbial book of frontier tales. "My work is to tell one small part of the larger story," he says. He views desert dwellers and builders as founts of knowledge who might hold key answers to a world suffering from climate change. Arizonans, for example, have learned to adapt to the summer heat and the intensity of the midday sun. "You hole up and stay inside," Clinco says. "We are going to have to look to homes in regions like these to understand how future generations are going to live."

Clinco declares any get-together at the
Jacobson House incomplete without a brief
reflective pause on the rooftop, where
he and visitors can take in the majestic
sunset. "That's when the house really
shines," he says. (11)

11

Yet, considering the built history of a place like Tucson is becoming increasingly difficult as vestiges of its past are erased. "It's always about developing something at the lowest cost for the highest return," Clinco says of a globalized real estate industry that is often divorced from local interests. After witnessing the tear-down of an art-deco construction—only to leave a vacant lot for fifteen years—an invigorated Clinco asked the mayor if he could join the historical commission. Within this circle of aging decision-makers, Clinco gave a presentation of all the buildings that have been destroyed in favor of so-called progress. Looking at one historic structure may feel insignificant, but when Clinco brought a collective of dozens to the table, the harmful trajectory clearly emerged.

Valleys of appreciation, or the lulls when people lose interest, are normal as societal tastes change. "Take Victorian houses," says Clinco, which used to represent a "creepy" feeling like in Alfred Hitchcock's *Psycho* or *The Addams Family* but are now revered for their quality of design, materials, and workmanship. Modernism has reemerged into the zeitgeist, but brutalism "is just coming out of its valley," explains Clinco. The Jacobson House came onto the market at just the right time and evolved into "a demonstration of responsibility."

Now listed on the National Register of Historic Places and designated as a landmark by Pima County, one of Chafee's masterpieces—and the land it sits on—is protected by Clinco's unwavering determination. It's infinitely easier to develop a strong sense of purpose when you're madly in love with the place that you live, and Clinco bleeds Tucson. The late afternoon light is beginning to create a zigzag pattern across the dining room as Clinco sets the table. An arrangement of flowers and a picnic spread grace the stage. He opens a bottle of sparkling wine, which is apparently all too excited to erupt. It bubbles over into a bowl of crackers, but no matter—what's a party without a little spilled wine? With so many irons in the fire, it seems like Clinco can hardly afford to stop and take a breath. But for this place—its rich history, gorgeous landscapes, and resilient people—Clinco will always pause for a toast. He raises his glass, bathes in the orange glow, and offers one big "cheers."

Climbing the stairs of the bookshelf
to the secluded nook at its top is
like ascending into a treehouse among
a canopy of saguaro cacti. The cozy
hideaway boasts expansive views on
three sides and accordion-style wooden
dividers for added intimacy. (12)

12

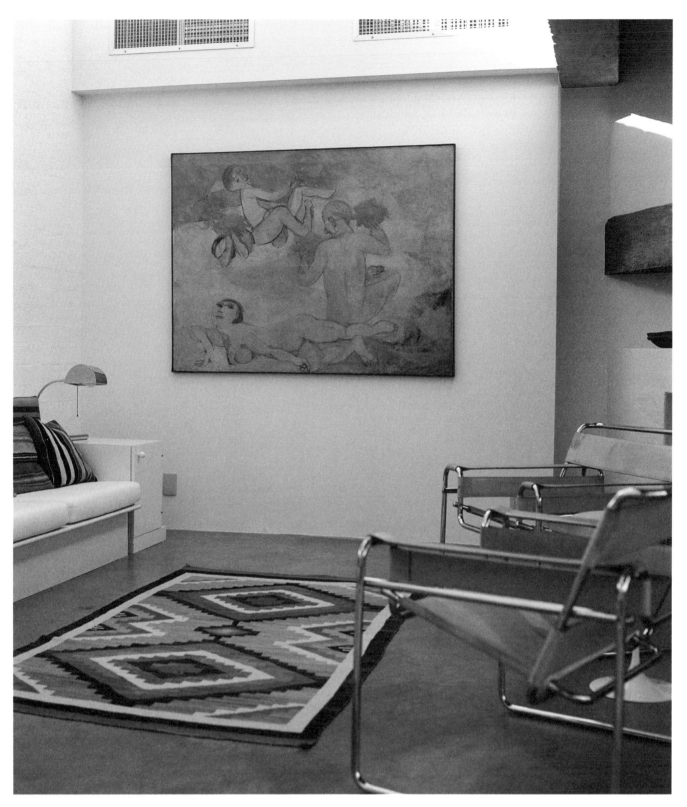

13

A painting by the Pennsylvania-born Sarai Sherman hangs in the living room. The artist has works in the Whitney Museum's collection, but according to Clinco is still "very, very under recognized." The homeowner pairs her masterwork with Marcel Breuer's tan Wassily chairs, a mid-century Navajo rug, and pillowcases repurposed from salvaged Turkish kilims, or handwoven carpets. (13)

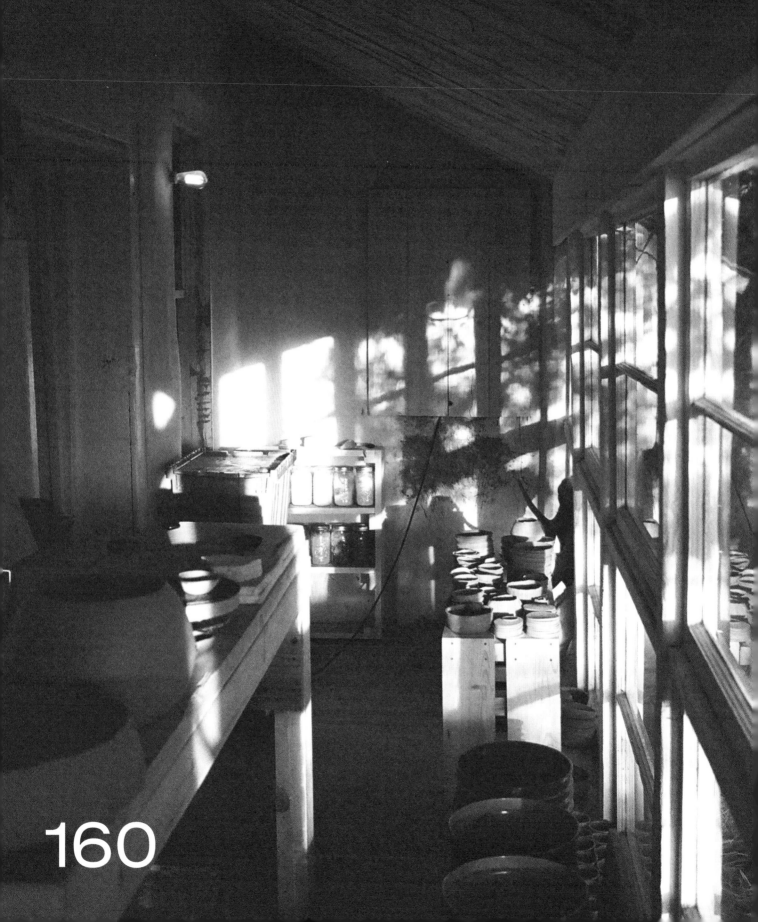

MAIDA
BRANCH

United States &

JOHNNY
ORTIZ-CONCHA

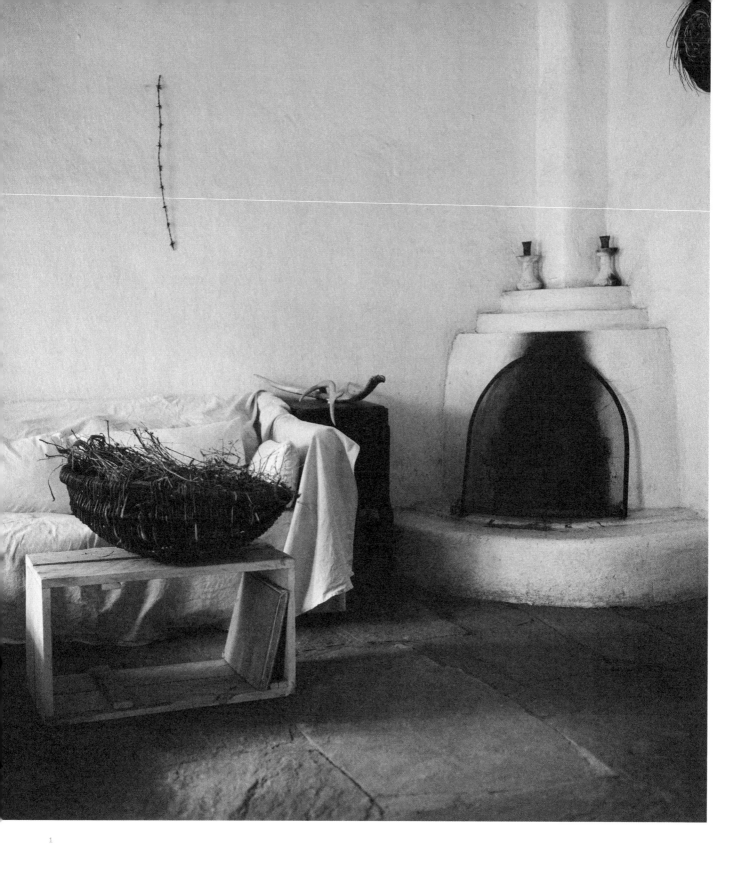

1

Branch and Ortiz-Concha cultivate an organic look and
feel, befitting of their rural environment. A white,
washed-linen sheet drapes over the sofa, a piece of
found barbed wire becomes art, Salinas candleholders——
handmade by the Española artist Camilla Trujillo and
based on found pottery from archeological digs in
Eastern New Mexico——adorn the mantel. (1)

A LABORATORY FOR A NOVEL, BUT NOT NEW, WAY OF LIVING

Ortiz-Concha's ceramic vessels
sit atop shelves of his own
design. Characterized by clean
lines and untreated finishes,
the polymath's furniture, much
like his work in clay, is an
ode to purity of material. (2)

Legend has it that in the Pecos Pueblo, the once thriving community situated in the Sangre de Cristo Mountains, a fire constantly burned bright. Members from the village were tasked with looking after the sacred flame, ensuring that it remained ablaze. If it were ever extinguished, they believed their people and culture would vanish along with it.

Maida Branch, whose paternal lineage stems from those very Pecos people, left New Mexico to pursue an acting career in New York and Los Angeles before she was drawn back after nearly ten years to the high desert lands of her childhood. She, after all, had a fire to tend to. Gravitating to the communities and stories from which she came, Branch founded her eponymous collective of Indigenous and Indo-Hispano artists. Then she met Johnny Santiago Adao Ortiz-Concha.

2

3

The chef-artist molds micaceous
clay into mezcal cups, coffee mugs,
bean pots, and bowls. (3)

The world of Branch and Ortiz-Concha extends far beyond their home. Their /shed dinners are moveable feasts, shifting between dramatically different venues. Here, the series takes up temporary residence at Sombra de Santa Fe, a modern home designed by the Tucson-based architecture firm DUST. Other times, it travels to the likes of La Hacienda de los Martinez, an early nineteenth-century adobe construction in Taos. The couple infuses each and every space with their signature look: decor harvested from nature, Ortiz-Concha's ceramics, and cherished tableware. (4, 5, 6, 7)

4

5

Ortiz-Concha, as it happened, had returned to stoke the same proverbial flames. Born and raised in Taos and of Tuah-Tah, or Taos Pueblo, and Spanish ancestry, he sought out fine-dining kitchens in far-flung places as a teenager. His tenacity quickly paid off. He earned an enviable position at Chicago's three-Michelin-star Alinea at just nineteen years old before moving on to Washington state's Willows Inn and Saison in San Francisco. "It was always second nature to leave," Ortiz-Concha recalls of his decision to decamp from his homeland. "Growing up in a small town, it felt like everyone was excited to get out." Yet, as he grew increasingly disenchanted with the restaurant industry's often overexaggerated embrace of locally sourced and farm-to-table food, he realized that his calling was in the very place that he had left behind. He now likens his years away to the Pueblo initiation tradition, an introspective journey in manhood and self-knowledge.

Like Branch, Ortiz-Concha sought to create more meaningful ties to his roots through storytelling. Back home, he dreamed up /shed, a project that centralizes around an atypical dining experience. A few select times each month, intimate groups gather around a shared table. The rareness of the dinners, or *récolecciones*, as the chef calls them, is deliberate. The concept builds on notions of sustainability and hyper-locality well-understood within the food world but elevates them to heights with little to no precedent. There's no sleight of hand. Executing these moments relies on a consistently monumental personal effort, as every component of every dish derives from the tireless efforts of Branch and Ortiz-Concha—from the foraged rose hips, pine shoots, cactus fruit, and clover to the meat harvested annually from their own Criollo cows. They've even employed friends to make wooden spoons from invasive species and commissioned bespoke silverware from a local knife

maker. With time and effort, the duo looks back to move forward, and in the process, manifests a new standard of modern and holistic living.

Before their partnership hit its stride, Branch and Ortiz-Concha connected quickly and deeply in 2019, two years into launching their respective projects, thanks to a shared commitment to the same corner of the earth. Friendship blossomed into love and in 2020, they moved in together. They purchased their house the very next week. The torrid pace that underscores their lust for life hasn't waned, and the centuries-old structure has become home to many things. It is a nursery and playground for their first child, Flora Inés, who was born within its very walls in 2023. It is a warehouse for Branch, who carefully curates the objects—from rings and necklaces to books and blankets—that she sells on her platform. It is a studio for Ortiz-Concha, who hand-shapes and fires ceramics that are made from the area's micaceous clay and ultimately grace

the tables of his monthly dinners. It is where the couple raises their Jersey cow, Dolores, whose milk is transformed into butter and ice cream, as well as their seven dogs, three cats, two semidomesticated sheep, and a flock of chickens.

The heritage home, like many in their village of Vallecitos, is composed of adobe bricks formed from the very earth where it stands. Its interiors are no different. Branch and Ortiz-Concha's aesthetics are a direct reflection of their specific setting, the place that has molded them over the course of their lives. They decorate with woven baskets, which they fill with the heirloom bean and corn varieties grown in their backyard, or racks of antlers from fall hunts. Every room's function is essential to the overall domestic ecosystem. The kitchen, with its curved wall and wide windows that survey the property, is a focal point of the structure. It's where the couple starts their days with butter coffee and ends them with thoughtful meals and where they store jars of cactus fruit juice, apple cider, and dried berries. The living room is the home's heat center—with a historic kiva fireplace as well as a newer metal furnace—and where the family projects movies onto the wall. A windowed corridor along the entire southern facade acts as a drying room for foraged tea, plums, and beans, and Ortiz-Concha's ceramics studio. It is at once functional and beautiful, ancient and contemporary, chaotic and serene. It is the nexus of their incomparable world.

With home life and work life so intrinsically intertwined, the duo relies on a steady execution of routines, but ones that change from day to day. They care for their livestock, bale hay, forage for local ingredients, mud plaster walls, dye wool from their sheep, press apples to create cider, build fences, and turn local lumber into furniture. "Every day with Johnny is like a magic carpet ride," Branch says. "It's always an adventure." There is one routine, however, that remains set in stone and punctuates each day—sitting down for a simple, shaken mezcal margarita with a Redmond salt rim.

Each month, Ortiz-Concha invites diners around the table for his take on New Mexican cuisine. The *biscochito*, for example, is the official state cookie, traditionally spiced with anise or fennel seed and citrus zest and topped with cinnamon sugar. Ortiz-Concha puts his own spin on the recipe by swapping cinnamon for microplaned oshá root. (6)

7

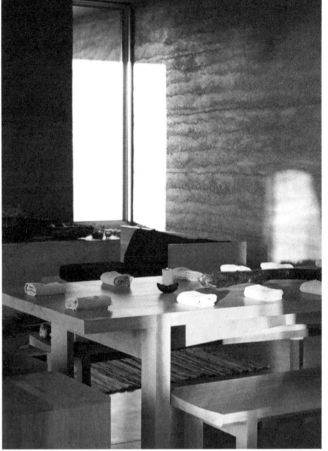

6

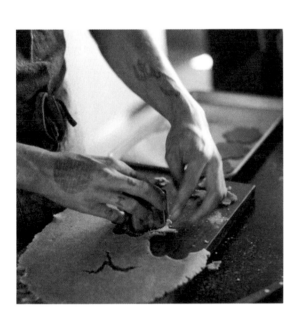

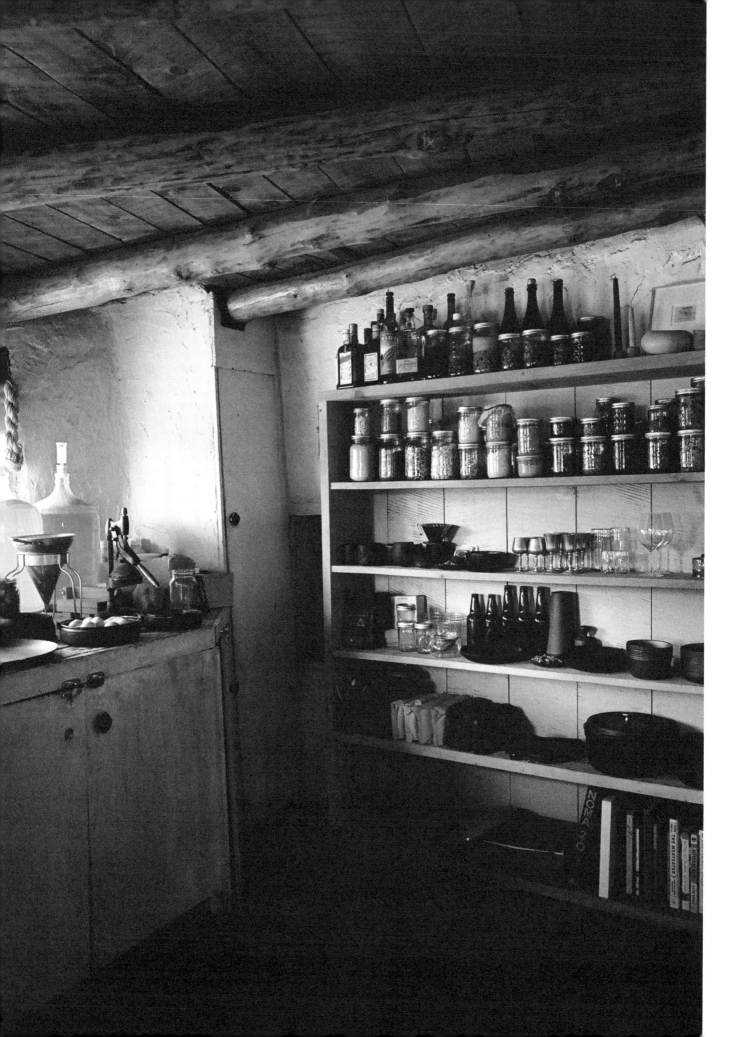

8

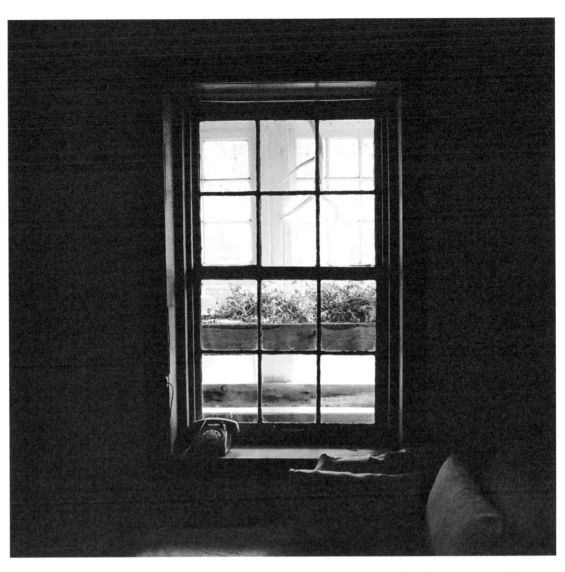

9

Layers of light: the sitting-room window
looks out onto the covered patio turned
sun-drying station and studio. (9)

The kitchen is often considered the heart of
the home, and it is especially so in the case of
Branch and Ortiz-Concha. It serves as a place for
gathering, sharing, and experimenting. Handcrafted
mezcals, low-intervention wines, and bowls of
freshly laid eggs from the chickens, plus objects
like a colander, a juicer, and beloved cups, might
be consumable or functional but are ornaments in
their own right. (8)

Rituals also have their seasonal specificity. The couple
starts a fire first thing in the morning in the winter. In the fall,
they hunt a deer or elk to be frozen and used throughout the
year. Come springtime, when the snow melts and the ground
softens, they harvest clay. Ortiz-Concha thinks back on
childhood outings where he and his mother gathered clippings
from the cota plant for tea. "She taught me to always say thank
you," he recalls. "That's something that I still do with my
photography practice. I say 'thank you' by documenting the
beauty in everything that I see."

And the desert crawls with beauty when you stop to look around. "I used to travel all over New Mexico to pick stuff," says Ortiz-Concha. "I picked wild oregano near Eagle Nest, plums in the pueblo, and piñon in Carson." After living in and being intimate with their land for so long, they came to realize that these same species also thrive in the very soils around them. Gradually, they have set their routines to their own tempo and synthesized their practices into a smaller radius.

"Desert plants are harder to get to and tend to produce less," says Ortiz-Concha. "But they're so much sweeter because they have to fight to survive, and it feels like the people here are kind of like that, too." The pair frequently returns to the notion that much of modern life is focused around always being as comfortable as possible—but comfort, as they see it, stands in direct contrast to nature. "It's okay to be a little bit cold in the winter," says Branch. "Experiencing discomfort is part of existing in the natural world—it's where growth happens." There

is also an inherent joy in the work it takes to get warm, to cozy up with blankets or sit next to the wood-burning stove.

Living with nature is to experience the cycles of life. "We see things die, of course, but we also get to see how so much lives despite challenging circumstances," says Branch. "Watching Dolores have her calves honestly helped me to have Flora the way that I did, here at home." For Branch, tapping into the life forces that exist all around has been a journey of self-affirmation.

With everything that they do, from revitalizing little-known cooking techniques to restoring abandoned buildings and firing clay ceramics with cedar wood on full-moon nights, Branch and Ortiz-Concha expand on the work of their ancestors and communities at every turn. "To simply preserve something is also to kill it," says Ortiz-Concha. "We aren't focused on preservation. We are focused on keeping culture alive and evolving." With a growing umbrella of influence in Vallecitos—they

Branch and Ortiz-Concha are renovating the adobe house on the neighboring property, which will become a permanent base for /shed. "It's a challenge to bring attention to a place that still feels very cultural," Ortiz-Concha admits, "that is tight-knit and where a lot of feeling exists." In an effort to familiarize with the longstanding community and take the right steps forward, the pair approaches any transformation slowly and with great care. (11)

10

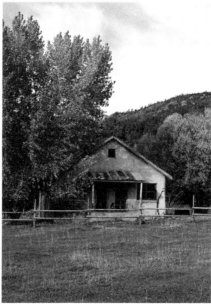

11

have acquired several buildings in addition to their home, including the former community center and some houses across the street—they want /shed and their other projects to bring life to the town without affecting the natural order of things too quickly.

Part of that process is listening to and learning from the town elders and established methodologies, explains Ortiz-Concha. "Unlike in Santa Fe where most of the vernacular architecture is becoming fake—stucco with some brown tint in it," he continues, "we still work with endemic materials." As the world becomes increasingly homogenized, the duo continues to understand that their culture is one that has been cultivated over generations. "We don't have many friends who live in the place that they are from anymore," says Branch. "We feel a huge responsibility to continue the traditions and not be the last ones standing." They liken the diffusion of customs to a relay race. When an elder passes, he or she hands off the baton. Branch and Ortiz-Concha are always at the ready to run with it or to encourage others to do the same.

Spending time with Branch and Ortiz-Concha may leave a visitor with a powerful urge to build, create, collaborate, and take action, no matter how small, to make the world a better place. The couple's air of humility and profound pride in what they do is part of what makes their approach to life truly contagious, for those wise enough to pay attention.

Ortiz-Concha says that being an Aries and born in the year of the ram, he is perpetually climbing a mountain, "not worrying about what is on the other side, just in a rush to get to the top." When one goal is accomplished, something else gets added to the mix.

12

13

As summer fades and the leaves begin to change, the couple relishes in time spent picking and processing apples, and the dairy cows, who get their fair share of cast-offs, don't mind it either. "It marks a break from hot days spent on hay and fencing, among many other things, into cool ones, shaking trees like bears and drinking thick, golden apple nectar with friends," Ortiz-Concha writes on his website. "It is always a reminder of the abundance around us." (10, 13)

In the village of Vallecitos, every day is a celebration of motherhood. With Flora Inés in tow, Branch corrals their Jersey cow, Dolores, into the milking barn, always ensuring that she leaves plenty of leftovers for the calf. (12)

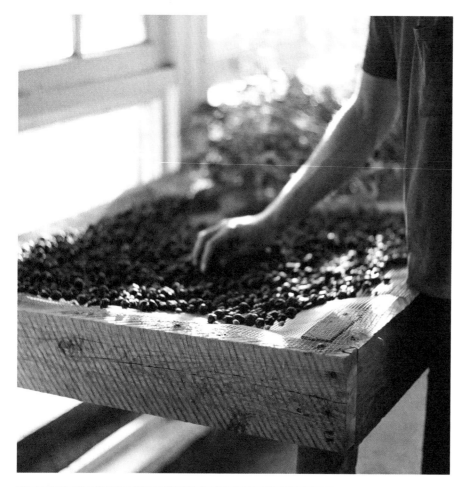

The window-clad, narrow room on the adobe home's sun-soaked southern face represents a cross-section of Branch and Ortiz-Concha's varied endeavors. Plums, native hops, and fetid marigold dry, firewood lies stacked, and tools wait to be called to duty, unifying into an organized yet raw wabi-sabi display. (14, 15, 16)

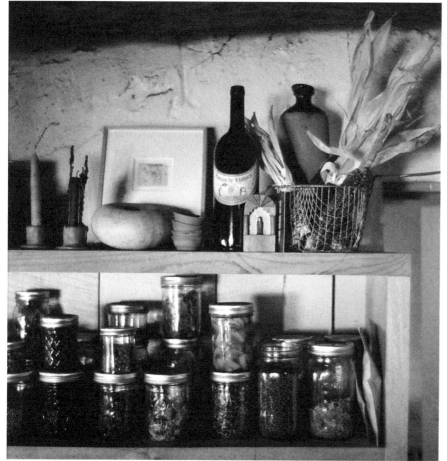

16

Heirloom beans, corn, and rose hips make it from the drying table into the kitchen, which doubles as an in-home laboratory where glass jugs of various ferments and mason jars full of preserves dot the shelves and countertops. (16)

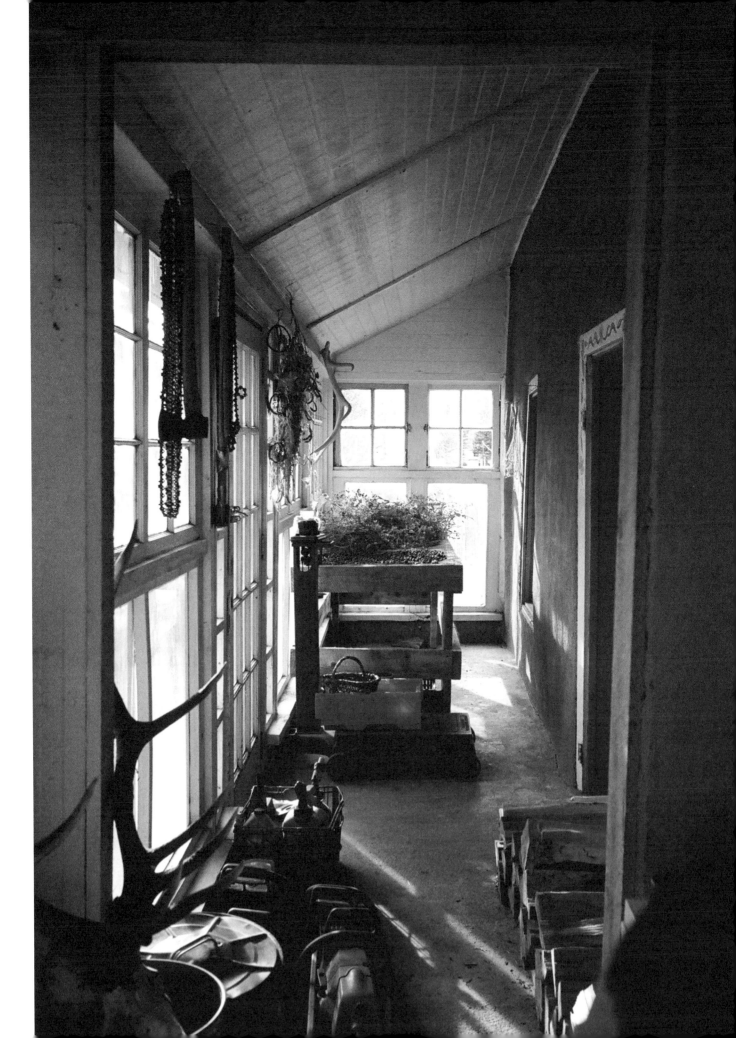

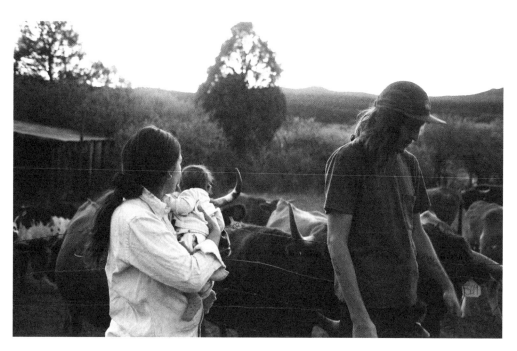

17

The couple connects with the Earth in a
multitude of ways, whether growing and
planting a garden or mixing mud, straw, and
water to form adobe bricks in the backyard
workshop. (19, 21)

18

19

Always mindful of the present moment, Branch
and Ortiz-Concha try to live in the "now."
Yet, with Flora Inés on the scene, they have
become more cognizant of the future. "We're
starting to talk about the long term," Branch
says. "How are we setting this up so it can be
around for Flora's generation?" (17, 18, 20)

21

20

His highest priorities currently lie on his property. He hopes to finish
out the ranch house for future /shed dinners and the other structures for
accommodation. He and Branch are striving for more to be visible on the
surface, so that guests can simply experience without the need for constant
explanation. "We want people to be able to see for themselves the cows, the
corn in the garden, the kombucha on the shelves," says Ortiz-Concha, "and
the beauty of this rural environment we call home."

People view magic as something that is almost unattainable or that
happens once in a blue moon or only for a lucky few. But magic, as Ortiz-
Concha says, is all around—"in the flowers blooming, in having a child, it's
everywhere you look."

ON CACTUS FRUIT

by Johnny Ortiz-Concha

I come from a people who have been born and raised in the high desert of northern New Mexico for generations. I didn't know it when I started, but I would later realize that my cooking is more a practice of learning and sharing *mi tierra*, or my terrain, and those who have come from it than one of simply preparing food. The foodways of my ancestors are at great risk of becoming distant memories. The stories, told in whispers, are still to be heard from *viejos* and *viejas*—old ones—recalling what their parents and grandparents used to do. Ask any elder from where we live about cactus fruit, and they may recount childhood tales of picking them with their bare hands, whacking the spikes off with sagebrush and sucking out the sweet juices.

I know I'll never be able to acquire all of the knowledge that has been lost to time, but I do know that a plethora of such knowledge is still to be found. Learning to use the native plants, like the beloved cactus fruit, of *mi tierra* is about remembering.

Every species of cactus blossoms in the spring, and in ideal conditions, the flowers are pollinated and begin to bear fruit. Each fruit is unique to the type of cactus, even to its specific terroir. The variety that we pick the most often, though easily mistaken for prickly pear, is rather the fruit from a similar endemic variety, one that grows in the high desert alongside piñon and juniper trees and tastes more of watermelon.

At a quick glance, the desert may seem like a barren place, but upon a closer look, peering behind pads of sharp needles and glochids are bright red little fruits full of sweet nectar, ripened by the harsh heat and minimal rainfall. In the desert, abundance takes on a different meaning. It is unsuspecting, hidden, covered in spikes, and full of seeds. It is in rattlesnake territory or laced along steep rocky cliffs. On this survivalist plant, the fruit is equally as rewarding as the paddles are threatening. Those willing to seek such abundance, who sacrifice a little time and risk getting a bit poked, will be rewarded by flavors and nutrients unlike anything that can be bought. The process is part of the magic.

Ortiz-Concha pushes the pulp through a vintage canning colander, moving one step closer to pure, delicious juice and eventually, a granita.

Cactus fruit is harvested in late summer
and early fall, when it is bright in color
and breaks off easily.

TO HARVEST

(a) Watch where you step.

(b) Pick as late in the season as possible,
usually around the first cold spells. This will
yield the ripest fruit. Just be sure you don't
wait too long, or the coyotes and birds will
beat you to them.

(c) Use long tongs and gather into a hard-sided
container so that the glochids and spines won't
find you later.

TO PROCESS

(a) Fill a pot with the fresh-picked fruit and
top with cold water just to cover.

(b) Bring the pot to a light simmer (around
200°F / 90°C) and turn off the heat.

(c) Let cool for a few minutes before adding all
of the fruit into a conical colander with a bowl
underneath. Begin smashing.

(d) Strain the juice through a fine-mesh sieve
into mason jars. Keep fresh in your fridge for
a few days or freeze if storing for later use.

TO CONSUME

It is my belief that some things are best
enjoyed in their most natural state. The juice
from the cactus fruit is one of those things. It
is great by itself or mixed with your favorite
spirit—Maida and I tend toward mezcal. We also
love to make a granita out of it because the
juice typically contains just enough natural
sugars to form the perfect ice crystals.

Here's how:

(a) Fill a shallow metal vessel with the juice,
either fresh or frozen and thawed. Wrap or cover
and place in the freezer.

(b) Once frozen, scrape with a fork to break up
the ice crystals until you are left with a fine,
snow-like texture.

(c) Serve, enjoy, and note that any leftovers
can be thawed out again and refrozen.

.

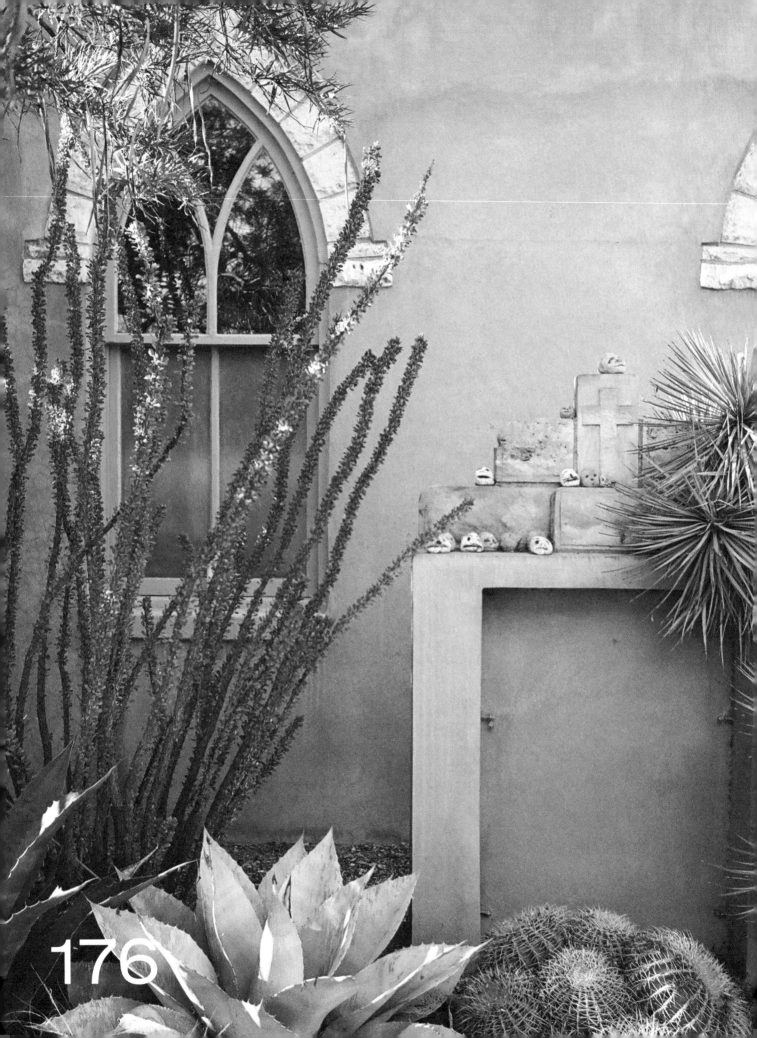

CAMPBELL BOSWORTH

&

Marfa, Texas

BUCK JOHNSTON

United States

IN A MINIMALIST TOWN, AN ISLAND OF MAXIMALISM

Marfa's first church, an adobe construction built in 1886, is holy in more ways than one. From the rectory, with its plant-covered, pink-painted exterior, two of the Texas town's most glorified souls have forged a universe all their own. They aren't ministers or priests. One is a visionary woodworker and artist and the other a graphic designer and shopkeeper, and together, they preach high-desert happiness. "I love this place. I love our home," Campbell Bosworth says. He's got hearts in his eyes and a glass of mezcal in his hand. "I have my dream studio and my dream life. I am truly content." Buck Johnston is quick to affirm: "Our quality of life is just incredible. We don't have to go anywhere. Here, people come to us. We always say, 'We moved to Marfa, and our world expanded.'"

When Bosworth and Johnston met in Dallas, they had no intent of decamping to the outpost of ranchers, border patrol agents, and creatives eight hours across I-20 and down US-67. Both were in relationships, and it took them nearly a year to muster up the courage to leave their partners and test the waters with each other. Their urban environment suited them fine, it seemed. Then, three months later in May of 2001, they set off on a road trip through Texas. Everything snowballed—or rather, rolled like a tumbleweed in the West Texas winds—from there.

They started at the Art Car Parade in Houston and meandered to Big Bend National Park and Chinati Hot Springs in South Presidio County. Finally, they arrived in Marfa. "By that point, we had already fallen in love with the landscape," Bosworth recalls. It was a Friday night, and when they woke up on Saturday morning, they glanced at one another and said, "Let's look at property." They visited the sites of two adobe ruins before a realtor showed them the church. "Camp walked in and went, 'We'll take

"I mean, it's insane," Johnston says of their omnipresent arsenal of books. From the bathroom to the bedroom, office, and living room, heaps of their amassed volumes---large-format tomes on Mexican history and Dolly Parton, an anthology on the Marfa mystery lights, and quirky novels from the Japanese writer Sayaka Murata---take root in unsuspecting corners, like a bench beneath a tumbleweed lamp. (1)

The duo tries to collect at least one work from every exhibition they put on. "We have to walk away from any show with at least a piece of paper," Johnston says. New acquisitions--- like the caricature-esque painting by Edward Emery, which depicts the couple with their canine companions, Chapo, E-Z, and Peyote, on one of their daily walks---frequently take up residence atop Bosworth's boombox-shaped chest of drawers before finding more permanent homes. (2)

Bosworth's carvings in concrete line the
gabion wall, a steel cage packed with
teal slag glass, which creates a backyard
sanctuary separate from neighbors and
passers-by. (4)

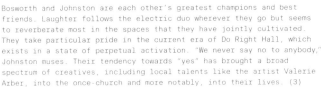

Bosworth and Johnston are each other's greatest champions and best
friends. Laughter follows the electric duo wherever they go but seems
to reverberate most in the spaces that they have jointly cultivated.
They take particular pride in the current era of Do Right Hall, which
exists in a state of perpetual activation. "We never say no to anybody,"
Johnston muses. Their tendency towards "yes" has brought a broad
spectrum of creatives, including local talents like the artist Valerie
Arber, into the once-church and more notably, into their lives. (3)

it,'" laughs Johnston. "We didn't even know the house was included in the sale!" The duo signed
the papers. There were no cell phones to speak of, so no one could talk them out of their spur-of-
the-moment real estate purchase. Bosworth and Johnston held hands on the drive home. "I looked
at him and thought, 'What have I done?!'" Back in Dallas, word spread like wildfire: "Camp and
Buck *just* started dating, and now they're moving to Marfa." Once the initial shock wore off and
people—Bosworth and Johnston included—realized that their acquisition wasn't merely a bit of
banter, twelve friends helped them pack up four cars and two U-Haul trucks, one filled entirely
with Bosworth's tools and wood from the shop, and escorted them to their new digs.

Walking through their front door and under the "Hooray for our Hovel" sign etched into
the frame of the rectory turned private home is like entering a portal. "I was trying to make
things minimal," Bosworth explains of their initial arrival to the Donald Judd–influenced town.
"Buck was like, 'We are *not* minimal people!'" And it's true—now self-described maximalists,
they are anything but. Hand-painted Mexican candelabras rest atop the mantel of the fireplace
Bosworth erected from scratch where a doorway between the living room and office used to be.
A giant hand in Appalachian basswood, also of Bosworth's design, takes the place of a typical
toilet-paper holder. His portraits, all characters with a distinctly Western spirit, which hang in
a collage-style arrangement, complement the square mosaic tiling in red, gray, pink, and the
occasional green or blue.

After moving to Marfa, Bosworth and Johnston embarked on a three-year renovation journey to transform the rectory into a mud-brick paradise of their own making. "We moved windows and added French doors in the bedroom," Bosworth says. "Everyone thought that we were crazy." Nevertheless, Jesusita Jimenez, a mason based in the nearby border town of Presidio, and her team tackled the adobe work, which included creating an archway to divide the sitting area and kitchen. (5)

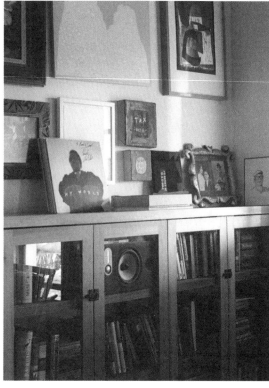

5

6

7

Numerous walls in the living and dining spaces are painted chartreuse green—one of Johnston's favorite hues—with a thick silver strip at the base to prevent discoloration from their pack of dogs that rub up against the surface. Enameled metal cabinets repurposed from the church and coated in a range of pinks complement the kitchen's vibrant, floral-patterned wallpaper. Flattened wooden figurines of cowboys and lucha libre wrestlers keep a watchful eye from the back of the vintage Chambers stove in "freedom red." When Bosworth and Johnston arrived in Marfa, neither could cook. "I don't even know if I could boil water," Johnston recalls. Twenty-plus years later, she roasts goose with a cherry glaze and whips up chilled avocado soup or chicken tacos with charred vegetables and indigenous varieties of beans like it's nothing.

Bosworth and Johnston's can-do attitude makes any task appear possible. "I think our biggest strength is that we can see things," Johnston says. "We have vision." Occasionally, that manifests quite literally. Early into their time in the rectory, the pair lay down for bed when Bosworth suddenly had an epiphany. "This is an old house. I bet it has high ceilings," he shrugged. He got a ladder and punched through the popcorn-textured surface to reveal original beadboard. Other times, their perceptiveness is more speculative. When a local businesswoman suggested the duo take over an empty storefront in 2010, they envisioned selling little more than Bosworth's excess work. "Why not?" they thought. His drawings, cheeseboards, candleholders, and

Every piece that hangs on the living room wall tells a story. Take the photograph of the couple riding a tandem bike, a silly, euphoric moment that was snapped after Bosworth made a big sale in San Antonio. (6)

Bosworth and Johnston keep their sliding doors ajar throughout the night, cooling their interiors with fresh air in the spring, summer, and fall before temperatures dip below freezing in the winter. In the morning, light trickles into the dining room and animates an accumulation of indoor plants. As the pair has learned, living successfully in the desert requires a masterful balance between creating boundaries with the natural world and letting it in. (7)

An ever-changing cornucopia of visual
delights, the back wall of Wrong provides
a platform for rotating shows. In front,
Johnston—the store and gallery's indisputable
soul—sells prints from Jason Archer and Eva
Claycomb, glassware and T-shirts emblazoned
with the Wrong logo, humorous books, hand-
crafted jewelry, and Bosworth's wooden cake
slices, corndogs, and tacos. (8)

"There are times when not being a practical
person has its benefits," Johnston says of
the 107 glass prisms brought back from Italy
and fashioned into an eccentric chandelier.
The graphic designer and curator pours her
heart into every square inch of the shop and
can be found behind its counter most days
of the year. (9)

8 9

door handles were a smash success, and soon enough, Bosworth started producing pieces—wood-carved and hand-painted stacks of drug money, slices of cake, and sprinkled donuts—specifically for the shop. They named it Wrong, and it took off in full force when they relocated the shop to the church. They had renovated the once-brown space—brown altar, brown floor, faux wood paneling—into a bright white volume bathed in natural light from the south-facing lancet window. Bosworth crafted a table with zig-zag edges and bulky legs in the shape of fists as its centerpiece. "We started expanding to other artists," Johnston says. "It was very organic." In 2018, *Architectural Digest* named them "The Most Beautiful Independent Store" in Texas, but shortly thereafter, they set their sights on something else.

The one-story corner building with plentiful windows that long housed the regional newspaper on the city's main drag became available, and the owners were willing to give Bosworth and Johnston carte blanche. "I asked so many questions: Can we paint

A giant wooden skull covered in gold leaf, which Bosworth made for his 2014 show El Otro Lado at the The Old Jail Art Center in Albany, Texas, now presides over the studio. With its intricate shape and carvings, he likens crafting the piece to having solved a Rubik's Cube. (10)

"I'm in here every single day," Bosworth says of his beloved, light-filled studio a few paces from home. After many hours hard at work, flecked with paint and sawdust, he strolls into the kitchen for a tequila, sipped from a volcano-shaped cup of his own design. (11)

the floors? Can we knock out a wall? How about twelve? Can we redo the kitchen?" Johnston recalls. She received all the yeses that she needed, and the downtown iteration of Wrong was born, with its signature pink floors and show-stopping, asterisk-shaped table for displaying wares. Martha Stewart popped in during the grand opening and signed copies of Snoop Dogg's cookbook, *From Crook to Cook*, for which she had written the foreword. In other words, their vision paid off.

They transformed the church into Do Right Hall, a venue for rotating exhibitions, events, and, most importantly, other artists, who they often host in the casita at its back. Bosworth's studio occupies a large extension built from concrete block in the 1960s, which the couple refers to as the "Fellowship Hall." Light floods in through large church windows and skylights, and the rear doors conveniently connect directly to their house's yard. Bosworth can amble over at any time of day or night to realize an idea and further develop his practice. Inspired by folk art and the likes of Frank Stella and Kenny Sharf, he imbues everything he does with a sense of humor. As a child, Bosworth made swords and toy guitars to entertain his brothers. Now he makes enormous boomboxes and colossal revolvers that hide full-sized cocktail bars replete with glassware and tequila storage. Living on the border and learning about its complex politics, he found influence in *narcocorridos,* or the ballads that tell stories of the drug trade. He thought, "What would a drug lord have in his house?" His elaborate golden gun bars were his answer.

The studio teems with saws and planers, cans of paint, and, of course, wood. Partially carved Dairy Queen ice cream cones, a huge gilded skull, and an oversized telephone rest alongside scrap pieces or hunks of logs awaiting a makeover. "I couldn't afford this space anywhere else," Bosworth acknowledges. "I am able to wake up and be an artist." Johnston says the same of the shop. "If we were in New York or Los Angeles," she explains, "we would be struggling to pay our bills." Here, they have it all, including the culture that often goes hand in hand with sophisticated urban centers. Thanks to Judd and the many creative minds that moved to the rural hamlet in his wake, Marfa is home to an eclectic mix of enterprising individuals. "But it's great because you don't just hang out with your peers," Johnston says. "Because of the size, you develop relationships with people from different generations and backgrounds." They count beekeepers, contractors, and historians as some of their closest companions. Marfa, which boasts happenings from live music shows to art openings, educational talks, film screenings, and dance performances, also receives a steady stream of visitors from around the globe. "We have great friends here," says Bosworth, "*and* we have great friends who visit all the time."

Most nights, Bosworth and Johnston are throwing a dinner party, attending one, or heading to some kind of enriching event. "You can be anywhere in three to five minutes," Johnston says. "Taking away the driving or getting there aspect creates a really beautiful thing." Bosworth nods. "You end up doing a lot that you wouldn't do elsewhere," he adds. But they have their personal rituals, too. Every morning and evening, they head to the edge of town and walk down the dusty dirt roads along the creosote-lined train tracks with their canine sidekicks. On Sundays, they play reggae and devour a dish that they have dubbed "Bob Marley Eggs": tostadas topped with a

Late nights at Bosworth and Johnston's frequently culminate in dishwashing parties. With the Bee Gees or Beyoncé blaring over the speakers, the hosts groove, scrub, and rinse while willing guests dance, dry, and return dishes to the cabinets, powder-coated in five different pinks by Marfa multihyphenate Cody Barber. (12)

Bosworth devises custom pieces—like a hulking, hand-shaped toilet-paper holder—for the house with regularity, further transforming the space into a physical manifestation of his creative mind. He draws inspiration from artists including Alexander Calder and Wharton Esherick, who seamlessly incorporated their practices into their home lives. (13)

scramble, beans, pico de gallo, cheese, and other fixings. Then, in January, they trade one desert town for another, heading to a seaside village in Sonora, Mexico, where giant Cardon cacti and fresh clams converge. They turn off, cook out, and bury themselves in stacks and stacks of books.

Johnston and Bosworth are insatiable readers. Some surreal novel, brainy work of nonfiction, or a magazine like *Harper's* is always bedside or next to the toilet below the humongous hand. Books are displayed in the living room, and boxes overflowing with them—some of which date to their years in Dallas—take root in the office and church storage. The pair doesn't get rid of any titles until the house becomes overwhelmed, at which point they spread everything across the floor. For a work to land in the donation pile, consensus is mandatory. It's not always only about them either. "We often think, 'Someone else *needs* to read this,'" Johnston says, and they wait until the right person comes along. It's not infrequent that visitors leave their home with a treasured literary gift.

The couple fervently stockpiles more than books. They return from all of their trips with one-of-a-kind jewels like a cast-iron mortar and pestle found in Toronto or a cerulean octopus-shaped salt dish from Puglia. "It's always something absurdly heavy," Bosworth grins. They collect art—Bosworth's, of course, but also pieces from shows at Wrong or the many dear friends that have turned into family over the years. There is always space somewhere.

Now, it's Easter Sunday and Bosworth and Johnston are hosting their annual potluck. Mimosas and coffee—perhaps with a little tequila for festive measure—line the narrow island, and the dining table has barely enough space for all of the homemade quiches, salads, breads, and cakes. Friends spread out across the backyard. People eat on wedding china at the picnic table under the retro umbrella from Marfa's original Thunderbird Motel or atop the diving board that leads to no pool. Bosworth and Johnston are dressed to the nines in their own trademark ways. He wears effortlessly cool paint-splattered clothes and a hawker cap with "Wrong" imprinted across the top. She dons blue stripes and striking lipstick. "So many people email me or call to ask for lipstick recommendations," she giggles. "A blue matte red—always!" Holidays here are an all-day kind of affair. As evening sets in, Johnston lights candles in Carla Fernández holders from Michoacán but purchased at San Francisco's Heath Ceramics. They are hand-painted and shaped like dogs, but a multicolored avalanche of wax has doubled their size. Jazzy jams from India shift to poppy dance hits from an Irish producer. A portable party light projector turns the kitchen into a miniature disco club. Someone slathers toasted bread with mayonnaise and tops it with leftover Easter ham, delivering late-night snacks to the dancing cohort. Bosworth and Johnston clink glasses and look at each other with a knowing smile. They have everything they need and then some. *This* is happy.

13

14

Bosworth and Johnston scored their cherished Chambers stove at a secondhand market in Terrell, Texas, for a mere 150 dollars and promptly hauled it to a restorer in Oklahoma City. "The minute he saw it," Johnston recalls of the machinist, "he was like, 'I'll give you two thousand dollars cash.'" But there was no way they were giving up such a rare find that easily, and it has since become a staple of their Marfa existence. (14)

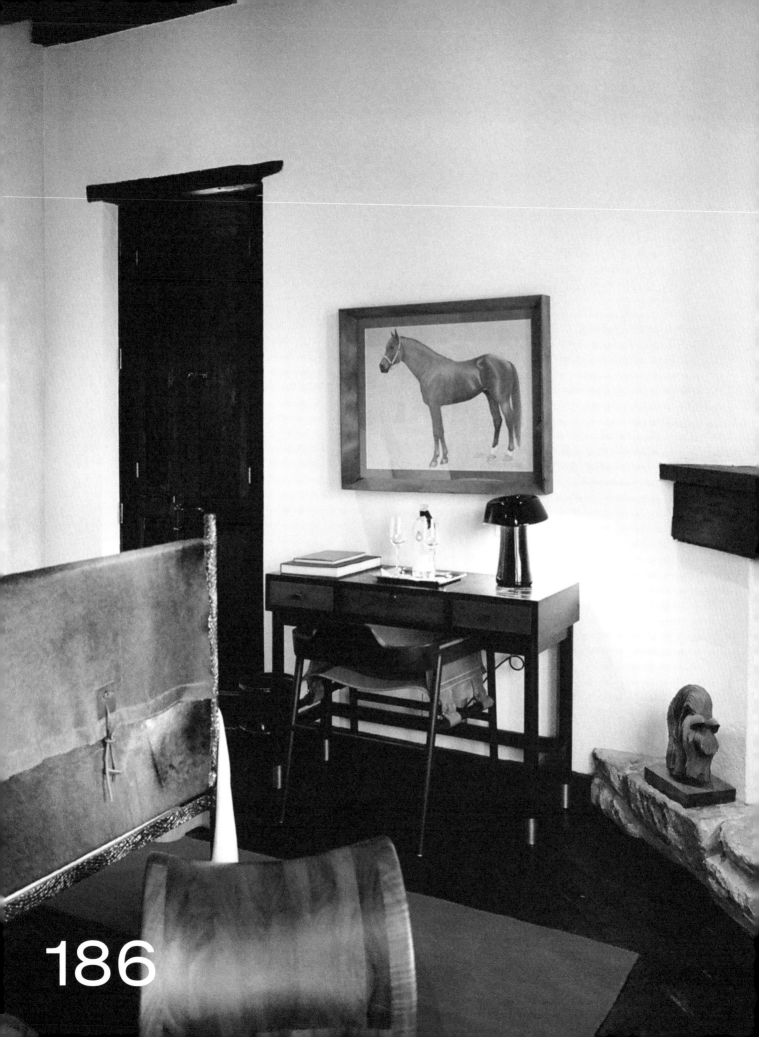

186

San Miguel de Allende

BERTHA

Guanajuato

GONZÁLEZ
NIEVES

Mexico

A DISTILLATION OF MEXICAN SPIRIT AND BAJÍO SOUL

There are the celebrities—like George Clooney, Kendall Jenner, LeBron James, and Dwayne "The Rock" Johnson—who slap their names on bottles of tequila. There are the *maestro tequileros,* the distillers who masterfully transform the agave, a plant that takes eight to ten years to mature, into the much-beloved Mexican spirit. And then, there is Bertha González Nieves. The *maestra tequilera*—Mexico's first official female tequila master—is something of a celebrity in her own right. The founder of Casa Dragones, a company that produces the very elixir, she co-hosts events with Martha Stewart, clinks glasses with Oprah Winfrey and Quincy Jones, and throws dinner parties with chefs like Elena Reygadas and Daniela Soto-Innes. Recently, while on vacation in Switzerland, she logged onto a video call in the middle of the night. One powerhouse couple—comprised of VIPs who cannot be named but are bona fide cultural icons—was visiting

the tasting room, and she wasn't going to miss the opportunity to share a toast.

Now, González Nieves is tucked into the dining room, a stone-walled alcove that opens directly onto the patio of a once private guest home transformed into a base for her business and a physical manifestation of its values. Vintage tools from agave fields, a nod to the hard labor that goes into producing one of modern day's most fashionable liquors, hang behind her. Sitting at a large copper-clad table, she holds a hand-engraved Riedel glass —it looks like a champagne flute but is designated specifically for tequila—and looks out on the house where Casa Dragones was born.

It was 2007, and the compound, which features three stand-alone buildings around a courtyard, belonged to MTV founder Bob Pittman. The media mogul had a penchant for Mexico, hence the house in the high desert town of San Miguel de Allende,

1

A William Spratling chair and an antique saddle add warmth to the entry of the tequila-filled cellar. (1)

"This is a real place of reunion," González Nieves
says of the house and the many tastings, cocktail hours,
dinners, and all-out parties hosted within its walls.
Some of her fondest memories were made in the intimate
dining room, but she, her partner Wells, and their design
team infuse every corner with love so that even the most
mundane tasks, like grabbing a bottle or moving between
rooms, prove unforgettable. "Our tequila storage and
even the stairs are just so special," she explains. (2)

2

and had taken to buying bootleg tequila. He referred
to it as "smooth moonshine," which in drastic
departure to the tequilas then on the shelves, could
be sipped straight. A business idea quietly brewed in
his mind, but he didn't take it too seriously—that is,
until he stumbled into González Nieves at a friend's
anniversary party in Brooklyn. At the time, she
was a director at one of the world's largest tequila
companies, and though the two were drinking bubbly,
the conversation quickly turned to the luscious liquid.
Things snowballed from there. Pittman, González
Nieves, and her partner, Mishele Wells, convened
at his San Miguel outpost and spent three weeks
brainstorming ideas. Two years later, they drove from
Jalisco with their first release, some of which had
been bottled just the night before, and launched Casa
Dragones with a party—the first of many—in the
complex's walls.

　　Their tequila was different. It wasn't meant
to be downed with salt and chased with lime or
blended into some slushy, too-sweet version of a
margarita (though they now produce a crisp blanco
variation, which can be used in delicately crafted,
spirit-forward cocktails). It was intended to be served
neat, or over ice. A bottle of Joven, their small-batch
blend of silver and extra-aged tequila that rests in
new oak barrels, retailed at 275 dollars. "We were
rebellious," says González Nieves. "We wanted to
push the conversation around tequila production
and consumption forward. We wanted people to see
Mexico through its craft in the same way that they
see Spain or Italy or France."

　　As it turns out, the house where Pittman and
González Nieves conspired is steeped in rebellion,
too. It contains walls that date back to 1671 and once
served as the stables for Dragones de la Reina, the
cavalry led by Ignacio Allende, the army captain who
helped spark Mexico's independence movement
in the early nineteenth century. "This is a place of
unsung heroes," González Nieves says. "They died

3

Ancient meets modern: Gold fixtures and a shower curtain in
an Alexander Girard–inspired fabric pair with the stone-
clad bathtub in the downstairs guest quarters referred to
as the Caballeriza room. (3)

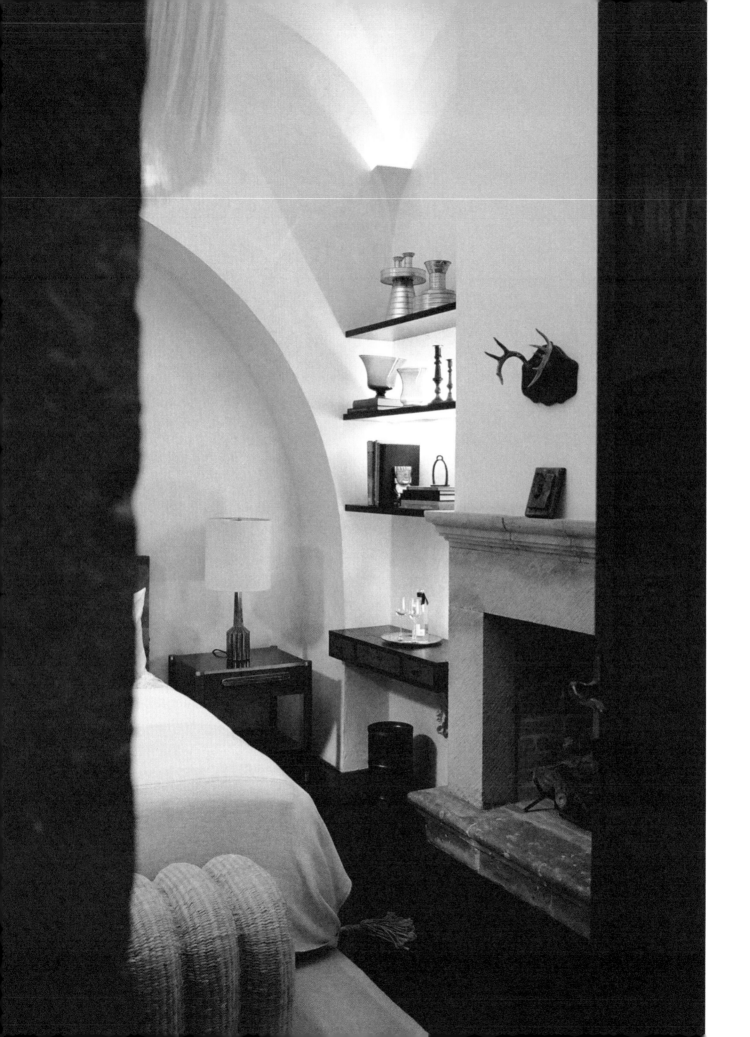

Each of the four bedrooms has a name—
Aldama, Allende, Caballeriza, and
Cuartel—that carries historical or
social significance. With the designers
Cabra and Mallet, González Nieves
homed in on furniture and decor that
tells the story of the house, the
region, and the country. (4)

very early on in the war. But if it weren't for their vision and courage, I don't know that our history would be the same." She may not be fighting for sovereignty, but she is fighting for her country to be viewed with respect. "I think I have always been in love with Mexico," the tequila connoisseur, who was born and raised in its capital, continues. "Showcasing its craftsmanship, its professionalism, the gifts it has to give has become my life's work."

González Nieves pushes her chocolate brown hair behind her shoulders. Her dark eyes read serious, but she has a smile that lights up the room. She swirls her tequila like a fine wine. As it reaches her lips, she inhales deeply, taking in the subtle aromas of burnt sugar and citrus. González Nieves has been drinking tequila since her youth. Every Monday, her maternal grandmother hosted long, vibrant family lunches, which would always begin with a serving of Herradura Blanco. At thirteen, she finally convinced her elders to let her have a small portion of her own. "It completely captivated me," she recalls. "It was such an important ritual."

Here, González Nieves, much like her grandmother, brings people together over the clear but powerful beverage. The house has always been the spiritual heart of Casa Dragones—and where she and Wells stayed when they came to San Miguel. Technically speaking, the duo call New York and Mexico City home, but they spend almost as much time traveling between their production facilities in Jalisco and this small desert city nestled into the mountains of Guanajuato. "At some point, we thought, 'It's time to purchase this place,'" remembers González Nieves. "It's such a part of our roots." In 2018, their company formally took over.

5

The bedside in the upstairs Cuartel room
pays tribute to popular Mexican culture.
The table from the Cabra-led design
collective Oax-i-fornia is an homage to
the anafre, or portable stove. On it sits
a vase from the artist Fabien Cappello,
who collaborates with the few remaining
family workshops that specialize in tin
and galvanized metal to develop objects
that marry utilitarian function with high
design. Meanwhile, a lamp from Axoque
Studio in Morelia looks further back,
taking inspiration from zapandukua, or a
ball of woven cloth and twine used in the
Aztec game pelota purépecha. (5)

6

The more that González Nieves stayed on property, the more that she became completely enamored with it. Yet, she always felt that she wanted to share the intimate space with others, hosting everything from public tastings to private parties. "We produce something that people drink, that they literally put in their bodies," she says standing at the balcony of the primary bedroom that she has stayed in regularly over the years. "What's more personal than that?" (6)

The Aldama room honors raw materials, from husk and sisal to tzalam and mesquite wood, coyuchi cotton, and agave leaves. (7)

A small, three-seat rooftop bar offers vistas to the center of San Miguel. (8)

7

8

SIPPED, NOT SHOT

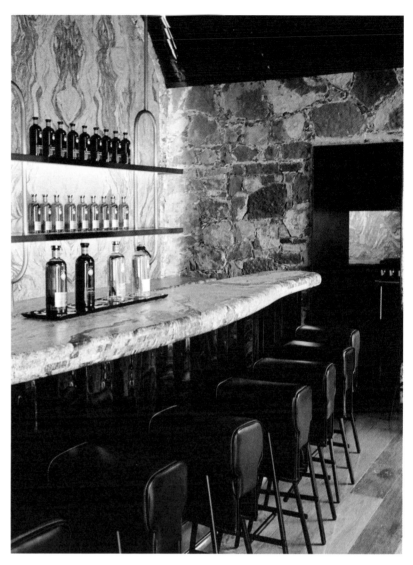

Sipping is not reserved for spirits like single malt Scotches, rare cognacs, or aged whiskeys. A thoughtfully produced tequila should be savored just the same. "Tequila has such sophistication," González Nieves explains. "For example, it holds space in a pairing dinner—and not just with Mexican cuisine—right alongside champagne and fine wines." Here, she imparts some wisdom to explore the liquor's complexities.

Choose your weapon—or in this case, your glass. Mr. Riedel came to Mexico and was amazed by the quality of the spirit but noticed that we had no stem glass to serve it from. He invited some of the top *maestro tequileros* to roundtables to determine the perfect solution. The end result may look like a champagne flute, but it's not—and it really does elevate the experience.

Consider subtle touches. For the añejo and the reposado, I recommend chilling the glass in advance or adding one small ice cube, which can open it up in a very nice way. I love to serve the blanco in an old-fashioned glass with a two-inch ice cube and a twist of grapefruit, which celebrates that beautiful, fresh citrus profile. I am otherwise a purist.

Examine the visual characteristics. Hold the glass up to the light, perhaps with a white napkin behind it, to observe the tequila's color and clarity. Swirl, and note the structure of the legs, an indicator of smoothness.

Smell the back of your hand, and then take in the tequila. The back of your hand brings you to a neutral place so that you can appreciate the aroma. It is a trick you can apply to wine and other spirits. In your mind, divide the opening of the glass into thirds: the lower part, which is closest to you, the middle, and the top. Start at the bottom and pause between each section to survey the distinct scents.

And finally—sip away. In a traditional tasting, we ready our palettes by starting with a neutral-grain spirit before moving onto the tequila. Either way, the first sip prepares us for the tastes that lie ahead. Slowly enjoy the second sip, its mouthfeel, flavor, and finish.

9

"Working on a house is a journey," González Nieves says. "You have to dedicate time to find the solutions. It's about patience." She knew that she wanted to introduce obsidian, revered by Aztecs for its powerful energy and health benefits, into the bar. The brittle stone cracks easily, but with determination, she and her close-knit team of designers managed to create distinctive iridescent tiles to complement the white granite countertops, brass accents, and timber floors. (9)

"You have to live in a space to renovate it," says González Nieves. "And we hadn't exactly lived in this one, but we had this profound personal connection and twelve years of experiences to go off. We had so many ideas." During the pandemic, they hired the local architect Marco Valle and Meyer Davis' Will Meyer—whose client roster includes Jenna Lyons, hospitality brands from the W to the Four Seasons, and retailers like Oscar de la Renta—from New York. For the interiors, they tapped Mexico's own Ana Elena Mallet and Raul Cabra, and they commissioned the artist and designer Héctor Esrawe to create a site-specific piece. The imposing, twenty-two-foot illuminated brass sculpture, which is suspended in the center of the winding staircase, draws inspiration from the unfinished twentieth-century frescoes of David Alfaro Siqueiros just around the corner. González Nieves wanted to enlist her community of creatives to keep the four-bedroom house feeling like home. "Everyone comes here," she explains, "and finds a token of themselves."

She also wanted to ensure that any person she brought on board would honor the structure and its history. "We were talking to Ana Elena Mallet,"

González Nieves says, "and she went, 'Let's tell the story of Bajío.' It just felt so right." The five-state region that includes Guanajuato has a rich design history that weds international sensibility with Mexican heritage. In the 1950s, authorities began offering incentives to international outsiders in a plea to save its nearly abandoned towns. They received the likes of Gene Byron, a Canadian artist who expanded on local techniques with hammered tin, Giorgio Belloli, a Venetian architectural designer who produced leather-and-iron chairs modeled off of Bajío *parteras,* or birthing seats, and New York's Don Shoemaker, who designed furniture and objects with native rosewood. Alongside Mallet and Cabra, González Nieves curated works from mid-century luminaries like these and placed them alongside their contemporary Mexican counterparts including Fabien Cappello, Antonio Cornelio Rendón, and Fernando Laposse—a generation that she deems "truly effervescent, creative, and entrepreneurial" and strives to highlight at every turn.

González Nieves carries a bottle in one hand and crystal stemware in the other (if not already obvious, when she is in San Miguel, she is seldom without

Casa Dragones accessories like these). She shows off design gems like the Clara Porset wicker lounge chairs and an enormous tapestry from the Oaxaca-based Danish textile artist, Trine Ellitsgaard. She stops at the primary suite, now called the Allende room in honor of the revolutionary leader, and smiles. "This was our room," she says. Even as they have opened it to the public for tours, tastings, and varied events, the house remains deeply personal and reflective of her and Wells. "Every one of our projects has its own flavor," she adds. "They're connected by passion. We just love to build homes together." And though the space serves many functions and its furnishings may be impressive, it is just that. "This is a home," she insists. "It's not a museum."

Guests range from visitors to San Miguel who have booked a private tasting to the couple's closest friends. If you walk through the door of the narrow blue facade—painted the same color as the cavalry's flag and all things Casa Dragones—you are meant to get comfortable. Cozy up to the bar, made of four thousand tiles crafted from obsidian found in the agave fields. And make sure to get a closer look at the doors, modeled off of those from the original stables but

10

Héctor Esrawe's brass, bullet-shaped sculpture that punctuates the staircase contrasts with the rough stonework of the Colonial building, exploring light, depth, and shadow across different planes and surfaces. (10)

now in steel and glass instead of oak. At parties, move furniture out of the way. Dancing is encouraged. Spill a little tequila on the floor? No problem, though don't forget—that stuff is precious. "Sometimes, we have to kick people out," González Nieves laughs. "All of the sudden, it will be four in the morning, and nobody wants to leave."

It's eight o'clock and her turn to go. Dinner calls. She walks through the long corridor filled with planters and closes the heavy pine door behind her. Tonight, González Nieves has invited her entire team to a favorite restaurant. "This town is all about its people," she muses. "In big cities, I find that people are victims of where they are. People *choose* to be here. They are committed." She is referencing the community at large, but also the people who take care of the house-turned-headquarters. When she arrives at the long table, servers are ready with pours of tequila. "Bertha!" her staff squeals. She greets everyone with a customary kiss on the cheek, and excited conversation ensues. "San Miguel is a little slice of magic," she says. "And our place here? It has a much bigger heart than its footprint."

12

In the desert, where mornings and evenings offer blissful reprieve from warm days, open-air spaces are essential. Here, every room in the house opens directly to the outdoors, and the courtyard doubles as an al fresco living area featuring side tables hand-carved from volcanic stone, vintage coffee tables, and seating designed from contemporary studios like Casamidy and Oax-i-fornia. (11, 12)

11

196

EDUARDO BOSCH

& SUSANA PARIENTE

A FAMILY MUSEUM: PRESERVING THE PAST, IMPROVING THE NOW

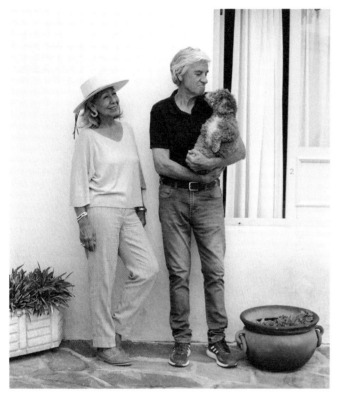

"My name is Barbarita Cruz, potter of Purmamarca," she said with an outstretched hand. Eduardo Bosch stood in awe of the self-assured woman before him. "What a presentation," he remembers thinking. The setting of this encounter was San Salvador de Jujuy, capital of Argentina's Jujuy province, where high desert meets verdant plains in the country's northwest. A young Bosch was working in the tourist sector when the director of culture brought him to meet influential figures in the region. "Come visit my home," Cruz insisted shortly thereafter. Accepting her forthright offer, Bosch dug out a pen and paper to take note of the pertinent details. "No, no," she shook her head. "Don't write anything down. I live in *Purmamarca*." She placed particular emphasis on the location's name before continuing. "When you arrive at the entrance to town, ask for me."

A few short weeks later, Bosch made the forty-five-minute journey from the capital to the foot of the iconic Cerro de los Siete Colores, or Hill of Seven Colors, where the tiny hamlet of Purmamarca sits. The mountainous valley—now a UNESCO World Heritage Site—that

"I'm surprised that life has led me on a path similar to that of my aunt," Pariente says of her career, "though it's not specifically related to the arts." Standing in front of their recently modified wing of guest rooms—the latest significant update to Casa Barbarita Cruz—she and Bosch recall those that have helped them grow with the space. From the preservationist architect Carlos Gronda to their three children, local artisans, and those who maintain their digital channels and day-to-day operations, the duo takes pride in the spirit that keeps their historic structure alive. (1)

A solitary clay vase, personified with a face and arms along the receptacle's neck, rests on a chest in a hallway that separates the kitchen from a private office. The arched door fitted with amber-colored glass stays propped open throughout the day to promote airflow through this high-traffic channel to the interior courtyard. (2)

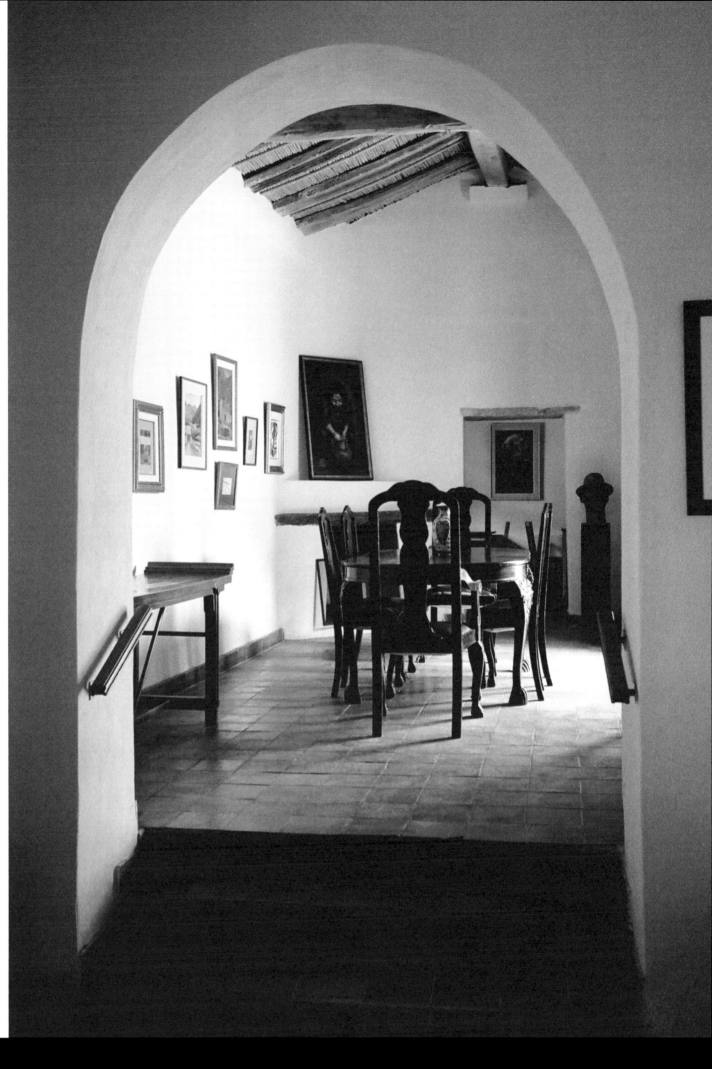

engulfs the village has been the scene of human communication and trade for millennia, witness to prehistoric nomads, travelers of the Incan trail, and Spanish settlers alike. Following Cruz's directive, Bosch asked a local for help and was rewarded with turn-by-turn instructions. "I arrived right here," he says, pointing to the home's entrance. The door flew open, and the two spent the rest of the afternoon talking and telling stories.

Bosch, it turned out, was in good company. Over the years, Cruz hosted and championed the likes of pianist Miguel Ángel Estrella, filmmaker Jorge Prelorán, singer-songwriter Leda Valladares, journalist Eduardo Galeano, and composer León Gieco. Her open-door policy came to be well regarded by many, though perhaps no one more than her impressionable niece, Susana Pariente. Inspired by her formidable aunt and like Bosch, Pariente landed in the tourism industry hoping to foster cultural dialogue and exchange.

She and Bosch first met at a conference, introduced by a colleague who recognized that the two were following a similar trajectory. It was a cordial interaction, but nothing more. Pariente was just twenty at the time. "Eduardo was eight years older than me, which felt like a lot," she says, feigning terror. Months passed before their paths crossed again. This time, they became closer, which would inevitably lead to the shocking revelation that he had met Cruz. "You know my aunt?" she asked, reanimating her reaction when he dropped the bomb. Sitting in the green-tinted kitchen of the more than century-and-a-half-old house where Bosch and Pariente spend much of their time, Bosch shrugs with a cunning grin. "And well," he says, "here we are.'"

The courtyard house—now part home, part bed and breakfast, and part museum—of thick adobe walls, cactus and cane ceilings, and terracotta tile floors dates to the 1870s. Its long, tiered living and dining area gives way to a central court with a stone floor. Mountains and technicolor hills shoot up on all sides of the exterior volume, with a tree at its center for shade. In the home's early incarnation, the bedrooms that flanked the exterior space remained windowless to keep cool in the summer heat—sleeping was the only function of the quarters anyhow. The property was the stomping grounds of Cruz, who was born in 1922, and her eight siblings until their parents decided to pack up and move to the big city. After six decades in the family, it was shuttered.

The clan had left their rural outpost so that the boys could pursue a better education, but Cruz found her way academically, too. After studying fine arts, she turned to teaching, where she found more than a profession. Education was her true calling. Nonetheless, in the mid-twentieth century, a mandatory retirement age of forty-five forced the ending of her first career. Cruz became resolved to move back to Purmamarca and revitalize her childhood home. Her parents voiced their concerns. The mud-and-straw structure hadn't been maintained for years—and a woman restoring it alone? Though she was living in a man's world, Cruz always pushed back against social norms. She wore pants, smoked, and made conscious decisions to never marry or have children, all unthinkable choices at the time. "She was really a fighter, a free thinker at all levels," beams Pariente. "She said what needed to be said, and she acted on her words." Cruz taught her niece that everyone has the power to make their own choices and design their destiny. "Above all, she taught me to look at people without prejudice," Pariente says.

Upon Cruz's return, the family's once residence became a haven for freedom of expression and a factory for creativity. She dedicated herself to the proliferation and conservation of cultural knowledge, recognizing that time-honored arts of shaping clay, writing poetry, and even making wine and goat cheese were rapidly disappearing. She began hosting workshops for children, which Pariente often attended. "You had to work with joy," she recalls. "My aunt was very playful."

The long corridor that makes up the home's primary living space ascends in small increments from the foyer to the sitting room and, finally, to the dining room. Bosch and Pariente play music for friends and guests from a speaker hidden within the fireplace—this secretive audio system is their attempt to minimize the introduction of modern trappings alongside Cruz's more heritage pieces. (3)

Neither Bosch nor Pariente claim to be
very adept cooks but nevertheless spend
a sizable portion of their day in the
kitchen. They drink maté, make lists for
the week ahead, catch up on local news,
entertain guests, and lounge with their
dog, Morgan. (4)

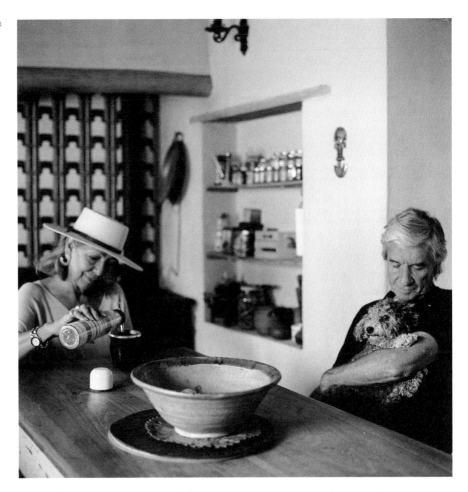

Bosch and Pariente frequently take a
left turn out their front door and go
past the Santa Rosa de Lima church where
they were married nearly five decades
ago to arrive at the town cemetery. They
pay a visit to Cruz's gravesite and then
proceed to the trailhead for Paseo de los
Colorados, a short loop hike that rises
to meet the vibrant colors of Cerro de
los Siete Colores up close and encircles
the village below. (5)

Pariente reminisces on one particularly festive December. Singing Christmas carols, Cruz and her young disciples decided to construct a manger. The artist's angel figurines from that series went on to become a stamp of her practice. Yet, for a devotee of Mother Earth like Cruz, the natural world was the harbor of any higher power. When Bosch and Pariente were married in the seventeenth-century Santa Rosa de Lima church at the heart of Purmamarca, Cruz organized the affair but didn't attend the formal ceremony. By that stage, she had largely severed ties with organized religion.

From their meeting to their nuptials, Purmamarca proved instrumental in bringing Bosch and Pariente together. Though the town continued to hold great meaning for the young couple, they had no idea the series of twists and turns that would lead them to be the next stewards of the historic family compound. Cruz's father had returned to Purmamarca at one point to reallocate various pieces of property, but none of his sons or grandsons wanted the house. Since Cruz was actively living in it, it remained hers, and she decided to give a share to Pariente's mother, her ninth and youngest sibling, who had been born in the city. Upon Cruz's death in 2016, it wound up in Pariente's hands. "Cosmic forces were aligned," she says.

She, Bosch, and their three children—two daughters and a son—contemplated its future. "We all felt a great responsibility," Pariente remembers. "But we kept asking, 'What do we do with it?'" She and Bosch were prepared to make the move from San Salvador. In fact, the couple had long dreamed of living in Purmamarca. Still, they knew that the house couldn't be relegated to a private home for the two of them. "It had to remain a place where art is experienced," Pariente says, "and where Barbarita's memory lives on." The pair decided to invite the outside in, hoping to attract not clients but guests—people who wanted to truly learn about and channel the spirit of Cruz.

The artist's space had always been a product of collaboration, so it made sense for Bosch and Pariente to proceed with the same basic approach. They brought on the architect Carlos Gronda and partnered with nearby makers. "We found people who became deeply involved with the project," Pariente says, "and who really do their job from the heart." They set to work, restoring walls, floors, and roofs and updating electricity. "There was one outlet in each room," Pariente explains. "Today, it feels like you have to plug your entire life in!" They replaced three large, dungeon-like bedrooms with smaller volumes and en-suite bathrooms, carving out windows and adding pops of color for a modern era of hosting. They kept the studio, lined with works from Cruz and her students, and maintained an essence of unfettered expression. A bowl of clay is always at the ready for those who wish to try their hand at pottery-making.

The house exists as a living and lived-in museum, where drawings and ceramics of Cruz's creation mingle with pieces from other beloved friends, like Michi Aparicio, the set designer for Ingmar Bergman and fellow Jujuy native, who added two frescoes to the living room wall. "I believe she was always the great attraction of this town," Pariente says of her aunt. Until she died at ninety-three, Cruz fostered a hub for makers and

6

7

A potted plant enlivens the corridor between the upstairs bedrooms. When a neighbor expanded with a second floor, Bosch and Pariente relented and did the same. The addition contains a small patio perfect for peering up at the sparkling night skies. (6)

The central patio, which has witnessed
countless poetry readings, dances, and
art shows over the years, benefits from
simple ornamentation—a sparse set of
furniture and a perimeter of clay pots,
which contain a smattering of desert plants,
young bougainvilleas, or nothing at all.
The vessels, after all, are objects to be
celebrated in their own right. (9)

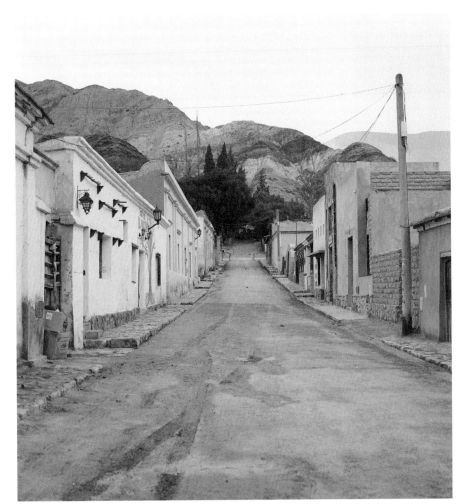

8

Much like the rest of the residence, the salon
pays homage to the many characters that made their
presence felt in the home. A portrait drawn by Cruz
resides alongside the work of her peers, including
one of a pair of frescoes by Michi Aparicio. (7)

The house's sloping street looks much like the others
in town, where desert-hued buildings stand shoulder
to shoulder. Casa Barbarita Cruz is steps from the
bustling central square but removed enough to capture
the feeling of an oasis. (8)

doers, and no creative pursuit was unfit to occupy her home.
When people arrived in town looking for a place to stay, they
were directed here. If the walls could talk, they would describe
decades of lively gatherings and important meetings of powerful
minds. Much of the furniture is original to the house, and Bosch
and Pariente frequently serve on Cruz's dinnerware sets or
adorn the table with her silver. Receiving visitors is a pleasure
for consummate hosts like them, who are always ready to share a
meal and a story with anyone who darkens their door.

The kitchen remains a locus for interactions. Like Cruz,
Bosch and Pariente hold formal get-togethers in the dining room
but otherwise congregate with friends and family at the hearth.
"Everything is cooked here," Pariente says with a wink. She isn't just
referring to food but also innumerable relationships and countless
ideas hatched around the repurposed wooden ironing table.
Ceramic bowls, carved wooden spoons, and green glass jugs are
employed as functional decor. Concrete countertops and glazed
earthenware tiles, each hand-painted by local artisans Eleonora

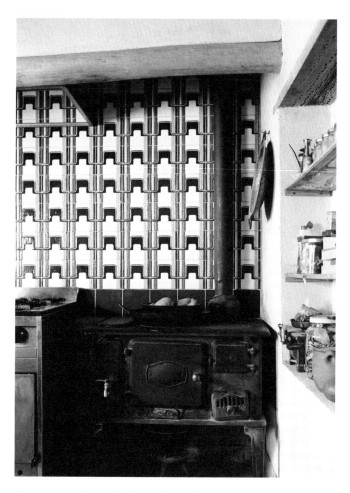

Physical manifestations of memories in the form of letters, artworks, and photographs detail the house's past lives. Many embellish rooms, while others remain in storage awaiting proper organization. Having absorbed so much from Cruz's rich life within its walls, the home seems to resonate as a character in and of itself. (11)

11

10 Vestiges of the home's guardian angel, like Cruz's wood-burning oven, stand prominent. A set of handcrafted Mayolica tiles——a striking example of the pervasive green theme——brighten her beloved kitchen staple, which neighbors a more contemporary model. (10)

Cornejo and Sofía Sirena in a geometric motif, give an air of modernity. It's the best of both worlds—the days of Barbarita Cruz meet those of a new generation.

Pariente pours hot water from her carafe into her maté cup, a daily ritual for millions of Argentinians. "My aunt didn't like maté," she says. "She drank tea." Accompanied by their curly-haired dog, Morgan, and their cat of twenty-plus years, Bosch and Pariente start mornings like these slowly. "We're less than an hour from the capital," Pariente says, "but life here is so different." In Purmamarca, she and Bosch continuously realize how little they need to be happy. They revel in the quiet of their courtyard, in long breakfasts shared with guests, and in walks through the natural pinks, yellows, purples, and greens that surround Casa Barbarita Cruz. "It's everything," they say in unison.

The duo begins poring over a box filled with photos and memorabilia, precious moments from a life well lived. They are slowly archiving the myriad relics of Cruz's vibrant time in Purmamarca. But right now, they're just enjoying a bit of nostalgia. "Look at how the living room used to be," exclaims Bosch. Pariente points to a photo of Cruz gathered next to the tree that used to live in the courtyard. The couple has since planted an acacia in the same spot to shade future generations of visitors to the compound. The guest house, which boasts no website or advertising but is known only by word of mouth, has attracted curious travelers and like-minded individuals to share in the history of a cultural icon. While Bosch and Pariente run the show, Cruz's impact is tucked into every corner. "She is a permanent presence in this house," Pariente says, scanning the space from floor to ceiling. "I feel her everywhere."

12

The palette of the home draws from the native landscape, like with the roof and drain pipes that mimic red clay from the hillside and, of course, the soft green kitchen pantry, which pulls from the cacti and drought-tolerant plants of the valley. (12)

PIERRE BERGÉ

YVES SAINT LAURENT

Marrakech

FERNANDO SANCHEZ

Morocco

JANO HERBOSCH

1

Upon entering Dar el-Hanch, the main balcony---with its
many-layered vistas and open volumes---provides the first
moment of expansiveness. A shirtless Saint Laurent was
famously photographed on the exterior corridor during his
tenure. Today, Herbosch stands in reverence of her home's
forebears. (1)

3

2

FROM ONE ICON TO
THE NEXT, A HOUSE WITH
SERPENTINE HISTORY

With plentiful reminders big
and small—like a shiny metal
cobra with a curved lamp to
match—the Dar el-Hanch theme
is on full display across the
house. (2)

Herbosch continuously curates
a library replete with texts—
well-read and many containing
a bookmark—that harken to her
home's former occupants. On the
primary balcony, Pierre Bergé's
Letters to Yves and *A Moroccan
Passion*, both of which contain
reference to Dar el-Hanch, rest
on a table beside a sunny
reading spot. (3)

Jano Herbosch sports a glistening snake ring—two actually—as she takes a sip of her morning coffee. She is delicately stirring while soaking in the low-lying winter sun behind a big pair of black-framed sunglasses, a decidedly striking contrast from her pearly white bob. The former talent manager, who has long lived between Manhattan and Marrakech, is all about bold presentation, but her sweet smile and endearing New York accent reveal a modest and loving soul. The gems on her fingers are hard to look away from, and within the context of her home, her chosen jewelry is far from a random bit of flair. She and her daughter Alessa are enjoying a brief repose from the upper floor patio of Dar el-Hanch, their riad residence on the edge of the medina, whose name translates to "House of the Serpent."

Herbosch inherited the boxy structure with M.C. Escheresque geometries—staircases that lead from one volume to the next—from Fernando Sanchez, her former business partner and cousin by marriage. Sanchez was what the *New York Times* called a "fashion innovator," transcending boundaries between women's nighttime and daytime attire. Innerware became outerware. What was once considered scandalous turned sophisticated. "You don't have to be stuck in the bedroom to wear them," Sanchez famously said of his designs, donned by the likes of Cher, Madonna, Naomi Campbell, Elizabeth Taylor, and Tina Turner. At the age of sixty-eight, the Belgian-born Sanchez was bitten by a sand fly while traveling in his beloved Morocco. "He knew he was sick," Herbosch recalls.

The designer offered her his 57th Street apartment, where he had hosted his renowned 500-guest fashion shows that brought together the haute-couture crowd and the art scene alike, in New York. But it extended across 5,000 square feet, and she simply couldn't accept. "I mean, it was *huge*!" she laughs. "And we already had a lovely apartment." But when he shifted gears and suggested that she take on Dar el-Hanch, she found it impossible to resist. "It was a no-brainer," she says. In 2006, Sanchez died from the parasitic disease Leishmaniasis, and the house fell into the hands of its new owner.

But its story starts much earlier. In 1966, Pierre Bergé and Yves Saint Laurent, one of history's most influential couturiers, traveled to the desert city. Marrakech isn't known for its rain, but during their first few days, it poured. The Frenchmen holed up at the La Mamounia Hotel, which then sat largely in a state of disrepair. "One morning, we awoke, and the sun had appeared," Bergé wrote in his memoir, *A Moroccan Passion*. "A Moroccan sun that probes every recess and corner. The birds were singing, the snow-capped Atlas Mountains blocked the horizon, and the perfume of jasmine rose to our room. We would never forget that morning, since in a certain way, it decided our destiny." They returned to Paris with keys and a deed. They had purchased Dar el-Hanch.

Love at first sight manifested in a home away from home. "Dar el-Hanch was a small house," Bergé mused, "which we decorated modestly with tables and chairs found in the souks." Saint Laurent, who endlessly sketched and painted, dressed up the dining room wall with a large, multicolored snake, galvanized by the house's moniker. "Could this be why Yves always drew so many?" Pierre asked. "Snakes are found nearly everywhere in his work." They embellished letters to friends, and his series of year-end "LOVE" greeting cards boasted many a slithering creature.

By the time Bergé and Saint Laurent made it to Morocco, the pair had become entrenched in the fashion world. Saint Laurent had helmed Dior as its head designer, a post he took on at just twenty-one years old, and after a tumultuous departure, he and Bergé founded his eponymous couture house. In France, they were cultural fixtures. Dar el-Hanch, then, became a refuge from fame and a playground for experimentation and inspiration. The couple hosted their equally well-known friends, big names like Paul and Talitha Getty, Mick Jagger, Loulou de la Falaise, and Andy Warhol. Saint Laurent ambled around in cotton clothes made by a local artisan, and the duo "spent many happy moments there," according to Bergé. By 1974, however, they were ready to expand.

When they found their next digs, they sold Dar el-Hanch, a place dear to their hearts, to another regular houseguest and Saint Laurent's oldest friend: Sanchez. Saint Laurent and Sanchez had met while both enrolled at L'École de la Chambre Syndicale in Paris. They studied alongside each other, and Saint Laurent even hired Sanchez to design lingerie briefly while at Dior. Sanchez set off for New York, but the two remained close, even if on opposite sides of the pond. As it happened, both men became equally enraptured by the North African country—its textures and tones—where they would come to reside part time. "While Yves Saint Laurent had the greatest color sense of any fashion designer ever," the author and editor Marian McEvoy wrote for a 2021 exhibit at the YSL Museum in Marrakech, "Fernando Sanchez was right up there in the top ten."

Yet, he maintained Dar el-Hanch as a toned-down, comfortable sort of affair. "When it came to decoration, he had a kind of natural, unfussy good taste, which was often low key but always mindful and worldly," explained McEvoy, who knew Sanchez from her early days reporting on fashion in New York. In 1990, Sanchez also determined that he was ready to expand but simply by buying the house neighboring Dar el-Hanch, which was built by the same architect, Maurice Doan, in 1967. Sanchez and his partner, Quintin Yearby, renovated the structure, Dar Andalusian, connecting the two and forging

4

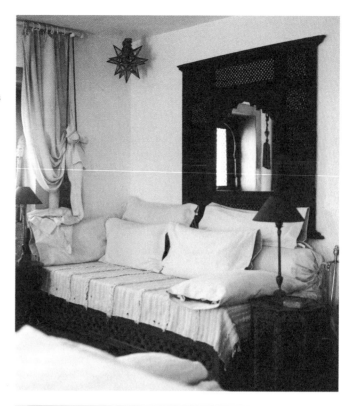

5

The shelves in the living room act as an ever-evolving catchall of family portraits, cherished objects, and books. Herbosch points out some favorites, like a photo of Saint Laurent and Sanchez smiling in tuxedos and a celebration of life pamphlet embellished with Sanchez's red "F" that she and Alessa created after the designer's death in 2006. (5)

Across owners, Dar el-Hanch has retained
a certain aesthetic language. The primary
gathering space, for example, is furnished
with Moroccan designs, elegant yet modest
textiles, and a latticework mirror that
echoes the original windows. (4)

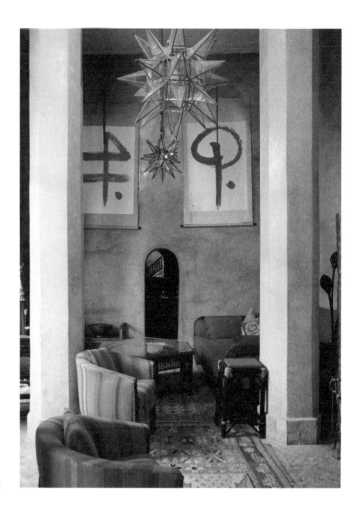

6 7

In the dining room, where Saint Laurent's
painted snake rules supreme, Herbosch employs
textiles in red, yellow, blue, and green hues
to reflect the central figure. In order to
preserve the iconic work from the extreme sun,
she and Alessa frequently cover the space's
large skylight when it isn't in use. (6)

Scrolls emblazoned with Sanchez's "F" and
his partner Quintin Yearby's "O" hang in the
double-height salon of the Dar Andalusian
wing. Warm shades of red and yellow accent the
room, and a soft pink plastered wall bears a
narrow arched doorway—a minimalist nod to a
classic Islamic portal. (7)

a very different aesthetic, but one that maintained the same overarching spirit. They recruited their dear friend, Bill Willis, the same decorator who took on Bergé and Saint Laurent's subsequent properties, to install a fireplace with geometric patterns and a pyramid-shaped top. Two columns in jasmine yellow frame the construction, which is composed of locally made pink bricks, and a star-shaped, iron-and-glass light fixture accentuates its pointed peak.

Dar el-Hanch may have grown in size, but it remained intimate and deeply personal. "It was not a party place," wrote McEvoy, "but rather a gem of an incubator, as contemplation and nurture seemed built into its warren of cozy spaces." And thus, Herbosch arrived to this place for the closest of friends and family. She and Sanchez were steadfast in their devotion to one another. Herbosch had entered into a toxic marriage at a young age, and when she finally resolved to "get rid of" her husband, Sanchez took her under his wing. "Come and work for me," Herbosch remembers her cousin insisting. With no experience to speak of, she was flabbergasted—and at the time, painfully shy.

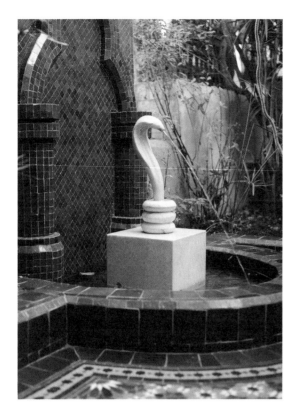

Numerous courtyards and terraces give residents
and visitors to Dar el-Hanch——and its Dar
Andalusian expansion——the feeling of being in
a city within a city. These outdoor seating
areas offer a sense of privacy and in the hot
summer months, a cooler, cozier way to enjoy
the fresh air. (9)

9

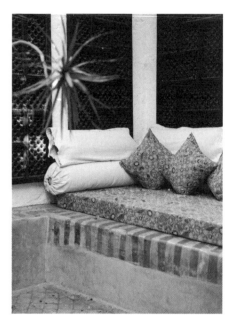

When an old twisting tree finally snapped, Herbosch
was heartbroken. "It was like a snake itself," she
recalls. "It was magical. I couldn't replace it
with something that just stood straight up." And so
instead of replanting, she installed a green-tiled
serpent fountain in its honor. (8)

"Never mind, you'll learn," he said when she brought up her concerns. For the last thirty years of the designer's life, the two worked side by side.

"I had never been here," Herbosch recalls of her first Moroccan escapade. "My mother thought I was insane for bringing a four-year-old. But I got off the plane, and I felt that this was where I belonged." Once she saw the house, her feelings only cemented. From that first visit, Herbosch and a young Alessa spent practically every June and July in the city, falling into the electric orbit of Sanchez, who revealed people and places that Herbosch could only have dreamed of. She was introduced to the glittery personas of the fashion industry, film icons, and figures such as Paloma Picasso and Farah Pahlavi, the last Empress of Iran. "He offered me a life that I never would have had otherwise," she smiles.

Sanchez was something of a magnet, attracting individuals of all backgrounds and ages. "He had a big hand in bringing up Alessa," Herbosch says, glancing at her daughter, who now has a successful career as a clinical and forensic psychologist, often lending her hand on television dramas and reality shows. "He was just one of the most extraordinary, kind, lovely people that I have had the privilege to meet." Herbosch once stipulated that Sanchez be in charge of Alessa should anything happen to her. Some minor arm twisting ensued until a compromise was reached: Herbosch couldn't die "until I turned eighteen," Alessa chimes in with a laugh. Thankfully the informal contract agreement never needed to be enforced, and Sanchez happily contributed to her cultural education along the way.

(NOT SO) GARDEN VARIETY

with Madison Cox

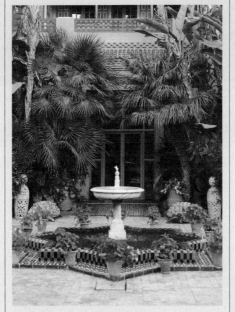

Majorelle used pots, which he painted that iconic blue, and Saint Laurent later introduced vessels in shades of yellow and orange. I love using pots in general, so that's something that we continue to incorporate—but we ensure that they are in constant motion. In other words, we'll highlight certain specimens when they are in bloom and swap them out when they aren't. All of these different, shifting moments preserve a certain dynamic spirit.

The balcony of Villa Oasis overlooks Jardin Majorelle, where Saint Laurent's ashes were scattered in 2008.

After selling Dar el-Hanch to Fernando Sanchez, Bergé and Saint Laurent acquired Dar Es Saada, which translates to the "House of Happiness," and enlisted the American émigré Bill Willis to decorate. The structure was near Jardin Majorelle, the French painter Jacques Majorelle's estate, which would shortly thereafter come under threat from developers. Bergé and Saint Laurent jumped at the opportunity to purchase the house and later the gardens, once again employing Willis to lend his keen eye to the property. Villa Oasis was the duo's ultimate acquisition in Marrakech and where the couturier drew up some of his best designs and threw his most radiant dinner parties. "Most of the meals were outside," recalls Madison Cox, their legal heir and president of both Fondation Pierre Bergé–Yves Saint Laurent and Fondation Jardin Majorelle.

Before Bergé and Saint Laurent passed away in 2017 and 2008, respectively, Cox, a celebrated garden designer in his own right, reimagined the grounds alongside the pair. He installed an outdoor dining pavilion, an octagonal structure of painted cedar that opens on all sides for warm-weather months and closes to create a cocoon in colder ones, and a long, rectangular fountain. Both in green, they hide among the plentiful cacti, agaves, and aloes that further enliven the space. "I discussed color with Yves Saint Laurent frequently," says Cox. "He was a truly great colorist." Now, the garden surrounding the private retreat is open to the public—"except on Wednesdays," Cox clarifies, when a diligent staff maintains the plot and paints, keeping the compound's dusty pinks, bright blues, and earthy greens vivid and vibrant. And just off a bustling street, it *really* is an oasis. The din of buzzing city life all but fades. The roar of honking horns and raucous chatter of the morning commute drifts away with each additional step onto the grounds. The gurgling fountains, fluttering songbird wings, and swaying palm fronds begin to dominate the soundscape. It's hard to identify just what makes Villa Oasis so magical in these early hours—the prevailing legacy of luminaries, the cornucopia of desert plants, the rich hues warming against the rising sun—but Cox sheds light on some of its finest features.

GRAVEL, NOT GRASS

Replacing the grass was one of the major interventions that I made in the nineties. I convinced Bergé and Saint Laurent in the name of water conservation, but it was *not* easy at the time. Now, there is a younger generation of gardeners who are much more sensitive to issues like these. We used gravel from the Ourika Valley, a very fertile area between Marrakech and the Atlas Mountains. The natural material saves water, but it also elevates the garden, which isn't about flowers and big colors. It's about textures, forms, and shapes. It's easier and more dramatic to read all of its greens against the neutral rosy gravel than a lush lawn.

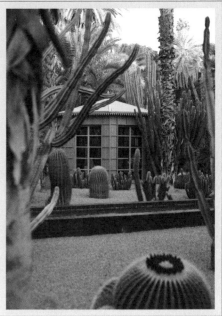

FLORA ABOVE ALL

The garden contains so many species of interest, most of which are from those three main families: cactus, agave, and aloe. I love the *echinocactus* and the *ferocactus* near the dining pavilion, and the *kalanchoe beharensis* and *kalanchoe luciae*, which line its walkway. Then, on the central axis, a double-row planting of *Washingtonia robusta*, or Mexican fan palms, border the front door. These were put in alongside cypress trees in the mid-1920s by Majorelle, but by 1990, most had become overgrown or been destroyed by various storms. We removed the cypresses, replacing them entirely with these palms and shifting away from a more European sensibility. There is also, of course, *phoenix dactyliferia*, or our native date palm. Today, we are in the center of town, but when Majorelle built this house, it stood alone encircled by groves. As they have disappeared, these trees have become an increasingly important nod to the past.

A meditation on the color green

10

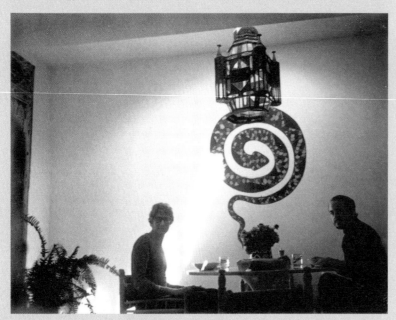

In the 1960s, Bergé and Saint Laurent were captured enjoying their morning meal in the Dar el-Hanch dining room. Today, the space boasts a much larger table and is primarily used for more formal gatherings. (10)

11

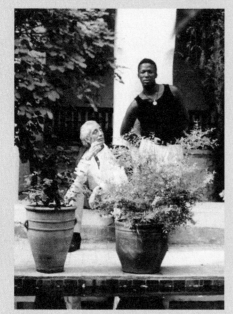

Marrakech left "a lifelong influence" on Saint Laurent, according to Bergé. The city had equally profound impact on Sanchez, Yearby, and the cohort of creative minds that came together on its streets, in its gardens, and across its riads over the years. (12)

12

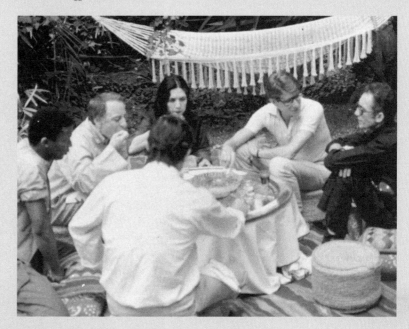

Sanchez and his partner, Quintin Yearby, delighted in many an afternoon luxuriating by the house's pool, surrounded by trees and potted plants. (11)

When Herbosch acquired the historic home, the early phases proved much less glamorous than the star-studded evenings of her memory. Sanchez had a habit of shirking gritty jobs such as fixing plumbing issues, so she inherited the tall task of rejuvenation. "We had to start with all the nasty water and electrical work," she says. "The fun stuff." With time and dedication, the structure morphed into something as layered as the many personalities that it has sheltered beneath its roof. "We have given it new life," Herbosch says, like with an updated kitchen and sections of flooring, "but still kept to its original style." With special Herbosch touches such as a fountain in the shape of a serpent, the dwelling's archetypal figure made iconic by Saint Laurent, and a complementary colored courtyard in the Dar Andalusian wing, the owner knows that the hallowed space should and will always be a little bit Bergé, a little bit Saint Laurent, and a little bit Sanchez.

"Fernando was very protective about people taking pictures," alleges Herbosch. "He said, 'It's private. It's my house,' which is the way that we try to treat it now," carefully curating the moments when Dar el-Hanch is seen in the public eye. Herbosch and Alessa have honored many of Sanchez's wishes. When Yearby, his bona fide soulmate, died, he had two scrolls made in New York's Chinatown: one with his signature "F" and another with a "Q." His health too poor to return to Marrakech, he requested that Herbosch and Alessa bring them to Dar el-Hanch. Today, they hang perpendicular to the fireplace, their red ink brightening the already rosy walls. "Some of their ashes are here, too," Alessa says, noting that their presence will never fade.

The unassuming facade of Dar el-Hanch is painted white with a black wrought-iron gate encircling the fire-engine red door, a Herbosch addition. The portal swings inward to reveal her tall figure, partly obstructed by the low opening. She grins widely and matches the structure with a black-and-red getup. From a compressed foyer a bit larger than a phone booth, a dark and narrow staircase ascends to the light-filled interior balcony punctuated by thin columns. The view frames a series of exterior rooms below—a white-tiled courtyard, a dipping pool, and, even lower, the Andalusian outdoor living space. Each corner possesses its own form, texture, sound, and color palette. From the main balcony, a staircase rises to the snake-adorned dining area, which abuts the kitchen. Farther up is the formal living room. Off the gathering space are a series of patios on three separate levels, culminating in a rooftop lounge with sweeping views of Marrakech and the Atlas Mountains. It's a marvel. It's a wonderland. It's a trip. It feels like a toddler's block house come to life, but it works just so. Every transition is a surprise and delight. "Just be sure to watch your step," Herbosch warns.

In their casual chic ensembles, she and Alessa take off for lunch at Farasha Farmhouse, a project brought to life by consummate Marrakech party people, Fred and Rosena Charmoy. The Charmoy's enviable brand, Boutique Souk, has put on shows for Dior and Chanel and a slew of weddings and bespoke events where the guests of honor's identities are often heavily classified. Herbosch's hired black van weaves through the countryside and comes to a halt beside rows of olive trees. It's Christmas Day, and the sun is beaming bright. They crunch along a path covered with argan shells, following the sound of a heavy beat that grows louder and louder. They reach the music-filled courtyard, brimming with friends who likewise call Morocco their part-time or full-time home. They greet the multihyphenate Danny Moynihan, painter, curator, and co-founder of the Marrakech Biennale. Next, they embrace his wife, Katrine Boorman, an actress, daughter of the legendary film director John Boorman, and queen of the intricate headdress. Inside, they catch up with Amine el Gotaibi, the artist, whose works line Farasha's immense interior volumes and who leads the country's contemporary art scene.

After a hearty meal, the crowd ascends to the rooftop as the mountains begin to glow. Floor cushions are shoved aside to make more room on the dance floor. Drinks are topped up. Laughter and hugs become contagious. Bergé, Saint Laurent, and Sanchez may be no longer but in their glorious shadow, another generation—inspired by this desert land and fervently creative because of it—takes hold. Charged with preserving a small piece of a giant legacy, Dar el-Hanch's latest steward stands at its center, proverbial torch firmly in hand.

216

SAEED ABU-JABER

&

MOTHANNA HUSSEIN

THE ART OF EVERYTHING: WHEN HOME AND STUDIO ARE THE MOODBOARD

Ever the gentleman, Mothanna Hussein lights Saeed Abu-Jaber's cigarette. The gray sky is lurking, threatening to burst, as the two sip espresso. But this scene might be a bit misleading, and not because of the smoking or the coffee. Winter is rainy season, but this is also Amman, capital of one of the driest countries on earth. "We had a good friend visit," Hussein recalls, as droplets begin to fall. "He wasn't from here, and he kept running the tap. We were like, 'Stop! No!'" While Amman may be cooler than most of Jordan thanks to its comparatively high elevation— between 2,300 and 3,600 feet above sea level—it is no stranger to the adverse effects of climate change.

It's not unusual for Jordanians to run out of water, and many citizens, or at least those who can afford it, turn to private tankers for refills. Abu-Jaber

and Hussein are reticent to call out their influences— inspiration in a creative field like theirs comes from the most unlikely of places and everywhere, really. "But those trucks..." Hussein says of the water lorries before trailing off. "I mean, that calligraphy!" Abu Jaber chimes in, noting that their Arabic lettering is in fact a creative catalyst. Moments like these, where the two finish each other's thoughts, occur with regularity.

Abu-Jaber is ebullient. He seamlessly shifts between topics—design, music, food—as Hussein peers stoically through his trademark yellow-tinged sunglasses. Where Abu-Jaber is the talker, Hussein is the thinker, constantly absorbing until he drops a nugget of truth or witty observation into the conversation. It seems that they couldn't be more different, but within their polarities lies their collective strength. Abu-Jaber

1

At one point, Abu-Jaber and Hussein dreamed up a coffee shop, but in the end, they opted to keep it an in-studio café for two rather than pursue a public venture. Its name, Yes Yes, was drawn up on the wall by the calligrapher Hassan Kan'an, and the pair brightened the corner with a yellow La San Marco espresso machine and Jawad stools from Local Industries. (1)

2

The Turbo twosome occasionally broadcasts
live shows from their Amman studio for
Radio Alhara, the community-based,
grassroots station that they co-founded
with friends in March of 2020. The online
platform provides a public space for
poetry, protest, and plenty of music,
whether funk, pop, disco, or Bahraini
wedding songs. (2)

The oversized windows of the garage
turned Turbo headquarters let in an
abundance of natural light and are rarely
shuttered. Since its opening, Abu-Jaber
and Hussein have deliberately allowed
the cultural venue to turn the heads of
passers-by, inviting the outside—other
designers, artists, and collaborators—
in, rather than simply maintaining it as
a private office. (3)

and Hussein, who make up the yin-yang duo behind the self-initiated graphic design agency Turbo, have been disrupting the scene since they joined forces in 2015.

Hussein had developed a reputation that preceded him early in his career, and before they ever crossed paths, Abu-Jaber found himself a self-proclaimed "fanboy." At one point, both were asked by a mutual friend to design a skateboard deck as part of an exhibition for Amman-based skate brand Philadelphia—the moniker a call back to the desert city's one-time name during the fourth century BCE Greek rule. After turning in his submission, Abu-Jaber received a phone call. "My name is Mothanna Hussein," uttered the voice on the other end, "and I don't do this often, but I really like your skateboard artwork." Abu-Jaber was floored. "I said to him, 'If Mothanna Hussein likes my work, it doesn't even have to make it to the exhibition.'" The two started getting together and bonding over drinks before Abu-Jaber up and moved to Beirut.

Hussein found himself in the Lebanese capital—and staying with his new friend—shortly thereafter. "I started coming out nine or ten times a year," he recalls, "mostly to see Saeed." The pair frequently holed up in one place to work, and posters became their medium. The streets of Beirut were inundated with quality designs, a driving force to better their own style while reveling in the form's ephemeral nature. "We love temporary things," Abu-Jaber says. "We can go crazy with them."

While Hussein remained bound to Amman, Abu-Jaber set his sights on landing a gig with a boutique studio, of which Beirut boasts many. But once again, Hussein came knocking. "Why don't you come back?" he asked. There was just one little thing, Abu-Jaber points out. "There were no small studios in Amman," he explains, "and your best bet was to be hired by an ad agency." Having worked at such agencies and for an independent actor like him, such a fate was unthinkable. "Okay, so we'll do something together," Hussein suggested. Being on the vanguard was better than falling in line.

The duo searched for sleek offices, eventually stumbling on something that they deemed even greater: an old garage. The two-floor structure was way too big, had been shuttered since the '80s, and would need a lot of work. Nevertheless, they took out a loan and called in favors for the services of the renowned local architect Sahel Alhiyari,

3

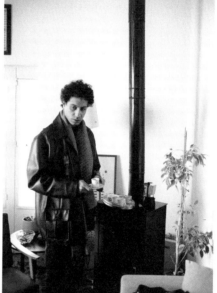

Framed works—like a yellow poster that the
Turbo team made for a show in Dubai with
their collaborators, the Bethlehem-based
furniture makers Local Industries, and a
photograph from their dear friend Mohammed
Zakaria in the dining room—line the walls
in Hussein's apartment. (4)

who kept the industrial aesthetic of the space while adding modern touches like sculptural lamps, a tinted mirror topped with a row of vanity lights, and a striped ceiling that pays homage to Gio Ponti's Villa Planchart.

Turbo's potent international output may give the sense that a mighty team is pulling the strings. They have crafted visual identities for the likes of Huda, a Levantine bistro in Brooklyn, the Lisbon art gallery Beirut Contemporary, and Amman Design Week. The media company Monocle featured them in its *Book of Entrepreneurs*, and WeTransfer's editorial platform WePresent tapped them for a takeover of its fifth print issue alongside design giants Eike König and Paula Scher. Yet, Turbo runs on the creative fuel of Abu-Jaber and Hussein alone. It makes complete sense, then, that they envisioned their large downtown digs at 45 King Hussein Street, with its inviting windows and plentiful foot traffic, as more than a two-man studio but also a lively gallery and event space.

When Bethlehem-based Elias and Yousef Anastas, the multifaceted brothers behind the architecture firm AAU Anastas and creative incubator Wonder Cabinet, launched their furniture company Local Industries, the Turbo twosome hosted a pop-up for their longtime friends. For a period of time, Ted Riederer's nomadic recording studio, vinyl shop, and art project Never Records took up residence. Abu-Jaber and Hussein hired a calligrapher to paint a scripted logo on one of the massive walls, which would ultimately inspire their unrealized venture, the in-house café Yes Yes Coffee.

For Hussein, drinking coffee transcends from mundane act to spiritual exercise. The artist designer is rarely farther than a few steps from a cup of the beloved brew, whether at shops throughout the city, delivered to the studio on King Hussein Street, or in his apartment. (5)

A long, window-clad balcony illuminates Hussein's bedroom and one of the chamber's primary occupants: a solitary Mike X-Lounge chair from Local Industries in galvanized, powder-coated steel, which is dressed with an ornate rug in complementary tones. (6)

A painting from the Egyptian artist Hend Samir
hangs above Abu-Jaber's dark teal couch. The
work reflects the varied hues of the sectional
and its colorful flower-patterned pillows. (7)

7

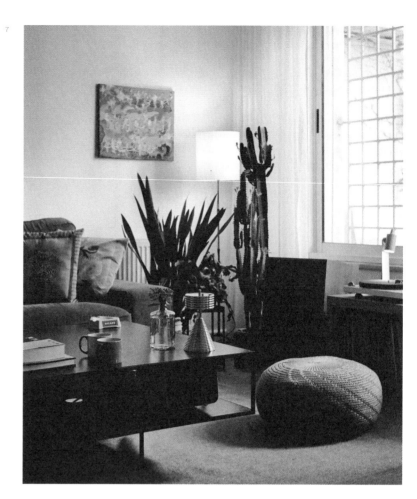

The Turbo studio and its founders' private
homes all share in the same design language
and flowing between the individual sites feels
more like moving between rooms of a house.
Abu-Jaber and Hussein have twin Local Industry
shelves in different shades, and Abu-Jaber's
dining room Ikea lamp matches one that lights
the lower level of the downtown space. (8, 11)

8

9

Abu-Jaber's gargantuan black cat,
Johar, is practically a design fixture
himself, with piercing green eyes that
match the potted plants and shelves in
the living room. (9)

They bring in DJs to host a party for their biannual print sale. The opposite wall sees a rotating display, often featuring some incarnation of Tawfik El Deken, the famed villain of early Egyptian cinema. His characters, who tend to go against the grain and exhibit a playful mischief, make him a patron saint of sorts at Turbo.

Such activations are the beating heart of the brick-and-mortar, but most days the pair can be found in the natural light oasis of Hussein's home office. This arrangement suits Hussein just fine, as the introverted artist-designer is more of a homebody anyway. His apartment feels like how the inside of his mind might appear, which is to say, everything all at once with a bit of organization for good measure. The bedroom features a cluttered desk and select objects, like a single chair in green steel and a framed needlepoint text. The open living space—its vintage glass coffee table, couches covered in textiles, and well-used stereo tape deck—abuts a corner where a baby grand piano plays host to various catalogues, magazines, and a living biosphere. Heaps of coffee cups sit on a drying rack in the seafoam-colored kitchen. The dining area houses a lineup of yellow floor-to-ceiling Local Industries shelves, which display trinkets and inspirational design objects from glass sculptures to a quirky candelabra. Photographs from peers and chosen Turbo pieces lean against the walls, and the breezy balcony is a favorite smoking spot and refuge for a world of plants. "Mothanna is an artist," Abu-Jaber says. "And an artist is someone who is constantly developing their tools." Hussein's office space represents that very notion in physical form. A 3-D printer is the latest in an ever-growing repertoire. But the tall display case where dozens of pairs of sunglasses wait their turn behind a locked door could be the crown jewel of it all.

The commute to the apartment that Abu-Jaber shares with his wife and human-rights advocate Hiba Zayadin is a short one. The overlap in style between him and Hussein is obvious. "But it's good that we don't have the *exact* same taste," offers Hussein. Abu-Jaber's garden level unit opens to a poppy living area. A water-wise bouquet of Lego flowers sits on a modern accent table at one end of the L-shaped couch, while a corner of mature succulents occupies the other. Far-flung finds like a vintage orange pendant lamp picked up on a trip to Italy adds a retro warmth. Favorite books, records, and knickknacks inhabit a series of shelves that match Hussein's in green. Abu-Jaber rolls a cigarette and flicks the burned end into a standing wooden ashtray. An ornately framed poster from the event where he and

Abu-Jaber's mother claims the portrait of her young self in an Aquarius T-shirt looks nothing like her, but the painting has nonetheless become an iconic addition to her son's home bar. (10)

10

11

Zayadin met is propped up on the wall of the dining room, which has a table big enough for two. The whole thing is a playful mashup of colors, textures, and patterns, but perhaps the most unmissable element is the finely honed hi-fi setup lining the windows. "Don't go down that road," Abu-Jaber jokes cynically. Each component of the system has been painstakingly researched or commissioned from master engineers. "It's a slippery slope, and you will never be truly satisfied."

Standing in front of an infamous portrait of his mother painted on her honeymoon, Abu-Jaber mixes a Sazerac. One thing is missing: lemon. Thankfully, his building is more akin to a family compound, so he drops in on his parents' upstairs apartment for the necessary citrus. His mother is an exquisite cook, who holds a certain celebrity status thanks to a stint hosting a televised cooking show. Many dinners convene around her table. In truth, it might be Amman's best restaurant. Though Abu-Jaber and Hussein could not be considered recluses by any means, they have adopted a certain mentality that can be summed up in a succinct question from Abu-Jaber: "Why go out when I make better drinks and have a better sound system than any bar in the city?"

Being comfortable at home became an asset when they, like most of humanity, became housebound in 2020. "All I needed was whiskey and steak," quips Hussein, before mentioning that he often walked two hours to gather with family for a proper meal. The harder reality, however, was that work dried up in an instant, and connection with the outside world abruptly shifted. Early on, Abu-Jaber and Hussein got a call from Bethlehem. In response to a growing regional trend, the brothers Anastas wanted to team up to start a radio station in collaboration with a fifth friend, Yazan Khalili. Before long, Radio Alhara was born, broadcasting over the Internet from Bethlehem, Ramallah, and Amman. Abu-Jaber and Hussein both hosted daily shows for months, playing through their entire musical collection and taking requests from listeners. Thanks to their extensive work on events posters, they had maintained a strong connection to the music industry. They reached out to everyone they knew, looking for talented people to help fill the remaining airspace.

The station proved popular, but it really took off during a Palestinian solidarity broadcast in June of 2020, a response to the Sheikh Jarrah controversy. What was supposed to last twenty-four hours quickly turned into five full days as their extended network chipped in from around the world to keep it running. "We got support from local leaders and heard from the likes of Jamie XX and Nicolas Jaar," recalls Abu-Jaber.

12

Hussein's surfaces reveal a beautifully chaotic symphony of objects that reflect a life lived without pretense. In the bedroom, humorously stoic passport photos of the designer with a tighter haircut alongside the same of his girlfriend decorate a mirror. The bedside desk is riddled with a smattering of daily use bits and bobs. Meanwhile, in the kitchen, mugs and ashtrays air dry in a mound, awaiting their imminent use. (12, 14)

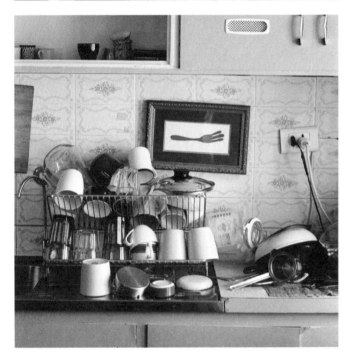

14

Being engaged with and bringing unique perspectives to political matters spawned the Sonic Liberation Front, which came to represent a solidarity with all people "from South Africa to Colombia," Hussein says. The station now gets heaps of submissions from DJs and audiophiles looking to land a slot. It's an open platform. "If you have good taste," Abu-Jaber clarifies with a grin. "I'm still the gatekeeper."

He insists on mixes feeling personal. "It's more interesting to know what people listen to at home," he says, "even, or maybe especially, when it comes to more famous DJs. Like, 'You and your girlfriend just woke up. What do you put on?'" Yet, when asked to get personal himself, he grows quiet. "We don't really have an approach," he says of his multifaceted practice. Hussein stares on, bemused. He lets Abu-Jaber take the reins on questions like these. "It's more like how an artist approaches his work," Hussein finally adds, taking a long drag from his Winston cigarette. "We're deeply connected to anything that we do."

Sometimes, forging such connection means finding space, and that's where living in the capital of a desert nation proves particularly advantageous. The expansive world of Wadi Rum, the largest valley in all of Jordan, is only four hours away. "We go there for silence," Abu-Jaber says. "It humbles you." It also forces the pair off their devices and recalibrates a modern-day sense of urgency. "You realize that it's okay to go away for forty-eight hours. The emails will wait," Abu-Jaber explains. "You play with stones and explore the mountains. It's revitalizing."

Back in their urban environment, they recognize that being on the forefront of a fledgling design realm has its perks, too. The comrades can champion the written form of their mother tongue, highlighting the beauty and versatility of Arabic type. They can employ the varied influences of their eclectic sensibilities and help dictate a burgeoning design language both within Amman and beyond. Absorbing diverse inspiration from the pop art of the surrounding gulf and desert states to the minimalist movement, from Jordan's vast and dramatic nature and Bedouin communities to the De Stijl school, the pair takes it all in, and puts it right back out.

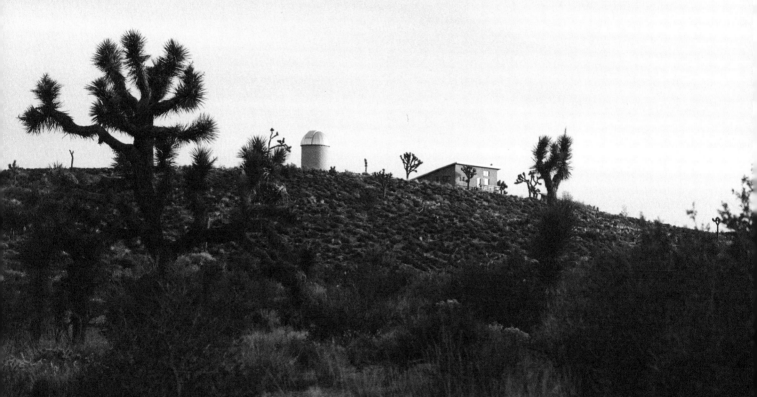

226

San Bernardino County, California

United States

SARAH LACHANCE

&

KYLE SIMON

STARS, STRIPES, PIGMENT, AND PAPER

The pair's set of tiered living room shelves showcases favorite pieces, including a wooden object by Dan John Anderson, which they utilize as a vase for dried plants, records from artists such as Alice Coltrane, and a diverse library with books like *In Search of Ancient Astronomies* by E.C. Krupp, *Genesis of a Music* by Harry Partch, Henry Miller's *Tropic of Cancer*, and Frank Herbert's *Dune*. (2)

Kyle Simon is a man of mystery, and he would prefer to keep it that way. The artist's location in the foothills of the San Bernardino Mountains is practically undiscoverable, so careful instructions are needed to achieve physical contact. It takes fifteen to forty-five minutes, depending on your driving style, along a four-wheel-drive path up rocky hills and through river washes to arrive from the nearest paved road. Being on site is a distinct privilege. And why shouldn't it be? Simon and his partner in life, Sarah LaChance, along with their two-year-old son, Cal, and their playful pups, have assembled a self-contained, multi-disciplinary universe. The off-grid, solar-powered hilltop property surrounded by centuries-old Joshua trees in the wilds of the Mojave Desert is the scene of their ever-evolving home, observatory, and artist print shop.

Simon, a Philadelphia native, grew acquainted with desert living while pursuing his Masters in Fine Arts, studying the physics of acoustics, at the Santa Fe University of Art and Design. After graduating, he apprenticed for printers in San Francisco, Los Angeles, and Barcelona before landing a master printer post at New York City's renowned Pace Prints. At Pace, he proved adept at dissecting his collaborators' work from both artistic and technical angles, and translating complex ideas across media became his forte. He worked alongside the likes of Kiki Smith, Tara Donovan, and James Turrell. While he earned his printmaking chops during the twelve-year stint, he continued to hone his personal practice, one which altogether belies classification, often combining painting, photography, musical instruments, interactive sculpture, unique sound devices, and performance within the same piece. He began diving deep into the worlds of astronomy and geology to understand human development, the Earth's history, and more. On excursions to upstate New York, Simon was expanding his understanding of telescopes when he was invited to participate

The house and observatory are
situated on high ground, while
the printing press is hidden
in a valley below. (1)

in The Outside Museum, a group-artist show in the rugged terrain of the California high desert. A growing interest in infusing astronomy into his work combined with the appeal of the dark skies of the Mojave solidified his decision to step away from New York and back into the area for a month-long stay at the Thousand Points of Light residency program helmed by the exhibit's curator, Chiara Giovando.

One month turned into two, which turned into an entire year. "I killed the residency," Simon laughs. "I never left." He put on shows across Southern California, teaming with different musicians to convert light from stars and planets into sound. He aimed to achieve a sort of synesthesia, a rare condition in which the boundaries between senses break down, as he interpreted stories. His particular brand of self-built instruments that he devised to achieve this light-to-sound decoding earned him the moniker of "Telescope Guy," and he frequently became wrapped up in heady conversations about aliens and deep space.

Simon was putting on these productions, selling his paintings and prints—even becoming a secret dealer of Jean-Michel Basquiat prints for a time—and gaining a foothold in the local art world when rumor of a mythical observatory hidden in the mountains appeared on his radar during a gig in Palm Springs. On his birthday, he and a friend went on a hunt. When Simon discovered the long-abandoned property, he was awestruck. Built by Dr. William B. Farrington and his children in the early 1970s, the carefully positioned observatory—and small adjacent house—was surrounded by a lack of light pollution and extraordinary darkness.

3

The never-ending views of a desert floor flush with Joshua trees, yuccas, and cholla cacti are at once a blessing and a curse. The landscape is an amusement park for the family of three—or five, if including the rambunctious dogs, Blue and Clementine—but in the singularly spectacular climes, Simon can also struggle to keep up with his own art practice. "Why compete with it?" he asks, ruminating on the intricate patterns, subtle colors, and diverse forms. "It's almost too beautiful in a sense." (3)

A section of counter in the living room—once the kitchen before
the cooking and dining space could move downstairs—houses the
couple's record player, books, and precious knickknacks. Behind
it, a stained-glass window and a bespoke door artfully separate
the sitting area and bathroom. (4)

4

5

LaChance, meanwhile, had completed a four-year run as
a teaching assistant in Japan before returning to her native
Connecticut to continue her career. Hungry for a change of
pace, she moved to Los Angeles to earn her master's degree in
TESOL—Teaching English to Speakers of Other Languages—at
the University of Southern California. She began making trips to
the desert, where she fell in love with the "peaceful and dramatic"
landscape. "There is an ancientness that you can feel," she says
with admiration. "The unpredictable layers of juxtapositions
kept me coming back." She and Simon began dating after
meeting at one of his performances. From there, they embarked
on a journey to discover each other and, through private one-
on-one shows from Simon, the cosmos.

All along, the observatory property "was looming large
in my mind," Simon says. He insisted on bringing LaChance
out. It was crazy, yes, but he wanted to glean her opinion on
moving to the isolated piece of land. Would she, he wondered,
ever consider taking such a mad leap with him? "I'm all for an
adventure," she responded. "Let's do it." With determination
and steely focus, Simon discovered who had been paying taxes
on the land and with little hope for reciprocation, opted to send
them a letter. The stars, as it happened, were aligned. What
began as a dream quickly recast itself as a reality. After selling
a series of prints in New York, Simon put a down payment on
the compound. He returned and proposed to LaChance on July
Fourth weekend. "It's a whole new life," he said. "We're getting
married. We're going up there."

A series of events ensued, in which one necessity gave
rise to another. The house was unlivable, "like walking into a
nightmare," recalls Simon. "Nature had taken over." Human
detritus and rat waste lay around every corner, but Simon had
a vision. While LaChance slowly phased out of Los Angeles to
become an elementary-age curriculum writer and consultant in
the region, the couple lived at a defunct motel in Joshua Tree
with other artists. Simon made the drive up to the property
every day to chip away at cleaning, basic construction, and other
tasks. After nine months of relentless effort and with the help
of friends, it became habitable—as in no-power, just-a-noisy-
generator kind of habitable. From livable, it slowly became
hospitable. The generator still rumbled, but they installed

In the hallway leading to the bedrooms, Simon
created a colorful frame directly on the concrete
for a yellow floor runner. Testing pigments and
plasters, some additions like this one have
lasted, while others remain in flux. "I can
always redo things or change them," explains
Simon. The house, as he sees it, should exist in
a state of constant evolution. (5)

A series of Martha Tuttle monotypes, in which she
and Simon printed found metal plates and segments
of handwoven fabrics, hang on the gallery wall
beside the family's kitchen. Intended to be
an ever-changing surface, LaChance and Simone
utilize the space to showcase their robust roster
of collaborators. (6)

6

CLEAR SKIES, FULL HEARTS

with Dr. Karl Gebhardt

Arid weather and a lack of artificial light make remote desert climes some of the best for stargazing—and you don't have to be a professional or have an observatory in your backyard like LaChance and Simon to enjoy gazing to the great beyond. In fact, Dr. Karl Gebhardt, who chairs the astronomy department at the University of Texas, explains that amateur astronomers might know the sky best. "We put coordinates into the telescope, and it does all of the work!" the astrophysicist laughs. Though Dr. Gebhardt is based in Austin, he frequently travels west to the desert surrounding Fort Davis, where he serves as the principal investigator for an experiment at the McDonald Observatory. There, he employs the Hobby-Eberly Telescope, one of the largest optical telescopes in the world, in an effort to produce the most extensive map of the cosmos and reveal the nature of dark energy. "In the middle of nowhere and from this tiny location on the top of a mountain," he says, "we are gleaning so, so much. Pretty cool, if you ask me." For those looking to connect with the celestial sphere, he suggests simply getting outside and away from light-polluted cities during the new moon, "when there are so many stars that you can't even distinguish the Big Dipper—that's when the universe comes alive." To look up, he posits, it's also worth looking around. Tools to help translate the sky exist in many forms.

ART

I recently went to a show at the Guggenheim focused on the Swedish artist Hilma af Klint. Her work connects the forces of nature and unseen particles. It's about spirituality, yes, but also connections in the universe and the multiverse. Even with the remarkable information that we get now, a lot of the ideas that I am exploring are truly conceptual. And so, Hilma af Klint's turn-of-the-century work really blew me away—people have been thinking about these things for a *very* long time.

FILM

If I'm watching a science fiction film, I'm not usually focused on the science. But *Interstellar* did a great job with higher dimensions, which is one of the harder concepts to understand. Though I had to watch it a few times, the 2016 movie *Arrival* really nailed the concept of time, which is something that science, math, and physics still all have problems with. These movies help us humans wrap our heads around what our brains might otherwise struggle to handle.

TECHNOLOGY

I lead these big classes of 250 students. They go to the telescope and say, "I can't find Jupiter!" My response? "Grab your phone." The apps that exist today can be awesome resources. I also teach a course for non-science majors called Popular Astronomy. It explores hot topics—how black holes are formed, what is beyond the observable universe—but also the ways that they can be distorted in the media. I always say that Wikipedia is pretty great. Scientists are so anal, and they ensure that these entries are written with accuracy.

7

8

When LaChance and Simon are away from home and wanderers make their way up to the private observatory, an attentive neighbor named JT gently stops them in their tracks. The couple, meanwhile, keeps an eye on the community from the watch tower above and has even called in local fires caused by lightning strikes. (7)

stained-glass windows, a wood-burning stove, and a green-tiled bathroom. They incorporated art, like a wood-block print from Yasu Shibata, into the space, and their neighbor in Yucca Valley, the sculptor Dan John Anderson, gifted them a hefty wooden totem to repel rattlesnakes. "It was like going back to school," remembers Simon. "We really learned a lot," from woodworking to plastering, solar panel management to roof repair and concrete pouring. As it turns out, he and LaChance were harboring skills they didn't know they had until a particular need arose. "It was all a big extension of my art practice," says Simon. "I see it as maybe the most elaborate project that I—and we—have ever done." And now, as they strive to move from hospitable to potential forever home, it's far from finished. They are transitioning a simple bedroom into a primary en-suite and hope to create a library in their upstairs office.

The decision had already been made to buy their first press when they found out they were having a baby. With new responsibilities on the horizon, things needed to change, and fast. Two months later, a slab was poured at the base of the hill below the observatory, the press was positioned, and a black metal kit building went up around it, all over the course of three days. Now, a roll-up garage door with screens provides views to the crooked, spiky trees beyond. Inside, machinery holds top billing, and supplies fill anodized aluminum shelves and a vintage red tool chest. Color tests and proofs hang on the walls. "We didn't choose to bring a print shop to the desert," Simon muses. "We chose the desert and returned, again out of necessity, to something I had done for a long time."

Necessity or not, in the time since it officially opened in early 2021, Farrington Press—named for Dr. Farrington, "the ruling spirit of the property"—has put together a small but esteemed list of collaborators. From artists including Lily Stockman, Matt Kleberg, Honor Titus, and Martha Tuttle to galleries like Gagosian, Timothy Taylor, and David Zwirner, the little press with no email address and no website has made waves. Farrington originals have graced the walls of institutions such as the National Gallery of Art, the Smith College of Art, and the Museum of Fine Art in Houston.

Farrington is decidedly *not* like other studios. Making the long trek to Simon's printmaking planet has a way of altering your headspace. It can feel like leaving Earth and its claustrophobic limitations behind. LaChance and Simon believe the minimal cell signal and inky nights of their isolated experience only contribute to enhanced expressions and deeper experimentation within their three-to-five-day sessions with artists. When someone arrives, Simon introduces them to the environment with a hike. "In other shops, they're like, 'Okay, go paint,' which is an intense thing to do," he says. "Sharing an experience in nature is a very quick way to form a bond." A meaningful connection and sense of trust are cornerstones of Farrington's production. "We're reaching a hand out and bringing these people into our world," LaChance and Simon explain. Whatever happens, the duo is along for the ride, and with each artist visit informing the next, they're building and learning on the fly.

9

LaChance and Simon restored the observatory's telescope—built by Dr. Farrington, purportedly with lenses that he ground by hand while off-duty on a World War II ship—to working order. Through the years and multiple owners, the sky-watching enterprise has remained a labor of love. (8, 9)

10

Simon has amassed a number of works, often proofs reserved for printers and artists, through his time in New York and into the desert with his new venture, Farrington Press. The master printmaker frequently revisits pieces, like a recent pair of monotypes from San Antonio's Matt Kleberg, which he co-published with Josh Pazda Hiram Butler gallery. (10)

11

12

LaChance and Simon understand that the demands of running a high-level operation such as theirs in such a remote locale are numerous. Everything needed to operate, from paper, ink, and rollers to basic necessities like water for the house and studio, needs to be hauled in. They diligently maintain the print shop, ensuring that it is ready for the next artist's arrival. Shelves, magnets, hooks, and small containers keep materials visible and at arm's length. (11, 12)

Looking to the past to move forward: Tomes
on the recorded history of printmaking
continue to inform and inspire Simon's work
at Farrington Press. (13)

Fragments of color tests serve as memories
of previous sessions and guidance for
residencies to come. (14)

13

14

The same can be said for parenting. "When I was pregnant," LaChance recalls, "I was like, 'Should we be doing this up here?' But I also realize that it is one of the most magical places for a kid to grow up." Cal is the first child to be raised on the mountain—among a small but fiercely protective and loyal community—in twenty-odd years. LaChance and Simon marvel at his relationship to nature and, in spite of living in a less-populated land, to people. "Being out here has created a real sense of self-determination in him," LaChance continues. "He wants to figure things out as he goes." When the artist Mary Weatherford was in residence, Cal walked down the steep, stony driveway for the first time, figuring out how to brace his tiny body as he descended to his father's workspace below.

When Simon isn't entrenched in the print shop, he can often be found tinkering in the observatory, a monumental representation of his other long-held passion. To return the dormant star-watcher back to its former glory—and improve it—Simon and a few select helping hands got to work. He sealed the leaky interior and with a portion of native clay, the exterior. He put in a bespoke, steel spiral staircase, which leads to a wooden hatch of his own design. The entire floor was reinstalled in a starburst-like circular pattern.

Tapered boards of various wood species all point to the telescope's base. The dome, which hadn't budged or let in light for four decades, was hooked up to motors to pivot and operate the window. Simon turns on an LED light show and plays Claude Debussy's "Claire de Lune" as the retractable metal panel slowly reveals the desert expanse and clear sky. Though it's midday, he holds Cal up to the oculus as he mimes looking into the great beyond.

Later, as the sun sets, Cal marches up the ridge—the very one that he perfected climbing down—with a toy bulldozer, one of many in his collection of model trucks. The toddler's obsession with practical-machinery miniatures may not be a direct result of the family's remote, self-reliant lifestyle, but it certainly doesn't go against it. "We've been teaching ourselves—and Cal—to take on as much as we can handle," says LaChance. "And to be able to recognize how to get yourself through whatever situation you're in," adds Simon. Their house on the hill may be the strongest example of that notion. The "to be-continued" nature of the original structure made extending the roofline a no-brainer. The expansion created space for a lower level that houses the two bedrooms and a kitchen that opens up onto an outdoor patio. The duo eventually transformed their makeshift cooking

set-up into something permanent with custom wood cabinetry and countertops. The wall beside the four-top dining table becomes a small-scale rotating exhibition space for framed pieces from the print shop. A lofted living room, office, and bathroom with an attached deck completes the one-and-a-half story structure and is connected to the ground floor by a wooden staircase. "We had originally planned for steel," Simon explains. "But we realized that this was a more natural way to go," harkening back to the house's days as a homestead cabin.

From the beginning and since they moved in, there have been many trial-and-error advancements and a few backtracks. Next on the docket: blending in with the raw nature. "I'm trying to have the house disappear," says Simon. Though they live next to a landmark—their very own sky tower—they don't want their presence to compete with the majestic desert vistas. They evaluate different plasters, but they know that these efforts will, too, be a learning curve. "I have been curious about a technique," the multifaceted maker continues. He explains a complex process where newly stuccoed surfaces are dusted with a material that oxidizes to form coppers and rusts. "I enjoy that the process is hard," he asserts. Pushing against the worldwide trend of everything being available and easy all the time, LaChance and Simon revel in the challenges. "Sometimes I get overwhelmed and emotional," Simon admits, "but the bigger part of me says, 'Let's get stronger. Let's get better. Let's grow.'"

15

Remodeling the house, which featured tags like "Believe in Satan" on the walls, seemed a titanic undertaking, but tackling it corner by corner made the endeavor approachable. Creating small sanctuaries, such as a bathroom—replete with a tub, concrete countertops, a ceramic sink painted with flowers, and green tiles with blue trim—proved paramount. (15)

16

"He is just so agile," LaChance says of her toddler, who has grown up "being able to just run out into nature." Cal and his collection of dump trucks and diggers maneuver through rocky outcroppings and around cacti with ease. No need to build a backyard playground—he already has the world's largest sandpit. (16)

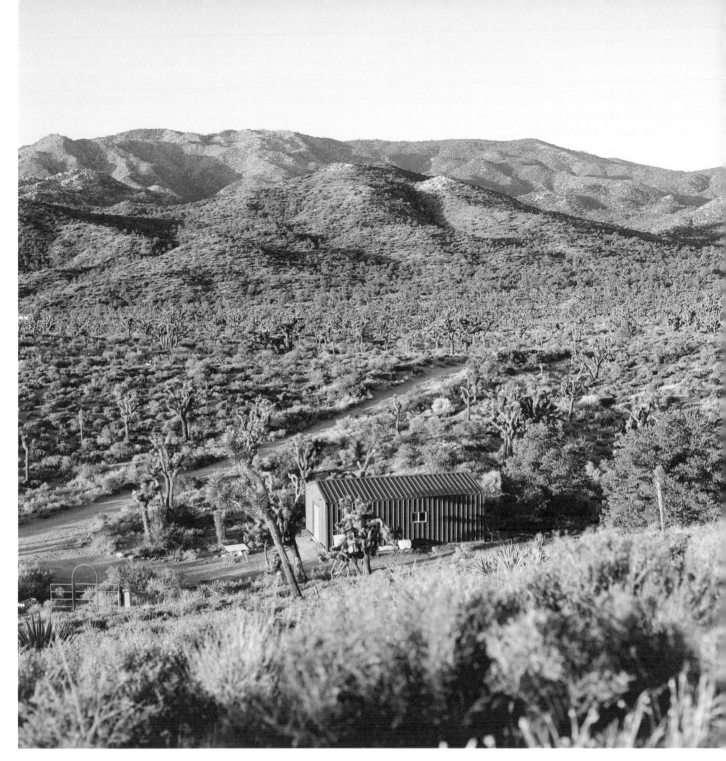

17

From the soft-hued steam that rises from the earth
after a desert rain to the technicolor blaze of
the Geminid meteor shower and otherworldly cloud
formations, artists that choose to work at Farrington
Press often become influenced by the shades and
shapes that appear on the landscape and in the sky,
infusing them into their work. (17)

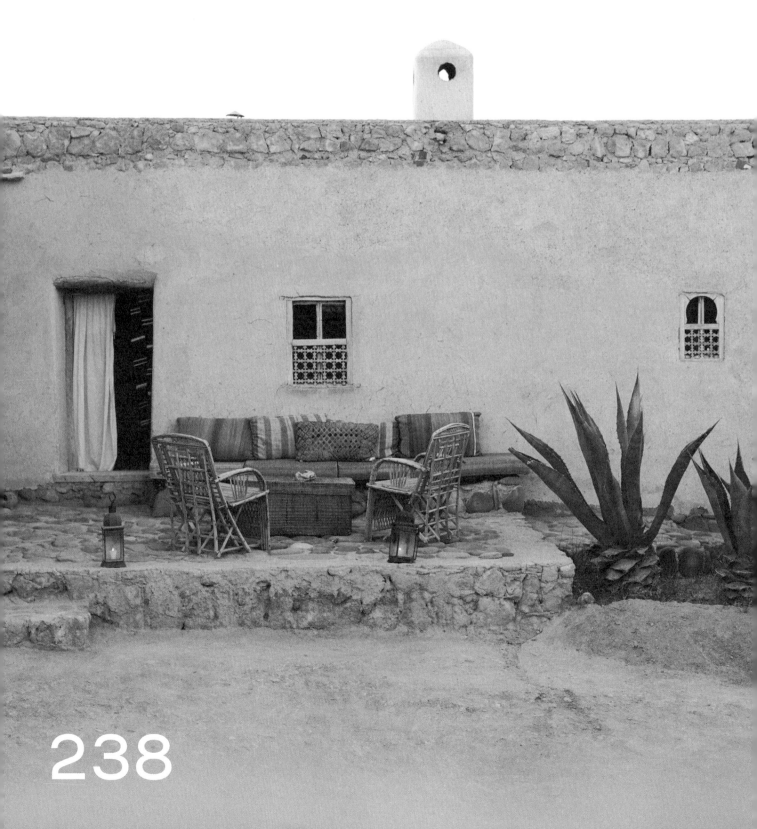

238

KARL FOURNIER

OLIVIER MARTY

JEAN-NOËL SCHOEFFER

SURROUNDED BY SILENCE AND SKY, A FARMHOUSE MADE WHOLE THROUGH FRIENDSHIP

Jean-Noël Schoeffer throws another log into the fireplace and sits down in a large leather armchair. His faithful Jack Russell terrier, Jackie, flies onto his lap. She curls up before bounding off again to greet an incoming guest. Welcome to Dar Rbaa Laroub, Schoeffer's home and riad nestled within the winding alleys of Marrakech's medina. Though his thick accent, style, and movements feel unmistakably French, the long-time expat has made himself into an indelible fixture within his adopted country. In a quiet corner away from the madness of the souk, or market, the seven-room oasis and one of the oldest private guesthouses in the city has been host to savvy travelers willing to stray from the beaten trail since the early nineties. "My passion is to live my life in nice places," Schoeffer says. Though the riad is where he most often hangs his hat, there is another house—a rustic courtyard property some forty-five minutes away—that has earned his particular brand of devotion. After all, his intimate island within the metropolis is inextricably linked to the openness of the Moroccan wilds beyond. In his mind, one cannot exist without the other.

Schoeffer is a man of few words, and what he does say is generally to the point—but his reserved nature should not be confused as gruff or uncaring. Those who are closest to him, like Karl Fournier and Olivier Marty, know that he loves deeply and often. Some people gift clothes, bags, and cars. Others, like Schoeffer, gift community, places, and opportunities. This is a story, then, that hinges on mutual respect and humans, often from wildly different backgrounds, giving the very best of themselves to other humans. It begins long before Fournier and Marty were spoken of in the same breath as Yves Saint Laurent, Pierre Bergé, or Hermès, before "Karl and Olivier" were rapidly uttered as a single name, before the birth of their formidable firm, Studio KO, which

Schoeffer's market haul lies in wait in the dining room adjacent to the farmhouse kitchen where Fatima prepares meals. "We're a real family," Schoeffer says of the cook and her husband, the property's caretakers. "They respect me, and I respect them. They have given me so, so much." (1)

1

The salon at La Ferme Kilomètre 33—
formerly the primary living space for
Salek and his family—is encircled by
natural fiber wall coverings and rugs,
as well as palm-woven chairs adorned
with shearling. (2)

2

3

designs boutiques for Aesop and Balmain, hotels like
London's Chiltern Firehouse, and residential projects
including the Flamingo Estate in Los Angeles.

Instead, it starts when Fournier and Marty
were young architecture students in Paris. They were
looking for a destination to travel with friends. What
began as a group of ten renting a house in Morocco
narrowed to four when, "like in an Agatha Christie
novel, they started dropping out one by one," laughs
Fournier. The plan was sidelined until someone—
"like a spirit in the air"—overheard their dilemma at
a party in Paris and urgently said, "you should go to
Jean-Noël's."

Fournier had traveled to various parts of the
North African country in his youth, but it was Marty's
maiden voyage. An eye-opening stint at Dar Rbaa
Laroub quickly turned into another. Schoeffer took a
liking to the duo and started bringing them to little-
trafficked spots, wide expanses of desert, and tiny
villages. Fournier insists that he and his partner—in
business and in life—developed an adoration for
Morocco thanks in no small part to "discovering it
through Jean-Noël's eyes." At the time, Schoeffer
shuttered the riad during summer and returned to
Île de Ré on France's central Atlantic coast to tend to
his former restaurant. "Why don't you come for July
and August to take care of things while I'm away?"
Fournier recalls Schoeffer asking. The couple happily
obliged, running the show in Schoeffer's absence and
tending to a small smattering of guests. "The job was
really easy," says Fournier, "and in those months, we
truly fell in love with the country."

At the end of that fateful summer, things got
even more serendipitous. Heading back to Paris, they
crossed paths at the airport with their friend Pascale
Mussard, who belongs to the sixth generation of
the family-owned megabrand Hermès. "Suddenly,
she asked us if we had any interest in doing work in
Morocco," Fournier says. A couple of months later,
they got a call from Mussard saying her uncle was

The trio made painstaking efforts to adhere to
specific elements of the region. In bedrooms,
minimal windows protect the privacy of inhabitants
and self-regulate temperature, while design
choices like an elaborate ceiling painted with
traditional Berber patterns and flea-market
finds give the impression of having existed over
generations. (3)

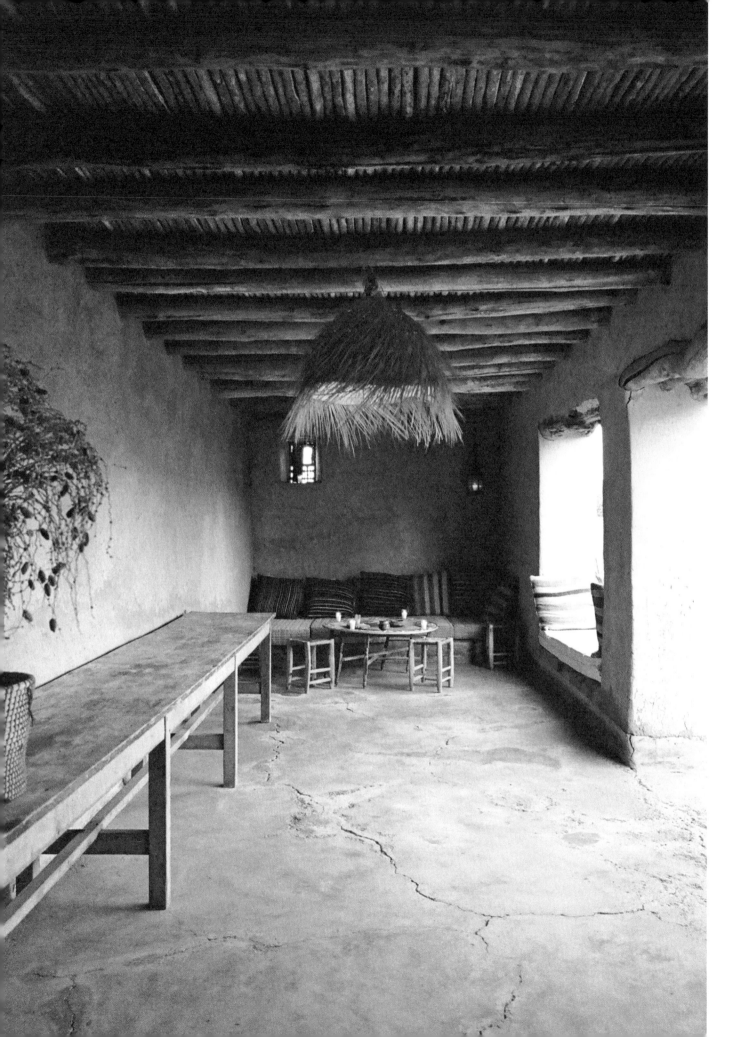

When Schoeffer arrives at the rural
property, he first sets the mood by
playing music—artists like Dorsaf
Hamdani, Javier Limón, Laura Marling,
and Dhafer Youssef—from a small speaker
hidden at the back of the space. His
thoughtful playlist seems to further
animate the grass lamp, wooden stools,
and woolen cushions that accent
the covered terrace, which overlooks
the garden. (4)

4

looking to build two houses in the north of the country. He wanted to be involved in the project and steer clear of egomaniacal architects. Fournier and Marty fit the bill perfectly. The ball began to roll. Their rapidly growing reputation for clean lines and a keen respect for materials, landscape, and setting led to more clients in the region, and eventually, an office in Marrakech to complement their Parisian base.

Meanwhile, on a Friday outside of the city—"I know because it was the market day," explains Schoeffer—a man named Salek was attempting to cross a rushing river with his donkey. Standing on the other side, Schoeffer happened to witness the farmer and his reticent quadruped, and decided to offer a hand. "I walked through the river, and he asked me to follow him," explains the hotelier. The two searched for another way to the market to no avail. As a show of gratitude for the companionship, Salek invited Schoeffer to his land, an encounter that would pave the way for so much more.

Salek's house was a simple one. His family's home life revolved around just a few rooms, and furniture was cycled in and out to accommodate the needs of sleeping, eating, and hosting. Other adjacent mud-brick structures existed for the shelter of animals and various farm uses. A warm spirit radiated from it all. Schoeffer had been entranced by the hospitality and giving nature of the hillside hamlet and had spent many a day and night on the property when he invited Fournier and Marty to join. Further disparate worlds began to collide. "A young gay couple from Paris and a

5

Schoeffer is a soft-hearted animal
lover and likes to spoil his four-legged
friends, often passing them small bites
of fish, meat, and even French fries
from the dining table. (5)

Before taking on the farm, Fournier considered constructing a "manifesto house," a brutalist statement piece, elsewhere in the Moroccan desert. "Olivier was absolutely against the idea," he laughs. Alongside Schoeffer, the Studio KO duo ended up on the right path. "Creating with as little impact as possible," Fournier continues, they established a real retreat. (6)

6

7

8

Djellaba robes hang on wooden rods beside the bed. The Berber outer garment is a quintessential element of Moroccan and Northern African culture and a welcome layer to help combat chilly evenings in the Agafay Desert. (7)

An intricate doorway and simple cotton sheet separates the exterior corridor from the sheltered sleeping quarters. (8)

9

While fireplaces remain uncommon in these parts and wood
often proves expensive, the features are a quality-of-
life necessity for Fournier, Marty, and Schoeffer. They
keep bedrooms warm in cooler winter months when nighttime
temperatures plummet, but they also add an unparalleled
multisensory ambience. (9)

Moroccan farming family," Fournier ponders. "We couldn't speak Arabic, and they couldn't speak French. Nevertheless, we became friends."

The connection was potent. For Fournier's thirtieth birthday, Salek and company cooked a couscous dinner for a group of seventy. Weddings of friends and other intimate events were held on the grounds, too. Fournier and Marty would come spend the weekend or pop in for a quick hello and a cup of tea. The cache of fond memories amassed over time made the news of Salek's departure all the more difficult. The gold-hearted transplant from Morocco's southern coast had grown homesick and decided to return to his roots. Fournier takes a moment to consider how to describe the feeling, opting to use an apt phrase in his native tongue. *"On reconnaît le bonheur au bruit qu'il fait quand il s'en va,"* which roughly translates to "we recognize happiness by the noise it makes when it leaves." The life change put the three Frenchmen at a crossroads.

Schoeffer quickly came up with the idea to buy the plot, at the very least to maintain the structure for fear of the raw building materials' inevitable decay. Complex rules and regulations made that notion impossible, but he, Fournier, and Marty discovered the next best thing: a ninety-nine year lease. All parties agreed, and the three began restoration of their treasured home away from home. "We thought that we could do a bit of work but leave it largely as it was," Fournier says. That concept was quickly thrown out the window to accommodate their specific needs. Though only one original wall remains, the rebuild, which consists of time-honored Berber techniques and natural materials of mud, chalk, palm, and eucalyptus, kept the exact same footprint as Salek's family farm. Water consumption is a constant and critical concern, so the initial plans for private toilets and showers were tossed in favor of two shared bathrooms. Doorways were kept low, and the courtyard unpaved. "I absolutely did not want to disturb the harmony of the

village," emphasizes Schoeffer, who had cultivated the respect of locals over years. Integrating within the landscape and the vernacular was paramount.

The openings between the thick, earthen walls are like small tunnels, requiring conscious intention to cross. Schoeffer and Fournier, both avid thrifters, pride themselves on the one-of-a-kind doors that they sourced from souks throughout the country. Each one varies in weight and dimension, and requires a certain set of tactile movements to operate. The updated interiors of the building with no real name—referred to as La Ferme Kilomètre 33 for its approximate thirty-three kilometer distance from Marrakech—feel like they are stuck in time. Sturdy sticks suspend from the ceilings to hang clothing and over the low-slung doorways, where simple, translucent textiles create a soft transition between inside and out. Green ceramics from Tamegroute, Berber-painted ceilings, handwoven rugs, and antique wooden chests punctuate the space. Vintage, foggy mirrors prop against mantels, while faded black-and-white photographs and paintings decorate the otherwise minimally adorned walls.

Keeping with its austere aesthetic, the remote compound lacks modern tethers of Internet connection and phone reception but boasts bountiful comforts. Each of the six sleeping quarters contains a wood-burning fireplace. An added second-story tower leads to a rooftop bed for stargazing. A vegetable garden provides fresh produce for home-cooked meals served in various corners depending on the season and time of day.

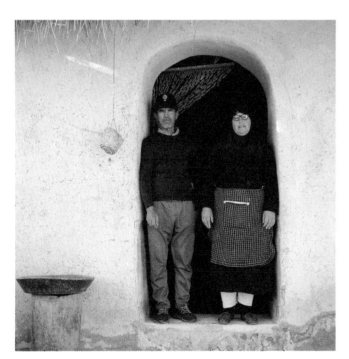

10

Fatima and Omar, the formidable couple that ensures the farm's gears stay in motion, take pride in maintaining the project that they have watched evolve over years. They can easily keep a close eye on things when Schoeffer and the rest are absent, as their own homestead in the tiny village is no more than a few paces away. (10)

11 12

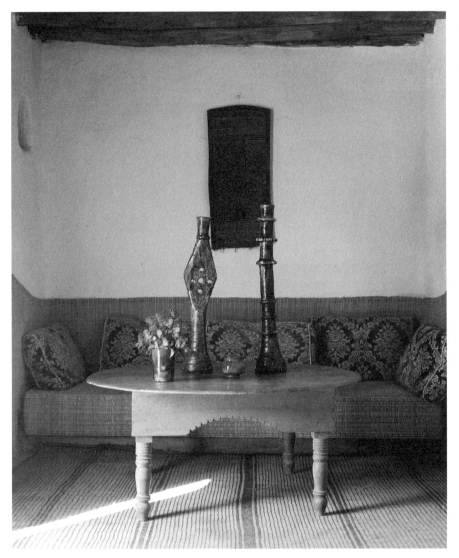

Aside from the naturally beige tones
of the mud, plaster, wood, and stones,
another color prevails. From the table
and chairs beneath the shade of an
old olive tree to dining sets and the
ceramic candle holders from Tamegroute
in the salon, greens stand prominently
on display. (11, 12, 13)

13

Mealtimes are celebrated at the farm, and every component, down to the serving spoon, is considered. Several large tagines—heavy-bottomed pots with tight-fitting conical lids—carefully displayed like design objects, take their place on a ledge outside the kitchen. (14)

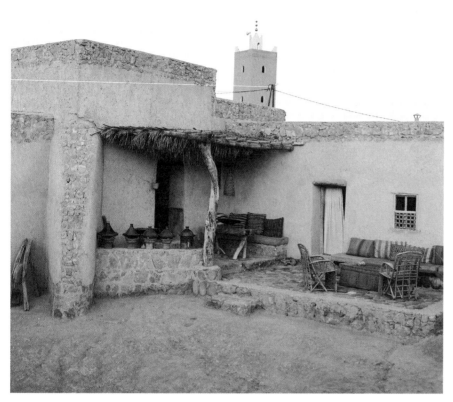

14

15

Though chimneys are nearly absent from town life, the many that exist on the roof of the farmhouse are designed with soft edges and small openings to blend in with the surrounding homes. "It's more well-groomed. It's more well-dressed. It's more imposing than the rest of the village," Schoeffer says of the house. "But we try to be fair in relation to the people and in relation to the country. It's very important." (15)

A wood-fired hammam for steaming and bathing offers a perfect transition of body and mind from the vibrations of the bustling city to the quiet solitude of the Agafay Desert. When the sun goes down, candles become omnipresent, drenching the rooms in a golden glow. The property's managers and old friends of Fournier, Marty, and Schoeffer, Fatima and Omar, breathe life into the farm and make it the kind of home that sucks you in and doesn't let go.

With the addition of a son and careers that have done anything but slow down, Fournier and Marty visit the farmhouse less often than in years past. For the trio's own sanity and the protection of the village, it has never been a guesthouse but rather a personal retreat to bring dear friends and family, to break bread, and to share in one another's warmth. But having a place for their own pleasure that sits unoccupied much of the time felt wrong. "Sometimes when I'm tired and need a rest, I'll escape to the farm in my head," says Fournier. "Even when I'm not there, it's still on my mind. It's a way to calm down." To spread the positive energy that emanates from Kilomètre 33, they have opened it up for a select artist residency program, cultivating a community of like-minded people. Fournier regards the house as a living thing. "It needs sustenance, and it needs to be shared," he says, and so he, Marty, and Schoeffer provide a platform and an opportunity for people to engage with and give back to it.

Nonetheless, it is still a sacred sanctuary for them and especially for Schoeffer when he needs reprieve from his urban universe. After navigating dusty dirt roads, he parks his car outside the gate. Jackie hops out of the front seat, whimpering with excitement to be back at her second home and with her resident feline friend. Schoeffer and Omar begin unpacking bags of groceries from the trunk. The enormous square-shaped door creaks open onto a long corridor, and Schoeffer ducks his head to enter the courtyard. Fatima awaits with open arms, throwing him into the kind of hug reserved for long-lost family. After settling in, the property goes quiet. Fatima cooks in the cozy corner kitchen. Omar sets out dozens of candle-filled lanterns and trims branches of pink bougainvillea, placing them in bouquets that suddenly appear at every turn. Schoeffer puts on a gentle playlist and settles into a sunny spot, reading a book grabbed from a recess in the wall. He smokes a cigarette and flips pages with Jackie by his side.

As the sun dips behind the surrounding mountains, the aromas from the kitchen grow increasingly intoxicating. Calls to prayer ring out and fade with the day's light. Schoeffer stokes the fire and sits down at a coffee table delicately set for dinner. Fatima emerges into the room with a tagine, opens the lid to reveal chicken sizzling in an unctuous olive sauce, and smiles with pride. Schoeffer pours a glass of wine and leans back. "I'm not an architect, and I'm not a designer," he says. "Karl and Olivier have been the best influences of my life." He scans the room, recalling the more than two decades of mental souvenirs that he has collected here alongside Salek and his family, Fatima, Omar, and theirs, Fournier and Marty, and the countless loved ones who have graced the farm. All of these residents and visitors have contributed a part of themselves, collectively stitching together the fabric of this place. Fatima returns with a large bowl of freshly made chocolate mousse—her secret ingredients make something of a French-Moroccan culinary crossover. Schoeffer dips a spoon into the bowl. "This house is something that I did with the best of friends," he says quietly. "It's all just a dream."

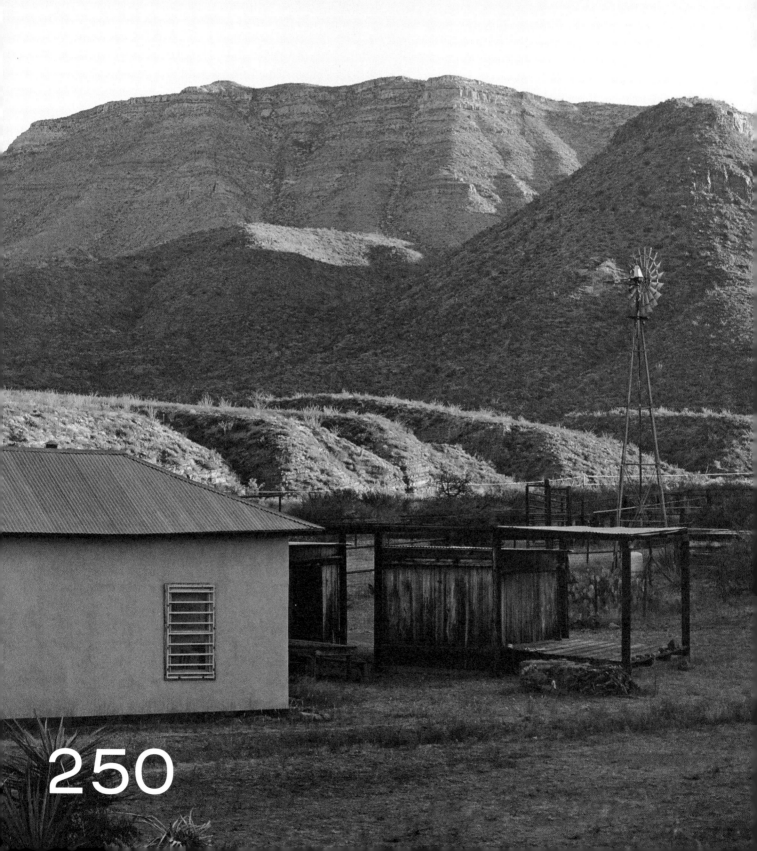

250

DONALD

JUDD

IN THE SHADOW OF MOUNTAINS, A RANCH HOUSE TURNED ARTISTIC REFUGE

After the artist Donald Judd's premature death, the result of lymphoma, in 1994, his two children, Flavin and Rainer, found themselves faced with the momentous task of not only managing their father's estate but preserving his legacy. They also found themselves with inextricable ties to the desert. Flavin likens spending time in the wide-open West Texas lands where he grew up to drinking water. "There's only so long you can go without it," he muses. While Rainer became president of the Judd Foundation and now helms the ship from Marfa, Flavin took on the role of artistic director. He currently calls Paris home, and despite his evident penchant for the French capital, he acknowledges that it will always lack a certain *je ne sais quoi*. He is, after all, a self-proclaimed "desert boy," and his mind will forever wander to the ranch. "I have trees to trim. I have fences to mend," he says. "I have to get back."

Flavin inherited his love of the land from his Missouri-born father. Donald Judd, frequently considered the "high priest of minimalism" despite an aversion to the title, developed a successful practice in New York only to become dissatisfied, confined by the limits of urban life and the city's art scene, which he described in a 1985 essay as "harsh and glib." After scouting trips to in Mexico's Baja California, he landed on the American Southwest and ultimately, the Big Bend region of Texas that he had first laid eyes on in 1946. A soldier traveling by bus from Fort McClellan, Alabama, to San Francisco, Judd sent a telegram to his mother depicting the "beautiful country mountains" that he would come to call home in the early 1970s.

The artist wrote that he chose the town of Marfa, where he would create spaces conducive to living, working, and establishing permanent installations, because "it was the best looking and most practical." Its practicality partially lay in its proximity to even more remote locales. "He liked being connected to the land, experiencing it," says Flavin. "You just can't do that in town." And so while Marfa and Judd seem inseparable today, it's impossible to understand his relationship to the place without looking south. There, fifty some-odd miles toward Mexico, off an unpaved dirt road, and just beyond a cattle gate, sits Casa Perez.

1

2

With a constant slate of varied projects, places of rest proved invaluable to Judd. The secondary bedroom features a daybed—its functional form a reflection of the basic human need for recovery—of his own design. (1)

"The space surrounding my work is crucial
to it," Judd wrote in a 1977 text. "As much
thought has gone into the installation as into
a piece itself." At Casa Perez, he paired
his geometric, industrial sculptures with
understated furniture, like rustic Mexican
tables and chairs. (3)

3

The house is the second of three—and the most accessible—that Judd would purchase on the 33,000 acres of land that he acquired and collectively labeled Ayala de Chinati. "At the ranches, you understand why Don was actually in West Texas," says Flavin. In this rugged stretch, where ocotillo, yucca, lechuguilla, and sotol plants stand firm in the rocky soil, it's hard to see emptiness. Rather, this is a place punctuated by life, by light and colors, and raw geology. "You can spend a whole day looking at one square meter of that desert," says Flavin. "Then, you can look up and out over forty miles of the river valley. It's amazing."

Its magnificence made an enormous impact on Judd, who worked hard to minimize any new development in the area. Instead, he made updates to the likes of Casa Perez, a modest adobe home built in the early 1900s and nestled into Pinto Canyon. The two-bedroom construction, which formerly served as the primary dwelling on a goat ranch, needed certain amenities but instead of adding to "its conventional aspects," Judd built separate structures for shade, bathing, and storage.

He filled the house with treasured items from Mexico, furniture that he designed himself, and of course, books. Judd was a supreme bibliophile, and the ranch proved advantageous for his brand of voracious reading. "There is an incredible amount of daylight," Flavin explains. "In the summer, you have sixteen hours and with the heat, there's a limit to the amount of work you can do outside. You read there, whether you like it or not."

4

Today, visitors, who range from participants
in Ranch Day, an open house of sorts, to close
friends of Flavin and Rainer, record their
names in a guestbook at the front door. The
leather-bound volume is emblazoned with the
Ayala de Chinati ranch brand, a logo that Judd
designed himself and also stamped on his truck
and the exterior of his Marfa office. (2)

When people think of Judd, they often think of
art—his own and the works that he collected
from others including Yayoi Kusama, Josef
Albers, and Rembrandt but he was also a man
of objects. On trips abroad, he frequently
shopped, seeking out everyday pieces crafted
with integrity, like a wooden spoon, ceramic
candleholder, or metal pitcher. (4)

5

Judd leased property south of Marfa, which he used for camping trips, before beginning to purchase acreage—and his first ranch house, Casa Morales—in the mid-1970s. He came to consider greater Presidio County home. "I'm a resident here and I vote from the ranch, so I'm a resident, not of the town, but of the county," he told the journalist Regina Wyrwoll in his final interview. "I feel it's my job to be a citizen somewhere. And it's my job to interfere, and it's my job to try to make it better." (5)

"Don liked the landscape because you could actually see it," Flavin recalls. "It's clear. Time is evident." In the early days, he would often pile into the pickup truck with Judd and his studio assistant Jamie Dearing, setting down rough dirt roads and over boulders. After becoming landowners, the family explored more frequently by foot. (6)

6

7

Rainer and family often explored stretches off the beaten track, finding themselves among rugged rocks, cacti, and sometimes even cows. "Cattle should be supported," Judd once said, recognizing the importance of livestock to the region's economy. But the artist only kept a small number of animals in his time out West. The land had been overgrazed, and for him, nature took precedence. (7)

8

Always with a keen sense of a building's
history, Judd named his second ranch house
for the Perez family, who tended goats on
the property in the late 1940s. (8)

Judd also installed art at Casa Perez, something he hadn't done at the first ranch house, Casa Morales, and would go on to do more of at the third, Las Casas. A multicolored work in the bedroom contrasts the white wall and simple platform bedframe, and in the dining room, an anodized aluminum and red acrylic piece provides a pop of color. Judd hung compositions from others, too: a map, hand-drawn by his longtime studio assistant Jamie Dearing, and *Mala Noche*, an etching from the venerated Spanish artist Francisco Goya. As with Judd's other now-iconic properties, the art, architecture, and many of the objects are preserved exactly as he left them, a stipulation he had made in his will.

"I think I probably have a different idea of what is an agreeable space than that of most architects and most people," Judd admitted in a 1992 interview. "I think it's very important to have a connection with the outside and that the inside and the outside are not separate from each other." In this sense, Judd was successful at Casa Perez. To this day, the house

encourages a relationship with the natural world. "You know, 99 percent of the time you're sitting on the porch watching the sun go 'round," Flavin says. "Or you're having dinner or drinks of some kind outside." Now, the Judd Foundation periodically opens the rarely toured residence for Ranch Day. It is an opportunity for the public to not only explore the structure but also to dive into Judd's connection with local flora and fauna and converse with experts about conservation and other environmental issues under the two large pergolas he built in the 1980s.

Flavin—and his sister, Rainer—still spend significant time at the property, alone and with friends. He has graduated from sleeping almost exclusively outside to the daybed in front of the fireplace but sticks to the staples of his youth: a pot of beans, a black-and-blue steak, and tortillas. "It's in our system. Rainer and I, we can't leave it," Flavin explains. "People say you can't ever really go home, but if you don't move anything, it's right there, exactly as it was forty years ago. It's completely stable and static,

which most people don't want and don't strive for, but it has a certain quality amongst the landscape, one which also hasn't changed but for millions of years." As Flavin describes it, Judd "made his own little country" in these parts, and he and Rainer remain its most ardent citizens.

As it happens, their father's presence endures—and not just in the spiritual sense. In the years leading up to his death, he increasingly spent time in the borderlands below Marfa and in a 1989 interview, he noted that he was "slowly moving to the ranch." Thus, when he passed away unexpectedly at the age of sixty-five, his children laid him to rest in the very wilds.

"To me, it's not the middle of nowhere," he said in an interview during the summer of 1993. "As I said, it's the center of the world, and it's basically because I like the land and I like to be here. A rancher once said to someone who criticized his piece of land, which was very barren—you know, asked him why he had it—he said he had it and he liked it because it held the world together. If you took it away, the world would fall apart." Years later, Judd's three beloved homes—Casa Perez, Casa Morales, and Las Casas—and the desert expanse that they occupy continue to hold his world, his center of the universe, together.

Though Judd wasn't much of a cook---his children recount stories of thick, burned steaks and vegetable crudités---the artist passionately accumulated kitchen utensils and dinnerware. (9, 10)

9

10

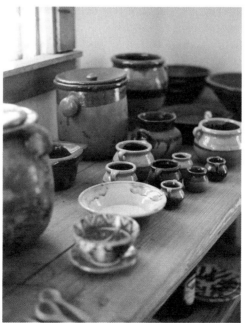

TAKE ROOT

with Jim Martinez

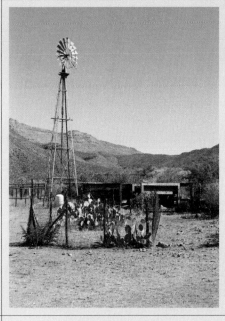

Water is the source of all life, and at Casa Perez, Judd introduced features to sustain humans and plants alike. He built platforms, which surround the water tank at the base of the windmill, to provide access to the tank for swimming and a designated place for sunning. He also installed twenty-eight evenly spaced faucets across the property to create an irrigation system.

"I've never built anything on new land," Judd wrote. A staunch believer in keeping nature wild, he only developed structures, like his system of outdoor furniture and pergolas, for absolutely necessary functions and, in this case, shade.

In West Texas, Jim Martinez might be considered the patron saint of native plants. He is a soil scientist, water-wise landscape designer, co-author of *Marfa Garden: The Wonders of Dry Desert Plants*, board president of the Chihuahuan Desert Research Institute, and one of the region's most coveted experts. Alongside Judd's daughter, Rainer, Martinez is also the mastermind behind the grounds restoration, an integral part of the Judd Foundation's overall conservation mission and an extension of Judd's own beliefs, at Casa Perez. "Leave it alone or return it to its natural state," the artist would say. In Marfa and beyond, Martinez has perfected the art of making that return a community-focused, fun affair. He frequently works alongside volunteers. "We cook up breakfast and lunch," he says. "It is essentially a big picnic." And then bit by bit—whether by way of seeding or mulching—he and his crew work to rehabilitate the precious desert ecosystem. Being well-fed might be his biggest secret, but he has a few other tips and tricks up his sleeve, too.

Learn your land. I always tell people, "If you don't know where you come from, you don't know what you can produce." Understand the history, geology, and natural environment around you, so that you can make an assessment about what you have and what you want.

Watch, read, and listen. There is so much information out there. Look to local and national organizations, like the Native Plant Society of Texas or the Natural Resources Conservation Service in the United States. Check out your local library. Take advantage of the Internet. Use YouTube, the visual encyclopedia of the world. These days, you can find specifics on almost anything you're interested in. Looking for pollinators in the Chihuahuan Desert? There's something on that.

Start small. Even if you only dedicate a quarter of your garden to native species, you're headed in the right direction. Introducing one native plant into your yard improves it a thousandfold.

Buy smart. Don't wild harvest or purchase things that have been stripped from the land. Go to nurseries, or order by mail. You can source most everything—if not in plant form, in seed form—that you could dream of.

Look closely. A lot of invasive species are introduced through nursery plants. Perhaps there are a couple of weeds in your little pot, but you might not realize that there are also a bunch of seeds in there. Take the top layer off, and throw it away. You can even remove all of the soil, dip the plant in a bucket of water, and just put the root system directly into the ground.

Find your footing. The most common pitfalls in a desert garden are no water or too much water—and the biggest culprit is probably the latter. Don't water every day, and adjust your watering schedule in the winter. Create a maintenance plan. Trimming is a human thing—we like to have order—but 98 percent of plants respond really well to it. Think of pruning like a haircut.

Make it manual. When it comes to weeding and pruning, hand tools are always better than mechanical tools. If you don't want to use herbicides to remove invasive species, you can look into organic methods—but for the most part, hand removal is the answer.

Be patient. Put in the time, and give a garden with native plantings five years to really come to life. You will start to see a whole new ecosystem forming. These species will attract some really wonderful birds and insects, too.

Reframe the work. These are jobs that can feel really good—for the environment but also for you. This time spent can be meditative and introspective, but it can just as well be social. Either way, take a moment to enjoy being in nature.

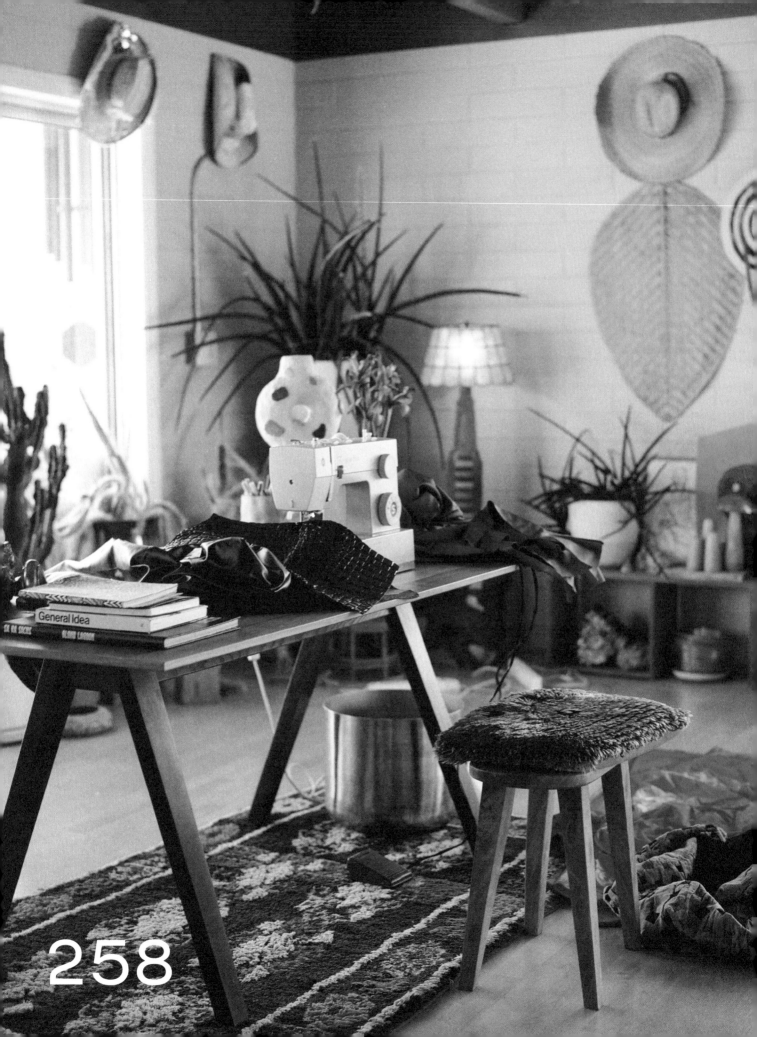

258

RYAN
HEFFINGTON

California

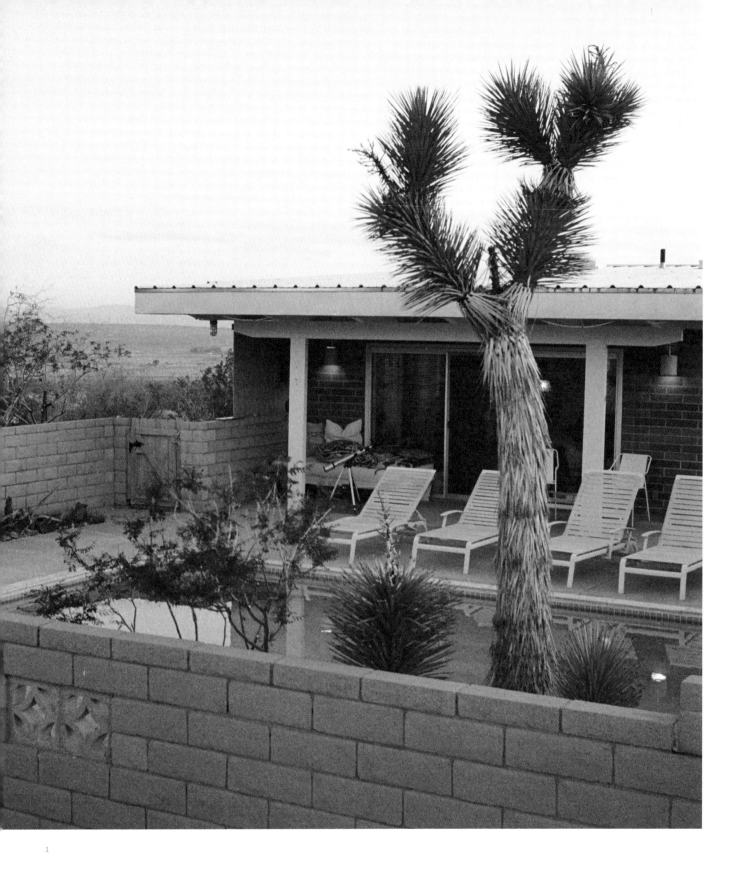

1

For Heffington, the ability to look out in any direction for miles gives way to calm. "There are really three main colors here," he says. "Beige, blue, and green." The simple palette, as the choreographer sees it, clears the mind and simultaneously promotes productivity and relaxation. (1)

Since removing a wall to combine the kitchen and living space, Heffington has more room for his special brand of entertaining. "It's pretty humble," he says of his 1950s home, "and it's always better with twenty to fifty bodies in here." (3)

AT THE EDGE OF CIVILIZATION,
A BEACON OF INGENUITY

"I always envisioned a pink mantel,"
Heffington says of his fireplace
concept. But his first attempt
"turned out like Barbie's desert
house. It was disgusting." After the
initial trial run and while easing
into the home, he and a small group
of friends were sleeping on the
living room couches. Eventually,
in the midst of this transitional
phase, they devised the multicolored
grid system that accents the brick
form. "It ended up being this total
collaboration, Heffington grins, "and
it just fits with the house in this
sixties sort of way." (2)

Vestiges of a late-night dinner party fill the kitchen, where leftover chocolate cake, uneaten ears of corn, and well-used dishes sit on the counter. The day's first rays of light filter through a prismatic triangle of stained glass and into the open living room. On the coffee table, a leather Carla Fernández mask faces the rising sun. A blue ceramic giraffe keeps cozy at the foot of the fireplace beside a brass peacock-shaped screen. A straw cowboy hat turned lampshade adorns a light fixture. The arrangement is loud, yet inviting—a festival of colorful details. Aside from the cooing mourning doves and the rustle of creosote bushes, the rocky hills beside Joshua Tree National Park feel dead quiet. Ryan Heffington suddenly appears around the corner from his bedroom, wrapped in a long bathrobe, treading lightly with soft eyes and a gentle smile to match the morning's serenity.

The far-out choreographer spent nearly three decades in Los Angeles lending his peerless style and energy to numerous creative ventures. After cutting his teeth teaching genre-bending dance classes throughout the city, he opened his very own studio, The Sweat Spot, which focused on classes for nonprofessional adults, in 2010. He resolutely tossed technical terms—*battement sauté*, *jeté*, and *chassé* were no longer—and created his own language with naturally evolving vernacular that included cues like "inflatable car lot man," "pretty pony," "prepping for the club," and "hot pepper" to elicit particular moves from his students. He harbored no filter for what might inspire him and with an inherently giving disposition, was always keen to share from his deep internal curriculum with whoever

2

3

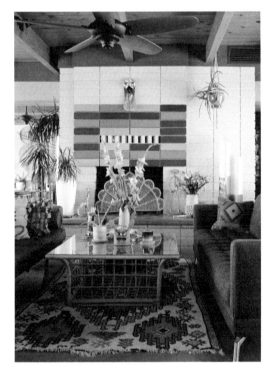

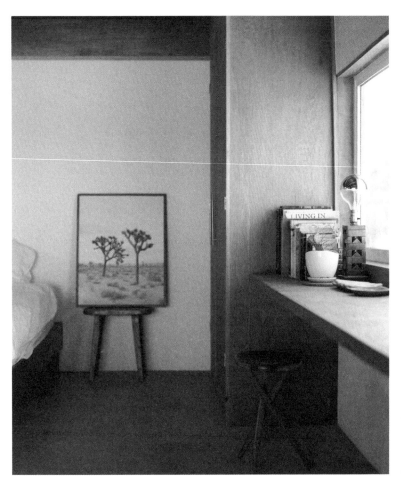

In addition to sealing up several superfluous points of entry, the once garage—reincarnated as a livable casita—received a significant makeover. Aside from practical elements like a kitchenette, a couch, and a desk, the one-room space became a haven of comfort with the intervention of a skylight above the shower, a set of sliding glass doors installed poolside, and a lofted sleeping area. (4)

5

4

cared to join in. As a nexus of creativity, The Sweat Spot even expanded its programming to include screenings, recitals, and a slew of parties. Heffington's blend of methods, contagious persona, and highly approachable process catalyzed a sensational venue where he would try his darndest never to turn people away. But with a throng of up to seventy-five eager dancers, the space was fit to burst at the seams. "We were all there in the name of dance and positivity," he smiles. "It was a major hub for LA."

With an insatiable appetite for collaborative artistic pursuits, Heffington and a gaggle of like-minded souls began initiating guerilla installations around the City of Angels. Simultaneously, his booming clout, one which reverberated from his Silverlake epicenter, landed him behind-the-scenes gigs on music videos, movies, and commercials. He created works alongside Sia, Arcade Fire, FKA Twigs, Lorde, and Chet Faker, and developed choreography for Spike Jonze's Kenzo campaign, the Netflix series *OA*, HBO's *Euphoria*, and the Lin-Manuel Miranda film *tick, tick...BOOM!*

All the while, Heffington was making jaunts to the desert to explore hot springs, celebrate birthdays, and—when he was in "the psychedelic trance scene"—throw raves. As he developed a burgeoning engagement with the area, the concept of a second home began bubbling to the surface. "I first came out to look at property to share with a friend," he says, but it soon turned into a solo pursuit. "I always felt calmer out here," he continues. "I know most things can hurt you and there is nowhere to hide, but this ability to see forever gave me a sense of safety." The feeling harkened back to one he had in his childhood when he discovered Colleen's Dance Factory, a refuge in Yuba City where he could unabashedly be himself—no holds barred. "I didn't realize it, but I was in the country," he reflects, musing on the rural Sacramento Valley town where he grew up. He remembers frequently arriving for class and parking his bike next to the donkeys. In Southern California's drylands, another kind of country, and in 2018, Heffington was shown nearly two dozen properties, often ones which

Heffington refers to the property's last incarnation, which included many a turtle object, as the "Tortoise Queen Ranch," a cheeky nod to the previous owner's near deification of the long-living reptile. Now, the mustachioed steward of the home decorates with a variety of figurines himself—or as he refers to them, his "friends"—like a wooden crocodile in the shower, a stick figure sculpture by the hearth, and a gilded mountain lion lording over his bed. (5)

Architecture, according to Heffington, can evoke "an emotional connection, and therefore a pride" in where people live and take space, something that he lacked in his own upbringing. He hopes that groups, both local and global, "feel literally part of" his Desertrade artist residency compound. The main building, temporarily plastered in a dark gray but ripe with possibility, will shift over time, whether by way of new exterior colors or whimsical artistic touches. (6, 7)

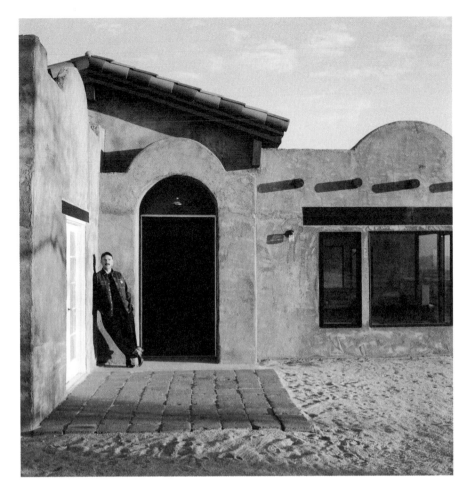

6

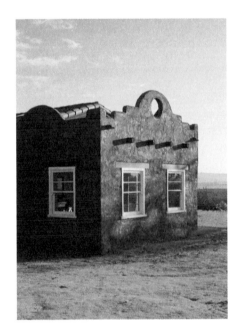

7

tested the limits of his extraordinary optimism. "If we just bulldozed the whole thing, it would be *great*," he laughs. He and a realtor persevered, proceeding eastward to Twentynine Palms.

It was a crystal-clear day in this small city on Highway 62—one of the last gasps of civilization before the vast Mojave Desert takes over—when Heffington made his initial approach to the property. "There was literally one cloud in the sky," he recalls. "It was round and flat and just hovered above the house." Turning from the highway onto the dirt road that ascends into the neighborhood, he became flooded with emotion but couldn't pinpoint the root cause of the feeling. When the wooden gate to the home, a 1958 brick construction, swung open, he finally knew why. This was his place.

With a robust foundation and sturdy walls that the inspectors deemed to be in nearly perfect shape, Heffington could focus on aesthetic details to make it his own. From afar, he organized the removal of a kitchen wall and a set of cabinets to free the compartmentalized space and give way to a greater

central volume. On the perimeter of the pool, he created small celebrations of desert flora—Joshua trees, cacti, and agaves. He transformed the detached guest house "with way too many doors" into a sanctuary overlooking the chlorinated waters and the expansive arroyo below, a steep drop from the property's edge. Both buildings were outfitted with bespoke tubs dreamed up by their eccentric owner, though he is quick to qualify them as accidentally far too cavernous—perhaps a subconscious vision of more social bathing.

He started going on design benders and slowly bringing out loads on top of his car. "I would look up thrift stores between LA and here," he explains, "and stop at every single one," packing to the brim with lamps, furniture, and sundry items. His shared apartment in the big city had five couches stacked in the dining room, awaiting a permanent home. Heffington echoes a concerned roommate posing the fair question: "Can you *not* buy more couches?" But like with everything, he reminded them that he had a vision. "Just wait."

In 2020, when his ability to lead large, in-person dance classes was put on pause, Heffington supplanted himself into his Twentynine Palms life and, brimming with energy, started Sweatfest, a remote dance class for his homebound students. He propped up his phone in a corner of his bedroom, cranked some campy tunes from a thoughtful playlist, and welcomed the world into his incomparable universe. His infectious personality quickly turned the platform into a virtual arena for tens of thousands from around the globe to shake their stuff. With all eyes on Heffington's home turned one-man dance studio, and in the midst of particularly tumultuous times, he eventually transformed his hoards of dancers into givers, raising hundreds of thousands of dollars for organizations like the National Association for the Advancement of Colored People, the American Civil Liberties Union, and Black Lives Matter, and even partnering with A-list names like Emma Stone to enhance the spirit of generosity.

Anxious to continue working on his forever passion of building community—in real life—he left the confines of his house and started a dance night at Out There Bar, an even farther flung locale where the queer community, marines from Camp Wilson, local desert rats, and highway warriors danced and sweated together under the orchestration of maestro Heffington. The interactions were meaningful but fleeting. In the end, he needed more. In July of that same year, some sort of cosmic forces were at play. After making a series of difficult life choices—to shutter his pivotal studio and leave LA for good—he got a call from his realtor neighbor in Twentynine Palms. She had something unique about to go on the market. With no particular itch to expand into other real estate realms, Heffington and a friend saw the listing out of curiosity, but something strong washed over him in an instant. The main house, with its series of outbuildings that once sheltered stationed marines, was *it*. He knew. This would be his next big point of connection, of creativity, and love—a residency program.

9

Heffington's dance moves celebrate the weird, wild, and organic. His wave-making choreographic style earned him an Emmy Award in 2022 for his work on the HBO series *Euphoria*. The shimmering statue now stands prominently on a shelf in his multifunctional office and in-home dance studio. When considering what's next on the horizon for his personal practice, one word comes to mind. "Broadway," he beams. "That's for sure." (8)

Totems across the house emanate a sense of movement. A set of three glass works in an oversized homage to the classic 1960s-era toy, Barrel of Monkeys, props on the windowsill of Heffington's guest bedroom, refracting the evening light. (9)

Sitting on a bar stool at his kitchen counter, Heffington takes a bite from a California citrus cupcake. "My nervous system has never been so calm," he beams. "It's nice to go to cities and then come back. Hearing the birds, seeing the lizards, is just heaven to me." Having just returned from a three-month stint in Santiago, Chile, choreographing a feminist protest film, he is still settling back into the vibrations of his high-desert existence. He sets out bouquets of flowers everywhere. He "zhuzhes" with gusto. He hosts potential artist collaborators for evening festivities. He catches up with his "bestie and her husband," and brings a bag of gifts from his travels for their children, his "god-kids." He is everywhere. But the lion's share of his energy is focused in one place, on his newly minted, free-form program, Desertrade—the name a fitting mashup of the words "desert" and "trade" to elicit an ethos of exchange.

A fifteen-minute walk or three-minute drive from home within the same sloping neighborhood where he lays his head, the retrofitted ranch house turned multi-use building overlooks the wide valley. Thanks to Heffington, the interiors are largely brand new, having endured a serious renovation over the past year plus. The screened-in porch with low ceilings was punched up and closed in, and sliding pocket doors were installed to clear floor space for dances, performances, and events.

Heffington almost flies, weaving his way outside past the pool, which early in his tenure held tiny raves but will soon be a place for local kids to learn to swim. The smaller soldiers' quarters will be studios and spaces for visiting artists to live and work, to write, make music, and craft ceramics. He peeks into the former underground wine cellar that holds memories of convivial days of yore, including bottles from the 1930s, and considers potential future uses for the bunker-like room. He describes his plans for an outdoor kitchen and wide deck beside the pool with shade structures to mitigate the blistering sun. Two huge stacks of metal wheels from irrigation systems will be semisubmerged around the perimeter to mimic wagon wheels, a playful acknowledgement to this quirky desert region's pioneering past. When all are complete, these innovative components of the compound will be relatively bare and minimal, especially compared to Heffington's house up the street. He provides a canvas—floors, walls, and roofs—but the character will deliberately evolve with the friends, artists, and countless others who will be

encouraged to weave their story, adding hand-painted mosaic tiles to the pool, a sculptural element to the fireplace, murals to the facades, and untold other interventions into the Desertrade fabric.

"I'm the daddy in a way," Heffington says with a grin beneath an immaculate bushy mustache. "I build these spaces where people can come and feel taken care of, and in turn, I feel I'm being taken care of by my community." As a philosophic tenet, Heffington preaches the mantra of circular giving. "Everyone has something to give," he believes, "whether it's a smile to give, a hug to give, money to give, or even knowledge, time, and expertise to give. That's the North Star of this place." As a work in progress, the primary structure is up and running with residents on site, and an aura of positivity is already lining the walls and radiating outward.

Teaching people to have fun and to connect mind and body was a defining characteristic of Heffington's Los Angeles chapter. "Now I'm entering my mentor phase," he explains. "I'm moving towards *why* we dance and *how*," while continuously building a space for education from all angles and integrating ideas from a multitude of disciplines into the umbrella of Desertrade: "That's kind of the goal," he says.

For Heffington, his only ritual is that he has no rituals. He might be harvesting aromatic plants, like creosote and desert lavender, with his friend Sa Ra Sachs's young son to create a fragrance, or later, savoring the last drops in a tiny perfume bottle. He might be hosting a meditation under the ancient palo verde tree, the "matriarch" of Desertrade. He might have a meeting with his contractor or with the city to acquire a necessary permit. Every day is a new adventure. In his office, a wall of mirrors sits opposite windowed doors of the same dimension. The room truly glows. Heffington makes space on his desk and plops his Singer sewing machine in the middle. Surrounded by fabric, he begins to concoct something new—a costume for a future show, maybe, or for Halloween, or just because. "In the city, you don't have time to breathe," he says. "You have to punch your card and pay your bills." In a capitalist society, artists rarely have the opportunity to explore without the pressures of life looming over them. "They should be treated like royalty, regardless of where they are in their practice," maintains Heffington. It seems that for this transcendent dancer and profound dreamer, "one" truly is "for all."

Desert flora surrounds Heffington's ranch-style home built from rose-colored bricks, and with the rising mountains of the national park to its south, the structure recedes right into its natural surroundings. (10)

Sitting on the porch of one of Desertrade's outbuildings, Heffington is flooded with inspiration. Dance will, of course, remain integral to the residency, but he talks all sorts of other components, pinballing between "the psychology of creation, how we prepare food, and writing workshops." The approach is multidisciplinary, and the end goal is simple. "Just a really strong culture of people," he says. (11)

10

11

12

In the bathroom off of Heffington's home office, curvy, sculptural forms—like one of his too-voluminous tubs—are on prime display thanks to a large picture window that welcomes in the afternoon sun. Dried branches, earthen face cups, and one of a series of portraits sketched by a friend that memorialize visitors to the abode rest on the tiered shelves. (12)

SAPNA

Dera, Rajasthan

BHATIA

India

GROUNDED IN PLACE:
A HOTEL TRUE TO ITS ROOTS

1

2

In the Thar Desert, trees are
"sacred beings" to be worshipped,
according to Bhatia. The innkeeper
passes on botanical knowledge
gleaned over years, encouraging
her guests to connect more deeply
with flora and fauna here and at
home. "It's all about symbiosis
and cooperation," she says. (1, 2)

The air is still. An army of ants blazes a tiny highway along the sandy ground, and a herd of goats
pick their way across the bone-dry landscape. The sun begins to set, its orange light diffused
by the thick and dusty desert sky. Sapna Bhatia makes her way into the *oran*. These sacred
groves, stewarded by local communities in the name of a deity, are protected ecosystems
endemic to the western desert region of Marwar, Rajasthan. While foraging is permitted,
the plants, or "gatekeepers of life" as Bhatia refers to them, cannot be cut. In the most
densely populated desert in the world, these spaces are invaluable sources of knowledge and
sustenance. The untrained eye may view this stark terrain as harsh and threatening. But what
some might describe as barren, Bhatia describes as bountiful. "I don't see thorns," she says. "I
see defense systems. I see fighters. I see resilience. I see courage."

Brought up in the countryside outside of Jodhpur, Bhatia speaks with reverence for the
group of formidable women who never went to school but were the most progressive that
she ever met—the ones who truly raised her. They assembled away from the male gaze to
smoke hand-rolled cigarettes, share stories, and sing Marwari songs. They knew the ins and
outs of medicinal plants and how to tread the line between self-sufficiency and reliance on

At Kaner, the dining room is generally reserved for breakfast. For the remainder of the day, eating spaces materialize outside—under the shade of a tree in the property's gardens, in a neighboring olive grove, or atop the surrounding sand dunes. Bhatia treats these locations with as much care as any indoor area, decorating to complement the environment's colors, textures, and patterns. (3)

3

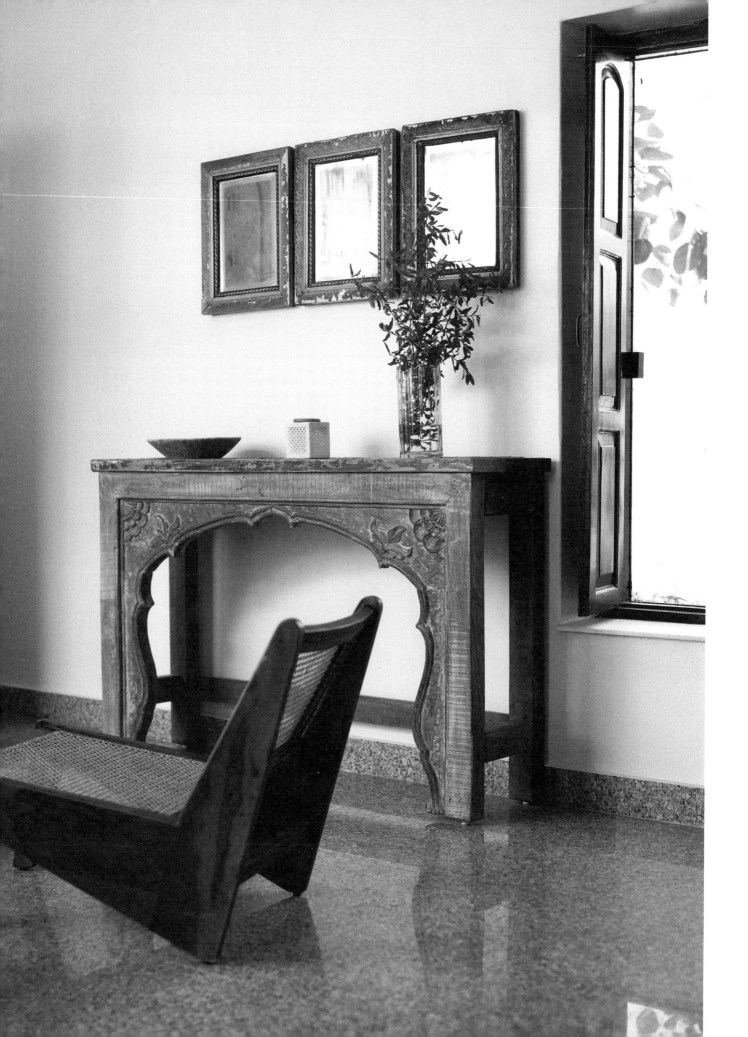

4
Early on, when Bhatia explained that she
intended to make use of native and dried
plants in the rooms and around the property,
her team responded with horror and confusion.
"Ugly and prickly," they thought. Over time,
they witnessed guests' appreciation for the
homegrown decoration and in turn developed
their own. Now, they often join Bhatia on
walks to collect branches and stems. (4, 5)

Sustainability is ingrained in the ethos
of Kaner—and into its aesthetics. Much
of the furniture is antique or composed
of reclaimed wood, while handicrafts,
like the camel belts that grace the walls
of the tea salon, are handmade by
Marwari artisans. (4, 5, 6)

5

6

community. Among them, Bhatia's grandmother defined humility. She had only two skirts and never owned a refrigerator. When Bhatia brought up the modern contraption, she cackled. "Why would you want to feed me stale food?" she asked.

Meals were basic but always fresh: a sweet potato roasted over the coals in the *chulha*, a U-shaped earthen oven, for breakfast and a bowl of lentils for dinner. Even so, abundance was everywhere. "You can only be happy if those around you are happy," Bhatia says, dropping in a pearl of her grandmother's wisdom. She was taught to cook the first chapati, or wheat flatbread, for the cow, the second for the dog, the third for a less privileged family, and finally, the fourth or fifth for her own. With seemingly little to provide, the desert—its people, flora, and fauna—exudes a spirit of giving and reciprocity that oozes from Bhatia's every pore.

Bhatia is a storyteller through and through. She took notes from women like her grandmother and transferred them to a successful journalistic career between India and the United Kingdom that led her to the front lines, where she covered conflicts for news organizations including the Associated Press and Al Jazeera. Her professional

Bhatia strives to remove boundaries between
indoor and outdoor spaces. Custom-made arched
windows dot three sides of the dining room,
flooding the lofty space with natural light
and allowing for cross-ventilation. (7)

7

path, however, wasn't a linear one. With a staunchly conservative father who believed women shouldn't work outside the home, finding a way into the world took time and eventually, marriage. Romance be damned. "I told Samir I was only marrying him to get out," she says of her now beloved husband. On work trips, she came across plant-based projects from culinary experiences to gallery exhibitions, and the more she saw, the more the wilds of her childhood called. Dreaming up a proposal of her own, she homed in on its focus: desert botanicals. "Isn't that an oxymoron?" she recalls being asked. Most people associate "botanical" with something exotic, perhaps even tropical. "Maybe," she remembers replying. "But I've always loved a challenge."

Confident free thinkers like Bhatia inevitably run into skeptics and naysayers along the way. The village head approved her bid for a small hotel but not without his share of concerns, among them, "How many local people will you employ?" and "How much water will

you take?" He nearly laughed her out of the room hearing her replies of "Everybody" and "Very little. I'll use native vegetation." Though going against the grain—most rural Indian hotels outsource employees and commit to low-water use before turning around to install sprawling lawns, pools, and exotic flower gardens—these were no empty promises. She did it all, and the community took notice. When she needed a fence, they installed it themselves. Now, when guests get lost roaming the nearby streets, townsfolk escort the foreign faces back to the premises.

Bhatia derived inspiration for her construction on walks in the village. The buildings, composed mostly of the area's red sandstone, tend toward a basic formula. "They're often simple courtyard houses with one room," she explains. "I wanted that same feel for Kaner." Her idea, though straightforward, didn't resonate with Delhi-based architects, who lacked connection to the land and its materials. In stepped Hanif Khan, a Marwari man in his seventies. Khan had dropped out of school before the fifth grade but went on to develop experience in temple building and an uncanny understanding of stone. His tools were few: some string and a bit of chalk.

To prepare for the project, Khan studied old buildings in the area and with Bhatia's drawings in hand, got to work. Though the two embraced a do-it-yourself, trial-and-error mentality, they proceeded with great care. As Khan says, "In construction, you can't erase." Samir also pitched in. Bhatia would sketch plans, and he would add dimensions. "The creative mind met the mathematical mind," she quips. Their teenage daughter Sanvi even insisted on certain design details, like a large sandpit, to appeal to children. With patience and persistence, Kaner—the elongated ten-room guest quarters, dining room punctuated by large, window-clad archways, three-story staff building, stage for events, and tea salon—was born.

To complement the understated architecture, Bhatia wanted the interiors to feel like the rooms of an art gallery, starkly contrasting the royal, maximalist aesthetic that reigns supreme in Rajasthani hospitality. Low-slung wood and rattan chairs and minimalist, built-in daybeds pair with vernacular craft and simple handmade creations like wreaths of woven grass.

"The building wasn't important," Bhatia says of the guest rooms. "It was about the breeze, the bees, letting the desert in." Screened-in doors and windows give the sense of being outside. The small courtyards, where Bhatia designed chairs with local rope based on childhood memory, offer private spaces for respite.

All of the rooms center around a particular desert flower, and their four walls are an opportunity to pay homage to the muse in color, texture, and decor. Bhatia commissioned art to represent each bloom and uses essential oils to add distinct fragrances. "Every visual, whether you're in the bathroom or the dining room," she explains, "should contain an element of botany." She always considers the frame, creating touchpoints to tell a story, a trait she chalks up to her filmmaker background. Elsewhere, she decorates with densely braided camel belts embellished with beads and shells, an ode to the local herders, and hand-painted figurines from the region. But these spaces, while an homage to Marwar, are not Bhatia's focus. Here, life takes place outdoors. Pots line the paths, a metaphor for collection and conservation in the desert. *Charpai,* or woven beds meant for reading a book or enjoying a gin-and-tonic, can be found under the shade of trees or next to the stepwell-inspired pool. Tables are everywhere. Dinner is almost never served inside.

The intense summer heat and heavy monsoon season keeps the business shuttered and Bhatia in Delhi from April to October.

8

9

Reds and pinks appear throughout Kaner 10
from planters to the backboards of
daybeds, the camel herder-cum-tour guide's
turban, and even some of Bhatia's own
clothing. The property's palette appears
like a burst of color on the mostly beige
and green desert scene, but it echoes
vernacular architecture, made of locally
sourced sandstone, and oleander, the
"desert rose" and origin of the small
hotel's name. (7, 8, 9, 10)

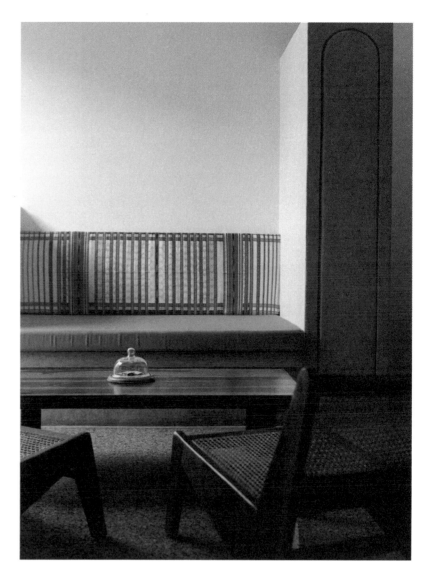

A hotel's design is only as good as its
staff's dedication to detail, and Bhatia
is constantly awed by the commitment of
her team. When she's not on site, they send
her unprompted photo updates, ensuring that
their table settings are up to snuff. Once,
when they were low on pattus, her service
lead Manoher drove two hours to his village
to borrow the decorative textiles from his
mother. "Do they ever stop thinking about
the guests?" she wonders with a smile. (11)

The rooftop terrace, one of the many spots
to enjoy a meal, provides panoramic views
of the desert wilderness beyond. The
boxy, rectangular table mirrors the cubic
architecture of Kaner and gives nature's
more organic forms center stage. (12)

Come fall, Kaner's fearless leader flees the Indian capital and its thirty-five million inhabitants to return to the land of her roots, remaining on site throughout the six-month season. "I'm a one-woman show," she says. And it's true. She feels omnipresent, ready to offer a refreshing glass of vetiver root–infused water to a guest, organize a jeep safari, schedule a dinner, or simply chat over tea. Above all, Bhatia wants visitors to walk away with a fresh perspective when they leave Kaner. This is far from the average desert camp with its safari tents and trope-laden experiences. It's about building memorable moments based on real heritage. Bhatia offers candlelit dinners atop a nearby sand dune. Bright red, pink, and orange floor cushions, rugs, and tablecloths set the scene, and the meal highlights foraged desert beans, millet bread, and smoked meat from a nearby purveyor. The next day, guests can visit the weavers responsible for the textiles, or a family of potters in the neighboring village. The arc of time spent at Kaner feels like a movie—but less like a Disney flick and more like a captivating documentary—as new scenes and characters pop up in unexpected ways.

With her unilateral vision and strong persona, Bhatia may lead the charge, but she isn't alone. Samir and Sanvi make frequent visits to the desert outpost. She has also built a robust team of Kaner devotees who proudly don their uniforms, vests that are block printed by hand and jootis, or flat-soled leather shoes from vendors down the road. Hiring women proved impossible, though remains a goal, and training a group of men, most of whom dreamed of a military post, was a learning curve for all. Bhatia's knack for reading people and playing into each individual's strengths has fostered a micro-community of extraordinarily talented doers, contributing to a genuine and holistic expression of this striking terrain. Experience aside, their willingness, savvy, and camaraderie built over multiple seasons combines to form a cohesive unit.

Like many of the talented people that contribute to Kaner, Bhatia's chef, Virender Singh, boasts no formal training. He hasn't completed stints in world-renowned restaurants, but his grasp of flavors speaks for itself. From the traditional Rajasthani thali, a complete, multicomponent meal served on a circular platter, to a lavish Mediterranean spread, his dishes taste of the

Bhatia's woven garden chairs, which occupy the
courtyards off each guest suite, are an homage
to her mother, who used to commission rope from
local makers. (13)

Always mindful of water use, Bhatia designed a
small pool just big enough for a dip. The form
honors the subterranean stepwell structures that
have been a defining characteristic of India
for centuries. (14)

13

14

terroir—thanks to local ingredients like camel's milk
feta, olive oil, and honey but also a keen ability to balance
sweet, spice, and acid. Bhatia adorns the tables with
patterned tablecloths, or sometimes a bed of flower petals,
and dinnerware featuring delicate floral motifs. The
eighty-something musician and one of the last remaining
masters of the double flute infuses the atmosphere with an
intoxicating refrain that, like the property's native plants,
feels as though it emerged directly from the earth.

Bhatia grasps a cool glass of nimbu pani, a lemonade-
like concoction seasoned with black salt, the best potion
to combat the dry heat. Looking out from the oversized
glass windows in the dining room and through the haze
that has settled on Kaner's down-sloping site, she points
out a tall Calotropis swaying in the breeze. The milkweed
"is completely poisonous, but look at the flowers," Bhatia
says. Tiny purple buds are beginning to form on the dusty
green stalks. "The structure is beautiful," she continues.
One lesson she gradually took to heart and one that she
hopes to pass on to others is the art of looking deeply.
"The beauty is subtle here," she says. "You need to let your
eyes adjust to see the small things."

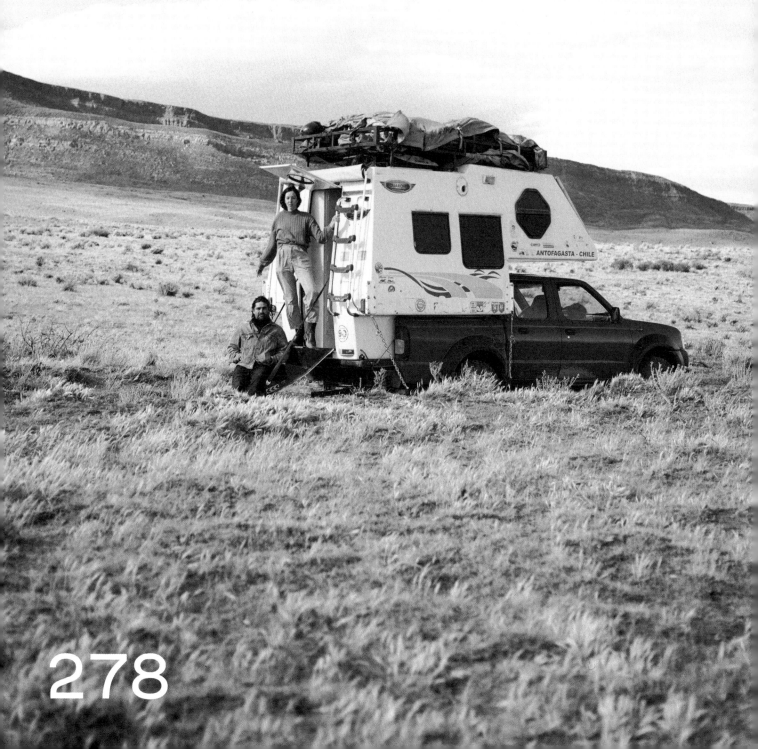

Argentina

VICTOR FERNANDEZ

&

SOFIE IVERSEN

ROVING TO REDEFINE HOME

A soothing, earthy aroma fills the air. In fact, there is a name for this scent. In the 1960s, scientists coined the term "petrichor" to describe the distinctly pleasant smell that comes after rain falls on dry ground. Now, following a night of showers and high winds, the morning is still. Victor Fernandez and Sofie Iversen step out of their bedroom door, followed by their trusty companions—two shaggy dogs, Kosmo and Motika, and their sleek, black-and-white cat, Suri. They breathe in the fresh air, the sun warm on their faces, before glancing over at the studio, a one-room, gray-and-orange camping tent, and the kitchen that they have built into the side of a rock. All survived the storm.

"We set up a house in each place that we go," Iversen says. "We are designing living spaces constantly." Currently, she and Fernandez reside at the edge of a lake. Its water, called "glacial milk" because of the way that light hits its silt and sediment, shimmers a deep-blue green. It meets a rocky shore, which gives way to golden desert grasslands in every direction. While the couple may call Argentina's Patagonian Steppe home for the time being, they have plans to relocate in a week or maybe two.

Nomadic existences have been synonymous with the desert for as long as humans have walked. From Bedouins and Berbers in North Africa to the Aboriginal peoples of the Australian outback and pastoral communities in the Andes, nomadic populations have learned to live symbiotically with drylands, moving on in search of water or cooler temperatures before damaging and destroying a given

1

Fernandez and Iversen move fluidly between their well-stocked indoor kitchen and the exterior set-ups that they conceive of in each new location. In comfortable climes, including the dry Patagonia Steppe, engaging with nature is when the real magic happens, so the pair frequently opts to dry dishes in the open air or chop vegetables on a cutting board propped atop a log. (1, 2)

2

area's vegetation. "In a way, we are doing what humans have always done," Iversen muses. "If you live outdoors ninety percent of the time, you have to think about natural resources and adapt to the seasons. It may sound obvious, but it is a concept that modern society has lost touch with." For her and Fernandez, building "bubbles," where it's easy to lose connection with the environment, seemed antithetical to living on an earth that is facing severe ecological, social, and climate crises.

Plus, a migratory lifestyle felt natural. Fernandez was born in Caracas, Venezuela, to a Chilean father and Colombian mother before moving to Santiago, where he was largely raised. "I never truly associated the image of home with something physical," he says. "It related more to people and relationships across many different places." Iversen, meanwhile, grew up between Newcastle, the outskirts of London, and Bergen, Norway. Half-British and half-Norwegian, she never gained a strong sense of nationality. "I find the question 'Where are you from?' a difficult one," she says. Yet, in a world increasingly defined by borders, she became comfortable with the notion of "not belonging to one thing." An art school graduate, she met Fernandez on post-study travels through South America and when she did, her feelings only cemented. "We are from opposite sides of the world," she explains. "It was very organic to get to where we are now. 'Let's stay here for a bit. Let's move there.'"

Fernandez, a multi-instrumentalist and composer, and Iversen, a visual artist who studied sculpture, began asking themselves, "In all of this chaos, what do we do? What *can* we do?" Both viewed art as a critical means to obtain answers, so they established La Wayaka Current. The residency program, which, like them, is not tied to a singular location, provides space for artists to develop their creative practices, think critically, and interact with Indigenous and rural communities who live hand

3

Over time, Iversen has realized that she needs very little in the way of commercial tools and materials for her art practice. So much—from dyes, paints, and pastels to string and thread—can be sourced in her regularly fluctuating backyard. (3)

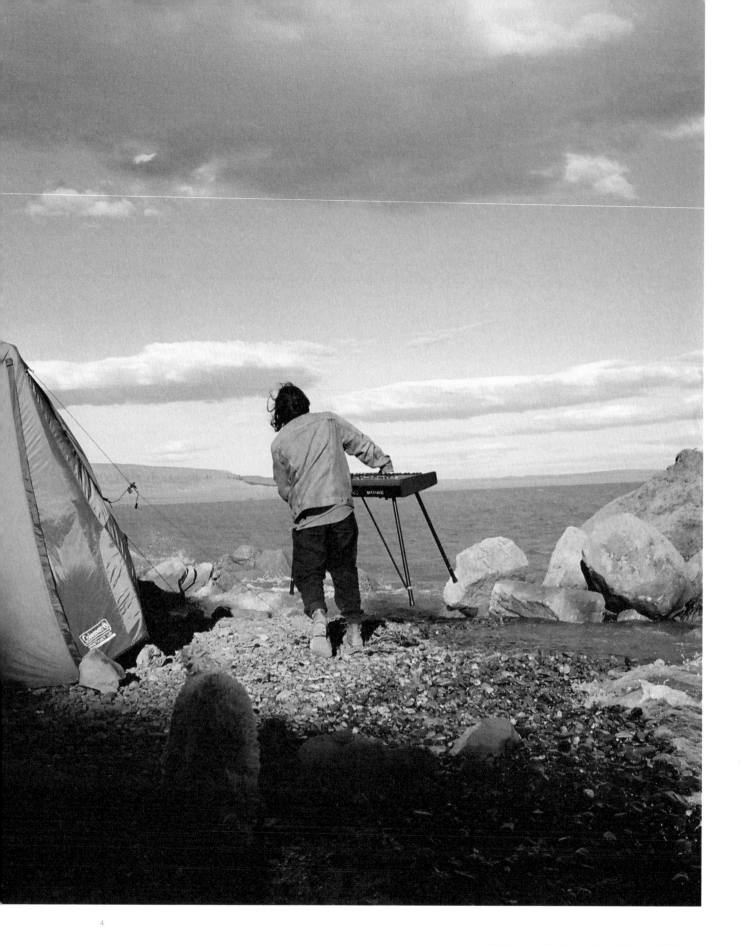

4

Guitars, synthesizers, drum kits, a violin,
and a gourd kalimba are among a collection
of instruments that compose their moveable
orchestral outfit. (5)

Fernandez and Iversen take great care in scouting resonant locations for their tented music studio and the unique outdoor venues where they choose to experiment and record. "I like to look back and listen to a song that was made in a specific environment," Fernandez says of his music, which he produces under the name Keta Lenis. "It always has an identity that's connected to place—it will be different if we were in a very windy setting like this one or around certain colors, in a cave or in a more open space, or creating at sunset versus at night." (4, 6)

in hand with nature. They have led programs on the border of Colombia and Panama, on a remote island off the coast of Norway in the Arctic Circle, and perhaps most consistently, across Chile's Atacama Desert.

"I always felt a special energy, a sort of mysticism, in the desert," Fernandez explains. "The expansive horizons bring you closer to the stars and the sky. And that openness transmits into your mind and being." In other words, it's a great place to produce work, to meditate, and to absorb knowledge. "The desert is extreme," adds Iversen. "But it has so many secrets. There is always something new to discover, something to surprise you." The Atacama became La Wayaka Current's—and its founders'—most permanent base.

Several structures made of mud, rocks, and branches serve as a headquarters of sorts. They belong to Iversen and Fernandez's partners in the region, Carlos and Sandra, who both hail from the Lickan Antay Indigenous peoples. "You have the safety of your bed, but life happens outside," says Fernandez. "The rooms are comfortable, but they're intended for sleeping." Being engaged with and maximizing the potential of what nature provides is the name of the game—and for Fernandez and Iversen, that meant hitting the road. As the desert iteration of the residency program and its team became slightly more established, they could become more mobile.

Adopting an itinerant lifestyle, however, doesn't mean forgoing the intimate act of homemaking. "There are the basic spaces—for cooking and eating, for shelter and protection—that we always want to have," says Iversen. "But these aren't inherently attached to something permanent. If you get creative, you can make them anywhere." In turn, she and Fernandez might discuss spatial design more than any nonprofessional. Their truck camper, with its bedroom, bathroom, small kitchen, and storage, is a lesson in efficiency, and objects like a matte-black espresso maker and wooden cutting board or textiles in muted tones imbue it with coziness. Elsewhere, they fashion environments that reflect their lives, habits, and necessities frequently and in the most unlikely of settings. "It's about finding harmony between the areas where you cook, where you clean, keep waste, create, and rest," Iversen continues. "We take that balance very seriously, but we also maintain a playful spirit."

When the duo arrives at a site, found via Internet forums, word of mouth, or just exploration, Fernandez offers up a song. "I sit down and play whatever comes," he says. It's a form of meditation, much like Iversen's walks. "I move mindfully around the place," she explains. "It's important to be respectful of and grateful for where you are." Then, they make it home. They set up an outdoor kitchen, often searching for signs of former firepits and adding components, like a piece of scrap metal, to block the wind. They look for a corner to erect the studio. They pitch a large tent or keep it open-air, if the weather warrants, and assemble a series of tables for Fernandez's instruments and recording equipment, which run via a system of solar panels and batteries, and Iversen's art. Over the years, her practice shifted away from sculpture to a more multidisciplinary approach that requires less physical space and fewer tools. Notebooks and collections of small objects like rocks, dried berries, plants, and bones—or "textures," as she refers to them—cover her surfaces.

PAY IT BACK,
PAY IT FORWARD

When Fernandez and Iversen arrive at a new location, they wake up early to welcome the sun and carefully select a site to provide an offering—like words, wine, tea, or flowers—to Mother Earth. It is a way of saying thank you, something that they continue to do in moments big and small on a daily basis. "Ayni, or the concept of reciprocity, is not merely one word, ritual, or ceremony," the duo reflects. "It is a way of life." The couple shares this Andean approach, which they first learned from the nomadic herders of the Atacama Desert, with their artists in residence, but it has also become an integral part of their journey on the road. "As we traverse new territories," Fernandez and Iversen explain, "our commitment to cultivating these values remains, regardless of where we find ourselves." These acts of gratitude encourage a harmonious relationship with the planet that provides humans their very sustenance. "Through this practice, we feel there is potential to create spaces and homes that honor the land and foster deeper connections with ourselves, our communities, and the natural world," they say. "It has taught us to reflect on the important balance between giving and receiving." In that same spirit, the artists supply some guiding principles for those who wish to consciously give back in kind:

Create a ritual. Find a personal and intentional action, no matter how small or meditative, that reflects reciprocity and care.

Connect with nature. Make the time to engage with the elements, whether in a city or a more natural setting. Feel the wind, listen to birdsong, or simply observe the world around you.

Communicate with the earth. Create a channel to express your feelings and intentions to the earth, either silently or out loud. Convey your gratitude, ask questions, recite a poem. Request permission to take space and to use resources.

Extend an offering. Present something organic and of value to you as a symbolic gesture of giving back. This act illustrates sacrifice and unity, countering our contemporary culture of extraction and consumption.

Honor the ancestors. Take a moment to celebrate and acknowledge the people who lived in and shaped the place that you inhabit. Recognizing their existence is a practice that can begin to decolonize our collective memories and narratives.

Give before receiving. Consider how you can give before seeking to receive. Whether through art, community service, or nurturing the environment, proactive giving nurtures a more meaningful relationship with the world.

Their process also relies heavily on natural formations: a boulder with cavities that make the perfect shelving system, a small protected pool where they harvest water and create a dishwashing station with large stones for drying racks, or a felled tree trunk that doubles as a table for dining or computer work. Wide-open landscapes become a stage for musical performances, and nature's soundscapes and earthly vibrations weave into the couple's melodies. Sometimes, like here in the Patagonia Steppe, they even enjoy a luxurious private bathtub. "It's really special when we're living next to a body of water," Iversen says. "Once we submerge in it, we somehow become a part of it. It holds us, and we stay connected throughout our time together." Outcroppings that dot the lake's edge transform into benches to soak in the sun and dry off, and pointy bits act as hooks to hang towels. Design, the pair contends, is all around. "We really live in paradise," they say of the diverse desert worlds that they inhabit.

"People think that there is nothing here," Fernandez says, "but it is full of life." In the Atacama, he learned about the desert's extremophiles—microbes that adapt to harsh, hyperarid climates and employ specialized capabilities like seeking out and extracting water from rocks and converting carbon dioxide to oxygen. Humans, he says, aren't so different. People become self-sufficient, but

7

The intimate quarters of the duo's efficient camper may see only small, incremental adaptations over time, but the view out their front door—like onto the silty, glistening waters of Lago Argentino, or Lago Kelta as it is known in Indigenous tongue—is ever-changing. "There's a certain sensation when you constantly see this kind of nature," Iversen says. "You notice that ideas and thoughts really begin to flow in your mind." (7)

Rock formations take center stage in Fernandez and Iversen's temporary outdoor home in the Santa Cruz province of Argentina. One with natural cut-outs and craters serves as storage for teapots, maté cups, and various sundries, while an assembly of stones and boulders—upgraded with found metal and a grate—becomes the perfect windbreak for a makeshift open-fire barbecue. (8, 9)

9

they also gain a more acute awareness for what *does* exist. "A lot of these places are less populated," Iversen chimes in. "People live farther apart, so when they do gather and share resources, it's really meaningful." She points to cities, "which might be full of people but where you can find yourself feeling very alone."

The duo has nurtured an appreciation for other things, too: the primitive act of building a fire for warmth, a few minutes dedicated to looking up at the sky and connecting with the cosmos, the process of manually heating water for their shower, a moment to put work away and split a gourd of potent maté. "We have numbed our senses to these things that are so life-affirming and rewarding," Iversen says of contemporary life. "We don't care about them anymore because they are so 'basic,' but when they're done right, they're the most magical." Slowing down, in her experience, begets gratitude, and gratitude leads to self-acceptance and love.

Fernandez grills chorizo, corn, and a steak over the flames, while Iversen prepares potatoes to cook in the coals. She remembers Sunday roasts from her childhood with fondness, so the pair perpetuate the ritual. Though they spend twenty-four hours together seven days a week, these meals provide an opportunity for them to toast to one another and to Mother Earth and to engage in deeper conversation. "I just want us to design a life that we're proud of, that we enjoy, and that feels important to us," Iversen says. She crouches over the firepit, their hearth for the night, and slathers a bun with punchy chimichurri and a piece of sausage. Fernandez looks around. Since embarking on this adventure, he knows exactly how to define home: "Wherever Sofie, my pets, or my animal family as I like to call them, and my instruments are." If it is pride that Iversen strives for, Fernandez seems to absolutely beam with it. "We may not have a huge house, but we're doing what we love. We have everything."

When Fernandez and Iversen change regions, they change diet, too. "We like to eat what is locally available," they say. "We don't consume meat often, and when we do, we feel it's something that should be appreciated" by way of cooking methods, a unique table arrangement, or simply a little bit of extra consciousness and presence. (9)

The camper, which the couple purchased secondhand in Chile, provides a sense of stability—but the real stability, they say, comes from traveling between lands that feel like home. "Most of the places that we go," Fernandez explains, "are desert environments. Even if they're new to us, it's like I already know them." (10)

10

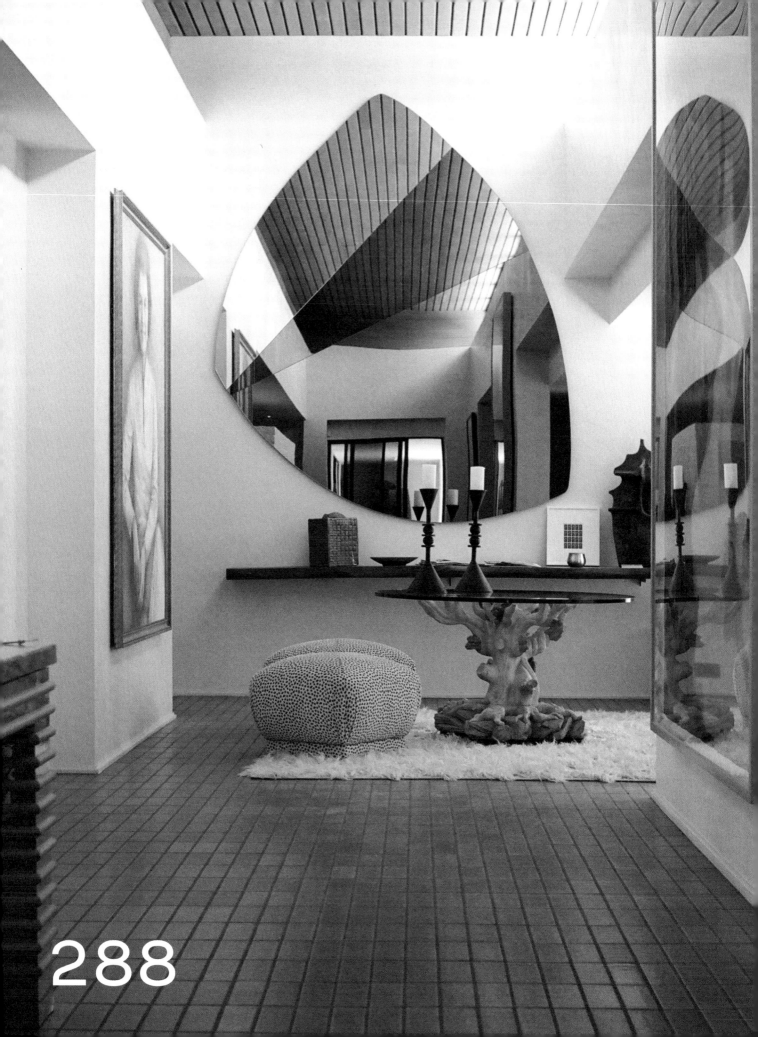

BILL DAMASCHKE

&

JOHN MCILWEE

ASKING, "WHAT WOULD BETTY FORD DO?"

Precious objects: Books, framed photographs, and one of Damaschke's many Tony Awards fill the shelves of the den and media room. (1)

The half-height wall appears like a mere divider between the dining room and living room, but it contains a covert volume, which the Fords used as a bar. With Damaschke and McIlwee at the helm, it briefly became a DJ booth for parties before McIlwee converted the space into an intimate office. (2)

While Damaschke and McIlwee add plenty of their own flair to the compound, they insist that reminders of its storied past remain prominent. Take the living room set that includes a sofa and chairs or the mammoth Betty Ford portrait in the entryway. The Ford family originally intended to auction the latter off at a Gerald R. Ford Presidential Foundation event but for the couple, removing the piece was a dealbreaker. They made a donation, and the painting remained with the house. "It just had to stay," they explain. (3)

1

2

When Gerald Ford succeeded Richard Nixon to become the president of the United States in 1974, times were tumultuous. But he and his wife, Betty, were determined to turn lemons to lemonade. They put on their daughter's senior prom, hosted an eclectic array of guests from country singers to Hollywood stars, and reinstated dancing at state dinners. "Gerry and I tried to make the White House a place where people could have fun and enjoy themselves," the former First Lady told *Vanity Fair* in 2010. And so when Bill Damaschke and John McIlwee purchased the couple's 6,300-square-foot post-presidential property in Rancho Mirage, they set out to do exactly the same.

"We *use* this house," McIlwee explains of the structure in the low-desert enclave, which is approximately half an hour from the popular Palm Springs but gets an hour of additional sunlight each day because of its distance from the snow-capped San Jacinto Mountains. With the exception of a "no red wine in the living room" rule, he insists that "nothing is precious." He and Damaschke purchased the home, which faces the fairways of the Thunderbird Country Club, from the Ford family, who put it on the market in 2012 following Betty's death. "As soon as we realized that we wanted it, we went full-court press," McIlwee recalls.

3

While other prospective buyers scoffed at original details—the lime-green dining room, fully intact furnishings, and seventies-era light fixtures—McIlwee and Damaschke delighted in them. Sitting on a lounger, a Ford piece with only updated upholstery, McIlwee squeals. "I mean, if it's good enough for a president, it's good enough for me!"

With the help of the California-based firm Marmol Radziner and the interior designer Darren Brown, the couple made tasteful changes while staying true to the structure's roots. "I certainly didn't want to waste anything if I didn't have to," McIlwee explains. Were the floor tiles their favorite? Not exactly. "But it was 4,000 square feet of tile in perfect shape," McIlwee says. He and Damaschke instead took liberties where things had been executed with less durable materials, or when something was in disrepair or altogether out-of-order. They redid the kitchen and the bathrooms, replaced the molding, and swapped surfaces. Formica out, marble in. Still, they kept what they could. The lightbulbs framing Betty's vanity transformed into a gridded ceiling fixture for the primary bedroom, and the ex-president's trophy cupboard morphed into a bed frame.

Brown came up with a lookbook to define the house's spirit as it entered a new era. At its center was a still of Richard Gere from the 1980 movie *American Gigolo*. Gere is driving from Los Angeles to Palm Springs in his Giorgio Armani suit and terracotta-tinted glasses, or he is in his apartment with its sleek, minimalist furniture and art propped up against the walls. Either way, shades of beige, brown, and rust—with the occasional muted blue and warm gray—pervade. In classic neo-noir film aesthetic, the scenes are dreamy but sophisticated. "And just like that, dusty desert rose met a little bit of modern," McIlwee recalls.

He and Damaschke clearly don't mind embracing a theme. Texture thrives here, be it in shag carpets or heavy, patterned curtains. Poufs covered in a cheetah chenille and Alfredo Barbini table lamps in opulent Murano glass reinforce the retro-glam effect, while additions in brass bring a stately touch. The couple installed their art collection, which mostly dates to the late twentieth century. "It might be '90s. It might be present day," McIlwee muses, "as long as it goes." In the living room, they traded a pea-green motif for lilac and pale purple, still nostalgic but more reflective of the area's natural surroundings than the manmade golf course out the back door. They brightened a once-dreary office and shaped

it into a cozy den. "It's our cocoon," Damaschke chimes in. But keeping with character, they opted for a sectional designed for the Calvin Klein residence in 1985 by Joe D'Urso, known for his hard-edged, spare creations.

McIlwee's hand grazes the swirling grisaille fabric that stretches over the Fords' original couch. He and Damaschke could easily be confused for set decorators in the way that they revel in the details. They're not, but they do work in Hollywood. The oldest of seven siblings and the president of Warner Bros. Pictures Animation, Damaschke emanates an air of collected cool. He left Chicago, where he grew up, long ago, but unpretentious and polite, he's still got a certain Midwestern nice about him. In 1994, a young Damaschke landed in the motion-picture metropolis as a production assistant on Disney's *Pocahontas*. He was then hired at DreamWorks, where he quietly worked his way up the ladder, bringing animated movies like *The Prince of Egypt* and *Shark Tale* to life, until he reached chief creative officer. When he did, he brought on talents like Charlie Kaufman, Noah Baumbach, and Guillermo del Toro, earning praise from the *New York Times*, who called him "one of the film industry's most important executives." Eventually, he made his way to Broadway, overseeing adaptations of *Moulin Rouge* and *The Prom*. When Netflix picked up the latter, he produced that, too.

McIlwee, meanwhile, was raised in San Diego and is the salt to Damaschke's pepper. Publications like *The Hollywood Reporter* and *Variety* bill the business manager, who represents industry insiders like Kevin Costner, Caleb Landry Jones, and Jane Lynch, as "the top" and "elite" in his field. Handling financial affairs for Los Angeles A-listers requires discretion. While he might be hush-hush when it comes to work, on any other topic, he is so upbeat that he almost appears buoyant. When it comes to the Ford Estate, McIlwee gushes over the contradictions. "We're two gay Democrats in a Republican president's house," he says. "But that's the way the world *should* work!" He relishes the opportunity to start a discussion. "We need to talk," he explains. "We have got to figure it all out."

If it's middle ground that McIlwee wants to promote, it seems that there is no better person to put at the center of his campaign than the home's previous owner. The Fords may have been on the right-leaning side of the political spectrum, but that didn't stop Betty from advocating fiercely for her beliefs in the Equal

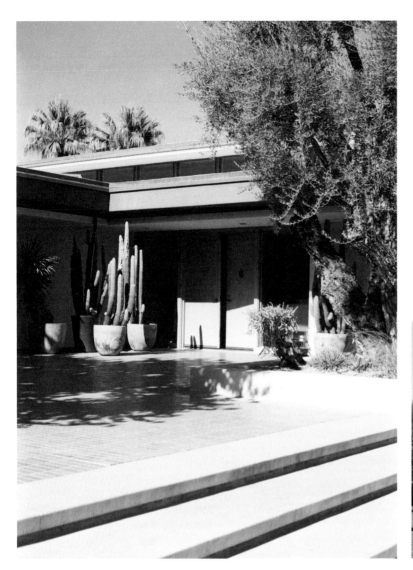

Numerous "almost sinister" hedges served as a security measure during the Fords' tenure. Since Damaschke and McIlwee aren't a former first family, the duo opted for less obstructive desert landscaping. (4)

The satin-finish, stainless-steel Von Ringelheim sculpture stands at twelve and a half feet tall and was bestowed upon the Fords by Welton Becket Associates, the architecture firm commissioned to build the Rancho Mirage refuge. (5)

5

Rights Amendment and women's liberty to choose. She remained outspoken on topics considered taboo, like depression and premarital sex, in and out of the White House. "Why should my husband's job or yours prevent us from being ourselves?" she famously asked. "Being ladylike does not require silence." She was transparent with the public about her battle with breast cancer in the 1970s, bringing the disease out of the shadows and into public consciousness, and her later struggles with addiction. Her candor earned her an affection that transcended party lines.

In Rancho Mirage, vestiges of Betty appear around every corner. In the entryway, there is the seven-foot-tall portrait, a birthday gift from Nelson Rockefeller that once hung at 1600 Pennsylvania Avenue. A peach-hued photograph of the trailblazer from a 1980s *Vanity Fair* shoot is framed in the powder room. A shot from Annie Lebovitz graces the walls of the dining room, which has stayed bona fide Ford from the hand-painted mural to its bespoke lattice-printed chairs. The room, which has seen visitors from the likes of Henry Kissinger to Bob Hope, is what McIlwee calls a "conversation piece."

It is also where the home's new owners start many days. Others begin outside, just off the thirteenth hole of the fairway, on the curving, concrete benches that they poured upon

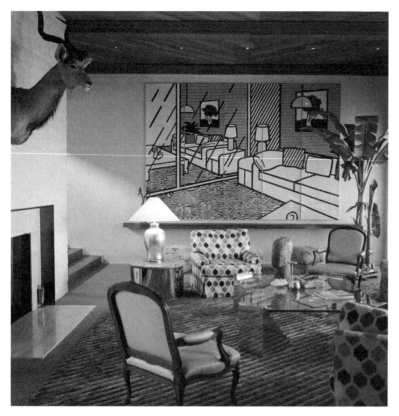

In the Verde Lapponia granite powder room, a
photograph of Betty Ford—taken in front of the
very portrait that now graces the entry—meets
another framed 1980s-era work. *Tussling Babes*, a
painting by Patrick Nagel, who is best known for
his work on the album cover of Duran Duran's *Rio*,
is placed prominently above the toilet. (7)

6 The couple is all about making the old new again. They reupholstered 7
 the Fords' original living room loungers and covered eighteenth-century
 French chairs that their designer discovered at a San Francisco antique
 shop in Edelman cream leather. (6)

arrival. The view over the country club is juxtaposed by Paul Von Ringelheim's towering sculpture *Endless Force,* which had been gifted to President Ford to symbolize the past, present, and future of the nation. Whether indoors or out, they set the day in motion with dedicated time for reading. "We are religious about newspapers," McIlwee admits. "We always get the *Wall Street Journal* and the *New York Times.* And the *New York Post*—you've got to have a little trash."

Quiet moments like these, especially after a good night's sleep in the comparative calm, provide sharp contrast to the couple's busy urban existence. "It might be the aquifer, the golf course, or the air," Damaschke reflects, "but there's just something specific to this house. It feels like it's sited quite perfectly." He finds himself in constant awe. "We have had it for ten years already," he continues, "and it is still full of surprises, from the way the light comes in and changes throughout the day to how the plants evolve."

The Ford Estate remains a second home. After selling John Lautner's almond-shaped Garcia House, one of the most significant mid-century structures in Los Angeles, they set their sights on a new primary residence—this time, a design from the little-known Mexican architect Raul F. Garduno. Even so, they haven't stopped frequenting the Rancho Mirage getaway. "Over the course of the pandemic, I spent a lot of time unraveling what I thought I had to do," McIlwee says. Gone are the Monday-to-Friday workweeks in the office. "Working here, for example, has so much value," he explains. "It's another environment, and I think differently. I can be relaxed *and* get a lot done."

The house also became a venue for family gatherings. Damaschke's parents and siblings frequent Southern California to escape the bitter Illinois cold. Here, it's a balmy fall day, and they have just retired from the pool, wrapped in towels that McIlwee and Damaschke

With wall-to-wall shag carpet and
striped, textured Larsen wallpaper,
the primary bedroom gives off all
the feels. (8)

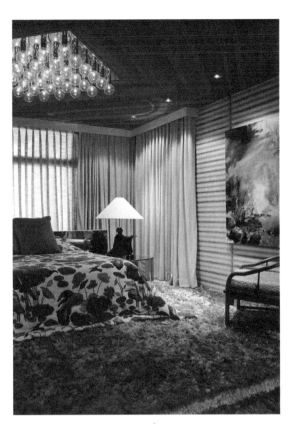

8

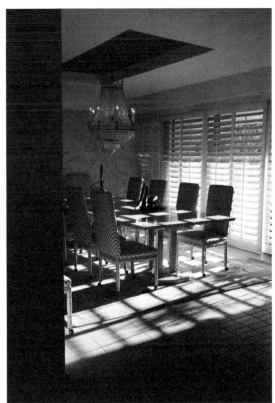

9

While Damaschke and McIlwee made minimal adjustments
to the Ford's dining room, they couldn't resist
adding a touch of their own flair: a nineteenth-
century French chandelier and bronze swans sourced
at a Parisian flea market. (9)

Much like the Fords, who were photographed by Lara
Jo Regan drinking coffee and reading the paper at
the dining table. Damaschke and McIlwee begin their
mornings by catching up on global affairs. (10)

10

designed based on the artist Garth Benton's leafy
green wall paintings in the dining area. The television
is on, and the sound of football commentators blares
through the gleaming, contemporary kitchen. With
each touchdown, his mother and father hoot and holler.
Damaschke smiles. "I actually see my family more now,"
he says. On longer stints like these—they are currently
in town for three weeks—he commutes between work
affairs in the city and downtime in the desert. "And
what's beautiful," McIlwee adds, "is that everyone has a
sense of privacy here." The layout of the five-bedroom
structure, with its multiple entrances and plentiful
outdoor space, was designed with the Fords and their
stream of guests in mind. Another touchdown, and
more cheering ensues. With the evening approaching,
snacks and drinks begin to materialize, and something
rich and buttery bakes in the oven. Everyone retreats
to their room to freshen up and put their game face on.
Damaschke pulls Yahtzee out. "We just love this one," he
says, pointing to the bright red box. "We play at that big,
shiny table. You know, it's funny. I bet the Fords sat right
there in that very spot and played Yahtzee, too."

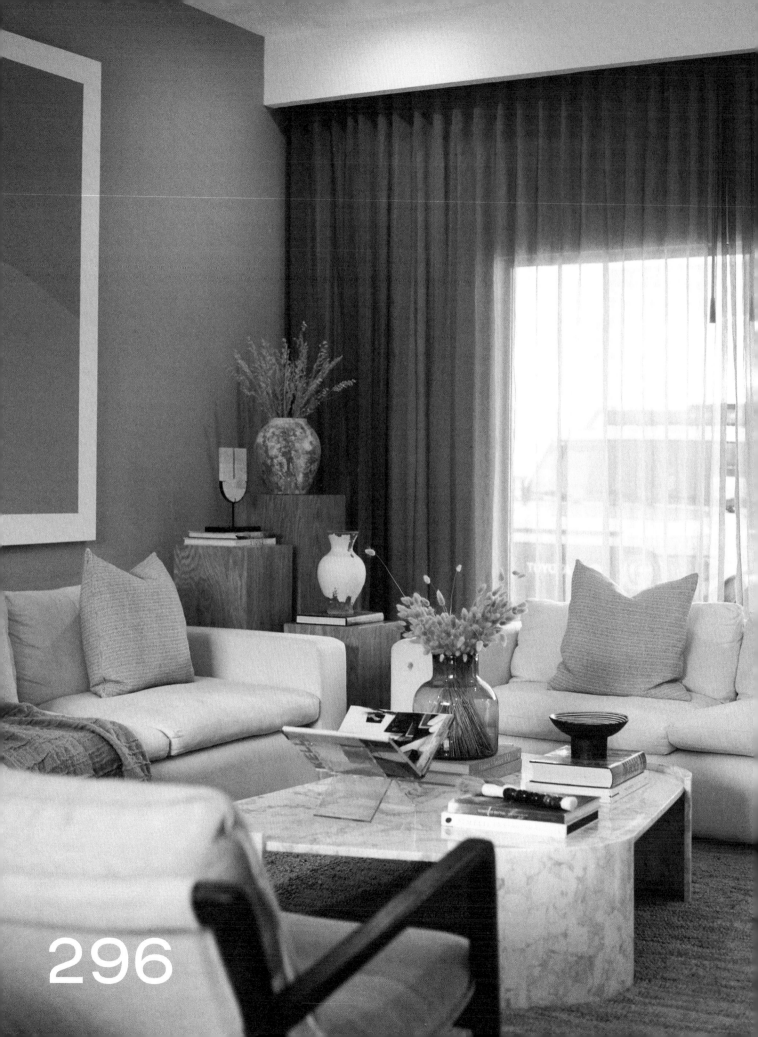

JOSE LUIS DESCHAMPS

Mexico

&

CAMILLE LARRINAGA

SAND, SEA, CACTI, AND KIN

Jose Luis Deschamps may hang his hat in the inland city of Hermosillo, but his mind frequently wanders to the sea. Brought up along the shores of Tampico, Tamaulipas, on Mexico's gulf coast, he meandered a bit farther afield to Brisbane, Australia, in his early twenties before finding himself drawn to yet another—sort of—coastal city in the state of Sonora. An hour or so from various favorite locations along the Sea of Cortez, Deschamps and his modified Toyota FJ Cruiser, sand-hued like the desert beaches, are always ready to hit the road or the dunes. "I can go spearfishing in the morning and be home by noon," Deschamps emphasizes with his patented ear-to-ear grin. Wherever he has found himself, his adventurous spirit has always attracted kindred souls, and more recently, love and family. His wife, Camille Larrinaga, a Hermosillo native, their two young children, and a shepherd dog named Swampy are all along for the ride.

As it happened, Deschamps was lured to the Sonoran capital by fellow expats and some of its very own natives while in Brisbane, a place whose laid-back denizens he refers to as "cowboys from the ocean." Even when he was surrounded by surf culture, something a little *ranchero* resonated with him. If there is one thing that seems to motivate Deschamps above all else, it's being in the company of like-minded people trying to make something of themselves and by extension, their communities. An opportunity arose to combine his love for athletics with business, so he traded the east coast of Queensland for the west of Sonora, transplanting to the desert, knowing next to nothing and nobody. But the characters that he had met abroad had him convinced: This area in Mexico's north exuded the right kind of collaborative, go-getter energy. He started a gym and then another in Tijuana, Baja California, decisions that opened doors, built a network, and cemented his roots in the borderlands.

"Desert people are very friendly and warm," Deschamps observes, a juicy *taco de cabeza* in hand, "and here, they are always pushing, always trying to move forward." When the first venture started to lag, his entrepreneurial eye turned elsewhere. Connecting to others with similar drive, Deschamps continued on his mission of building the city that he wanted to live in. An abandoned textile factory and its surrounding land proved the ideal canvas for Deschamps and his two partners. It started small. Phase one: cleaning up the site and bringing in a couple of food trucks. Before long, Parque La Ruina blossomed into a bustling hub of culture, and a rapid succession of "next phases" brought a live music venue, skate park, brewery, outdoor movie theater, and tons of culinary offerings to the site. The brick walls of the factory showcased the work of artists from the Mexican desert like Citlali Haro and It's A Living's Ricardo Gonzalez, and the grounds became the nexus for a new era in the evolution of this perseverant desert city. "Nobody thought that an outdoor bar would work in this climate," Deschamps recalls, "or that people would even sit together at communal tables." Reminiscing on the accomplishment—the little things like witnessing a multigenerational family gathered for a birthday celebration—are what elicit the greatest joy. "That's what nourishes me," he beams. Though he recently sold his shares in the project, he maintains focus on cultivating collective consciousness, and as he says, of "looking towards the same north."

Parque La Ruina "was like a campus for me to address all of my creativity," says Deschamps, who remains steadfast in his goals of synthesizing his own influences and filtering the best from abroad in creating positive platforms for the city. "We have a

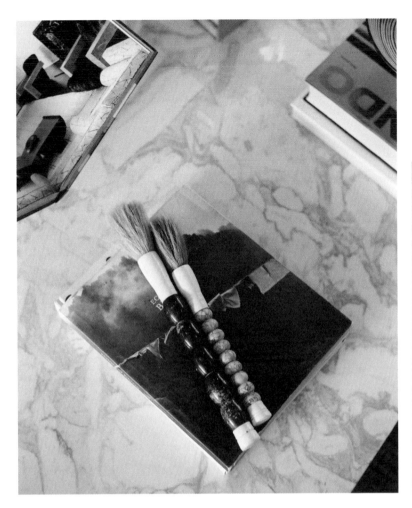

With a baby and a toddler at home, Larrinaga has put her career on pause. "I haven't learned how to let go yet," she laughs. Now, she turns her attention toward her own interiors, constantly evolving the intimate, tranquil design language that she has cultivated throughout. As a busy mother in a desert climate, she opts to decorate with dried grasses and flowers, which provide a sense of warmth and vibrancy, from shelves in the primary bedroom to the marble coffee table in the living room. (2)

1

2

Deschamps and Larrinaga's surfaces teem with objects—like a book about Bhutan and ceramic ball calligraphy brushes from Asia—that reflect their love for travel. For them, temporarily transplanting to a new environment can be the best way to engender gratitude for the place that they live. (1)

responsibility," he continues. His adopted hometown welcomes the dedicated efforts. "People from Hermosillo appreciate that not everything is given," Deschamps explains. "You have to fight for what you want to see in your community." His love for Hermosillo and the surrounding terroir oozes out of him. Thanks to his foray into fatherhood, paving the way for future generations to carry the torch is paramount.

Like many outsiders scrutinizing from afar, Deschamps originally perceived the desert environs as barren and lifeless. "But you come to know and love every plant and animal," he says, "and appreciate every time it rains." Transitioning from a verdant, humid land to the polar opposite has focused his attention on what *does* thrive, rather than what doesn't. Pointing a magnifying glass at the environment's subtle beauty has also affected his personal aesthetics. The home that he and Larrinaga brought to life together leans heavily into hues visible all around them. In a country known for vibrancy of color, from textiles to pottery, furniture, and clothing, Deschamps and Larrinaga are pointed in a different direction. They are attempting to blend in.

One day, the couple hopes to move into a construction of their own design, but in the meantime, they have taken root in the former model home of a desert development dreamed up by Larrinaga's father. When they moved in, opportunity was ripe for

3

In Hermosillo—a bustling desert metropolis—
younger generations are bucking global trends
in favor of consideration for local context.
"We value the flora and fauna," Deschamps says,
"and work with the resources that are already
here." He and Larrinaga hope to encourage this
type of thinking in their two young children
by planting a waterwise garden on the perimeter
of their patio or showing them the beauty
of underappreciated plants like rama blanca,
or brittlebush, which explodes with bright
yellow flowers in the early spring. (3)

4

Larrinaga's window design was instrumental in
transforming an ordinary space into something
altogether eye-catching. The long, rectangular
alcove promotes the infusion of indirect light,
while a scrim-like sheer curtain softens the
direct rays. These elements brighten the open
living and dining room but prevent extreme
heat from entering. (4)

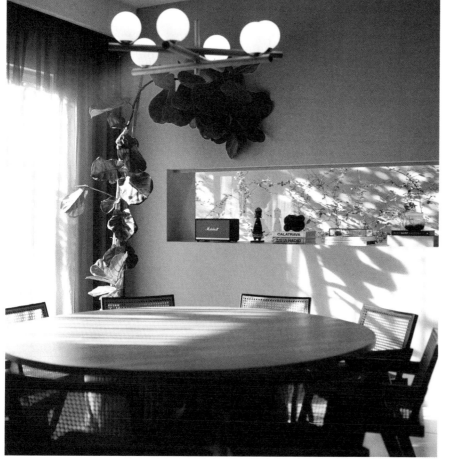

Larrinaga to tap into her architecture and interior design background and reshape the space for her family. She conceived of a large window opening where a solid wall used to be. The recess infuses more natural light into the dining room and doubles as a shelf to display books, records, and objects picked up on trips to Africa and India. Tomes on architectural idols such as Zaha Hadid and Tadao Ando, along with plentiful style references, permeate the warm living space. Deschamps adds personal, marine life–related touches, like sea-lion skulls found on camping trips and a shark tooth that calls to mind an iconic specimen Deschamps's grandfather discovered on his ranch in Tuxpan, Veracruz. But the *pièce de résistance* hangs above the second-floor family room: a black-and-white *gyotaku*, or natural fish print, inked by Deschamps memorializes his largest-ever catch, a gargantuan grouper from the local waters off of Tiburón Island.

On their back patio, Deschamps and Larrinaga take turns crawling into their son Lucas's workshop-themed playhouse to assist on a project, while Swampy looks for any willing participant in a ball game. The couple's firstborn has inherited a tendency toward adventure campaigns, both inside and outside of the house. The canopy of his bed is tent-shaped and a lantern hangs above his pillow. "My children have so many opportunities here," Larrinaga says, smiling, "which is so valuable for me." On any given day, she and her family might be camping, throwing a remote outdoor barbecue, riding horses, fishing, or biking on trails right outside their front door. Exploring has become integral to her little clan's DNA. "I just love it all," she says. Spending so much of their free time outside of the home means knowing how to cope with the elements. And make no mistake, this place is *hot,* frequently topping world temperatures in the summer months. "For Camille, living with the desert is a given," Deschamps says of his partner who has existed in this harsh climate her whole life. "But as an outsider, I have had to adapt to the patterns." Rising early, seizing the day, planning ahead, and always bringing extra water are foundational principles to Deschamps's learned lifestyle.

"This place feels like the Old West," he says with a laugh. "There's something spicy about it." Loading up his beloved rig in preparation for a seaside cookout with his chef friend, he runs through the necessities. Portable table? Folding chairs? Two-way radio? It's all there. Piercing the western edge of the city, Deschamps guns it on the open highway. As he grows closer to his destination, centuries-old Cardon cacti—branchier cousins of the archetypal saguaro—begin to host seagulls on their crowns. Rolling dunes appear on the horizon. He puts the cruiser into four-wheel drive. Down one sandy hill and up another, he arrives at a treasured spot. There's no other human in sight. He pauses to take a deep breath, soaking in the polychromatic sunset. On this border, where the desert meets the sea, Deschamps is home.

5

6

With one eye always looking toward the Sea of Cortez, an hour from his front door, Deschamps finds comfort in framed photographs of aquatic scenes and books like *Surf Shack: Laid-Back Living by the Water* on the bedside table. (5)

The Sonoran Desert bursts with plants that boast healing, restorative, and medicinal powers. For their daughter's room, Deschamps and Larrinaga selected a dusty green that mimics the calming effects of the shrubbery just outside their backdoor. (6)

ALL FIRED UP

with Rene Andrade

The chef and entrepreneur Rene Andrade may live in Phoenix, Arizona, but Sonora is in his blood. Born in Nogales, a border city in the Mexican state's north, Andrade relishes in the abundance of the desert land much like his friend Deschamps. "It is one of those magic places where you can harvest year-round," he explains. "You have the Sea of Cortez, which gives you everything from tuna to scallops, oysters, and shrimp. And then, inland, it's the land of meat—some of the best in the world." Everybody talks about the south of Mexico, but he thinks it's high time that this underappreciated region gets its due. And so— with Deschamps and his many tools in tow—he picks up meat in the city, travels to the waterfront town of Bahía Kino for seafood supplies, and sets up shop in the dunes of San Nicolás to engage in an age-old tradition. "Cooking over a grill or cooking with fire goes back to all of our ancestors," says the James Beard Award–winning culinary artist behind restaurants like Bacanora and Huarachis. "It's a literal human act." But he is quick to note that tending to the flames and coals requires immense respect. The experience, according to Andrade, "is always a humbling one."

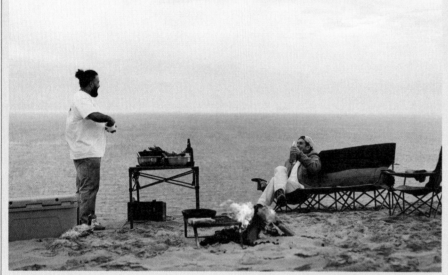

A scallop *aguachile* made with cilantro-chiltepín salsa, red onion, and avocado

Andrade and Deschamps revel in the act of carne asada.

The town of Bahía Kino receives some of the freshest seafood, like clams and scallops, in Northern Mexico.

Andrade fries potatoes in a cast-iron pan for a side dish, while bone marrow—which the chef adds to his beans—slowly cooks

Deschamps's camp table filled to the brim with ingredients—and a chiltepín salsa in the making

A WAY OF LIFE

Carne asada isn't just grilled meat. It is ritual—and one that is deeply tied to the state of Sonora. For me, it represents childhood, growing up, parties, and heartbreak. I connected with my dad most over cooking. Every Saturday or Sunday—after I would wash our car—we would start up the grill and throw on *carne de campo*, or grass-fed meat. We didn't have money to buy expensive cuts, so most often, we cooked chuck steaks. Carne asada helped me discover myself: "Oh shit, I want to cook! I can cook! And I get to see people happy." It's a practice close to my soul and close to my heart. The result can simply be meat grilled with salt and a drop of beer served on a flour tortilla—and that can be absolute glory. I mean, if I die, please bury me with *tacos de carne asada* topped with cabbage and *salsa de rajas*.

A PEPPER FOR THE AGES

The chiltepín pepper is often referred to as *oro rojo*, or red gold. The small, wild chile is native to a small radius on the Arizona-Sonora border, can only be handpicked during a brief window in the fall, and is very difficult to harvest. The chiltepín culture didn't transfer to the United States until recently. People think of drug smugglers, but then there's me. I bring peppers foraged from my family ranch in Baviácora. And I feel so lucky that I get to share the story of this fruity, flavorful chile with the world. It's not something that you can just eat. It's something that you have to understand. Make a salsa or two. They're simple and can go into almost anything at a cookout—here in San Nicolás, a scallop *aguachile* served in the shell, refried beans bolstered with bone marrow, clams cooked directly on the coals, and *carne apache*, a lightly smoked steak chopped finely and mixed with red onion and cilantro. All of that, my friends, is pure beauty.

Chiltepín Salsa, Two Ways

4 cloves garlic, peeled
1 teaspoon salt
Juice from 6 to 8 limes
½ cup (30 g) whole chiltepín peppers
2 tablespoons olive oil
1 to 2 tablespoons finely chopped cilantro

Let's be clear—you have to use a molcajete.

Smash garlic and a bit of salt to create a paste. Throw in a little bit of lime juice to hydrate that paste.

Add chiltepín and grind with all of your heart. We're trying to break the seeds to give that emotion, right?

Mix in more lime juice and salt, and let the concoction sit for five to ten minutes.

Reserve half. Add 2 tablespoons of olive oil, and stir, stir, stir.

Put finely chopped cilantro in the other half. Perfect for something like the scallop I'm making here at the dunes.

Always taste your work. Squeeze more lime and continue to salt as needed.

That's literally it—*dos salsas* done.

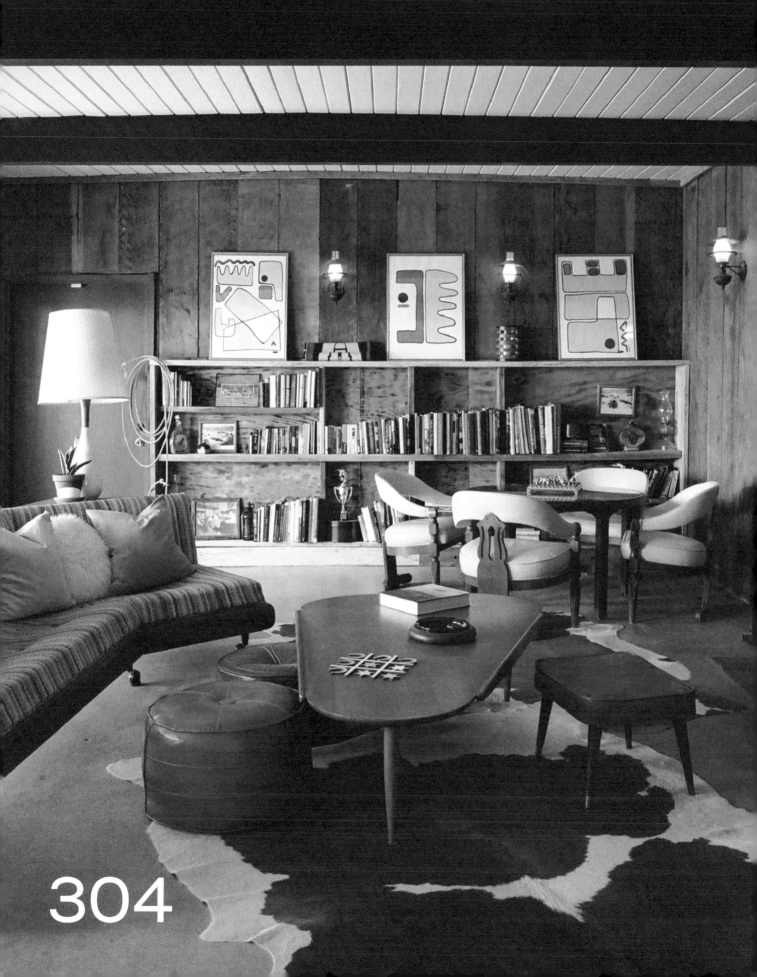

304

FERIAL
SADEGHIAN

United States

& JEFF
VANCE

A COMEBACK STORY:
MAKING THE OLD NEW AGAIN

It's Friday night. Cocktails come out in quick succession—something bittersweet and gin-forward for one guest, a refreshing mezcal sipper for another. Jeff Vance, a tall man with a gentle heart, greets friends and neighbors at the front door. Ferial Sadeghian lights taper candles that animate the wood-paneled dining room, which, replete with antler chandeliers and barrel-backed chairs, seems taken from a Western movie set. She wordlessly draws her cohort into the room. Perhaps it's her contagious laugh. She shuttles salads, stuffed acorn squashes, and roast chickens in from the kitchen, while Vance uncorks bottles of a juicy red. The dynamic duo gives a toast, and everyone digs in. Country tunes from the likes of George Jones and Buck Owens play, but the roar of lively conversation prevails. It feels a bit like Thanksgiving, but it isn't. And despite appearances, Sadeghian and Vance aren't at home—they are at Cuyama Buckhorn, the roadside motel and eatery they purchased in 2018.

Vance admits that he has been a "desert rat" for as long as he can remember. "I don't know how it works," he says, "whether it was just in me or if it was something that my dad nurtured." He describes his father as a "get-up-and-go" kind of guy, perpetually ready to hop into one of his Chevy El Caminos or Ford Rancheros or onto a motorcycle for the next adventure. They didn't have much money when Vance was growing up, but they did make plenty of memories on camping trips across the Mojave Desert. "He left me with that passion," Vance says. "I'm not someone who wants to come across rattlesnakes, but I like being way deep in these places where there's nothing and no one around. And they are so clean—there is just nothing cleaner than desert dirt."

For Sadeghian, the desert was more of a slow burn. "I grew up in Tehran, in Iran's north, which is lush and green," she explains. "But in my first few years in the United States, in Los Angeles, I found myself missing the seasons. I lost track of time." Then, in the high desert of Santa Barbara County's

1 2

The lobby is named after the late local rancher Lamar Johnston, who landed the nine bucks and one elk turned taxidermy mounts that dress up the Buckhorn bar. It oozes with Western flair, in part because Sadeghian and Vance hand-picked playful paraphernalia: old photographs, out-of-production board games, rare books, and an eclectic record selection that ranges from *A Charlie Brown Christmas* by the Vince Guaraldi Trio to Johnny Cash's *Blood, Sweat, and Tears*. (1, 2)

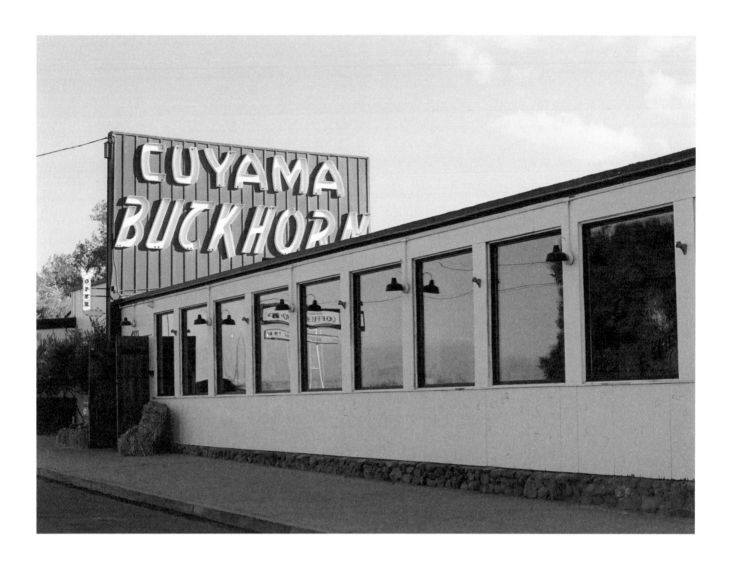

Cuyama Valley, she witnessed the foliage change color and the wildflowers bloom and regained a certain natural rhythm. "I love the nature," she says. "I love the vastness. I love mountains and the terrain."

Sadeghian and Vance are thick as thieves. Their worlds collided in 2012 when Sadeghian came on board at iDGroup, a small firm focused on luxury design-builds that Vance founded in the early aughts. The team tackles projects at every phase, from finding bare land to sourcing a rare chair for a family's living room. The auspicious meeting resulted in a slew of collaborations, including several self-initiated projects, like the revival of a mid-century, Arthur Elrod–designed home in Palm Springs. Sadeghian became a partner in the company, but she also became Vance's partner in crime. As the two developed an increasingly intimate

work relationship, they began to share dreams and brainstorm far-out ideas.

The more they learned about one another, the more they realized that hospitality was in their DNA and on their horizons. Vance hails from a California food-and-beverage family—his great-grandfather founded the San Francisco speakeasy that became the Coffee Dan's restaurant chain, and his grandfather served as president of a bartender's union. For Sadeghian, the daughter of diplomats, event planning was second nature. She traveled extensively as a child, taking annual family vacations to Europe. Road trips were feasts for the senses, and where she forged her lifelong appreciation for architecture and all things culinary. "You could be in the middle of nowhere, on the side of the road," she says, "and find something amazing." She describes

Cuyama's landscape, where dusty plains and grasslands give way to rolling hills and mountains, has earned the nickname "The Hidden Valley of Enchantment." Sadeghian says that its diverse topography and vegetation often surprises visitors. "This isn't like Iran's deserts," she muses. "And it isn't like a lot of deserts that you see in movies." (3)

a pork tenderloin grilled over the coals on the outskirts of a small village, a succulent strawberry cake at an Austrian castle, a mom-and-pop establishment with homegrown vegetables, and understated hotels run by imaginative chef-owners—places operated with love and integrity, and, of course, delicious food.

Vance had visited the Buckhorn, the 1950s hotel built by the Richfield Oil Company as a resting place for its executives, many times in his youth. On a scouting trip, he brought Sadeghian for a look-see of the highway pitstop, which had been designed by George

Vernon Russell, the architect responsible for the Flamingo Hotel in Las Vegas. "The bones were there," recalls Vance of the mid-century construction, "but it was all timbered. There was wood everywhere. It was just Disneyland." They roamed around town, until a moment of kismet stopped them in their tracks. On the grounds of the nonprofit Blue Sky Center and adjacent to the L88 airstrip sat a very particular cantina. The earth-built structure, composed of three interconnected arched rooms, was designed in 1986 by the architect and Sadeghian's former professor Nader Khalili. "The connection with Iran felt wild," says Sadeghian, wide-eyed.

"There were so many different things that brought us here," Vance continues. But one thing helped for sure. Vance constantly scrolls real-estate websites. "He has notifications set in Japan, in New York, Arizona, and New Mexico," Sadeghian says of the obsession. "It's craziness." One night he stumbled across it—the listing for the Buckhorn. "What does that have to do with us?" Sadeghian remembers asking when he texted her the link. Her vision of their hospitality project was more of a secluded country inn, not this refuge for weary highway travelers. In time, however, memories of the adventures of her youth reemerged. The enchanting surprises that she encountered in the most unassuming places may have been the spark that shifted her perspective.

Before they knew it, the paperwork was signed, and the keys were in their hands. Down came the iconic road sign, hoisted off the roof for a fresh coat of paint, that very first morning. The old motel rooms, assembled from concrete blocks, had been slapped with wood and decorated with chunky four-poster beds. Some rooms were used for storage or otherwise out of commission. Sadeghian and Vance moved into one to tackle the first phase of renovation. They removed bedside tables and other pieces, lining the curb for opportunistic furniture hawks. Thanks to the solid original architecture, stripping down instead of rebuilding was the name of the game.

A study in patience ensued as they engaged in a lengthy back-and-forth to acquire necessary permits. Once they ticked all of the boxes, they enclosed outdoor areas and installed a pool and bocce court where asphalt used to be. They modernized rooms, turning to their mid-century origins for inspiration, while still opting for distressed wooden backboards and decor that includes cowboy hats and worn novels with a sheriff or horseman on the cover. "There is still a Western spirit in Cuyama," Sadeghian says, "and it was important for us to infuse that into the Buckhorn." The bar, candlelit and riddled with taxidermy deer trophies, calls to mind cowboy joints of yore. Meanwhile, the restaurant retains a charming highway diner aesthetic with a lift of brightness and wide windows to take in the sun setting on the Caliente mountain range.

"The storage space, where the lobby is now, was filled to the brim," remembers Vance, and they couldn't uncover any photographs indicating its former glory. The new incarnation is inviting and filled with books, board games, and records. An upholstered couch in ochre hues, cowhide rugs, and, yes, timber-paneled walls, pay homage to a time gone by. "You brought the lobby back!" a Buckhorn employee from long ago exclaimed one day. It's those moments of bringing people together and bridging past and present that put a smile to Sadeghian and Vance's faces.

"I think that we listen more than anything," Sadeghian says of a process honed over years in the interior design industry. "You look at a wall, and it tells you what to do," adds Vance, who started his career as a Hollywood set decorator. "You look at the land, at the topography. You are always working with something that already exists, whether it is established by Mother Nature or built. So yes—you have to listen." Creating a space that appeals to a diverse set of visitors, from LA weekenders to roadtripping families and cattle ranchers, was a journey—and one that went far beyond painting walls, changing out furniture, and adding new amenities.

To elevate the Buckhorn experience and show a commitment to their community, the pair champions the area's farmers, winemakers, and purveyors. The restaurant's menu features nachos and chili but also a biscuit made with heritage rye flour and locally sourced steak with bourbon-rosemary butter and beef-fat fries. They hired a bar lead, Sam Seidenberg, who put together a cocktail menu with foraged and seasonal ingredients like quince from Rock Front Ranch and sage from the hotel's herb garden. Nonetheless, locals ensure that Coors remains a top seller. Seidenberg, in turn, crafted a drink in tribute called God's Country: fat-washed rye whiskey with Wagyu beef from down the road, Coors Light distilled into a simple syrup, and corn liqueur. His nerdy, man-of-the-people demeanor makes the bar a place for all.

The Buckhorn is once again the heart of Cuyama. With a constant stream of events—chuck-wagon barbecues, outdoor screenings of *Top Gun, Sandlot,* and *Grease,* and singer-songwriter concerts—it's the cultural center as well. After countless weekends on site, returning to the city midweek for office duties, Sadeghian and Vance were resolved to get a spot of their own. On the southern end of town where the pavement ends, the two make their way a few miles up a dirt road, past herds of cattle and oil fields, a drive so strangely meditative that the designers almost always take separate cars.

Their ranch house sits on a hillside, bordered by Los Padres National Forest to the south and the wide-open Cuyama Valley in every other direction. The two-story

Vance, who comes from a long line of
cocktail connoisseurs, insists on a
well-stocked, thoughtfully designed
bar across all of his projects.
At the Buckhorn, he can be found
drinking a take on the white Negroni,
and at home, he and Sadeghian often
prepare gin and tonics with a special
twist: Lillet Rouge. (4, 6)

dwelling basks in natural light owing to the double-height main living space. The statement stone fireplace towers above the long white couch covered in furs and the upright Butler Brothers piano. While the changes that Sadeghian and Vance made were mostly surface level, like amending "cowboy solutions" to wiring and updating finishings, they maintained the warmth and unpretentious energy from the previous owners.

Several outbuildings dot the property, including a bungalow guesthouse enveloped by alpine trees, an erstwhile walk-in freezer from the ranching days, and a barn, where the duo are building a covered event space. "We—or should I say one of us," Vance laughs, playfully nodding at Sadeghian, "has a tendency to inventory things." He might be addicted to property listings, but Sadeghian has a problem of her own: vintage goods. "It's a sickness," she says of her midnight browsing and affinity for estate sales. When it came to furnishing, they didn't need to do much in the way of shopping, and all the added space proved beneficial for her preexisting stash of wares, whether modern loungers, ceramic pheasants, or moody still lifes.

In this high-altitude desert basin, away from the pollution that envelops the City of Angels, the sun beats down fiercely. Sadeghian and Vance may be novices compared to some of the old-timers spoken of in hushed, reverent tones, but they're here to stay. Vance checks on a water tank, a ritual of sorts. "Out here, if you aren't tending to a water line or your water source, something isn't right," he jokes. Sadeghian has prepared a breakfast spread of spicy fried eggs, local cheeses, and—the star of the show—dried jujubes from a prolific farming neighbor down the road. They have about a million things on their plate, but in these parts it's a known fact that nothing happens if you don't stop to smell the roses or at the very least, enjoy your morning meal. "I wouldn't necessarily build your business plan around this," Vance says with a wink, "but I can go into the Buckhorn to work and then head out on an hour-long hike or hit a dirt road. Is there anything better?"

4

5

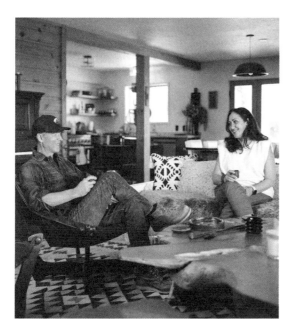

6

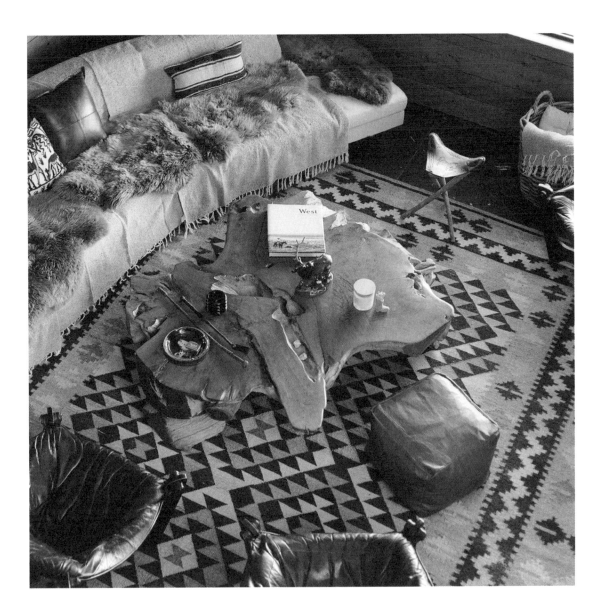

The designer duo purchased a rug in Palm
Springs, which set the tone for the rest of the
living space. The white couch initially found
a home in the Buckhorn lobby but its sleek,
modern look "didn't really belong," according
to Sadeghian. It eventually wound its way to
the ranch, where it complemented the rug just
so. Then came the oversized coffee table in
burl. "Not many tables were big enough to
match the sofa," Sadeghian says. "Moving it
in was hard. It won't be moving out." (5, 7)

Sadeghian chanced upon a still-life painting
from an estate sale in Los Angeles's Mar Vista
neighborhood. It came with an attached brass
light fixture, and she immediately knew that
it belonged in the home office atop the Western
star tiles. (8)

The fireplace's stone wall wraps around
into the ranch house entryway, where Vance
(literally) hangs his wide-brimmed hat. (9)

8

9

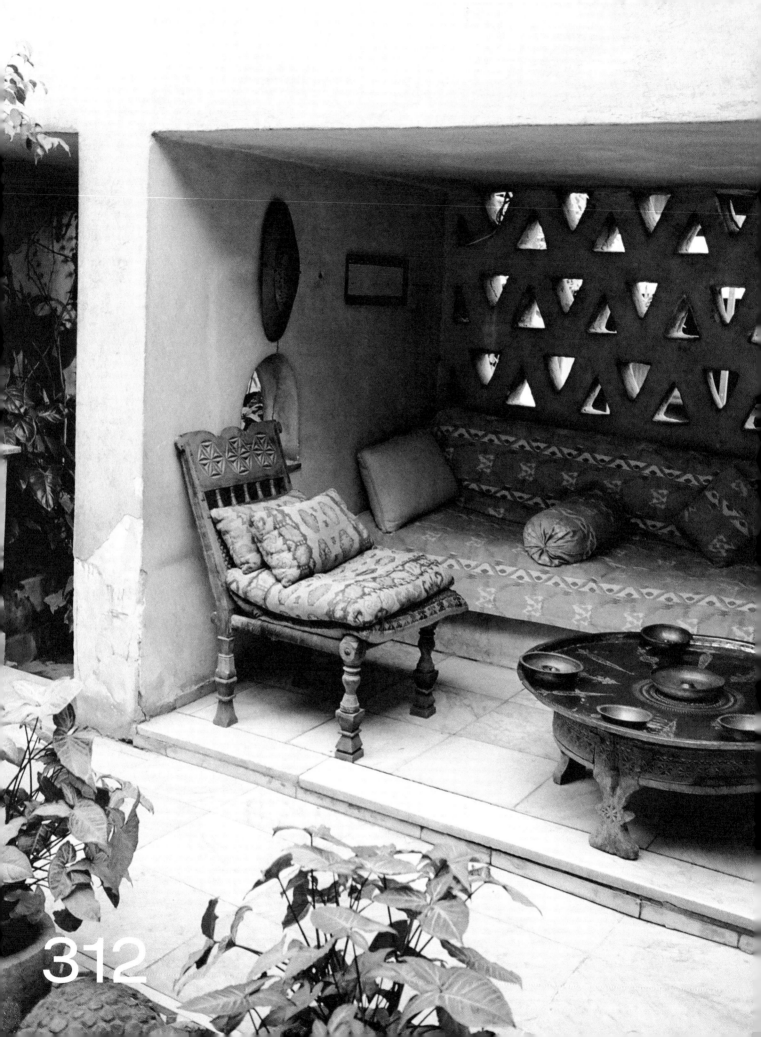

312

Cairo

SHAHIRA

Egypt

MEHREZ

IN AN URBAN JUNGLE, AN OASIS OF IDENTITY

These days, Shahira Mehrez can mostly be found in her bedroom, what she has affectionately dubbed her "cocoon." A patterned curtain shields her from natural light—she prefers to disregard the time of day and instead work when she is struck by inspiration. Next to photos of her late second husband and soulmate, Renaldo Tommasi, she leans into a pile of pillows, a lap desk over her outstretched legs. Papers are strewn alongside her, and a cup of thick Egyptian coffee, black like tar and spiced with cardamom, sits on the ornate copper-tray table that is home to cups of pens, highlighters, scissors, and other office miscellanea. Mehrez may be in her eighties, but she is full steam ahead. Her four-hundred-page book *Costumes of Egypt: The Lost Legacies,* the first in a four-volume series, has just published, and she is laboring tirelessly on its sequel.

An Islamic art and architecture scholar, a collector and researcher of traditional costume and craft, the once owner of an olive plantation, and a political activist, Mehrez has led many lives but all with one common goal—to promote and preserve Egyptian culture. Growing up, she felt torn between two worlds. Schooled in a French institution where students were scolded for acting like "little Arabs," and with a Mediterranean complexion, she lacked a sense of belonging. "To the French, I felt Egyptian," she recalls. "And to the Egyptians, I felt French." A university education brought her closer to Arabic language, literature, and history, and by the time she graduated, she knew what she wanted above all: an identity.

After a three-month tour of Europe, a graduation gift from her mother that she frequently says allowed her to "cut the umbilical cord" with her French background, a young Mehrez returned to Egypt with a fresh perspective and the eyes of a "romantic tourist." With a dictionary always in hand, she learned to speak, read, and write Arabic with fluency. She worked in the library of Sir Keppel Archibald Cameron Creswell, surrounded by one of the most comprehensive collections of Islamic art books in the country. She

dug deeper into Cairo, the city that she and her family had been forced to leave in the wake of the Egyptian Revolution. Her sense of self was deepening, but still, she perceived a rift between her Western education and her Egyptian background. That is, until she met Hassan Fathy. Arguably the country's most well-known twentieth-century architect, Fathy "was also a hybrid," according to Mehrez. "He helped me bridge the gap, to realize that we could study both cultures from which we came and choose the best from each."

In the late 1960s, she traveled with Fathy, who broke barriers between them—self-professed "urban elites"—and the rural peoples who had, in fact, preserved traditional culture by way of timeworn building techniques and craft. A young and impressionable Mehrez was left humbled. At the same time, her mother began constructing a building in Cairo's Dokki neighborhood, a residential strip along the Nile. "She wanted to return to the area that she had lived in with my father," Mehrez remembers. "It wasn't very logical, but that's how people are." Mehrez requested the top-floor unit and asked Fathy to draw up plans. The architect refused money from private citizens. He insisted that his real clients were those without resources. "He worked for the state, for governments, for those doomed to premature death because of bad habitat," Mehrez explains, "and not for individuals. But if he liked you, you got your drawings."

A pioneer of sustainable practices, Fathy is mostly known for standalone structures, vernacular forms built from the earth in remote locales like New Gourna in Egypt and Abiquiu, New Mexico. Yet, he managed to instill his principles in this comparatively small penthouse with an existing structural framework. Mehrez thinks back on the building's completion in 1971. "We weren't finished," she laughs. "All of the other apartments had doors and windows with the exact same dimensions. Here, every door and window was old. Every opening needed to be different."

"It is a house for all seasons," Mehrez proudly states of her beloved abode, and most of those seasons are spent in the courtyard. The airy yet private space has seen countless hours of use with minimal changes through the years, owing partially to a cohesion of honest materials. Marble is everywhere, from the floors to the benches and tables, while wood and earth play the perfect complement. "I don't feel that it dates," Mehrez says. (2, 3)

1

The apartment is truly an extension of Mehrez, and she of it. "I find the house very easy to wear," she says, surrounded by a towering wall of greenery. "It's my size." (1)

2

3

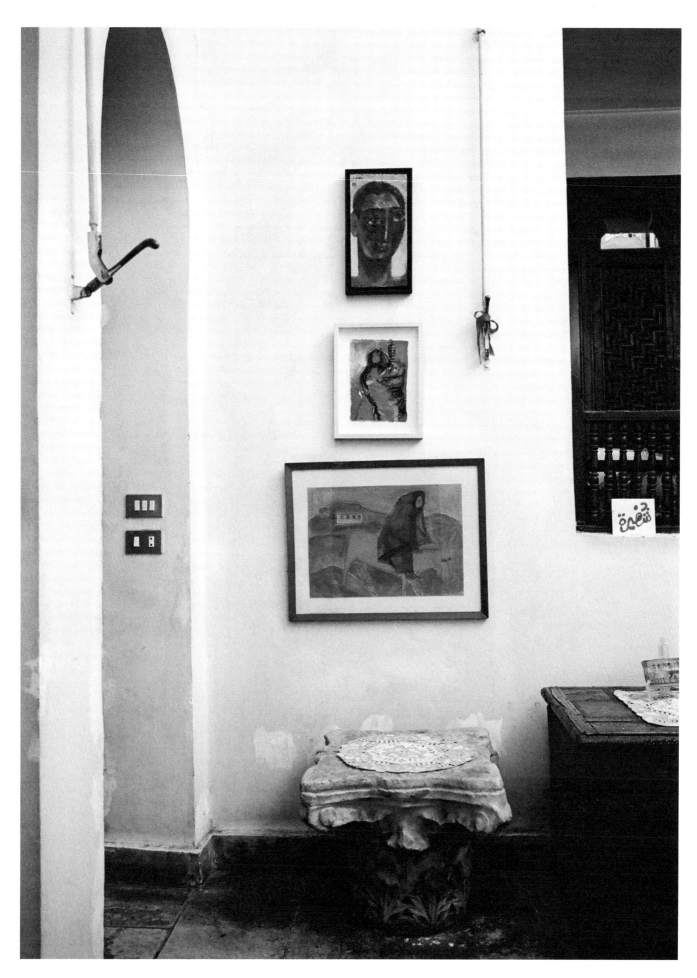

To get to the urban residence, visitors load into a cramped, wood-clad elevator that is much like a time machine taking travelers between different realities. They press the number six and are transported from the chaotic, smog-choked city streets below into a universe altogether new. A collage of enclosed or semi-enclosed spaces are connected by passageways and corridors. Floors and ceilings vary in level and height. Latticework window coverings allow natural light to permeate and diffuse into spaces, while controlling the amount of heat that enters with it. In the office and sitting room off the bedroom, a grand chimney-like tower made of wood features openings on all sides, forming an epic skylight. The result is something more akin to a large, elaborate house than the singular floor of an apartment complex.

"It is made to suit my needs," says Mehrez. "And I find it extremely versatile. I can host four people or sixty people all the same." She recounts parties, where friends and members of her large "adopted family" streamed into every corner. They sat on her bed, chatted in the hallways, and drank champagne kept on ice in her sunken marble bathtub. She muses on the first-floor unit that she inherited and renovated after her mother's passing. "It's a place to impress people," she shrugs. With less division, the rooms are bigger, but she quickly came to understand that larger, more open spaces don't equate to greater capacity. "I can invite more people to this apartment," she says of her own. "The layout is modeled off of traditional houses. There is no space lost."

Though, she notes, her books can get in the way. Books are *everywhere*. There are stacks on tables, some of which she has added for the sole purpose of spreading out to read and take notes. Shelves cover nearly every wall. "I belong to a generation that really used books," she says. "We didn't have television. We didn't have mobile phones or the Internet. So yes, we were living in books." She claims to mistreat her collection, which spans topics from cooking to history, geography, anthropology, urbanism, and travel. Bindings are worn from use, and tabs stick out to highlight particular pages.

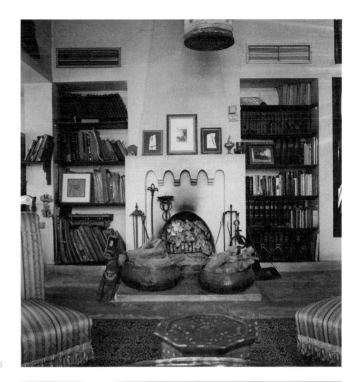

Hassan Fathy, the late architect responsible
for Mehrez's impressive apartment, often
employed opposing geometrical shapes reminiscent
of vernacular structures that he had seen
throughout Egypt's countryside. Take the arched
entry that separates public and private areas
and contrasts with large rectangular openings
between rooms—or the decorative curved motif
that softens the living space's sculptural,
tapering fireplace. (4, 5)

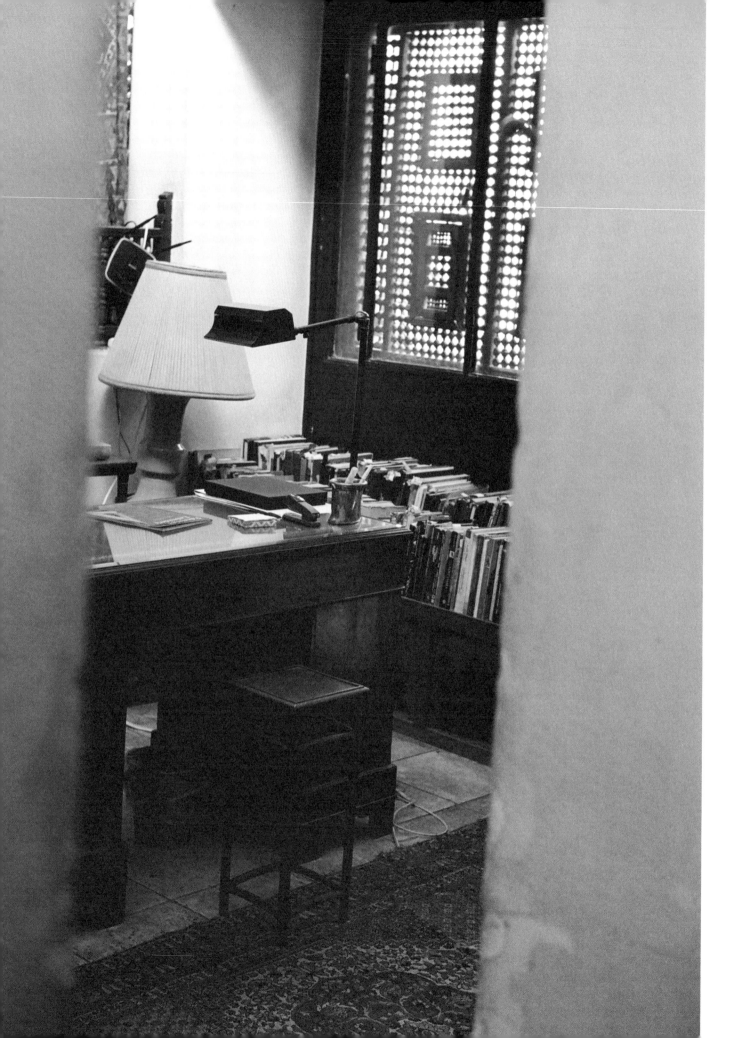

Mehrez knows "more or less" where her
books are—in her luminous home office,
stacked on tables in the library beside
the dining room, and everywhere in
between. "Sometimes things disappear,"
she laments, "or I make the mistake
of lending a book." After learning the
hard way that lent books rarely return,
she has taken to buying two or three
copies of the same volume, employing
visiting friends as so-called book
mules. (6, 8)

Collecting seems to be in her blood. Starting to rebel against her upbringing and with an indifference to Western clothing, she began to accumulate traditional costume at the age of sixteen. She now boasts the largest archive of regional Egyptian dress in the country and possibly the world. She stores them elsewhere, but artifacts of other kinds—pottery, basketry, silver vessels, textiles, everyday utensils, and framed photographs and artwork—abound.

Beyond a place for display, the interior living spaces—the sitting and dining room—mostly exist as "practical areas to welcome friends." Intricate serving dishes remain at the ready, waiting to be filled with biscuits or chocolates if a visitor pops over for tea. A tablecloth is set out and stores of homemade bitter orange and date jams are kept aside if someone decides to stay for breakfast or lunch. Mehrez, however, hardly spends time in these corners alone.

When not in her bedroom cocoon, she can be found outside except during colder winter weather. The open-air courtyard is "where I live for ten months of the year," she explains. Marble-tiled floors meet built-in benches of the same material. A covered nook features a long wall of adobe bricks stacked to create triangular vents, which filter the sun but also allow a draft in the hottest months. Mehrez often sits here, catching the breeze, and watching television. "I'm a news addict," she admits. The light pink plaster, textiles in muted tones, outdoor plants, and tiny central fountain provide a sense of calm when the myriad horrors of modern society flash on screen.

Mehrez is something of a dynamo, constantly juggling a steady stream of guests, in-depth writing for her next book, political and humanitarian initiatives, and day-to-day activities. Yet, she almost never leaves her rooftop retreat. In search of her roots, she studied, traveled, and met a laundry list of interesting characters. "And like Ulysses," she says, "my voyage brought me right back to where I started." On her family's land and in one of the largest desert metropolises, she has developed a space that is part private museum, part research center, part home, part office, and pure Shahira Mehrez.

While costumes are her forte,
Mehrez also collects objects made
with integrity, like Bedouin metal
pitchers and jugs. (7)

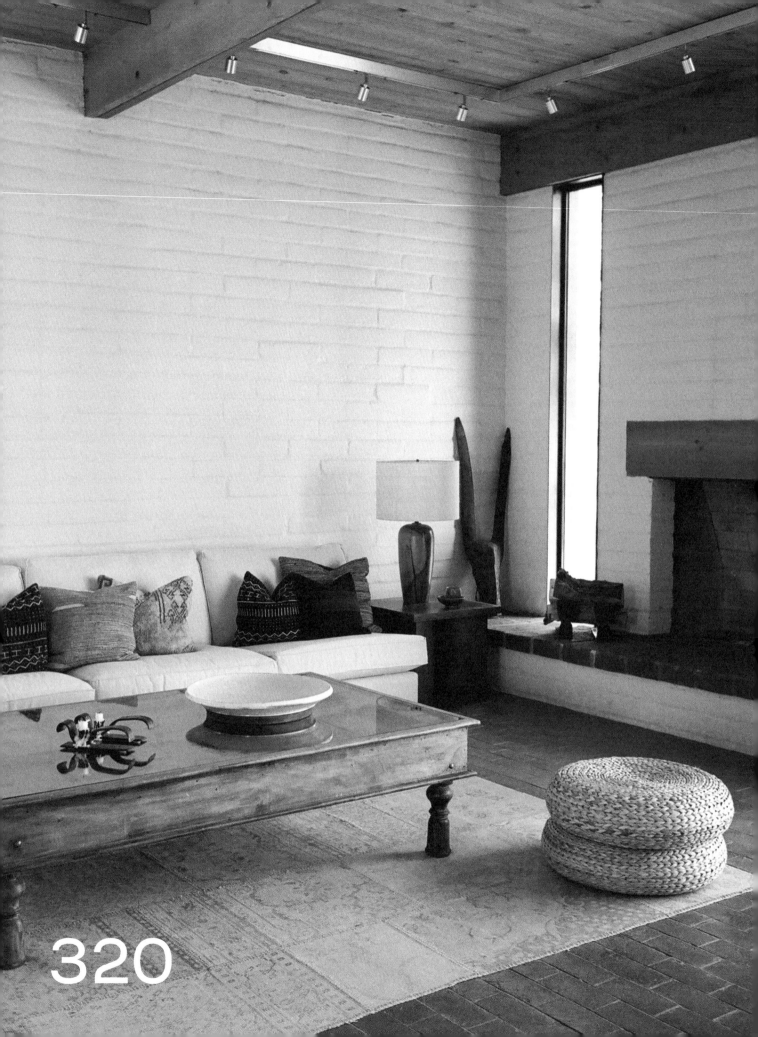

320

SCOTT PASK

WHERE THE DIVINE IS IN THE DETAILS

For Scott Pask, light and shadow are as inseparable to his craft as the stage itself. It is no surprise, then, that the Tony Award–winning set designer, whose keen eye is responsible for everything from Broadway's *Shucked*, *Mean Girls*, and *Waitress* to comedian John Mulaney's Netflix specials, considers them essential to his Tucson home. Set in the southern foothills of the Santa Catalina mountains, his house is intricately designed to track changes over the course of a day, each room functioning like part of an ancient sundial, and between seasons.

Raised in the low desert of Yuma, Arizona, a farming and military town wedged between the borders of California and the Mexican state of Sonora, Pask has maintained a lifelong attachment to horizon lines and the movement of light. "My orientations are somehow grounded in my youth and my upbringing," he says. "Charting how the sun enters the day in one space and then leaves us in another has always been very important to me."

That might explain why Pask, who initially studied architecture at the University of Arizona, complemented the original 1968 home design—marked by robust, plastered adobe pillars, red brick and concrete floors, and massive Douglas fir beams—with long, recessed skylights and large, unobstructed windows. Sunrise explodes through the singular glass panel of the center-pivot front door. Midday light rains down over the hall connecting the two guest bedrooms. In the late afternoon, shadows of a native ocotillo plant animate the walls of Pask's step-down shower. Then, as the sun dips towards the Tucson mountains, golden hues fill the entire space.

Even when working in far-flung locations, Pask claims that he can look at his in-home cameras and identify the time and day without a clock or calendar. That familiarity makes this now New Yorker feel rooted when off in places where an omnipresent forest of buildings augment and alter his perception of light. "Who needs a TV when you have these views?" Pask muses as the evening sky oozes that inimitable desert palette. This place has a palpable

hold on him. Once he settles in, his world in the East Coast's cultural capital fades away. He becomes a steward of this small piece of land. He cherishes time with friends and family. He goes on hikes and basks in the smell of the aromatic creosote bush after the rain.

Living in these climes equates with tapping into the rhythms of the natural world in a more intimate way, and desert dwellers frequently fall into two camps: those that revere the sun and those that hide from it. Pask is undoubtedly a member of the former. Yet, when he first visited the property with realtor Jane London and friend and former architecture classmate Chris Evans, Pask encountered a dark-ceilinged and compartmentalized interior with rooms of wall-to-wall carpet. "I could tell it had been done with integrity," he recalls. "When other people showed up at the open house the following day, I suddenly became very territorial." Within forty-eight hours, he had struck a deal.

With patience and precision, as if constructing a handmade watch, Pask tackled the house in phases, conceiving an identity that harkens to its past and brings new life to its future. He sought to transform it into a celebration of the elements—a healthy balance of exposure and protection—and the endemic materials that, when he arrived, were hiding behind renovation choices of the late 1970s.

And so he sought guidance from Evans, the local architect Graydon Yearick, the contractor Scott Woodward, and a slew of craftsmen, builders, and advisors, including Robert Nevins, his former professor and longtime mentor, to help realize his redesign. He endeavored to open up the arteries of the home, creating interior vistas and a space that showcases Pask's profound adoration for the natural environment, while shying away from clichés and trope-laden shortcuts. "I've always felt there's a brutality to the climate that's reflected in the way that people live here," Pask says, "and brutality for me is an aspirational concept." He holds firm that austere doesn't inherently equate with sterile.

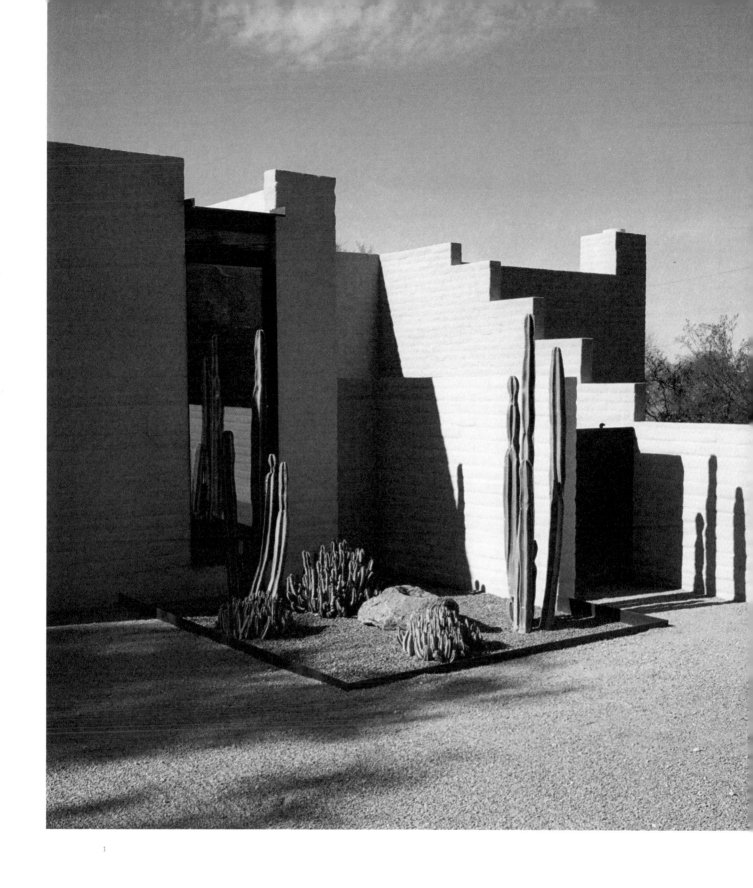

1

Pask has employed various tricks from his professional
trade into the house that subtly play with perception,
like dyeing the mortar between newly laid bricks to match
what had been in the house for decades or painting the
south-facing, sun-blasted wall two shades darker than the
rest of the "Pask Gray" that adorns the exterior. (1)

Pask revels in the particulars. The pool,
for example, was constructed to mirror
the exact dimensions of the living room's
interior volume. (2)

2

Early in the renovation process, a large steel pivot
window replaced its arched predecessor in the primary
bathroom, opening the rain shower directly to the desert
beyond. "When you're here, you just want to be outside
all the time," Pask explains. (3)

Being on tour or in the thick of a production
doesn't stop Pask from shopping. He purchased the
lamp and chest in the guest bedroom at Scout,
a vintage shop owned by his friend Larry Vodak,
while on location in Chicago. (4)

4

3

Pask commissioned Nate Danforth to craft everything from kitchen cabinets to doors, platform beds, shelves, and hidden closets from teak. "He's coming out of retirement," Pask mentions gleefully, to build the bookcase that will sit opposite the living room fireplace. Danforth is his ideal collaborator—beyond know-how and dedication, the master woodworker's attention to detail is as sharp as Pask's own. For Pask, no decision is made haphazardly. He selected Mexican travertine for the kitchen and bathroom countertops, as well as a wall in the primary bath. The porous limestone, though easily scratched and stained, mirrors the color and texture of the desert surroundings and develops a patina that he couldn't resist.

Meanwhile, in keeping with the spirit of patience, Pask has largely let the furnishings and art reveal themselves to him. Take the inexpensive set of Don Shoemaker chairs, constructed of cocobolo wood and black leather, that he found on eBay or the textiles and ceramics he picked up on trips to Turkey and Morocco. He purchased his coffee table, fashioned from an Erie Canal barge panel, on *The Book of Mormon* national tour, converted fabric from past shows into throw pillows, and devised a side table from a leftover chunk of travertine. Each piece is placed slowly over time and with great intention.

Pask, who creates work that is ephemeral in nature, strives to build a home that contrasts his professional practice. "I'm always dealing with dualities," he says. "Since most of the work I do is short-lived, it comes down to creating impactful moments— like how the light hits *that* person when they sing *that* note—which live in this kind of nostalgic place in your mind." These flash occurrences are hard to capture and even harder to hold onto. The house, on the contrary, represents the opposite—a tangible manifestation, an enduring legacy.

Pask extends that sensibility to his exteriors. Palo verdes, the state tree of Arizona, dot the premises, alongside various species of agave and prickly pear, saguaro, and barrel cacti. Opposite the front door sits a particularly impressive, six-headed yucca that Pask takes great pride in cultivating. "It's so special to watch things thrive," he says, "and to learn how to adapt or to help them when they need it." This property, after all, is much more than a design endeavor or a passion project. Rather, in returning to the landscape of his youth, Pask is establishing his own mental health refuge. "I gravitate towards the resilience—of the plants, of the people," he explains. "This is a spiritual place, a healing place. We're so often buried under the traps of modern life. But here? We have to learn to coexist to survive."

In an effort to create a sense of harmony between the traditional elements of his southwest surroundings and their more recent modernist ties, Pask pairs handcrafted rugs and ceramics with contemporary furniture, industrial pieces, and art—like a tryptic by Hollie Myles in minimalist frames or a leather-on-board wall hanging from Michelle Peterson-Albandoz. (5, 6, 7)

Creating seamless transitions between
inside and outside is a defining
characteristic of Pask's home.
Walls of windows enable a north-to-
south vista from the cantilevered
porch through the dining room to the
poolside patio. (8)

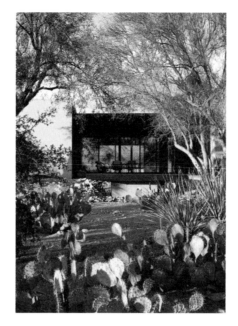

8

9

Pask takes a hands-on approach to landscaping, opting
to add native desert plants from nearby nurseries.
"I've always been protective of the landscape here at
the house," Pask says. "As long as I'm here, I'm the
caretaker of this place." (9, 10)

10

11

Clean lines play an important role
across the home, whether in the
travertine kitchen countertops,
the long, thin skylights, or the
door frames. (11)

12

After removing anything and everything
unnecessary to open up the primary bedroom,
Pask worked with with the woodworker Nate
Danforth to create a multifunctional
piece—both practical and beautiful—that
serves as a headboard, a shelf to display
prized possessions, and on the opposite
side, a hidden closet. (12)

THANK YOU

Gracias. Shukran. Merci. Hvala. Thank you. It's a simple phrase, and often one of the first we learn when taking on a new language or traveling to a foreign land. As children, we are constantly reminded of its importance by our teachers and elders. Yet, sometimes, as adults we forget just how much saying "thank you" means. It doesn't have to be big and loud and public, but there are occasions when it should be—and this is one.

They say that it takes a village. Our names may be on the cover of *Desert by Design,* but without our village, there would be no book to begin with. The biggest, warmest, most gracious thanks go to the people who opened their doors—often with practically no notice at all—and folded us right into their lives. *Desert by Design* is for you. You will inspire us, and likely so many others, for years to come. We tried our darndest to capture your essence in these pages, and *what an honor.*

We always say that a book's content—the text and photographs—are only as good as its design. One cannot exist without the other. Our long-time collaborator and friend Mario Depicolzuane, Benja Pavlin, and the Studio8585 team helped us transform a swirling cloud of ideas into something cohesive, thoughtful, and beautiful. We're eternally grateful.

We are likewise forever indebted to our editor, Laura Dozier, and the Abrams staff. We have worked with many publishers and editorial teams over the course of our careers and have never been gifted with trust quite like yours. Thank you for your endless support, for your suggestions, for your resources, and for your patience. It has been an absolute pleasure.

When at the eleventh hour, we asked the illustrator Kelly Knaga to help bring our cover to life, she replied with enthusiasm that we could only dream of. We're over the moon with the results.

This book is equally a love letter to desert people across the globe as it is to the people right here in the place that we call home—our Marfa people. We feel certain that we live in one of the best communities that there is. As such, there are too many names to name, but you know who you are and how deeply we appreciate you. We have so much gratitude for those who feed our birds, water our plants, check our P.O. box, tell us that our house is running cold, and send us words of encouragement, among many other things.

In the final days of writing, when our desperation was at an all-time high, lovely humans and kindred gourmands Simone Rubi and Rocky Barnette made us a delicious and heavily researched casserole. If we had asked them to temporarily move in with us and be our personal chefs, they probably would have done that, too.

Irolan Maroselli—and by extension, Odeylis Mederos—appeared in our first book *Made in Cuba* and then in our lives like two of the brightest stars in the West Texas sky. They are now our neighbors, but, more importantly, they are the family that we choose and the godparents to our beloved dogs. We owe our ability to travel for extended periods—and so much more, like our author portrait—to them.

If we're talking about the celestial sphere, our parents, collectively, are our North Star. Sharon Mandell is our first reader for always. She is one of the busiest people that we know and yet, she invariably carves out time for our work. And when it's done, she champions it like nobody else. Martin Burke, meanwhile, is our biggest cheerleader. "Persevering, striving, maintaining energy," he reminds us on the hard days, "are the sole ingredients for success." For as long as we have been together, David Mandell has been our sounding board on long drives across the desert. In the midst of production, we forgot about his birthday, instead furiously messaging him about the trials and

tribulations of travel, but he laughed it off and gave us a big hug when we finally did remember. Victoria Lovegren sent us uplifting notes, funny videos, and little bits of much-needed weekly love. Carolyn Doherty is a constant in our lives and never one to miss a greeting card or special occasion, even if we're halfway across the globe. Thank you, North Star, for being our guiding light—our compass—through the years.

To our families—in Austin, Cleveland, the Outer Banks, Philadelphia, Portland, and beyond—thank you for being our pillars. Everything that we do is in honor of the giants who came before us: Angela Burke, Eamon Doherty, Audrey Lovegren, and Maurice and Natalie Mandell. And to the younger generation, one that includes Ava Doherty and Juliet Burke: We push for a world that is more accepting, more sustainable, and more generous for you. Stay creative, always.

Through this journey, we used three trusty cameras—our Leica M6, Leica M5, and Hasselblad 500CM—to shoot hundreds of rolls of film. Each and every one was mailed to Richard Photo Lab (special shout out to the United States Postal Service!). Their team helped us hone our preferences to avoid excessive hours editing, and Courtney Droke fielded countless questions and urgent requests. During an uncharacteristic lapse in our concentration, one of our lenses took a tumble and the flange was damaged. Wayne Serrano of San Francisco's Leica store, who has been our guide for all things Leica from the beginning, pointed us in the direction of the masterful Don Goldberg. Hesitantly shipping our lens his way, Don had it back to us in no time, and in even better shape than it was before the fall.

There are a number of people who went above and beyond to make our travels easier, our production smoother, and our book better. Gabriel Acosta and Scott Thrasher took care of our car when we had to leave for Mexico at the drop of a hat. In a year when we thought all holidays were on hold, Alessa Herbosch, having known us just hours, invited us to Christmas lunch and sent us to Egypt and into the new year full of warm and fuzzy feelings. We then sent her on a wild goose chase to uncover archival imagery and acquire high resolution scans. When we had to pop from Cairo to Paris for an interview, Owen Dodd let us crash in his gorgeous apartment in the nineteenth—just down the street from a favorite spot, Parc des Buttes-Chaumont, where we got engaged in 2017. Sahil Khan piloted us through hundreds of miles of the Indian countryside and dense city centers alike, always ready with a joke and a smile. We have so much appreciation for the others who helped us get our ducks in a row: Hanne Sue Kirsch and Jean Tuller at Arcosanti, Siobhan Donnelly from the Artists Rights Society, Becca PR's Alyce Bonnar, Rachel Carruth of Desertrade, Fernando Gómez Aguilera and Irene Gómez at Fundación César Manrique, Emily Howard of the McDonald Observatory, Zahraa Safwat, Thomas William, Omar, and Rashid in Siwa, and the Judd Foundation's Andrea Walsh.

There are simply not enough expressions of gratitude for our innermost circle. *La familia Chilanga,* our Mexico City family—Alonso Madrigal, Alonso Maldonado, Lucho Martinez, Bógar Adame Mendoza, and all the rest—gracias por todo. You took us in and kept our bellies and hearts full during our last leg of production. Un abrazo grande to Mariana Arriaga, who gave us an excellent lead, steering us to the one and only Sonic Ranch. Los queremos tanto.

Since meeting in El Paso in 2019, we've been on an indescribable roller coaster with Michael Diaz de Leon, Ryan Prieto, and their epic little ones, Luna and Olivia. We're not super keen on using the phrase "ride or die," but for us, there is no other cast of characters that could better fill that role. Just before we set off for New Zealand, our first international trip for the book, they sent us an unprompted package of disposable cameras. The humble, twenty-seven exposure point-and-shoot has provided amazing behind-the-scenes images of our production process.

We have shared so much with Heidi Lender since we met in Havana all those years ago. We count it as a distinct privilege to call you a mentor. We want to send a toast to our California gang—Roberta Braciulyte, Kurosch and Lukas Hatami, Mary Hoover, James Kung, Gail Provenzano, Hilary Schneider, Ross Settles, and Rich Stebbins—who always keep us upright.

And it might sound silly but on our longest days, in the depths of computer purgatory, our dogs, Hario and Kalita, always make us smile and remember life's simple pleasures, and that this—whatever *this* is—too shall pass.

There are countless people who constantly inspire us or were pivotal to this process and who we want to celebrate day in and day out: Damián Aquiles, Louis Barthélemy, Alex Bernardo, CB Bhattacharya, Laurent Buttazzoni, Hugh Corcoran, Robert Ferrell, Fritzi Fürsich, Paul Hannah-Jones, Cade Hayes, Khushnu Panthaki Hoof, Viviette Hunt, Pankaj Kanungo, Allie Laird, Didier Largillier, Randy Lewis and the whole of the American Studies department at UT Austin, Erica Loewy, Partida Creus and company, Ashlyn and Dan Perry, the Pinchi Umami crew, Jésus Robles, Linda Rodin, Pamela Ruíz, Vladimir Sepetov, Muhammed El Shafei, the Spoor family, Simone Swan, Kasia Sznajder, Alex Tieghi-Walker, Chidy Wayne, Nathan Williams, and Sam Youkilis.

We firmly believe in credit where credit is due, but inevitably we have left a very important person off of this list. If this is you, we owe you a drink.

Desert love as big as the sky, y'all.

ABOUT THE AUTHORS

We—Molly Mandell and James Burke—specialize in creative production and independent publishing consultancy. We are arts and culture writers and photographers, and our work has appeared in *Kinfolk*, where Molly was formerly an editor, the *Los Angeles Times*, *Monocle*, *Texas Monthly*, *Travel + Leisure*, *Vogue Mexico*, *Wallpaper**, and books from the design publisher Gestalten. James served as copy editor, and Molly served as editor and art director for Nathan Williams's *The Eye*, an international Amazon bestseller in 2018. That same year, we authored our first book—our first baby, so to speak—*Made in Cuba*. We have since established editorial strategy for the platform Creative Voyage and overseen publications like *Creative Voyage Paper*, the 2023 tome *Designing Brands*, and *In the Mirror*, a monograph focused on the Barcelona-based artist Chidy Wayne. Outside of editorial work, we are the brains behind numerous events across the globe. We have collaborated with the Uruguyan creative institute CAMPO, the Big Bend desert retreat Willow House, the BV Doshi–founded Vastushilpa Foundation in Ahmedabad, India, and chefs including Michael Diaz de Leon, Alonso Madrigal, Lucho Martinez, and Jair Téllez.

For over a decade, we have nurtured a relationship with West Texas. It's the first place that we traveled to as a couple and somewhere we returned to time and time again, whether living in Copenhagen or Mexico City or working in Havana and Berlin. One of our favorite writers, Lucia Berlin, dubbed the desert expanse "the Holy Land," a sentiment that we couldn't find more true. As such, we are now permanently based in the artistic enclave of Marfa. In 2022, we purchased a former section house, which sheltered the local Southern Pacific foreman, who monitored somewhere between eight to ten miles of track, and his family. Built in California with native redwood lumber and square nails in 1897 before being shipped east by rail, it was last remodeled in the 1980s. We are slowly infusing it with new life. Simultaneously, we are developing a multidisciplinary, cross-cultural residency program in the region that provides a dedicated space to slow down, connect with likeminded individuals, and explore U.S.-Mexico border culture and the Chihuahuan Desert more broadly through the lens of art, architecture, food, science, and design—a physical manifestation of the very book in your hands.

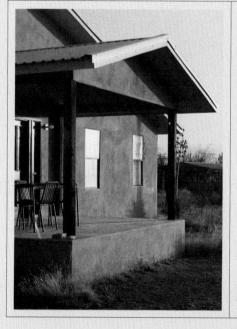

Our home——in Loomis Terracotta, a shade dreamed up by its previous owners——sits on several acres, which includes a historic barn made of railroad ties and pens in welded steel leftover from oil fields. We are carefully restoring the land where cows and horses once grazed and planting native species to create a healthy habitat for birds and humans alike.

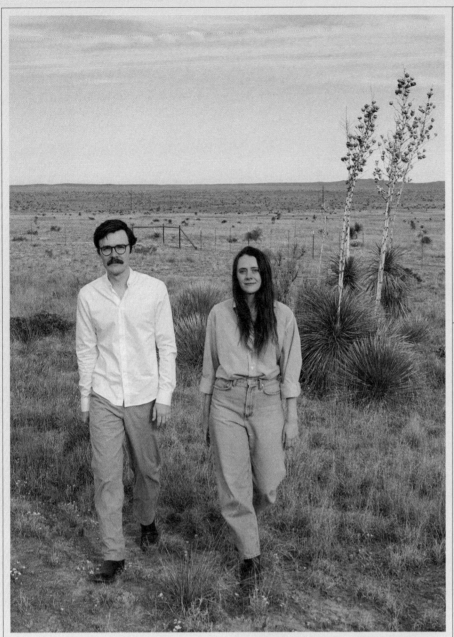

The "Mille Bolle" vase from Dana Arbib's *Vetro Alga* series—which we purchased from the gallery TIWA Select—stands atop the house's original hardwood floors and mimics the dusty greens of the cacti and grasses just outside our front door.

When we became stewards of the property, which we aptly dubbed "Section House," one of our first orders of business involved replacing wall-to-wall blue carpet in the breakfast nook. We opted for tatami mats, custom-made in Japan to better accommodate for Western-style furniture and our two mini Australian shepherds. The choice represents many things in our lives but, in part, a formative trip to the country that shaped much of how we move through the world and think about our spaces.

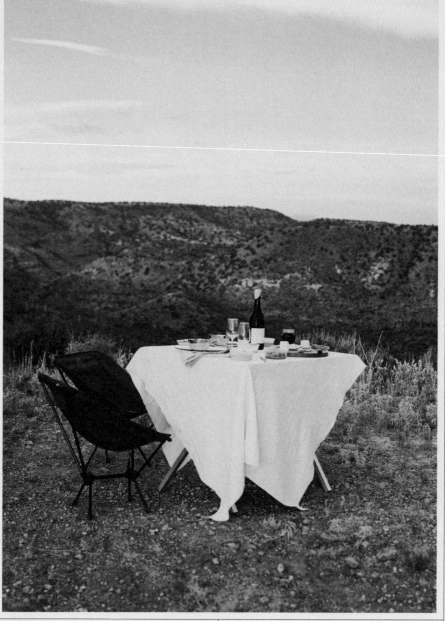

The tatami room, with its wide view of the train tracks to the south, is filled with many a guilty pleasure—miniature objects, cookbooks, and one-off stools.

For us, moving to the desert has meant better tuning in with daily and seasonal cycles. We take a moment to appreciate the sunrise, watching the landscape illuminate on our morning dog walk, and toward the end of the day, shut off our work brains to pause for a sunset cocktail. For full-moon rises, we often head south to a favorite, little-trafficked spot in our beloved rig, a modified 2002 Toyota 4Runner, which—thanks to its previous chef owner—is outfitted with a camp kitchen. These celebratory feasts offer periods of release complete with two-person dance parties as we welcome new beginnings. We'll never stop saying "wow" when the closest rock to the Earth pierces that mountainous horizon.

CREDITS

JENNY LAIRD (44–53)

Page 47, Image 2: Artwork by Thomas Schütte © 2025 Artists Rights Society (ARS), New York / VG Bild-Kunst, Bonn.

Page 48, Image 4: Artwork by Richard Serra © 2025 Richard Serra / Artists Rights Society (ARS), New York.

Page 50, Image 7: Donald Judd Daybed. Donald Judd Furniture © 2025 Judd Foundation / Artists Rights Society (ARS), New York.

Page 51, Image 10 / Page 52, Image 13: Artwork by Tracey Emin © 2025 Tracey Emin. All rights reserved, DACS, London / Artists Rights Society (ARS), New York.

THE ARCOSANTI COMMUNITY (90–103)

Page 98, Image 11: Students shoveling out the silt from under the Cat Cast roof. 1965. Photo Dan Pavillard © TheCosanti Foundation.

Page 98, Image 12: Paolo Soleri holding unfinished bronze bell in the ceramics studio. 1960s. Photo Art Twomey © The Cosanti Foundation.

Page 98, Image 13: Paolo Soleri with residents and workshop participants in the Ceramics Apse at Arcosanti in the mid-1970's. Photo Ivan Pintar © The Cosanti Foundation.

THE SONIC RANCH CREW (116–127)

Page 116: Artwork by Salvador Dalí © 2025 Salvador Dalí, Fundació Gala-Salvador Dalí, Artists Rights Society, New York.

Page 124, Image 12: Print by Pablo Picasso © 2025 Estate of Pablo Picasso / Artists Rights Society (ARS), New York.

CÉSAR MANRIQUE (128–137)

Page 135, Photo 10: César Manrique with Frei Otto and other architects during a workshop on housing of the future. © Fundación César Manrique.

Page 135, Photo 11: César Manrique and friends at the Taro de Tahíche pool. © Fundación César Manrique.

Page 135, Photo 12: César Manrique with various guests at Taro de Tahíche. © Fundación César Manrique.

PIERRE BERGÉ, YVES SAINT LAURENT, FERNANDO SANCHEZ, AND JANO HERBOSCH (206–215)

Marian McEvoy quotations from *Une Amitié Marocaine / A Moroccan Friendship: Tami Tazi, Fernando Sanchez, Yves Saint Laurent.* © Fondation Pierre Bergé-Yves Saint Laurent.

Page 214, Image 10: Yves Saint Laurent and Pierre Bergé in the dining room with the snake painted by the couturier, Dar el-Hanch, Marrakech, 1960s. © Fondation Pierre Bergé-Yves Saint Laurent.

Page 214, Image 11: Fernando Sanchez and Quintin Yearby on the Dar el-Hanch patio. © Fernando Sanchez-Quintin Yearby Foundation.

Page 214, Image 12: Pierre Bergé, Yves Saint Laurent, Fernando Sanchez, Quintin Yearby, and friends in Marrakech. © Fernando Sanchez-Quintin Yearby Foundation.

DONALD JUDD (250–257)

Quotations from *Donald Judd Writings* and *Donald Judd Interviews.* Donald Judd Text © 2025 Judd Foundation.

Page 252, Image 1: Donald Judd Furniture © 2025 Judd Foundation / Artists Rights Society (ARS), New York.

Page 253, Image 3: Untitled, 1985 / Donald Judd Art © 2025 Judd Foundation / Artists Rights Society (ARS), New York.

Page 254, Image 5: Truck at Casa Morales, Presidio County, Texas. February 1980. Photo Jamie Dearing © Judd Foundation. Jamie Dearing Papers, Judd Foundation Archives, Marfa, Texas.

Page 254, Image 6: Flavin Judd, Donald Judd, and Jamie Dearing. Presidio County, Texas. October 1975. Photo Jamie Dearing © Judd Foundation. Jamie Dearing Papers, Judd Foundation Archives, Marfa, Texas.

Page 254, Image 7: Rainer Judd at Casa Morales, Presidio County, Texas. February 1980. Photo Jamie Dearing © Judd Foundation. Jamie Dearing Papers, Judd Foundation Archives, Marfa, Texas.

BILL DAMASCHKE AND JOHN MCILWEE (288–295)

Page 294, Image 7: Artworks by Patrick Nagel © 2025 Estate of Patrick Nagel / Artists Rights Society (ARS), New York.

ABOUT THE AUTHORS (332–334)

Page 333: Portrait of James Burke and Molly Mandell. Photo Irolan Maroselli (Assistant: Odeylis Mederos).

Every effort has been made to trace copyright holders and to obtain their permission for the use of the material in this publication.

MASTHEAD

Desert by Design: Creative Minds, Arid Places, Tailor-Made Spaces
by Molly Mandell and James Burke

Editor: Laura Dozier
Design Studio: Studio8585
Design Directors: Mario Depicolzuane and Benja Pavlin
Graphic Designer: Iva Butkovic
Illustrator: Kelly Knaga
Design Manager: Danny Maloney
Managing Editors: Logan Hill and Krista Keplinger
Production Manager: Denise LaCongo

Typefaces: Immortel, Muoto, and Muoto Mono by 205TF

Library of Congress Control Number: 2024941007

ISBN: 978-1-4197-7579-6
eISBN: 979-8-88707-355-2

Text copyright © 2025 Molly Mandell and James Burke
Photographs copyright © 2025 Molly Mandell and James Burke,
except pages 98, 135, 214, 254, and 333

Jacket and cover © 2025 Abrams

Cover image from the profile of India Mahdavi and Mounir
Neamatalla (page 32)

Published in 2025 by Abrams, an imprint of ABRAMS. All rights
reserved. No portion of this book may be reproduced, stored in
a retrieval system, or transmitted in any form or by any means,
mechanical, electronic, photocopying, recording, or otherwise,
without written permission from the publisher.

Printed and bound in China
10 9 8 7 6 5 4 3 2 1

Abrams books are available at special discounts when purchased
in quantity for premiums and promotions as well as fundraising
or educational use. Special editions can also be created to
specification. For details, contact specialsales@abramsbooks.com
or the address below.

Abrams® is a registered trademark of Harry N. Abrams, Inc.

ABRAMS The Art of Books
195 Broadway, New York, NY 10007
abramsbooks.com